on April 28, 1986. Celebrating the extraordinary achievements of American artists and the diversity and richness of American art of this century, the 256-page book focuses on the quality and importance of specific paintings and sculptures in the Museum's collection.

WHITNEY MUSEUM OF AMERICAN ART: Selected Works from the Permanent Collection presents 130 outstanding works, each illustrated in color and accompanied by a brief essay by Patterson Sims, Associate Curator, Permanent Collection. Sims examines the importance of each of these masterworks within the artist's career and in the broader context of the period as a whole. In addition, detailed biographies and selected bibliographies are included for each of the 93 artists represented. Thus, the book serves as a chronicle of the development of 20th-century American art as well as an introduction to the Permanent Collection.

The Museum was founded in 1930 by Gertrude Vanderbilt Whitney, whose collection of 600 American paintings and sculptures formed the original Museum collection. More than 30 percent of the works in this publication were acquired directly

Whitney Museum
of American Art

Research for this publication was supported in part by
grants from the Andrew W. Mellon Foundation and the
National Endowment for the Arts.

Whitney Museum of American Art, New York
in association with W. W. Norton & Company, New York, London

Whitney Museum of American Art

Selected Works from the Permanent Collection

Patterson Sims

Library of Congress Cataloging-in-Publication Data

Sims, Patterson.
 Whitney Museum of American Art : selected works
from the permanent collection.

 Bibliography: p.
 1. Art, American—Catalogs. 2. Art—New York (N.Y.)
—Catalogs. 3. Artists—United States—Biography.
4. Whitney Museum of Art—Catalogs. I. Title.
N618.A53 1985 709'.73'07401471 85-17875
Paperbound ISBN 0-87427-025-1
Clothbound ISBN 0-393-02246-3

This publication was organized at the
Whitney Museum of American Art by
Doris Palca, Head, Publications and
Sales; Sheila Schwartz, Editor; Elaine
Koss, Associate Editor; and Emily
Sussek, Secretary.

Cover and title-page photograph: Anne Day

Contents

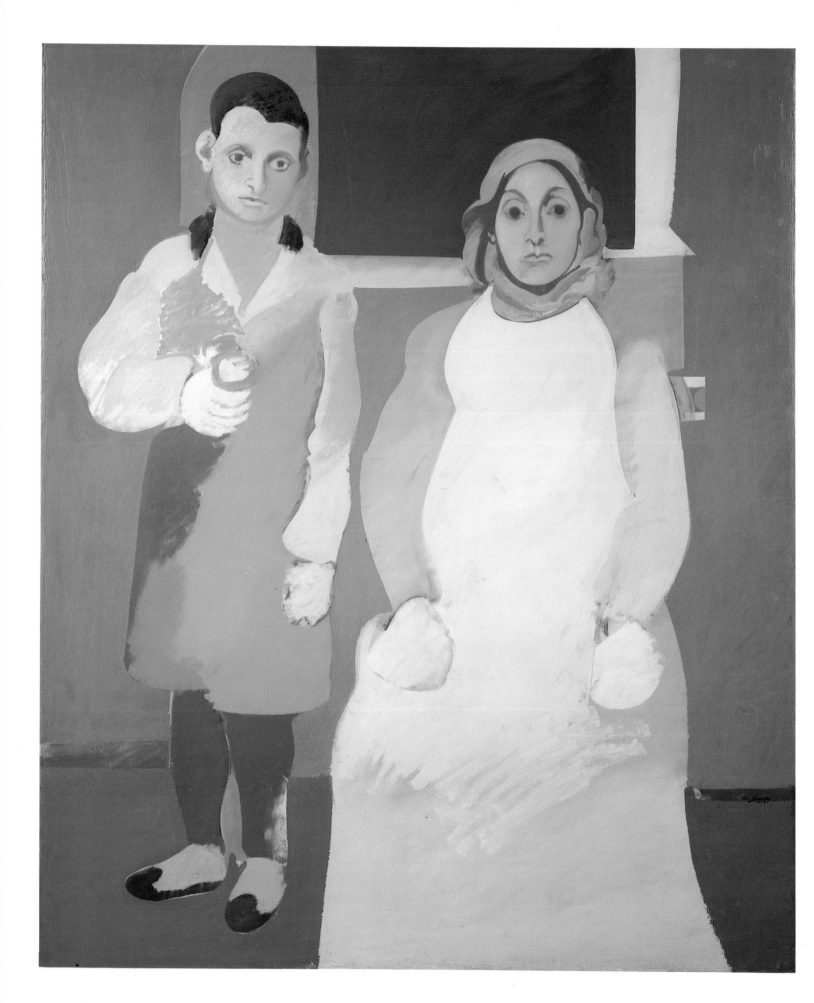

Arshile Gorky
The Artist and His Mother, c. 1926–36 (see p. 104).

Trustees and Officers
of the Whitney Museum of American Art

Foreword

A museum is distinguished from an exhibition center by the fact that it exhibits, interprets, and preserves a permanent collection; historically museums have been judged by the quality of their collections. The Whitney Museum of American Art has the most comprehensive collection of twentieth-century American art in the world. While the exhibition program encompasses the full historical range of American art, the Permanent Collection centers on the twentieth century—a reflection of the Museum's ongoing commitment to collect the work of living artists.

Gertrude Vanderbilt Whitney announced the founding of the Whitney Museum of American Art in January 1930, but her support of American artists had begun more than twenty years earlier. A sculptor in the academic tradition, she realized that there were few opportunities for independent artists to exhibit or sell their works, and from the early 1900s until her death in 1942, her abiding concern was to aid living American artists. She remains the greatest patron of American art of the twentieth century.

As early as 1907, Mrs. Whitney organized an exhibition of contemporary American art for the Colony Club, a women's club in New York City of which she was a founding member. The following year she purchased four of the seven paintings sold from the landmark exhibition of The Eight at the Macbeth Galleries. She contributed funds to the Armory Show of 1913, and for many years paid the deficit of the Society of Independent Artists, founded in 1917.

In 1914, Mrs. Whitney purchased a brownstone at 8 West Eighth Street, adjoining her Greenwich Village sculpture studio, and converted it into a small gallery known as the Whitney Studio, which featured regular exhibitions of the work of American artists. As her activities as a patron expanded, she also acquired 10 and 12 West Eighth Street. In 1918, she established the Whitney Studio Club: any artist introduced by a member could join the Club, where annual exhibitions gave members a rare opportunity to present their work to the public without first submitting it to a jury. Many artists had their first one-person shows at the Studio and the Studio Club, among them Guy Pène du Bois, Edward Hopper, Reginald Marsh, and John Sloan.

Mrs. Whitney aided artists in numerous other ways—sending them to Europe to study, paying their hospital bills and studio rents and, most important, purchasing their works. Her circle of friends and advisers for the most part comprised artists working in the realist tradition, and her acquisitions reflected her preference for art in that tradition rather than works which attempted to assimilate the concepts of European modernism.

By 1929, Mrs. Whitney owned more than five hundred works by American artists, and she felt the public should have an opportunity to see the collection. That year she offered the collection to the Metropolitan Museum of Art, whose director refused her offer before she even had a chance to express her intention to build and endow a Whitney wing. This abrupt rejection only served to challenge Mrs. Whitney, who announced in January 1930 that she would establish her own museum with a new and dramatically different mandate—to support American artists.

The Whitney Museum of American Art opened to the public in November 1931, in the three remodeled brownstones on West Eighth Street, with Juliana Force, who had run the Whitney Studio Club and aided Mrs. Whitney in all her activities as a patron, as its first Director. The earliest curators were artists who had long been associated with Mrs. Whitney.

In its fifty-year history, the Museum has been guided by five Directors: Juliana Force (1931–48), Hermon More (1948–58), Lloyd Goodrich (1958–68), John I. H. Baur (1968–74), and myself. The Museum has moved twice since it opened, in 1954 to a new building on West Fifty-fourth Street, on land donated by the Museum of Modern Art, and in 1966 to the present building designed by Marcel Breuer and Hamilton Smith, with Michael Irving as consulting architect, on Madison Avenue at Seventy-fifth Street.

Shortly after I became Director in 1974, a long-range Planning Committee was appointed to study the future direction of the Museum. The primary recommendation of the Planning Committee Report, approved by the Board of Trustees in 1978, was that the Museum focus on the Permanent Collection. One step had already been taken to accomplish that goal in 1976 with the hiring of the first full-time curator with specific responsibility for the Permanent Collection. In 1980, a yearlong series of exhibitions entitled "Concentrations" focused on nine artists represented in depth in the Permanent Collection, and over the past ten years both exhibition and acquisition activities have sought to build on the established strength of the Museum. Since October 1981, the third floor of the Museum has been devoted to the continuous exhibition of seventy-two outstanding works of art from the collection—the first long-term installation of the collection since the Museum was founded more than fifty years ago. The present publication complements and enriches this installation: it is the first book produced by the Museum to concentrate on the quality and importance of the Permanent Collection. The culmination of all these efforts to make the Permanent Collection a great public resource will be an expanded Whitney Museum, designed by Michael Graves, to which we look forward with great anticipation.

The works of art illustrated in this book were selected by the curatorial staff of the Museum as representing the best of the Permanent Collection. While it was hoped that collectively these examples would elucidate a history of significant developments in twentieth-century American art, their art historical context was a secondary consideration. The primary criterion in the selection process was the quality of the individual object.

Together, these works not only document the strength of the Permanent Collection of the Whitney Museum, but they reveal much about the history of the institution, its leadership, and how it has advanced Mrs. Whitney's commitment to living artists. Even more important, these objects celebrate the extraordinary achievements of American artists and the diversity and richness of American art of this century.

Tom Armstrong
Director

9

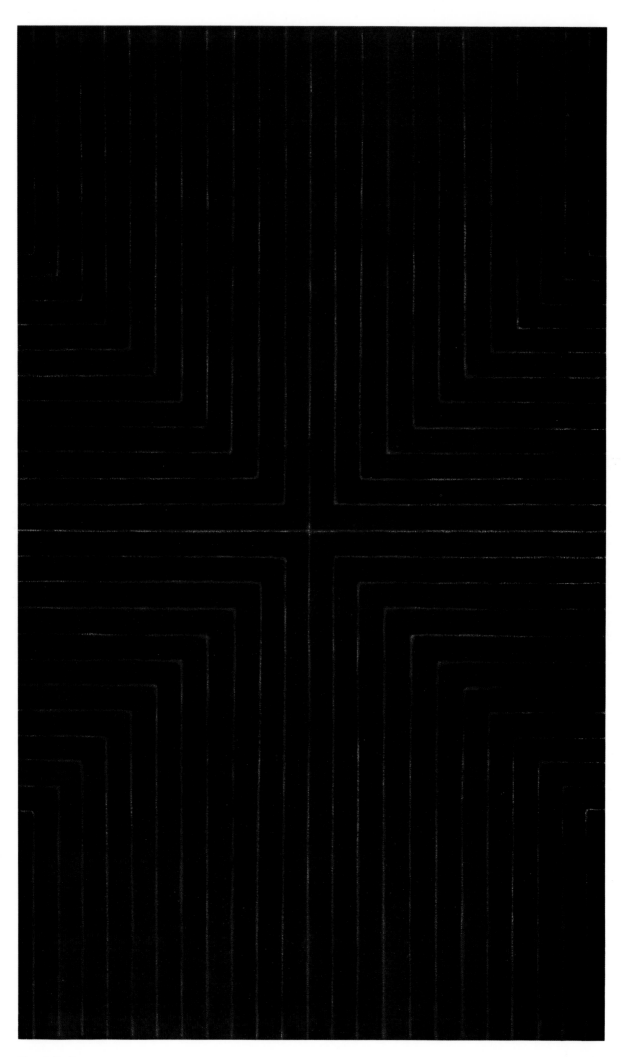

Frank Stella
Die Fahne Hoch, 1959 (see p. 156).

Introduction

In 1930, Gertrude Vanderbilt Whitney explained why she was founding the Whitney Museum of American Art:

it is not as a repository of what American artists have done in the past that the museum expects to find its greatest usefulness. . . . Ever since museums were invented, contemporary liberal artists have had difficulty in "crashing the gate." Museums have had the habit of waiting until a painter or a sculptor had acquired a certain official recognition before they would accept his work within their sacred portals. Exactly the contrary practice will be carried on in the Whitney. . . .

Mrs. Whitney's fundamental commitment to living artists, whether "recognized" or not, has remained central to the Museum's programs, and while acquisitions priorities have shifted from time to time, the Museum has consistently emphasized the importance of collecting works by contemporary American artists.

The five hundred works Mrs. Whitney acquired prior to 1930 form the nucleus of the Museum's holdings, which now include nearly ten thousand objects. In 1931, before the Museum opened to the public, she acquired an additional one hundred works in order to transform a distinctly personal collection into a more definitive survey of twentieth-century American art.

She continued to make regular gifts of works of art during her lifetime, and also bequeathed funds which were used for purchases after her death. More than 30 percent of the works in this book were acquired directly through Mrs. Whitney's patronage.

The paintings by The Eight which commence this selection, along with later works by Charles Burchfield and George Bellows, assert the realist foundation of American twentieth-century art. Throughout her life, Mrs. Whitney preferred realism to abstraction, and it was only after her death that works by American modernists were collected by the Museum in any depth. The pioneering explorations of color and form produced from the teens on by Arthur G. Dove, Marsden Hartley, Stanton Macdonald-Wright, Patrick Henry Bruce, Oscar Bluemner, and Georgia O'Keeffe were acquired long after they were made, and seldom by Mrs. Whitney.

A similar situation occurred with the Museum's acquisition of sculpture. With the exception of Gaston Lachaise's *Standing Woman* and *Dolphin Fountain*, Mrs. Whitney's acquisitions of sculpture were not notable. It was only after 1960, with the inspired support and generosity of Howard and Jean Lipman, that sculpture attained a position equal to painting in the Permanent Collection. Nineteen of the sculptures in this publication came to the Museum as gifts from the Lipmans or were purchased with funds they contributed.

Some of the collection's other strengths, however, can be traced directly to Mrs. Whitney. Key Precisionist paintings by Charles Demuth, Charles Sheeler, Joseph Stella, Elsie Driggs, and Ralston Crawford were purchased by Mrs. Whitney or with her funds early in the Museum's history. The more recent acquisition of John Storrs' monumental *Forms in Space #1*—a gift in honor of Mrs. Whitney, her daughter, and granddaughter—provides a sculptural equivalent to the lean classicism of these paintings.

Such cool assessments of America were replaced in the 1930s with a social concern, a nationalistic outlook, and a factual specificity that evoked the detailed reportage of The Eight. Social and urban realists —Peter Blume, Reginald Marsh, Guy Pène du Bois, Ben Shahn, O. Louis Guglielmi, Edward Hopper —and their rural counterparts, the American Regionalists, furthered Mrs. Whitney's aesthetic preferences. As a result of the Museum's long-standing commitment to Hopper and Marsh, their widows made sizable bequests to the Permanent Collection. Josephine N. Hopper's 1968 bequest of Hopper's artistic estate, comprising over 2,500 works, remains the largest gift of a single artist's work made to any American museum.

Following the death of Gertrude Vanderbilt Whitney in 1942 and that of Juliana Force, the Museum's first Director, in 1948, a pivotal shift of acquisition policy occurred. Through Juliana Force, Mrs. Whitney had supported the Museum solely with her own funds. With the deaths of these two extraordinary women, the Museum ceased to be an instrument of personal philanthropy and had to seek other means

of financial assistance for acquisitions. The first work to enter the Permanent Collection that had neither been given by Mrs. Whitney nor paid for by her funds to the Museum was Ben Shahn's *The Passion of Sacco and Vanzetti*, donated in 1949 in memory of Juliana Force. Since then such gifts have fortunately become commonplace and are now augmented by funds from acquisition committees.

This change in acquisition policy occurred just as artists in New York, buoyed by a wave of artistic and intellectual immigrants, were developing a native brand of emotion- and symbol-laden abstraction. Stuart Davis and Alexander Calder were the first American-born artists who bridged the gap between the insularity which characterized American art and the Whitney Museum prior to World War II and the internationalism which dominated the postwar years. Mrs. Whitney's early support of Davis provided him with his only opportunity to travel to Europe and resulted in the core of the Museum's substantial holdings of his art, now numbering twenty-one paintings, drawings, and prints. This concentration is modest compared to the Museum's holdings of Calder. More of Calder's art is owned by the Whitney Museum than by any other institution. The lengthy acquisition credit for *The Circus*, among the highlights of the Museum's Calder collection, is the most convincing evidence of the broad support the Museum now enjoys.

In the post–World War II period, American art achieved international preeminence and, despite the recent

emergence of a new generation of European painters, New York has remained the economic and artistic center for contemporary art. The works of three generations of American painters and sculptors—Abstract Expressionists, Pop artists, and Minimalists—have been acknowledged as the seminal creations of the age. Yet from the late 1940s through the mid-1960s, the Whitney Museum acquisition policy seemed predicated on a democratic spread of support that left many major postwar figures, such as Jackson Pollock, Barnett Newman, Robert Rauschenberg, Mark Rothko, and Clyfford Still, represented by just a single major work each. Moreover, following Mrs. Whitney's death in 1942, Museum funds had been increasingly devoted to operating costs, and only with the emergence of the Friends of the Whitney Museum of American Art (1956) did sufficient funds become available for the collection to pursue individual artistic achievement in depth. Funding from the Friends, the Museum's first membership group, has helped acquire eighteen of the paintings and sculptures presented here.

The acquisition of Frank Stella's *Die Fahne Hoch* as a partial gift and purchase in 1975—for what was at that time a record purchase price for the Museum—marked a new era: a commitment to attain masterpieces through specially raised purchase funds. This practice was dramatically continued with the 50th Anniversary Gift of Jasper Johns' *Three Flags* and the public-aided campaign to purchase Calder's *Circus* in 1983, led by the Museum's Director, Tom Armstrong. With this campaign, attention was focused upon the Permanent Collection as never before.

Over two thousand works have been acquired since 1976, representing one-fifth of our present holdings. In 1976, a curator with the primary responsibility for the Permanent Collection was hired for the first time, and later a separate adviser for prints and an adjunct curator for drawings joined the staff. In addition to the Painting and Sculpture Committee, individual committees were established for drawings (1976) and prints (1983). A new emphasis was placed on acquiring the works of individual artists in depth; among these, Marsden Hartley, Donald Judd, Willem de Kooning, Reginald Marsh, Agnes Martin, Georgia O'Keeffe, Ad Reinhardt, Mark Rothko, and David Smith now have major representation in the Museum's collection. Beginning in 1981, the third floor of the Museum was devoted to a permanent installation of over seventy masterworks of painting and sculpture from the Permanent Collection. Through special exhibitions at the Museum's new branches and in exhibitions organized solely for travel, the Permanent Collection has become more visible and received more critical attention than at any time in the past.

Through all its acquisitions, the Museum continues to reflect the diversity of American art. The realist tradition was once again advanced in the 1950s and 1960s with the acquisition of works by Larry Rivers, Alfred Leslie, and Edward Kienholz. It achieved new style and sociological scrutiny with Pop Art and cool detachment from its humanistic foundations in the work of

Philip Pearlstein, Chuck Close, and Duane Hanson. The continuities in American painting are underscored in the urban realism of John Sloan's *Backyards, Greenwich Village* (1914) and Richard Estes' Manhattan view, *Ansonia* (1977).

The modernism of the teens was carried to its ultimate reduction in the Minimalism of the 1960s and 1970s. The final nine works seen here are stripped of conventional content; they exist as pure, exhilarating visual expressions. Insistent upon a radical act of seeing unencumbered by subject matter, these works set a stark stage for the return of iconography and narrative to American art in recent years.

The support of the Whitney Museum for contemporary art is an ongoing commitment. Yet today, because the Museum has become the most comprehensive repository of twentieth-century American art, the acquisition of an artist's work confers more of what Mrs. Whitney termed "a certain official recognition" than she may have foreseen in 1930. In the more than fifty years since its founding, the Whitney Museum has become a vital "repository" of a now historic era of American greatness.

Patterson Sims
Associate Curator, Permanent Collection

Acknowledgments

This publication continues the process of making the strengths of the Permanent Collection of the Whitney Museum of American Art more visible to the public. Although it builds upon the numerous publications issued by the Museum since its opening in 1931, it is the first book to offer an in-depth assessment of the breadth of the collection. The texts on each work benefited from the often extensive literature on the artists; all of the authors listed in the bibliographies are acknowledged with gratitude. Numerous scholars and the artists or their families have responded to questions promptly and informatively. Curatorial colleagues at the Whitney Museum were generous with information about the artists they have studied and written about. The Registrar's office, in particular Elizabeth Carpenter, Sandy Seldin, and Heidi Shafranek, have facilitated the study of the more than 130 works and the documents that accompany them. The resources of the Whitney Museum Library and the assistance of Tim Nolan and librarian May Castleberry were crucial to the completion of these essays, as was the editorial contribution of Sheila Schwartz and Jennie Ratliff. Cheryl Epstein's patience and good humor in typing the numerous revisions of the essays are acknowledged with gratitude. The support of Whitney Museum interns Matthew Drutt, Leslie Shick, Jody Zellen, Mimi Balderston, Jack Becker, and Lee Stewart was critical to the realization of the project. Above all, the book was given its form and expanse by the Director, Tom Armstrong, and was carefully overseen by Jennifer Russell, Assistant Director, Program.

P. S.

Stuart Davis
Owh! in San Paô, 1951 (see p. 92).

Artists

Plates

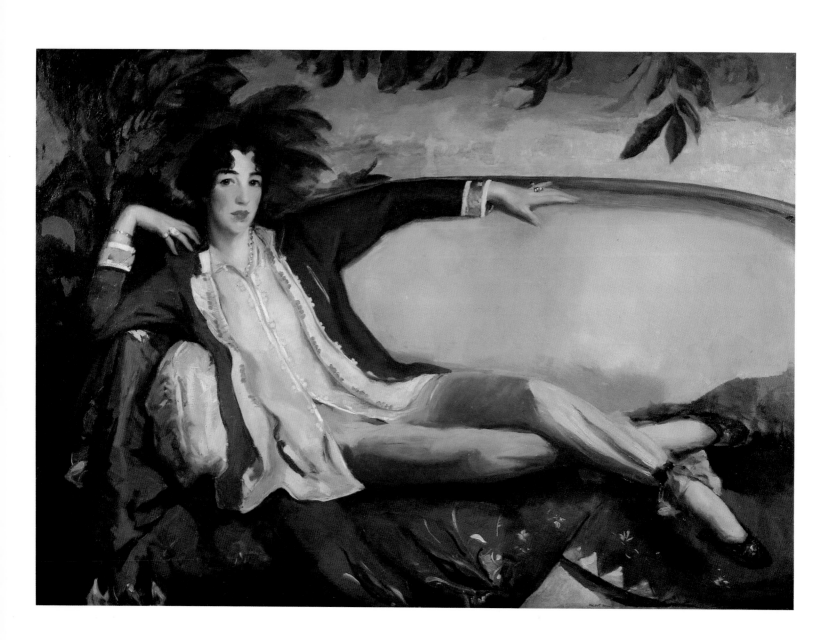

Robert Henri

Gertrude Vanderbilt Whitney, 1916

Oil on canvas, 50 x 72 inches (127 x 182.9 cm). Promised Gift of Flora Whitney Miller P.32.77

The influential artistic philosophy of Robert Henri, well-known teacher and leader of The Eight, stressed the direct representation of the urban scene. As a painter, however, Henri was increasingly absorbed in portraiture—in his early work he produced murky celebrations of commonplace types, usually rendered with thickly applied, confident brushstrokes that became even more assured and sleek as he aged.

Henri initially attracted the patronage of Gertrude Vanderbilt Whitney in 1908, when his *Laughing Child* (1907) became one of four works she acquired from The Eight's Macbeth Galleries show. Eight years later, she commissioned her portrait from him for a fee of $2,500. The portrait reveals how far Henri had moved from the dark palette of his earlier painting. Bejeweled and smartly clothed in a stylish silk lounging suit, Mrs. Whitney hardly looks her forty-one years, though a contemporary fashion photo by Jean de Strelecki confirms the painting's accuracy.

Like the reclining women painted in the nineteenth century by Goya and Manet, Mrs. Whitney presents herself to the public as she could only be seen privately. In the spirit of a court painter, Henri depicted her as youthful, stylish, and self-possessed. Of the numerous sculptures, paintings, photographs, and drawings of Mrs. Whitney, Henri's portrait most definitively reveals her openness and elegant bohemianism.

This painting was shown in 1916 in the first of a three-part series of exhibitions at the Whitney Studio, an exhibition annex to Mrs. Whitney's sculpture studio. The series, entitled "To Whom Shall I Go for My Portrait?," may have been inspired by Mrs. Whitney's appreciation of Henri's portrayal. She conceived the exhibitions as a way of matching up the economic needs of young American artists with the vanity of her friends.

Mrs. Whitney's support of twentieth-century American art had only just begun. For the next twenty-five years, she became a major collector of American art and provided encouragement and exhibition space for artists, first through the Whitney Studio and Whitney Studio Club and, from 1930 on, through her founding and support of the Whitney Museum of American Art.

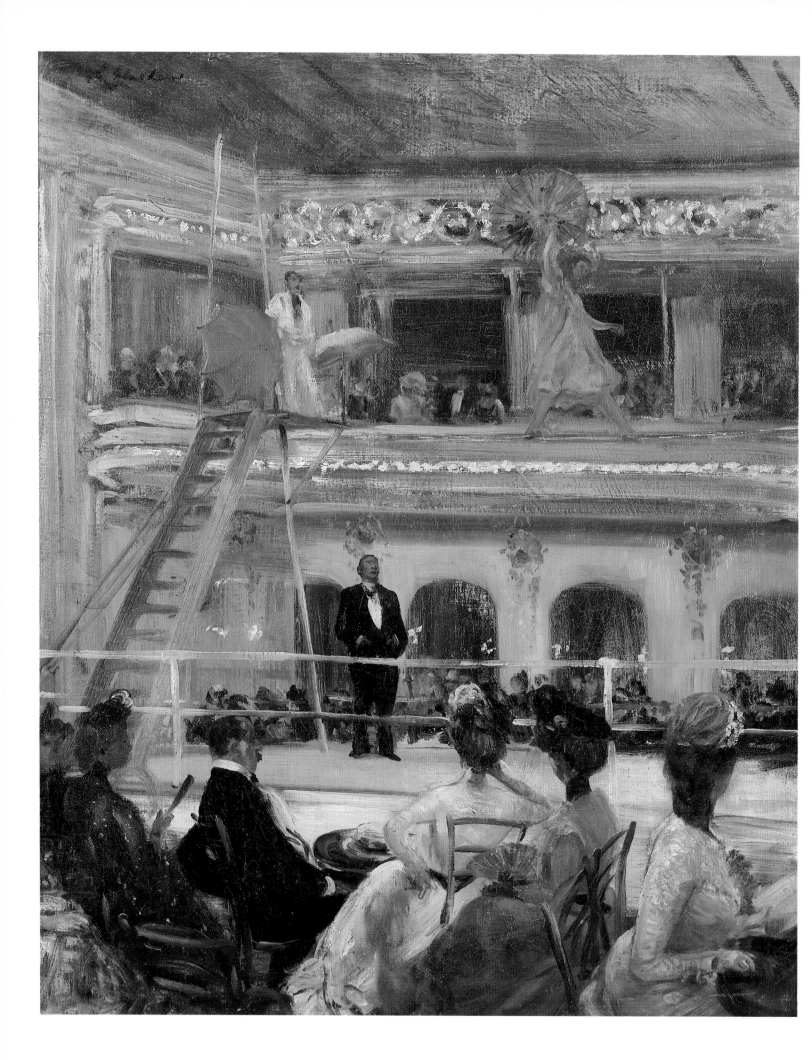

William J. Glackens

*Hammerstein's
Roof Garden,* c. 1901

Oil on canvas, 30 x 25 inches (76.2 x
63.5 cm). Purchase 53.46

In striking contrast to the turgid,
academic, or allegorical imagery
that prevailed in American art at
the turn of the century, a group of
Philadelphia-trained artist-illus-
trators chose dark, unglamorized,
or commonplace views of contem-
porary urban existence. Everett
Shinn, George Luks, John Sloan
(pp. 26, 27), and William Glackens
—urged on by Robert Henri—
made street life and the world of
popular entertainment their sub-
jects, always rendering them in an
impressionistic manner. After
Glackens moved to New York in
1896, he continued to support him-
self as a newspaper and magazine
illustrator, until the early 1920s.
As with the other Philadelphians,
Glackens found that his work as an
illustrator sharpened his consider-
able depictive skills and merged
with his art. In *Hammerstein's
Roof Garden* he chose one of the
most fashionable nightspots of the
day and used swift brushstrokes to
capture the scene. Oscar Hammer-
stein owned a succession of roof
gardens, built above his theaters,
which provided stage entertain-
ments in cabaret style, with patrons
seated at tables. Originally open-air,
they were later roofed over for the
colder months. The roof garden in
this painting was probably Ham-
merstein's Paradise Roof Garden,
which opened around 1900 above
both the Republic and Victoria
theaters, located at the then un-
frequented corner of Seventh Ave-
nue and Forty-second Street. It
contained a miniature, functioning
Swiss farm and dairy, complete
with a goat, cows, ducks, chickens,
and a costumed milkmaid. Its
vaudeville program varied from
the Spanish dancer Carmelita and
bicycling jugglers to the tightrope
act seen here.

The date of *Hammerstein's Roof
Garden* is not firmly set, but it was
probably painted shortly after the
roof garden opened for business.
The style of the work—its mono-
chrome tonality and uncontrived,
cut-off composition—further con-
nects it with the paintings Glackens
executed in the years 1901–03.

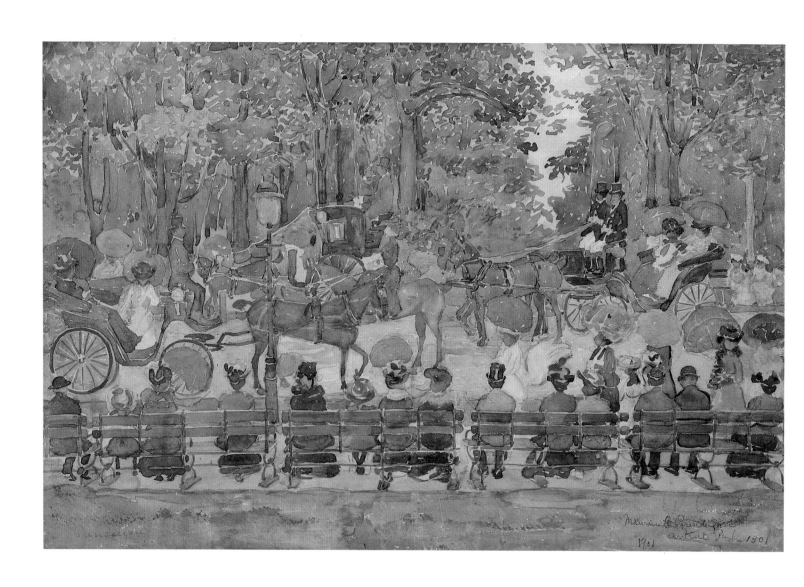

Maurice Prendergast

Central Park, 1901, 1901

Watercolor on paper, 14⅜ x 21½ inches (36.5 x 54.6 cm). Purchase 32.42

In 1900, Maurice Prendergast, newly returned to his native Boston from his second European trip, became affiliated with the important Macbeth Galleries in New York City. In March, the gallery held its first show of his watercolors and monotypes. It was critically well received, several sales were made, and Prendergast began to visit New York regularly. Among the first works that derived from these trips were numerous watercolors of Manhattan's Central Park. Along with his earlier views of Venice, Prendergast's Central Park watercolors demonstrate his extraordinary technical ability as a watercolorist. Richly detailed and precise in representation, their mosaic of colors conveys a visitor's delighted infatuation with this celebrated urban playground. The clearly theatrical presentation of *Central Park, 1901* —the watercolor's layered, frieze-like idiom—underscores the quality of detached observation which is an essential feature of Prendergast's aesthetic sensibility.

The loose, dappled brushwork of *Central Park, 1901,* reminiscent of the French Nabis group, is Prendergast's concession to modernism. But the treatment of the subject itself is purposely outmoded. Neither bicycles nor automobiles appear, and the representation of horses in motion ignores the breakthrough made in Eadweard Muybridge's 1878 photographs, which capture the exact movements of a striding horse. Prendergast's view is, instead, a halcyon vision of a well-ordered, placid world at the brink of a new century.

Maurice Prendergast

The Promenade, 1913

Oil on canvas, 30 x 34 inches (76.2 x 86.4 cm). Bequest of Alexander M. Bing 60.10

After 1905, the delicacy, detail, and clarity of Maurice Prendergast's early urban watercolors were supplanted by the blurred pointillism of such oils as *The Promenade*. Prendergast used this modernist style to paint pastoral seaside scenes of sites around Boston. Color is explored for its own sake, and figural proportions are enlarged. The whole effect is decorative and arcadian, in a manner that reflects the paintings of Henri Matisse, four of which Prendergast sketched in 1913 while visiting the Armory Show. By combining idyllic subject matter and opalescent color in *The Promenade*, Prendergast injects fantasy into his reportage of the Massachusetts seaside setting. His isolated and uncommunicating females disport balletically across the shore. The sylphs by the sailboat-dotted sea are randomly clothed and unclothed and sometimes nearly merge into the background. One figure seems to be striding on water.

Prendergast's artistic development and easy assimilation of modernism attracted American collectors of more advanced tastes than those drawn to the other painters of The Eight. In fact, *The Promenade* was formerly owned by John Quinn, the most discerning and acquisitive American patron of avant-garde art and literature in the first quarter of the twentieth century.

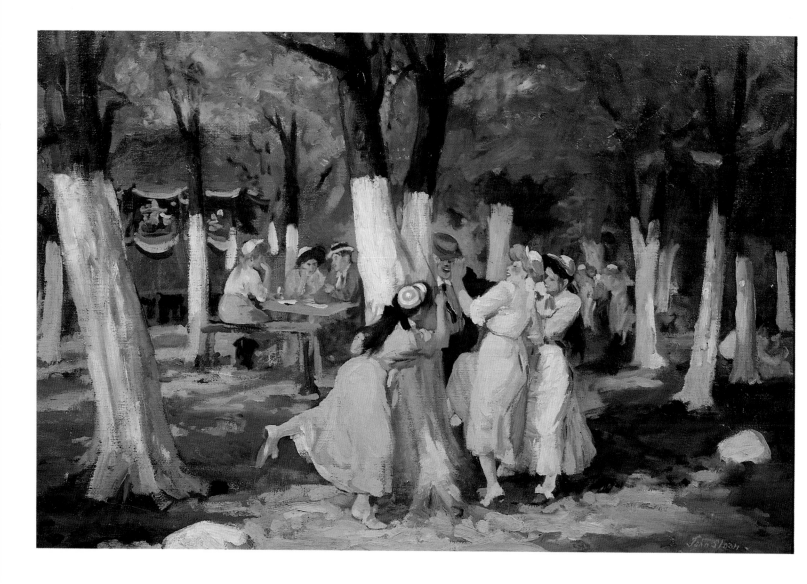

John Sloan

The Picnic Grounds,
1906–7

Oil on canvas, 24 x 36 inches (61 x
91.4 cm). Purchase 41.34

Backyards,
Greenwich Village, 1914

Oil on canvas, 26 x 32 inches (66 x
81.3 cm). Purchase 36.153

In 1939, John Sloan described his
early painting *The Picnic Grounds*
as a "scene in which these adoles-
cent boys and girls frolic like bear
cubs." Sloan and his first wife,
Dolly, had observed these goings-
on while spending the afternoon of
Decoration Day (May 30, 1906) in
Bayonne, New Jersey. Near a patri-
otically decorated dancing pavilion,
in a grove of trees treated with a
cheerful, protective, white coating,
Sloan saw "young girls of the
healthy lusty type with white
caps jauntily perched on their
heads. . . ." Back in New York
City a few days later, he began to
paint the scene from memory—his

usual practice. *The Picnic Grounds*
was not completed until the end of
the following February, in time for
inclusion in the National Academy
of Design annual exhibition. The
painting was not in The Eight's
landmark exhibition at the Mac-
beth Galleries in New York, but it
did accompany the traveling version
of the show. Despite this exposure,
it was rejected by the international
jury of the Carnegie Institute in
Pittsburgh in 1909.

 In *The Picnic Grounds,* color is
used in incidental patches and cre-
ates a bright palette, which was
unusual for the artist in this early
period. Also, by comparison with the
conventional, contemporary depic-
tions of women—perceived as silent,

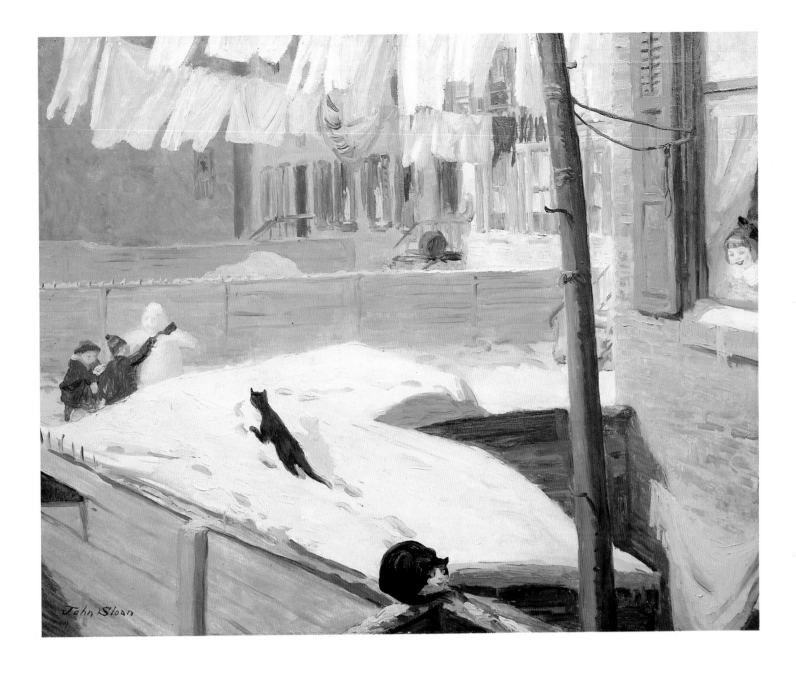

confined, and inactive—Sloan's females are communicative, joyous, and lively. *The Picnic Grounds* was conceived in a democratic spirit: whether talking or at play, the men and women are treated as equal beings, co-workers delighting in a special day off.

Sloan's participation on the all-artist organizing board for the 1913 Armory Show and his activity on the show's hanging committee made him a frequent visitor to this seminal exhibition of European and American vanguard art. These visits encouraged the development of new, formalist ideas in his own work and helped him move beyond his beginnings as a pictorial reporter. Henceforth, instead of depending on fortuitous inspiration and perceived social messages, his documentary observation would be fused with a concern for compositional dynamics and a more imaginative palette.

Sloan had his first measure of economic success in 1912 and that year he established a separate studio at 35 Sixth Avenue in New York. He was already "in the habit of *watching every bit* of human life I can see about my windows, but I do it so that I am not observed at it." These surreptitious "vigils at the back window" of his Greenwich Village studio and living quarters produced many of his most poignant and memorable prints and paintings. *Backyards, Greenwich Village* is a view from the previous apartment he and his wife shared, a few blocks away at 61 Perry Street. Painted from memory and based on a pencil sketch, it is an especially effective mixture of reportage and imagination. In Sloan's later assessment of the work, he found "the winter atmosphere and color well rendered, the cats unforgettable."

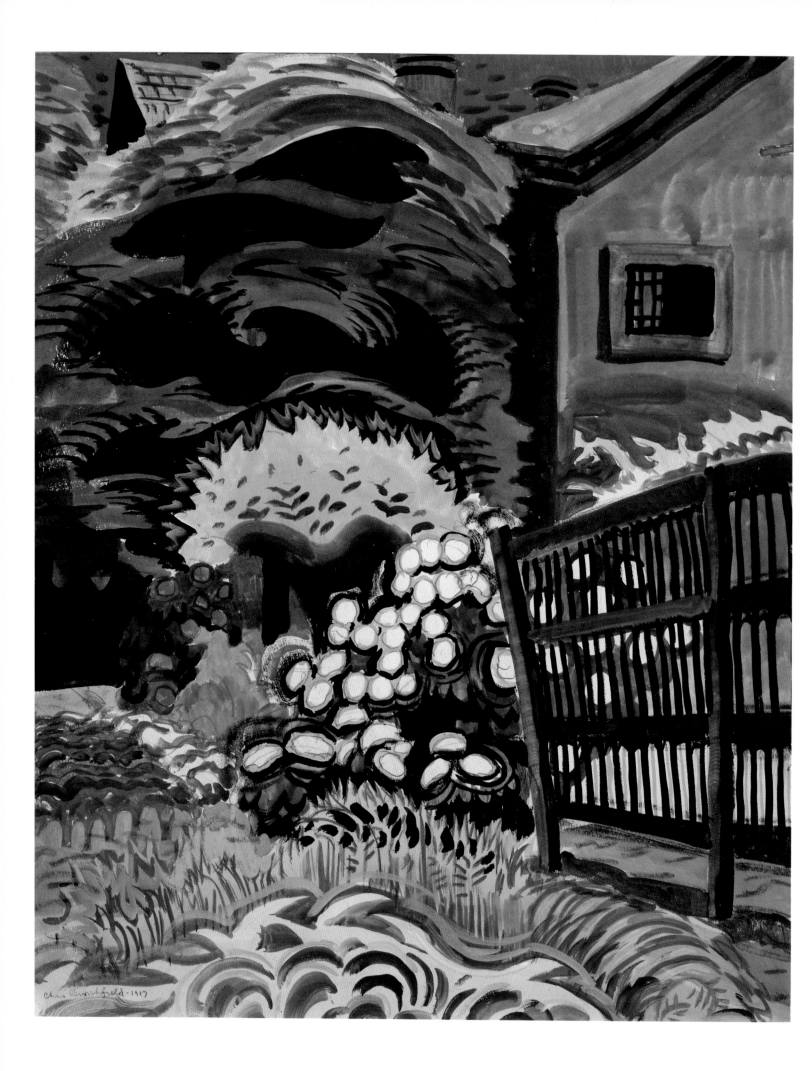

Charles Burchfield

Noontide in Late May, 1917

Watercolor and gouache on paper, 21⅝ x 17½ inches (54.9 x 44.5 cm). Gift of Gertrude Vanderbilt Whitney 31.408

After studying for four years in Cleveland and briefly in New York, Charles Burchfield returned to his hometown of Salem, Ohio, in late 1916. He began to paint in his spare time, using the landscape to convey his own moods and feelings. Following his two months in New York, his rural surroundings had a special resplendence for him. No longer a student, he now considered himself a professional artist, and he later described 1917 as his "golden year." He ceased his earlier practice of making a primary pencil sketch to be filled in with watercolor. Now he brushed colors directly onto paper and created the freest and most lyrical works of this first phase of his career. Paradoxically, this expansive freedom was accompanied by his compilation of a notebook entitled "Conventions for Abstract Thoughts"—small pencil renderings representing about twenty darker states of mind, such as Imbecility, Fear, Fascination of Evil, and Dangerous Brooding. While *Noontide in Late May* contains in its windswept tree and flowering bushes graphic stylizations that relate to some of these abstract conventions, it is hardly morose, but rather exuberant in mood. From a commonplace scene (the artist's rural Ohio backyard) Burchfield developed a dynamic, almost exotic, reality. The drab wood fence and building are not so much contrasted with the power of nature as suffused by its radiant beauty. Burchfield described the work, in a penciled note on its reverse, as "an attempt to interpret a child's impression of noon-tide in late May—The heat of the sun streaming down, & rosebushes making the air drowsy with their perfume." His poetic description only begins to evoke the work's tempestuous harmonies and its resonating sequences of patterns, colors, and shapes.

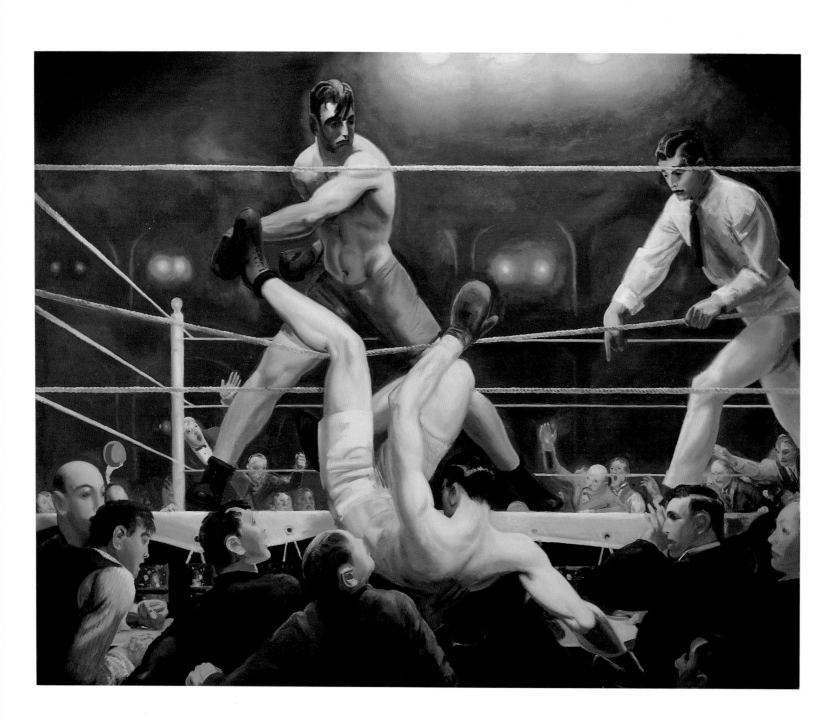

George Bellows

Dempsey and Firpo, 1924

Oil on canvas, 51 x 63¼ inches (129.5 x 160.7 cm). Gift of Gertrude Vanderbilt Whitney 31.95

Between 1907 and 1924, George Bellows used the prizefight as the subject of six major oil paintings and numerous related drawings and prints. *Dempsey and Firpo* was his final exploration of this theme. He remarked of the subject in general: "I am just painting two men trying to kill each other." Assigned to illustrate the fight for the New York *Evening Journal*, Bellows—and a crowd of 90,000—attended the event on September 14, 1923, at New York's Polo Grounds. Among the most famous matches of the century, the bout was short and dramatic. In the first of its two rounds, Dempsey, having knocked his Argentine challenger to the floor seven times, was himself sent through the ropes. As Bellows, sitting in the front row press area, described it: "When Dempsey was knocked through the ropes he fell in my lap. I cursed him a bit and placed him carefully back in the ring with instructions to be of good cheer." Although Dempsey went on to victory by a knockout in the second round, Bellows chose this earlier episode for the newspaper illustration (which never ran, owing to a printers' strike). A pair of prints, preparatory sketches, and this painting were made the following summer. According to his biographer, the artist's bald head can be seen at the extreme left, though recent scholarship suggests Bellows could be where he said he was, at the center, pushing Dempsey back into action. Only seven months after finishing *Dempsey and Firpo*, Bellows died at forty-two, at the height of his fame. The painting was acquired from the artist's widow, Emma, in 1931 for $18,500, the most expensive American work purchased by Gertrude Vanderbilt Whitney up to that time.

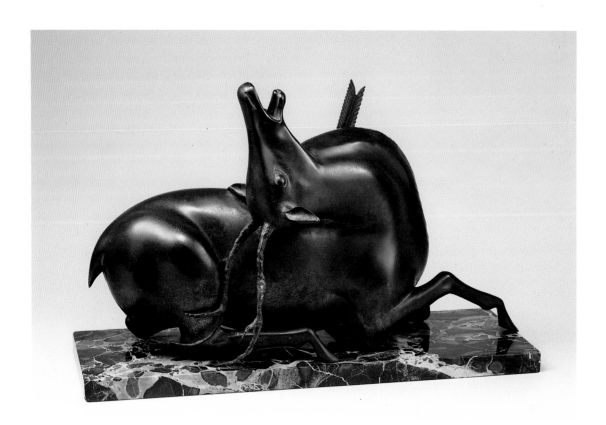

Elie Nadelman

Wounded Stag, c. 1915

Bronze, 13 x 21 x 9 inches (33 x 53.3 x
22.9 cm) with base. Gift of Mr. and
Mrs. E. Jan Nadelman 78.109

Sur la Plage, 1916

Marble and bronze, 23 x 26¼ x 7½
inches (58.4 x 66.7 x 61.9 cm). 50th
Anniversary Gift of the Sara Roby
Foundation in honor of Lloyd Goodrich
80.56

Like many sculptors before the
1940s, Elie Nadelman always cre-
ated his best work on the subject of
the human figure. But between
1912 and 1915 he turned briefly to
the depiction of animals: bulls,
deer, horses, dogs, and stags. The
period was one of major change in
his life, culminating with his immi-
gration to the United States in late
October 1914. Although Nadelman
was an artist of considerable celeb-
rity and controversy in Paris, known
for his stylish use of interplaying
curves and proto-Cubist conceits,
his animal sculptures were not pro-
duced in pursuit of polemical inno-

vation, but rather specifically
inspired by trips to bullfights in
Spain (1911) and his affection for
the circus.

Nadelman's bulls and *Wounded
Stag*, made around 1915, offer the
only views of mortality in his art.
It is tempting to conjecture that
Wounded Stag was his metaphor
for war-torn Europe. This sleek
stag, shot from above, impossibly
poised and elegant in its agony,
might well have symbolized Europe
from the perspective of the recently
arrived immigrant. In several of its
six (and possibly more) casts, the
arrow was omitted, its violence too
troubling to owners. From a formal
point of view, the piece concisely
exemplifies Nadelman's statement

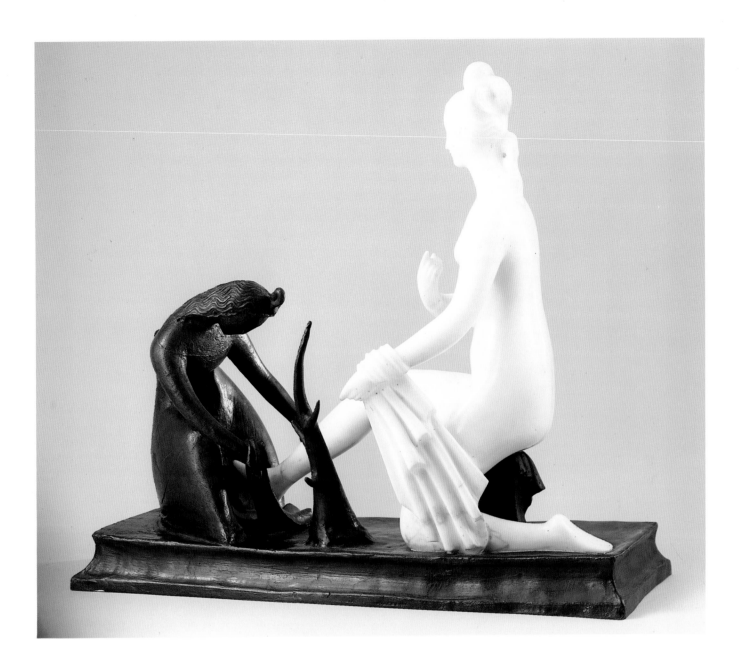

in the October 1910 issue of *Camera Work*: "I employ no other line than the curve, which possesses freshness and force. I compose these curves so as to bring them in accord or opposition to one another. In that way I obtain the life of form, i.e., harmony."

Nadelman followed these formal principles when treating the human figure as well. He was, above all, a master of the stylized female form. Unlike his fellow immigrant and rival Gaston Lachaise (pp. 34–37), he always sublimated sensuality to stylization, employing a formalized set of omissions and abbreviations—he left out ears, made noses short and pointed, hair coiled and chignoned, hands and feet fin-like.

His figures comport themselves theatrically, posturing as if being watched. Yet, after his arrival in America, he explored more profound narrative implications and started to use two-figure groups, as in *Sur la Plage*, the only Nadelman sculpture made from two materials. Divided by a stylized tree, the marble nude bather is being dried by her bronze servant, who is kneeling and comparatively small. The elegant, glistening lady and her shadowy serving girl are at odds, their polarized stances of leisure and toil underscored by distinctions of scale and material.

Nadelman was a discriminating but rapacious scavenger from the art of the past. The smooth, sinuous perfection of the marble bather in *Sur la Plage* is a streamlined version of a Neoclassical figure by Antonio Canova, while the servant bending to dry her mistress' feet—and the implied social stratification of the action—is provocatively analogous to Rembrandt's *Bathsheba at Her Toilet* in the Louvre.

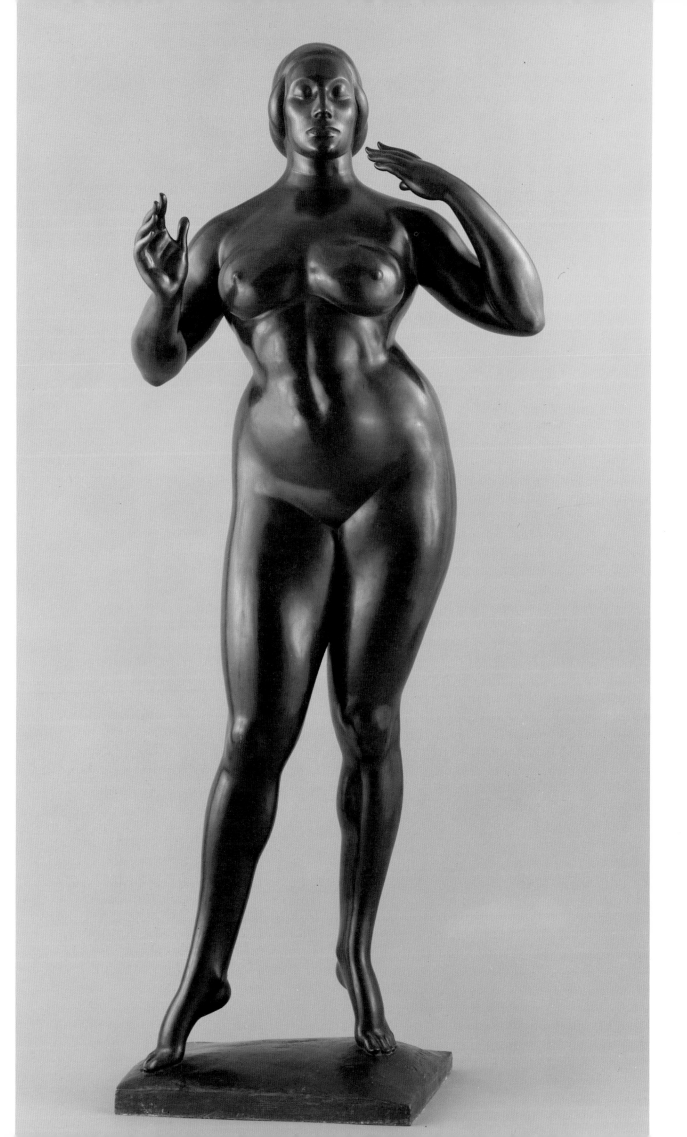

Gaston Lachaise

Standing Woman, 1912–27

Bronze, 70 x 28 x 16 inches (177.8 x 71.1 x 40.6 cm). Purchase 36.91

In *Standing Woman*, Gaston Lachaise made a twentieth-century sculptural statement about the enduring subject of the female form and, at the same time, produced his most classic and restrained monumental sculpture. Embodying the sensual with the spiritual, the figure is high-waisted, big-hipped, and full-breasted, her fecundity balanced by the calm strength and solemn introversion of her facial features and by the gesturing of her hands. Her hands have a divine eloquence that seems divorced from practical use—one draws attention to her facial repose and the other subtly resists advances.

Standing Woman was begun shortly after Lachaise's arrival in New York from Boston in 1912. Temporarily separated from his mistress (and later wife), Isabel Dutaud Nagle, he made the sculpture both a supreme homage to, and surrogate for, her compelling presence. Over life-size, and more ambitious than anything Lachaise had previously undertaken, it went through numerous versions before its earliest public exhibition, in plaster, at Lachaise's first one-artist show, in 1918 at the Stephan Bourgeois Galleries in New York. The dealer gave the piece its alternative, poetic title of *Elevation*. *Standing Woman* was first cast in bronze in 1927, for Lachaise's solo exhibition that March at the Joseph Brummer Gallery. The casting had been delayed almost a decade because of the artist's always tenuous financial situation. The Whitney Museum cast was the fourth of twelve and the first posthumous one.

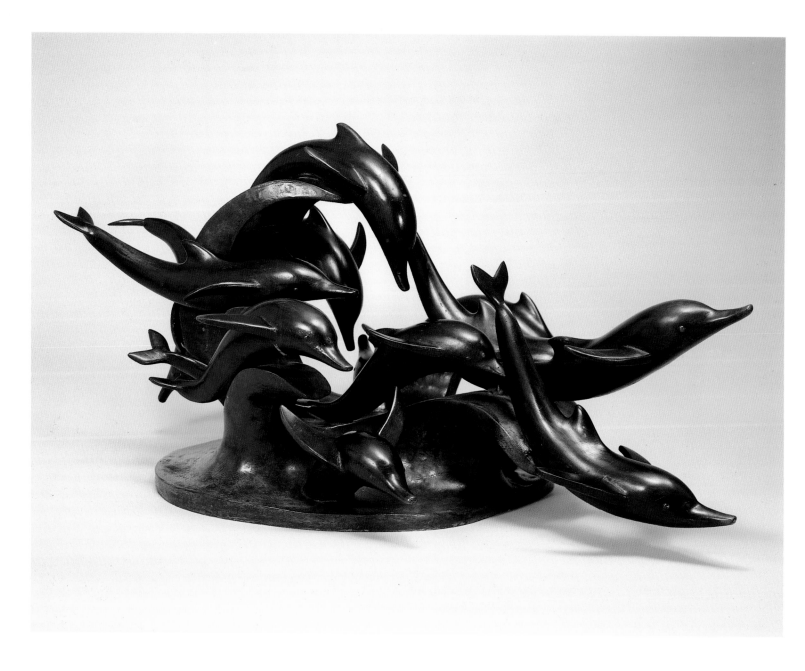

Gaston Lachaise

Dolphin Fountain, 1924

Bronze, 17 x 39 x 25¼ inches (43.2 x 99.1 x 64.1 cm). Gift of Gertrude Vanderbilt Whitney 31.41

Torso with Arms Raised, 1935

Bronze, 36¼ x 32¼ x 16½ inches (92.1 x 81.9 x 41.9 cm). 50th Anniversary Gift of the Lachaise Foundation 80.8

In a series of sculptures in the 1920s, Gaston Lachaise concentrated on the representation of figures and animals vaulting in air. The "floating" versions of his robust females seemed slightly preposterous since in reality they were supported. This paradox found a more natural expression in acrobat and animal groupings. It was with animals frozen in motion, made primarily between 1922 and 1924, that Lachaise achieved his greatest success with this theme. Sometimes graceful, sometimes whimsically comic, his leaping animal forms had their most accomplished and ambitious expression in *Dolphin Foun-*

tain. This work was the last in a series of single and multiple views of the gregarious, intelligent mammal, made from 1917 on in bronze (some of which were complete with water spouts) and in wood. Clearly among Lachaise's favorite creatures, dolphins appeared in a variety of views and sizes, ranging from this large-scale fountain (limited to an edition of two) to a commercially produced automobile radiator-cap ornament. Since the dolphin can leap 30 feet into the air, the cluster of diving and soaring forms amid cresting waves in *Dolphin Fountain* mixes realism with rhythmic arabesques. *Dolphin Fountain*, originally intended to spout water, represents Lachaise at his most appealing and most technically impressive.

36

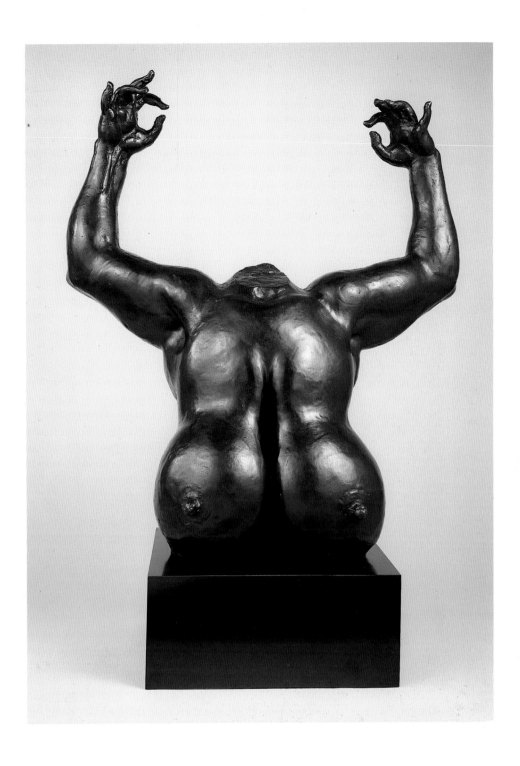

After 1928, Gaston Lachaise's sculptures and outline drawings became more frenzied and explicitly sexual. They often involved dramatic distortion, exaggerations of the female anatomy, and fragmentation. The concept of the sculptural fragment would have been familiar to Lachaise from his art studies in Paris, where students routinely drew from plaster casts of partial or damaged ancient sculptures. In modern sculpture, the use of the anatomical fragment as an artistic form had been legitimized by Auguste Rodin and was later carried into abstraction by Constantin Brancusi.

Lachaise's *Torso with Arms Raised* was made during the last year of his life, which had begun in the triumph of his retrospective at the Museum of Modern Art in New York (the largest show of his work in his lifetime and the first retrospective accorded a living sculptor by that institution). *Torso with Arms Raised*, like other sculptures from this final phase, was cast after Lachaise's death. It represents the more expressionistic turn taken in his late works. The headless form emphasizes the stark carnality of the figure. Valiant in attitude, the thickened, aging corporeality of these works is daunting. The controlled beauty of *Standing Woman* (p. 34) has been replaced by a very different conception. In his early fifties, Lachaise was clearly summoning new, more brooding, and frank meanings from the female form.

Arthur G. Dove

Plant Forms, 1915

Pastel on canvas, 17¼ x 23⅞ inches
(43.8 x 60.6 cm). Gift of Mr. and Mrs.
Roy R. Neuberger 51.20

Ferry Boat Wreck, 1931

Oil on canvas, 18 x 30 inches (45.7 x
76.2 cm). Gift of Mr. and Mrs. Roy R.
Neuberger (and purchase) 56.21

Arthur G. Dove was one of the first
artists in America and in Europe to
work non-objectively. After the
spring of 1910 he painted a series
of six small abstractions in oil on
wood. While the forms are not
clearly decipherable, they were
unquestionably based upon his
keen perceptions of the natural
landscape. Dove's modernism,
though reinforced by a trip to
Europe in 1907–09, was essen-
tially self-inspired and moved him
as far as possible from the anecdotal
figuration he was forced to pursue
in his work as a free-lance com-
mercial illustrator from 1904 to
1930.

By 1911 Dove had turned to
pastel as a more appropriate ar-
tistic vehicle than oil. Technically,
it performed well for him; it was
also easily portable and relatively
inexpensive. Moreover, since pastel
requires no liquid medium, Dove
considered it the most immediate
and direct way to render color. He
applied the pastel on linen canvas,
and sometimes on wood, so that it
became more substantial and more
easily worked than on paper.
Plant Forms is among a large
group of similarly sized pastels that
occupied Dove during the years
1911–20. Luminosity and a sense of
microcosmic space characterize the
interlaced forms. One appears to be
looking through seven or eight suc-
cessive layers of enlarged, swelling

38

vegetation. Dove's sinuous, sensate vision contrasts with the intellectual and geometric rigor of Cubism and Futurism. Its source in nature reinforces his uniquely American sensibility and defines his pioneering modernist achievement.

In the 1930s, Dove's paintings and their small preparatory watercolors became more evidently dependent on specific views, which he translated into a simplified vocabulary of nature equivalents. From 1929 to 1933, he was an unpaid resident caretaker for a Long Island yacht club, where he could see the ocean from three sides.

When *Ferry Boat Wreck* was exhibited in 1932, *The New Yorker* magazine critic accurately observed: "only the sun and the sea and the massive things of the earth are fit for Dove's handling." In *Ferry Boat Wreck*, based on a wreck in Oyster Bay, not far from where he wintered in Halesite, Long Island, Dove seemed to have realized a wish he had expressed a few years earlier: "I should like to take wind and water and sand as a motif and work with them, but it has to be simplified in most cases to color and force lines and substances." The dark forms of the wreck are outlined against a jagged band of sand

in the foreground and successive bands of waves that merge into gray-blue-green clouds. The light disk—sun or moon—that is a feature of so many of Dove's works in the late 1930s is a sign here of warnings unheeded, a mournful signal piercing the ocean's gloom.

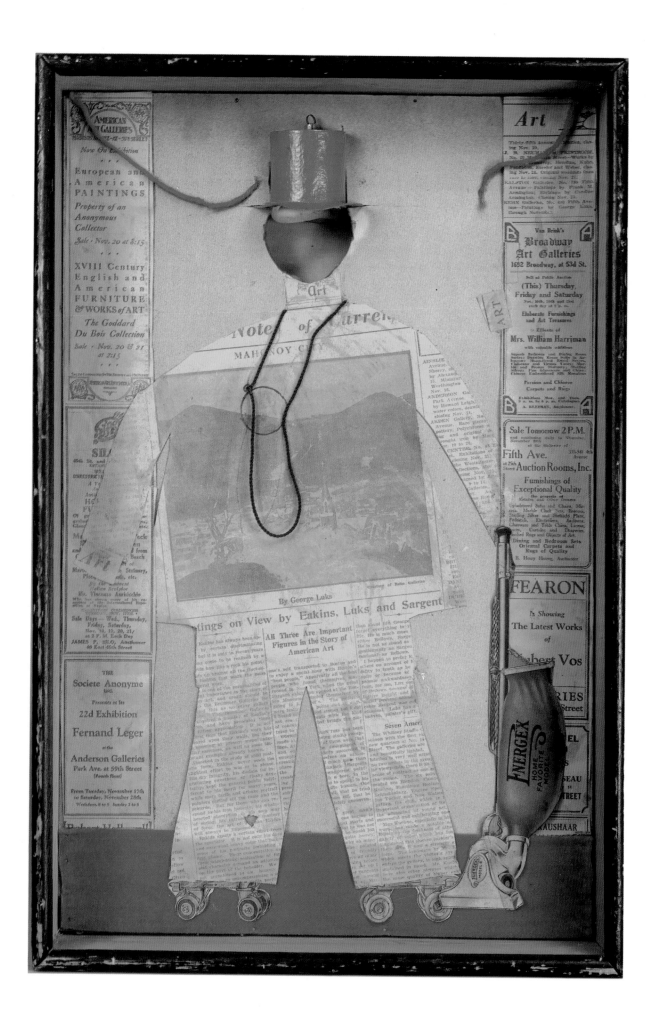

Arthur G. Dove

The Critic, 1925

Collage, 19¾ x 13½ x 3⅝ inches (50.2 x 34.3 x 9.2 cm). Gift of the Historic Art Association of the Whitney Museum of American Art, Mr. and Mrs. Morton L. Janklow, the Howard and Jean Lipman Foundation, Inc., and Hannelore Schulhof 76.9

During the 1920s, Dove found the cost of painting materials to be prohibitive and he turned to small collage constructions. He made about thirty such assemblages from 1924 to 1928, most of them during 1925. Collage appealed to him for other reasons as well. In the 1920s, Dove and the painter Helen Torr Weed, whom he later married, lived aboard a small sailboat whose cramped quarters made painting impractical. Moreover, Dove was genuinely attracted to working with "real" things.

Several of his collages took the form of symbolic portraits such as *The Critic*. Long thought to depict Royal Cortissoz, the influential, conservative art reviewer of the *New York Herald Tribune*, the figure can now be more firmly identified with Forbes Watson of the *New York World* and *The Arts* magazine. The anti-modernist stance of both these important critics made them likely victims of Dove's witty wrath. *The Critic* has recently been connected with Forbes Watson because he wrote the cut-out newspaper article that both forms the subject's body and establishes the work's date. The November 1925 review from the *New York World* lauds a trio of conservative American favorites and then praises, under the heading "Seven Americans," the current offering at the Whitney Studio Club. This exhibition of now obscure painters recalls Alfred Stieglitz's seminal modernist exhibition of "Seven Americans," held in early 1925. In reviewing the Stieglitz show, Royal Cortissoz dismissed Dove's work as "strained pleasantries," and *The Arts* magazine, of which Forbes Watson was editor, described them as "jokes" and "laborious efforts to bring in the light touch."

But Dove's collage satirizes what he felt to be the superficiality of all art critics. A portly, empty-headed man coasts swiftly through the art scene on roller skates. His top hat is ornamented with the cap of a Christmas tree ball, whose eggshell-thin fragment is stuck beneath the hat. The critic's looking-glass is unused. With his Energex vacuum he cleans the carpet, which may symbolize the then traditional red-plush gallery wall covering. Highlighting the relation between art and commerce, Dove positions the critic between columns of advertising and announcements for New York auctions and exhibitions, all from November 1925 issues of the *New York Herald Tribune* and the *New York World*. Only one of the advertisements concerns advanced art—the one at the lower left for Fernand Léger's first exhibition in America.

Marsden Hartley

Painting, Number 5,
1914–15

Oil on canvas, 39½ x 31¾ inches
(100.3 x 80.7 cm). Anonymous Gift
58.65

Unlike almost all his contemporaries who visited Europe in the first decades of the twentieth century, Marsden Hartley made Germany his geographical and aesthetic base. Quickly concluding the almost obligatory visit to Paris, he went on to Germany in 1913 and again in 1914–15, and there came into contact with the group of German avant-garde artists known as the Blue Rider, in particular Franz Marc and Wassily Kandinsky.

Hartley's rapid embrace of modernism was dramatic, self-conscious, and assured. *Painting, Number 5* is one of the most abstract of his series of so-called War Motif pictures, made during a second trip to Berlin. They were painted in homage to two friends: a young German officer, Karl von Freyburg, who had died in the war in October 1914, and another German officer, Arnold Rönnebeck. Evoking the militaristic atmosphere of Berlin at the time, the flags, insignias, and uniform accoutrements (among them Rönnebeck's black Iron Cross) merge in an abstraction that clearly combines Cubism, the influence of Robert and Sonia Delaunay, and the emotional content and color of German Expressionism. Like his fellow Americans Patrick Henry Bruce (p. 47), John Marin (p. 64), Morgan Russell, Joseph Stella (p. 66), and Max Weber (p. 44), Hartley developed an art strongly based on European precedents while clearly recognizable as his own. All of these artists, with the exception of Weber, were included in the 1913 Armory Show in New York. Despite their awkwardness and the occasional confusion of surface effects with fundamental aesthetic principles, the American modernists succeeded in establishing a place for vanguard art in this country. It was Hartley above all, with his audacious departures from observed reality, who invented the most charged non-objective pictorial vocabulary.

Max Weber

Chinese Restaurant, 1915

Oil on canvas, 40 x 48 inches (101.6 x 121.9 cm). Gift of Gertrude Vanderbilt Whitney 31.382

For six years, beginning around 1913, Max Weber painted his most clearly derivative yet brilliant syntheses of modernist pictorial ideas. Direct contact with advanced art during his years of study in Europe (1905–08) provided the foundation for his modernism, which was reinforced and amplified by the 1913 Armory Show (from which Weber had withdrawn but to which he lent several works by his friend Henri Rousseau) and by the exhibitions held at Alfred Stieglitz's 291 Gallery. In clustered Picassoid nudes, still lifes, and later views of the city, Weber's concept of a fragmented and activated picture plane emerged. It is an ironic footnote that Weber produced his most abstract art while teaching art appreciation to photography students. Writing in 1914 in reference to his teaching at the Clarence White School of Photography, he observed: "It is through an intermarriage of forms, enlivened each with its own destiny of position—horizontal, vertical or oblique—that one is to awaken emotions of awe, grandeur and wonder. . . . Art is the very fluid of energy made concrete. . . ."

In 1915, inspired by the dynamics of New York—he described it as "this great city of cubic form" —Weber drafted his major modernist statements. Among these works, *Chinese Restaurant* is considered preeminent. Blending Futurism and Synthetic Cubism, it overlaps repetitive motifs drawn from the African and American Indian art he had seen at New York's American Museum of Natural History. The subject was inspired by a visit to a Chinese restaurant, then still a novelty in America. Weber recalled that the painting's "kaleidoscopic means" were partially caused by the abrupt transition from the calm exterior darkness to the luminous frenzy inside the restaurant. The picture orchestrates "flickers here and there in fitting place of a hand, an eye, or drooping head." The waiters' incessant, Futurist movements in serving the multicourse meal, and the suggestions of tabletops, a tiled floor, and wainscoting build up a visual tumult. A subtle but significant feature of the work are the small, glued paper and drawn-upon scraps attached at the center. Reminders of his appreciation for the collages of Synthetic Cubism, they create a contrast of crude immediacy within Weber's geometric patchwork.

Stanton Macdonald-Wright

"Oriental." Synchromy in Blue-Green, 1918

Oil on canvas, 36 x 50 inches (91.4 x 127 cm). Purchase 52.8

Between 1911 and 1920, Stanton Macdonald-Wright and Morgan Russell developed Synchromism, the most original variation of modernism then practiced by American painters. Having been introduced by Russell to the work of Cézanne and Seurat, Macdonald-Wright came to believe by 1913 that form is color. "When I conceive a composition of form, my imagination creates an organization of color that corresponds to it." The two-man art movement created by Macdonald-Wright and Russell achieved a European acclaim greater than that accorded to any other American modernists.

Although briefly involved with non-objective compositions, by 1916 Macdonald-Wright resumed the color-infused figuration found in *"Oriental." Synchromy in Blue-Green.* Decades later, he recalled the picture as "based—in its forms & arrangement & subject matter—on an opium smoking group." A quartet of figures can be perceived among the painting's shifts of color, with the glow of opium radiating to the right of the center. A face, a bent elbow, a bulbous thigh, and an uplifted arm emerge from the hued planes. While the blue and green of the title predominate, a full range of hues fans out across the canvas. Like the dim vaporization of a drug-induced vision, the boundaries of forms in space, and reality itself, dissolve in aerated orchestrations of light.

46

Patrick Henry Bruce

Painting, c. 1921–22

Oil on canvas, 35 x 45¾ inches (88.9 x 116.2 cm). Anonymous Gift 54.20

With his life's work represented by fewer than 125 extant paintings, Patrick Henry Bruce has remained a little-known and underrated artist. His extended expatriate existence in France from 1904 to 1936 and his suicide at fifty-five on his return to the United States forcefully illustrate the difficulties of an American modernist who, in the 1920s and 1930s, did not want to compromise his earlier break-throughs. It was particularly in his

final series of abstract still-life arrangements (of which twenty-nine still exist, dated conjecturally between 1917 and 1930) that Bruce proved himself to be a painter of masterful authority and achievement. Although all the works in the series are strongly interrelated, four of them form a sub-group of which the Whitney Museum *Painting* is a part. In their tabletop arrangements, objects are recognizable—a hat, a vase, and flowers—yet abstraction, not still life, is the work's true subject.

Bruce's art showed the successive influence of Cézanne, Matisse (with whom he studied), and his friends the Orphist painters Robert and

Sonia Delaunay. Likewise, the ideas of the Synchromists Stanton Macdonald-Wright and Morgan Russell, those of the nineteenth-century color theorists Michel Eugène Chevreul and Ogden Rood, and the Purist art of Le Corbusier and Amédée Ozenfant are apparent in Bruce's forthright coloration and the starkness of his compositions. Through its boldness, *Painting* transcends its subject to become an exhilarating expression of the inter-action of pure color and geometric form. Like other works in this series, it anticipates the strict hard-edge ab-straction adopted in the late 1930s by so many pioneer members of the American Abstract Artists group, such as Ad Reinhardt (p. 146).

Oscar Bluemner

A Situation in Yellow, 1933

Oil on canvas, 36 x 50½ inches (91.4 x 128.3 cm). Gift of Mr. and Mrs. Harry L. Koenigsberg 67.66

Oscar Bluemner's emergence after 1912 as a painter and brilliant colorist occurred simultaneously with the introduction of modernism in America. Modernism's new, non-naturalistic approach to color could be incorporated in painting more easily than in architecture, which Bluemner had formerly practiced. Yet architecture as a means of creating a dynamic pictorial structure remained a constant in his aesthetic vision. Over the years, his use of color and manipulation of formal components became increasingly bold and planar. His color theories—derived from Goethe and others—equated hue with emotion. Describing color as "psychological plasma," he associated his favored red with women and sex. He even called himself and was called by others the "vermillionaire."

Colors other than red, however, can be found in Bluemner's fusions of man-made structures and nature. *A Situation in Yellow* was exhibited in his last one-artist show in 1935, entitled "Composition for Color Themes." While red predominated in the works exhibited, several paintings were composed of yellow, green, and blue. Signed "Florianus" (the middle name he assumed in 1933), the Museum's painting deals more with a mood than with observed facts. At the end of his life, Bluemner noted of his work in general that he used the combination of "lemon yellow and black to stir up an exquisite sensation." The color was also connected for him with the "yellow jealousies of Othello." The dominant house shapes of *A Situation in Yellow*, set amid gaunt, gray trees and earth and against a vermillion backdrop, remain Bluemner's major essay in the color.

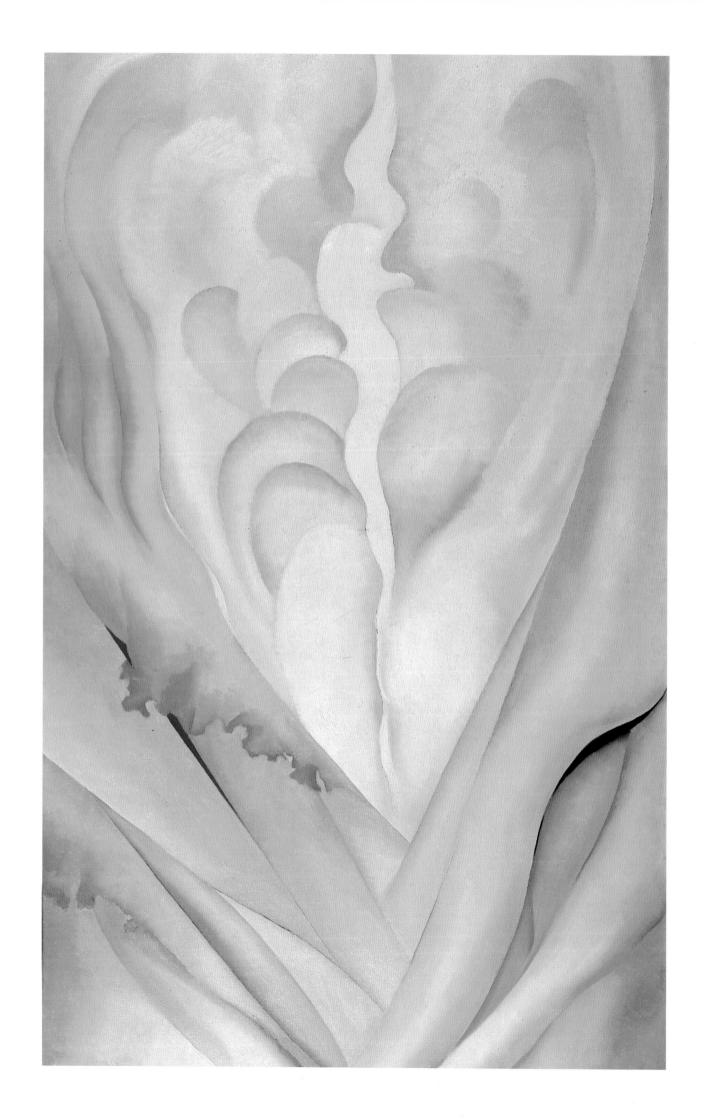

Georgia O'Keeffe

Flower Abstraction, 1924

Oil on canvas, 48 x 30 inches (129 x 76.2 cm). 50th Anniversary Gift of Sandra Payson 85.47

Flower Abstraction is among the earliest of Georgia O'Keeffe's well-known and characteristic large-scale flower paintings, which she continued to produce through the 1950s. At once abstract and realistic, the structure of Flower Abstraction recalls the works O'Keeffe produced between 1915 and 1919, the first period of her mature art. Working in South Carolina, New York, Virginia, and Texas, O'Keeffe at that time formulated a pictorial vocabulary of curves and undulating forms suggestive of regeneration and growth. This native American modernism, though akin to Orphism and Synchromism, is conceptually closest to Art Nouveau. O'Keeffe shared that movement's fascination with the floral form and its expression of sensuality through sinuous natural motifs. As in Art Nouveau, she unselfconsciously sought decorative effects: bathed in paleness, the layered, leafy shafts in the foreground of Flower Abstraction give way to vaulting, tumescent shapes. Complex, yet symmetrical, structure is defined by gradations of tone. As O'Keeffe had written of one of her related flower paintings, "what is my experience of the flower if it is not color." When Flower Abstraction was first shown, it bore the title Abstraction; however, its two areas of ragged-edged foliage at the left make her subsequent title more accurate.

It was O'Keeffe's aim in the flower paintings to make urban inhabitants see floral beauty as she did, a goal evident again in the Museum's White Calico Flower (p. 52). Filling most of the canvas, these simplified magnifications metamorphose the flower into the natural landscape itself. The petals may be seen as valleys and mountains, the curved forms as clouds or smoke, and the apertures and color variation as rivers, bolts of lightning, or waterfalls. O'Keeffe was not alone among American artists in the early decades of the twentieth century in perceiving details of nature microcosmically. Arthur G. Dove, the one artist of her generation whose work O'Keeffe truly admired, produced a series of pastels beginning in 1911 that interpret plant life even more freely. Works such as Dove's Plant Forms (p. 38) surely guided O'Keeffe. In turn, her vision anticipated the close-up view of nature, adopted by contemporaneous photographers, whereby nature became the primary formulator of pattern.

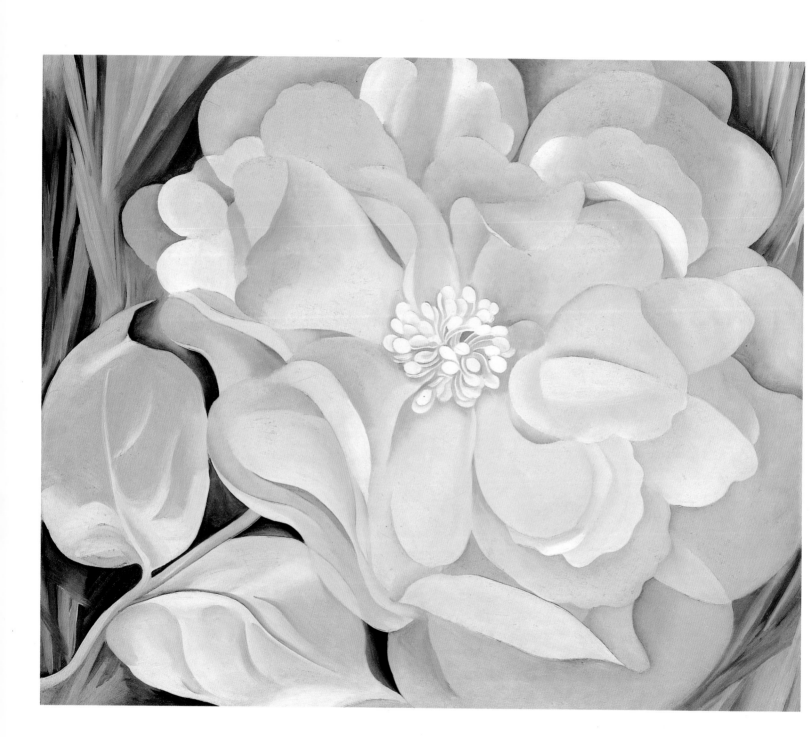

Georgia O'Keeffe

The White Calico Flower,
1931

Oil on canvas, 30 x 36 inches (76.2 x 91.4 cm). Purchase 32.26

As Georgia O'Keeffe's friend Marsden Hartley once noted about all her depictions of flowers, they are "so huge that they shut out the sky above them—shut out even the morning that opens them." O'Keeffe's intention was to "paint it big and they will be surprised into taking time to look at it—I will make even busy New Yorkers take time to see what I see of flowers." *The White Calico Flower,* along with O'Keeffe's other paintings of magnified isolated blossoms, is a by-product of her urban life, its scale like that of the gigantic buildings going up around her. Cut off from the rural landscape, she brought nature's beauty into her life through frequent visits to the florist.

O'Keeffe's blossoms, removed from their natural environment, are singled out and intensified to a degree that places them between abstraction and representation. Even as ostensibly representational a painting as *The White Calico Flower* was hung with its stem and leaves in the upper right-hand corner for over thirty years, until the Museum, informed by the artist, corrected its mistake. Actually, O'Keeffe's white flower is, as the title indicates, not a real one; it was based on the cloth flowers used in funerals and as an adornment by mourning women in the area of New Mexico where she started spending her summers in 1929. Unlike living blossoms, this artificial flower, unaffected by heat, remained unchanged during the extended process of painting. Taking a very novel and most limited view of the flower, O'Keeffe turned specific reality into an abstracted symbol.

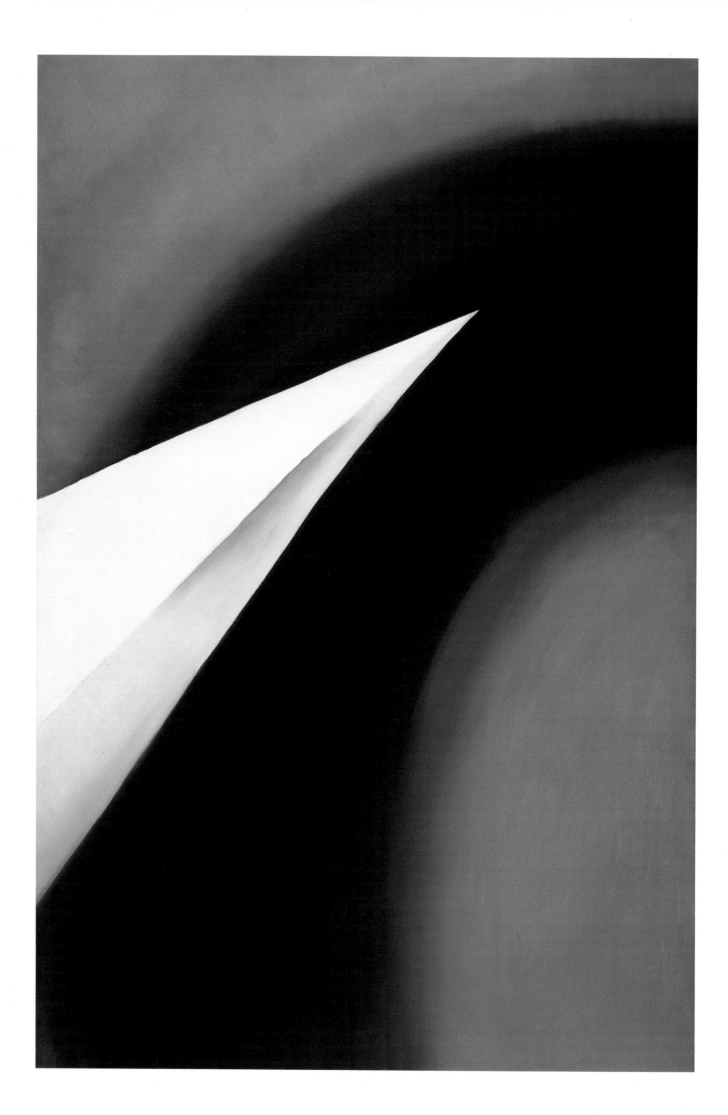

Georgia O'Keeffe

Black and White, 1930

Oil on canvas, 36 x 24 inches (91.4 x 61 cm). 50th Anniversary Gift of Mr. and Mrs. R. Crosby Kemper 81.9

Although Georgia O'Keeffe's work always evolves from nature, the forms in *Black and White* are among her most abstract. Her sense of abstraction is more metaphysical than structural: she looks to nature for the means to illuminate her inmost thoughts and feelings. As she wrote in 1976, "the abstraction is often the most definite form for the intangible thing in myself that I can only clarify in paint." In her discovery of a personal abstraction she—unlike all her American contemporaries except Arthur G. Dove—made no use of European avant-garde styles such as Cubism, Futurism, Neo-Plasticism, or Suprematism. Along with Stuart Davis, O'Keeffe was one of the very few significant American modernists who, prior to 1925, did not go to Europe. It has been suggested that her inspired abstraction of nature, and her belief in the supremacy of personal intuition, were derived in part from her readings of Emerson and Thoreau. O'Keeffe, however, credits the Russian painter Wassily Kandinsky's *On the Spiritual in Art* (first published in English in 1914) as her early guide. The book equated art with spiritual harmony and the unlocking of inner rhythms and impulses, concepts that find corollaries in *Black and White.*

Black and White's bone-white triangle against a somber, fugitive blur restates—in more abstract terms—the motif of a 1919 Texas plains landscape that O'Keeffe described as pictorializing the mournful lowing of cattle gathered for slaughter and separated from their young. *Black and White* and a related canvas were produced on O'Keeffe's return to New York City following her first summer in New Mexico. At this time, Alfred Stieglitz, whom O'Keeffe had married in 1924, was creating his Equivalent photographs of clouds and sky, which likewise were his most abstract statements.

O'Keeffe's commentary on *Black and White* exemplifies her prose at its most mandarin: "This was a message to a friend—if he saw it he didn't know it was to him and wouldn't have known what it said. And neither did I."

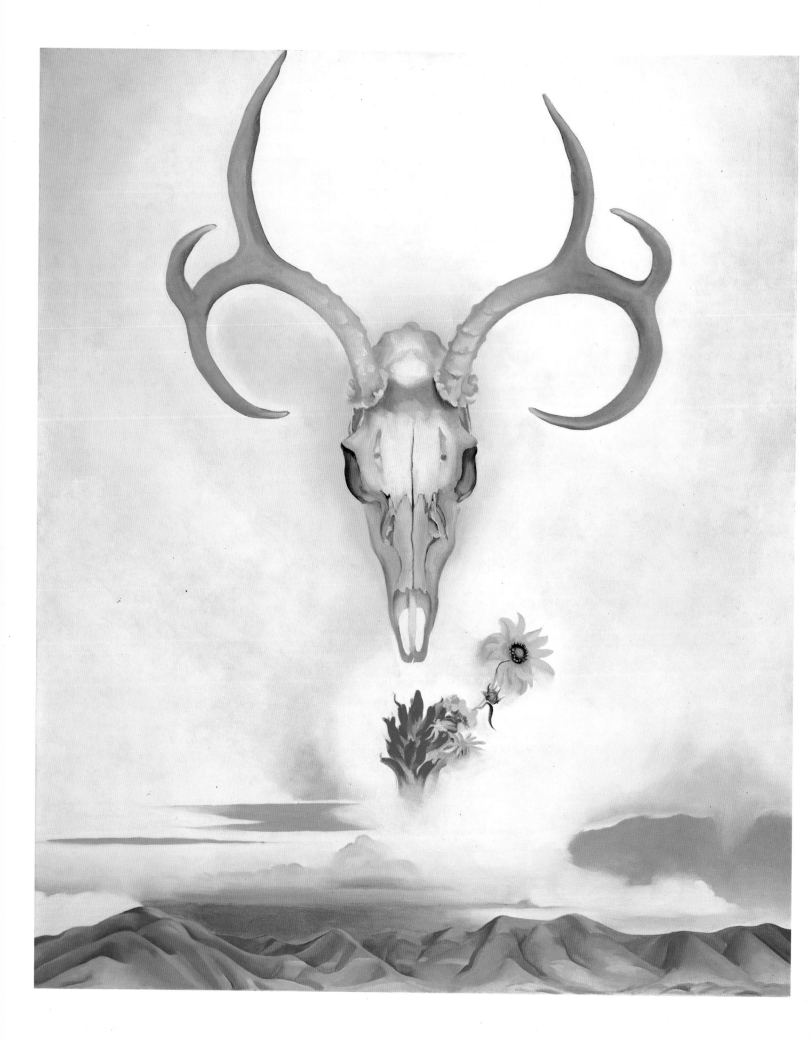

Georgia O'Keeffe

Summer Days, 1936

Oil on canvas, 36 x 30 inches (91.4 x 76.2 cm). Promised Gift of Calvin Klein
P.4.83

In 1936 Surrealism reached a height of influence in America with the Museum of Modern Art's exhibition "Fantastic Art, Dada and Surrealism." With the almost hallucinatory imagery of such paintings as *Summer Days*, even artists as idiosyncratic as Georgia O'Keeffe can be identified with the movement's provocative splicing of dreamed or imagined motifs with traditional representation. While few Americans qualified as official Dada/Surrealists, many others—from Walker Evans to Rube Goldberg—were, like O'Keeffe, in a section of the exhibition devoted to independent but related art. Indeed, Lewis Mumford remarked of another painting in this series that "O'Keeffe uses themes and juxtapositions no less unexpected than those of the Surréalistes, but she uses them in a fashion that makes them seem inevitable and natural, grave and beautiful."

The central, floating animal skull of *Summer Days* was a motif introduced in O'Keeffe's work five years earlier. From 1931 on, a succession of her paintings used the sun-bleached bones she had brought back east after her first summer in New Mexico. The deer, horse, mule, and steer skulls she collected, as one would gather wildflowers, became potent souvenirs of a landscape that had swiftly permeated her being. In *Summer Days*, she merges symbol and place by suspending the deer's skull and flowers (aster, cactus, and heliopsis) above the New Mexico landscape. The red hills seem minute beneath the lofty sky. The image joins a regenerative, springtime eruption of color in the landscape with a powerful reminder of the desert's asperity and unforgivingness.

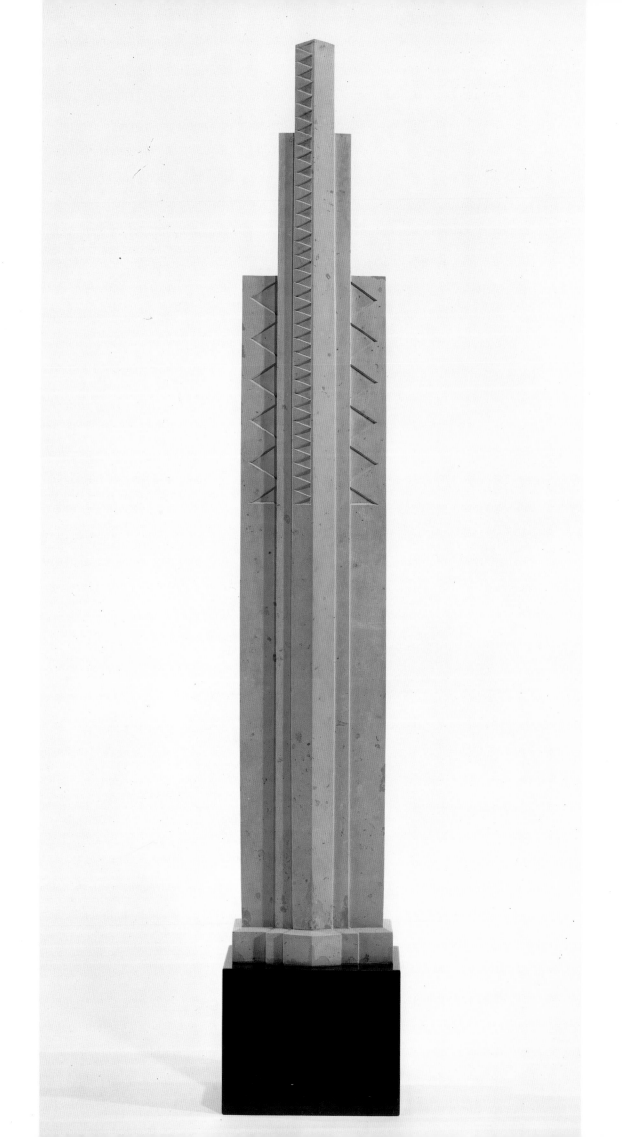

John Storrs

Forms in Space #1, c. 1924

Marble, 76¾ x 12⅝ x 8⅝ inches (194.9 x 32.1 x 21.9 cm). 50th Anniversary Gift of Mr. and Mrs. B. H. Friedman in honor of Gertrude Vanderbilt Whitney, Flora Whitney Miller, and Flora Miller Biddle 84.37

Although John Storrs preferred to live in France, after his father's death in 1920 he was forced to spend half the year in Chicago in order to receive his full inheritance. At this time, having abandoned the naturalistic forms of his teacher Auguste Rodin, he began an important series of geometric abstractions of skyscraper shapes. Proto-Minimalist in their refinement, these columnar forms of metal, wood, and stone, known generically as Forms in Space, grafted French Synthetic Cubism and Purist influences to the innovative structures of Storrs' native Chicago—the buildings of Louis Sullivan and Frank Lloyd Wright. Storrs produced at least twenty such sculptures, conjecturally dated between 1920 and 1928, some in small editions. From drawings, it is known that he planned the works on a monumental scale, but *Forms in Space #1*, a marble sculpture over 6 feet high, remains the largest extant piece. Storrs also created large-scale public works, commissions for architects in Chicago and elsewhere, but these pieces were figurative, and more conservative than his private sculpture.

The Forms in Space sculptures, made at the height of the Art Deco movement, have a quintessential, machine-age élan. As Storrs predicted in an article published in 1917, "Light, simplicity and grace of the ensemble—there you have the key to future art." With their industrial materials and fabrication, reductive attitudes toward form, and serial repetition of motifs, the Forms in Space constitute a seminal breakthrough in twentieth-century American sculpture.

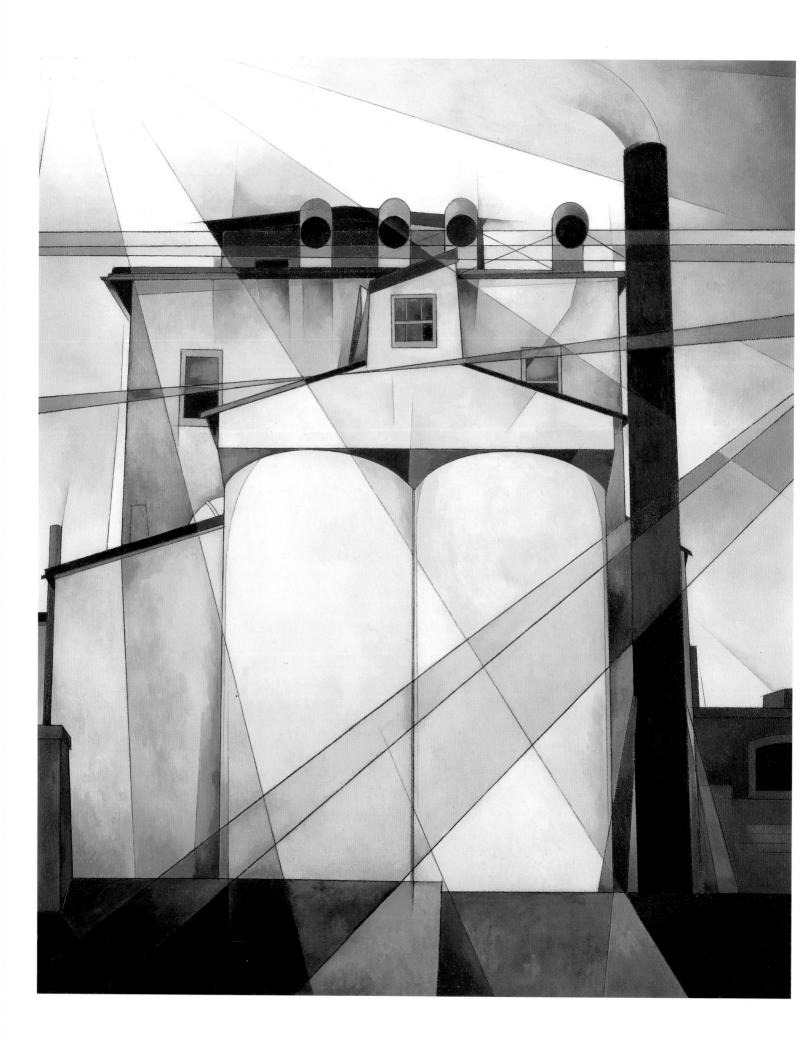

Charles Demuth

My Egypt, 1927

Oil on composition board, 35¾ x 30 inches (90.8 x 76.2 cm). Gift of Gertrude Vanderbilt Whitney 31.172

Charles Demuth's *My Egypt* expresses America's fascination with the sleek functionalism of the machine age and pride in the country's natural abundance. This iconic celebration of agricultural productivity focuses on the cement grain storage elevators (demolished in 1978) of the John W. Eshelman & Sons' Feed Mills, Lancaster, Pennsylvania. As in Charles Sheeler's *River Rouge Plant* (p. 62), no human presence is observed. *My Egypt* was painted during one of Demuth's frequent stays in Lancaster, and reflects his deep attachment to this rural community, where he was born and his family had lived since the late eighteenth century.

In *My Egypt*, the theme of industrialized, agrarian production received its most forceful, heroic, and modern articulation. A statement issued by Stieglitz's An American Place gallery during its 1935 Demuth exhibition described *My Egypt* as "perhaps the finest sense of a modern age that has been expressed." Its monumentality, frontal focus, and symmetry, combined with criss-crossed, atmospheric shafts of color (reminiscent of, yet distinct from, John Marin's use of lines of force in his watercolors [p. 64]) combine to create the quintessential Precisionist rendering of a vernacular structure.

Demuth's association with Marcel Duchamp, who used witty, paradoxical designations for his works, may well have inspired the painting's wry title. Recent scholarship has also suggested that the enduring monumentality of the ancient Egyptian pyramid and its assertion of life after death might also have attracted the always sickly and then truly ailing Demuth. Whatever the explanation, the modernist formulation of *My Egypt* intensifies its brilliant fusion of representation with abstraction, and its transformation of a rural functional structure into a national icon. The painting's compressed construction also demonstrates Demuth's frequently quoted conviction that "All of us drew our inspiration from the spring of French modernism. John Marin pulled his up in bucketfuls but he spilled much along the way. I had only a teaspoon in which to carry mine; but I never spilled a drop."

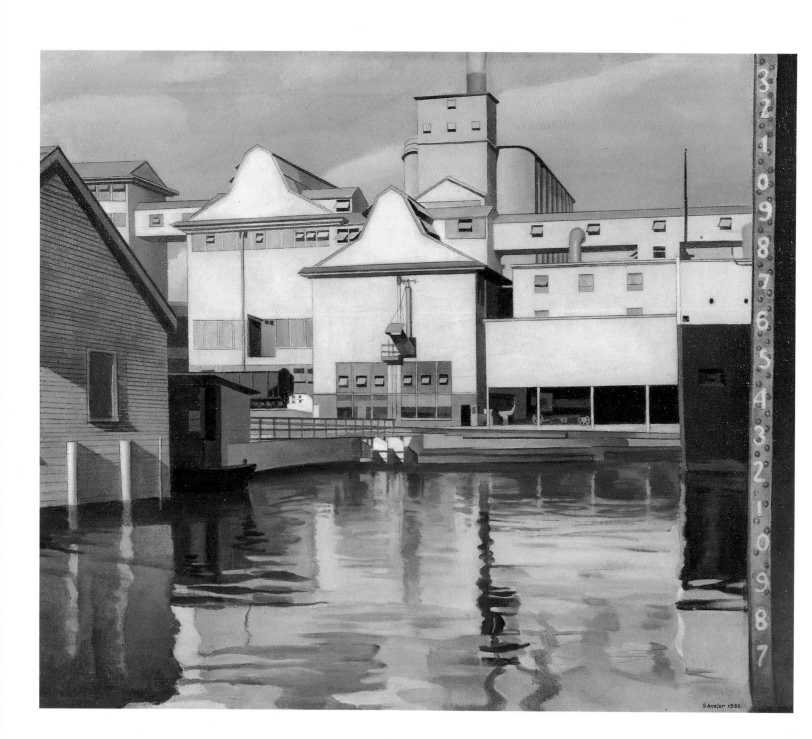

Charles Sheeler

River Rouge Plant, 1932

Oil on canvas, 20 x 24 inches (50.8 x 61 cm). Purchase 32.43

Beginning in 1912, Charles Sheeler took photographs for himself and, on commission, for architects. He later worked as a photographer for industrial corporations and advertising companies, and even took fashion photographs. These works constituted his artistic capital. The compositional schemes and the precision provided by the photographic medium transformed his painting style. His art increasingly became a rendering of the world as seen through the neutralizing mechanism of a camera, especially when his theme was machinery and industry itself.

Sheeler's first industrial subject was the Ford Motor Company's River Rouge Plant outside Detroit, which he visited in late 1927 and early 1928. He went there to document the plant in photographs for N. W. Ayer, a Philadelphia advertising agency, in conjunction with its massive advertising campaign for the Model A Ford, the successor to the Model T. With the introduction of the Model A, the company's manufacturing operation had shifted from Highland Park to River Rouge, where Henry Ford realized his dream of completely assembling an automobile on one site. The River Rouge Plant's awesome machinery and enormous scale—it covered 2,000 acres and employed 7,500 workers—fascinated Sheeler. He produced a set of thirty-two carefully composed photographs, which were printed in

Ford Motor Company publications and elsewhere, but have never been exhibited or published together. From these photographs and his experience at the facility, Sheeler subsequently made five paintings, three conté-pencil drawings, two watercolors, two pencil-and-gouache studies, and a print. In 1932 he completed *River Rouge Plant*, his third and smallest painting of the factory, and the only one whose title refers directly to its source.

Focusing on the buildings at the end of the boat slip, *River Rouge Plant* shows the unusually roofed structures where coal was processed and stored for use as fuel in the nearby cement plant. At the extreme right are the bows of two ships, one of them depth-gauged, which transported the coal. *River Rouge Plant*, like other works in the series, is subdued in color—Sheeler did not return to the site until 1935, and he made the painting aided only by black-and-white photographs. Beneath the meticulous surface of this placid and unpeopled scene, another message is conveyed: Sheeler's belief in the power and sanctity of American industry. Between the time he took his source photographs in 1927–28 and the completion of this painting in 1932, brutal hostilities had broken out between River Rouge workers and management, and America had undergone a devastating economic reversal. But Sheeler ignored all this, preferring to create an immaculate shrine to American productivity.

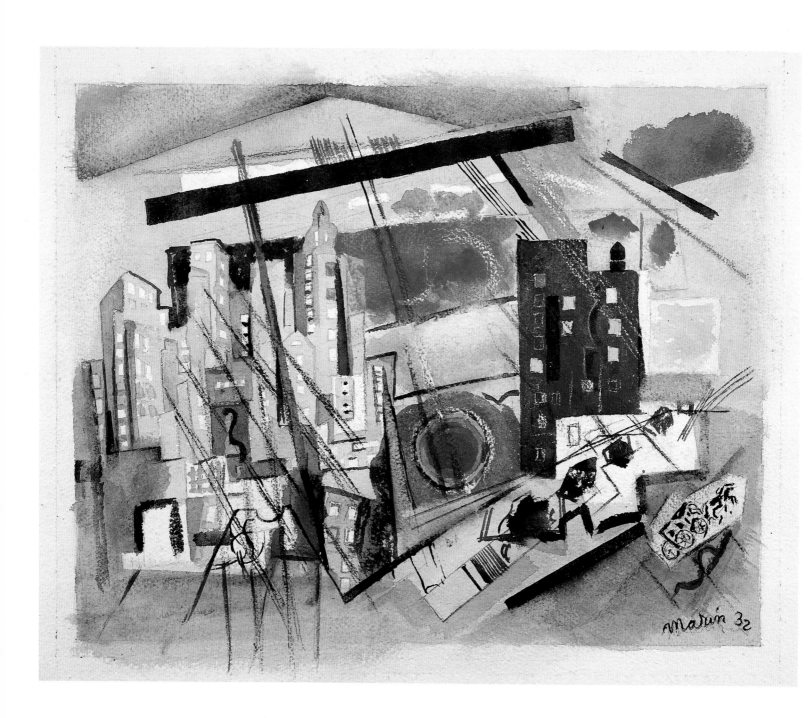

John Marin

Region of Brooklyn Bridge Fantasy, 1932

Watercolor on paper, 18¾ x 22¼ inches (47.6 x 56.5 cm). Purchase 49.8

Though the urban landscape prompted some of John Marin's most memorable work, he turned to it infrequently—as infrequently as he painted in oil. For just as the predominant subject matter of his art was nature, his preferred medium was watercolor on paper. Watercolor permitted the swift fusion of color with his strong sense of structural line. Following his return to New York from Europe in 1910, his art moved from Impressionist rendering to more modernist transformations of his chosen subjects. His descriptive, vigorous style, influenced by Cubist pictorial organization and expressionistic spontaneity, came about through his excited perception of New York City—specifically the Brooklyn Bridge. Marin viewed New York as an equipoise of "warring, pushing, pulling forces," in which the Brooklyn Bridge's delicate tracery of cables and massive masonry became a key urban metaphor.

Region of Brooklyn Bridge Fantasy elegiacally comments on and combines the great changes Marin had observed in New York over the previous thirty years, from horse-drawn carriages to automobiles, and from small commercial loft buildings to skyscrapers. The bridge's structure, rendered as an airy curtain held between heavy bars, is more energetic than it is factual. Cables hang in semi-transparency before a frieze of buildings and a glowing solar disk.

Marin chose to keep this watercolor for himself until near the end of his life, when it was selected and purchased from the Museum's 1949 Annual Exhibition of sculpture, watercolors, and drawings. *Region of Brooklyn Bridge Fantasy* has since become famous for its lively rendering of a favorite metropolitan motif.

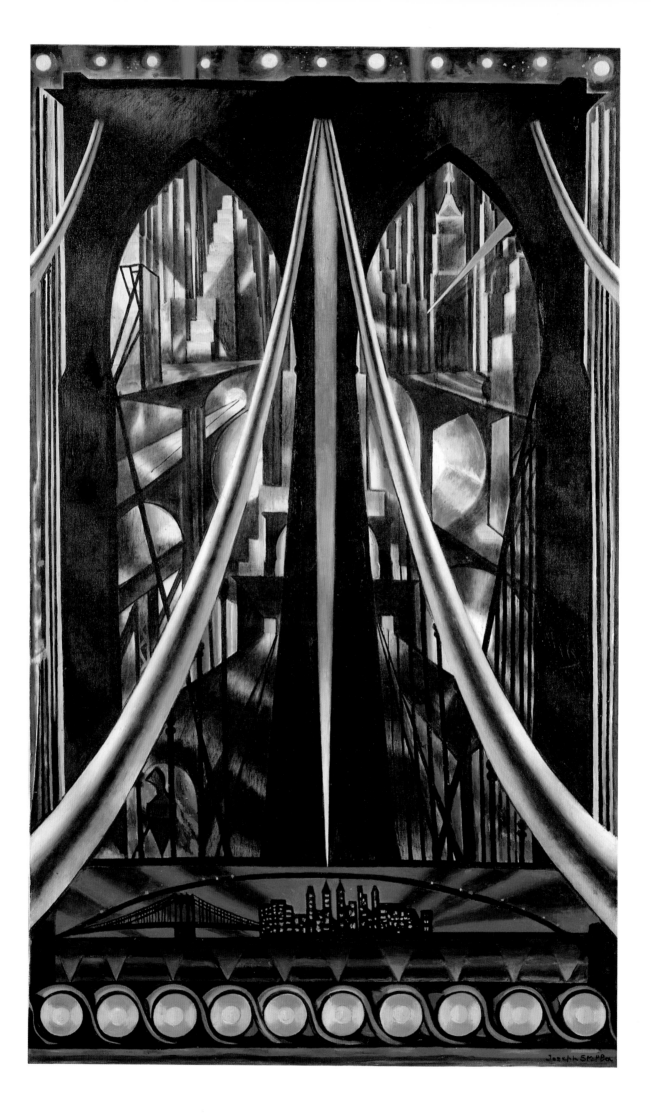

Joseph Stella

The Brooklyn Bridge: Variation on an Old Theme, 1939

Oil on canvas, 70 x 42 inches (177.8 x 106.7 cm). Purchase 42.15

Joseph Stella's infatuation with the Brooklyn Bridge was even more intense than John Marin's (p. 64): "Many nights I stood on the bridge —and in the middle alone—lost—a defenseless prey to the surrounding swarming darkness—crushed by the mountainous black impenetrability of the skyscrapers—here and there lights resembling suspended falls of astral bodies or fantastic splendors of remote rites—shaken by the underground tumult of the trains in perpetual motion, like the blood in the arteries—at times ringing as alarm in a tempest, the shrill sulphurous voice of the trolley wires— now and then strange moanings of appeal from tugboats, guessed more than seen, through the infernal recesses below—I felt deeply moved, as if on the threshold of a new religion or in the presence of a new DIVINITY."

Between about 1917 and 1941, Stella made numerous drawings and preparatory studies and completed six major paintings of the Brooklyn Bridge. *The Brooklyn Bridge: Variation on an Old Theme* was the fifth painting of the series. In this work, and in the other views, he used the bridge to codify his earlier, swirling, Futurist paintings into iconic symmetricality. As if observed through a prism, rays of light fragment the span; majestic solidity, ceaseless flow, and geometrized pools of mottled tonality are carefully organized within its dissected, arched perspectives.

In the Whitney Museum version of the theme, the top of the bridge, with its sweeping cables, crests near the upper edge of the canvas. At the bottom appears a miniature profile of the bridge's span to Manhattan's beacon-like skyline. Salient details of a billboard and of a Brooklyn factory appear at the left. The work asserts its documentary realism while remaining a symbolic expression of the modern machine age. Painted toward the end of Stella's life, *The Brooklyn Bridge: Variation on an Old Theme* is a clarified, retrospective view of the subject most closely associated with the artist. For Stella, the Brooklyn Bridge—by then over fifty years old—remained the quintessential American achievement.

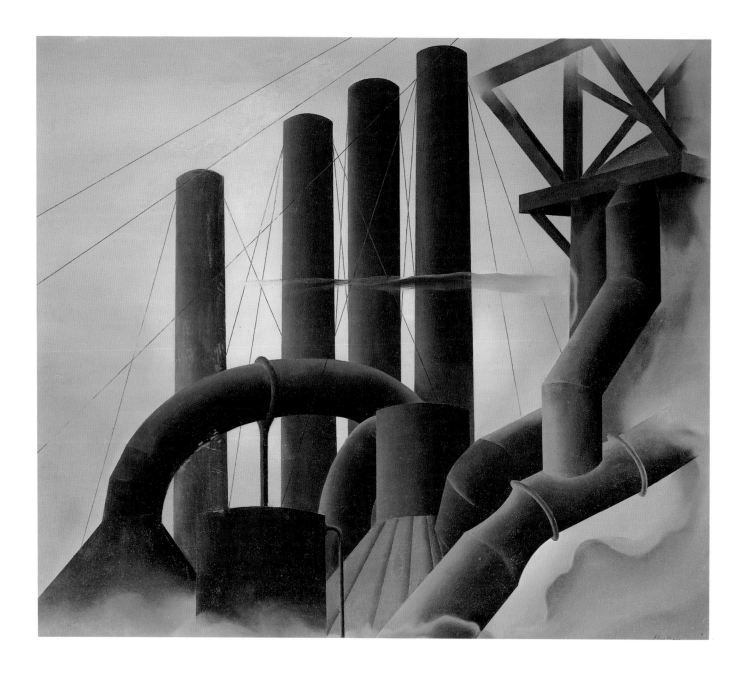

Elsie Driggs

Pittsburgh, 1927

Oil on canvas, 34¼ x 40 inches (87 x 101.6 cm). Gift of Gertrude Vanderbilt Whitney 31.177

Elsie Driggs passed through Pittsburgh on a train as a child and, returning there from New York in 1927, relived her experience of its dramatic, steel-mill skyline. She produced a series of precise pencil drawings, among them the preliminary study for *Pittsburgh,* which was painted on her return to New York for her 1928 one-artist show at the Charles Daniel Gallery. The pristine rendering of the painting may well have been influenced by the gallery, which was the institution most closely identified with Precisionism, exhibiting the works of Charles Demuth (p. 60), Preston Dickinson, Charles Sheeler (p. 62), and Niles Spencer. Nothing before or after in Driggs' art displayed the pictorial exactitude of the five paintings in that show, which also contained views of Wall Street, the Ford Motor Company's River Rouge Plant, a Ford Motor Company plane, and the Queensboro Bridge.

Purchased from the exhibition by Juliana Force for Gertrude Vanderbilt Whitney, *Pittsburgh* blended elements of the Jones and Laughlin Steel Mills and Carnegie Steel Works against a gray background that somberly challenged Driggs' childhood recollection of "the glorious night sky of racing flames." By the late 1920s the Bessemer method of steel production had been largely discontinued and with it the shooting flames she had so vividly recalled. As Driggs noted, "due to soot and smoke the sky is but a backdrop"; she abandoned the exhilarating image of her memory for the reality of stark and threatening industrial monuments.

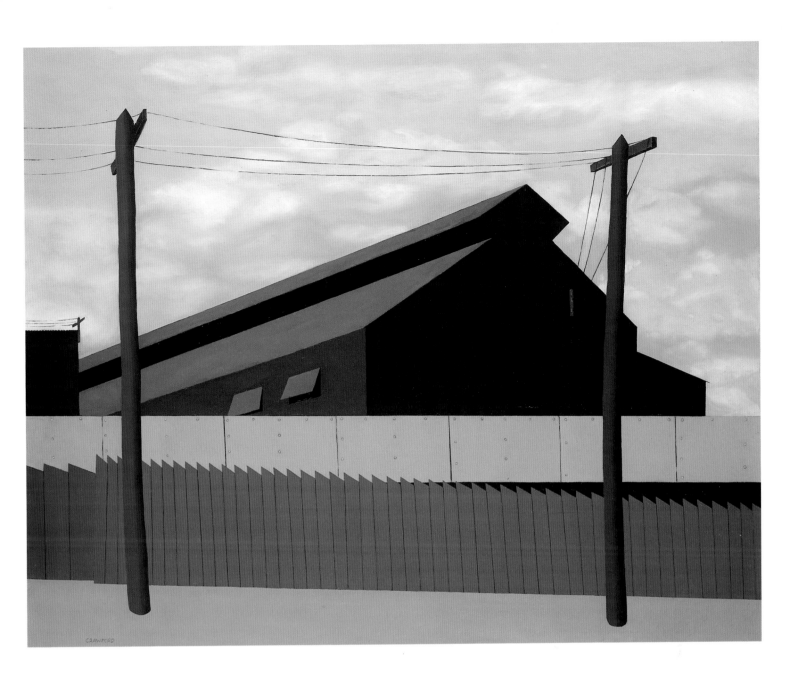

CRAWFORD

Ralston Crawford

Steel Foundry,
Coatesville, Pa., 1936–37

Oil on canvas, 32 x 40 inches (81.3 x
101.6 cm). Purchase 37.10

Ralston Crawford's sharp-edge dis-
tillations of the uninhabited Ameri-
can scene in the 1930s and early
1940s, produced at the beginning
of his career, are among his most
significant achievements. Like other
works of this period, *Steel Foundry,*
Coatesville, Pa. depicts the func-
tional architecture of commerce
and industry in a Precisionist style.

Coatesville, still a center for steel
production, lies between Philadel-
phia and Lancaster, where the sub-
ject of Charles Demuth's *My Egypt*
(p. 60) was located. Crawford had
originally come to know this area
while a student at the Pennsylvania
Academy of the Fine Arts and the
Barnes Foundation; from 1934 to
1939 he lived in nearby Chadds
Ford and then Exton, Pennsylvania.

"My pictures mean exactly what
they say," Crawford later wrote,
"and what they say is said in colours
and shapes." These refinements of
representational data present a

modernist perspective on the Ameri-
can admiration for factuality. At
the same time, his affection for
place links him to Regionalists of
the period, like Thomas Hart
Benton (p. 70). Crawford's art in
this period can be interpreted as
part of the general reaction in the
1930s against urban influence and
non-objective painting and sculp-
ture. The knife-edge crispness of the
fence in *Steel Foundry* and the diag-
onal sweeps of the foundry's roof
lines show Crawford's art at its
most studied and literal. With his
predilection for planar simplifi-
cation, Crawford's later works took
a more abstract approach to his
varied surroundings.

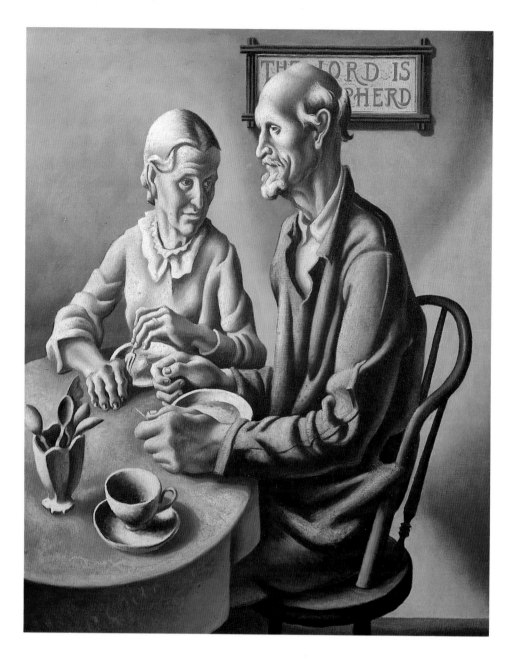

Thomas Hart Benton

The Lord Is My Shepherd, 1926

Tempera on canvas, 33¼ x 27⅜ inches (84.5 x 69.5 cm). Gift of Gertrude Vanderbilt Whitney 31.100

Thomas Hart Benton's *The Lord Is My Shepherd*, one of the landmarks of American Regionalist art, was painted in Chilmark on Martha's Vineyard, off the Massachusetts coast. It is part of a group of Benton's self-professed "Yankee" subjects and best exemplifies his transition from devout modernism to nationalistic, narrative figuration.

Benton's experience in Martha's Vineyard, where he spent every summer from 1920 on, revitalized his ties to America. The grand-nephew and namesake of a renowned Missouri senator and son of a long-time congressman, Benton had unusually intense opinions on politics and patriotism. *The Lord Is My Shepherd* portrays George and Sabrina West, inhabitants of Martha's Vineyard, whom Benton first sketched in 1922. They lived down the hill from the newly married Benton and his wife, Rita. The Wests, a hard-working couple with three children, were deaf mutes. Their somber, unconnected gazes and expressive, prominent hands emphasize their stark circumstances. They are finishing their evening meal (one coffee cup remains on the table). The painting's title, drawn from the sampler on the wall, speaks of uncomplaining, pious humanity. The Wests display the working-class solidarity that dominated later Regionalist portrayals of the 1930s. One of the earliest Regionalist works, *The Lord Is My Shepherd* anticipated the democratic and representational character of American art in the 1930s.

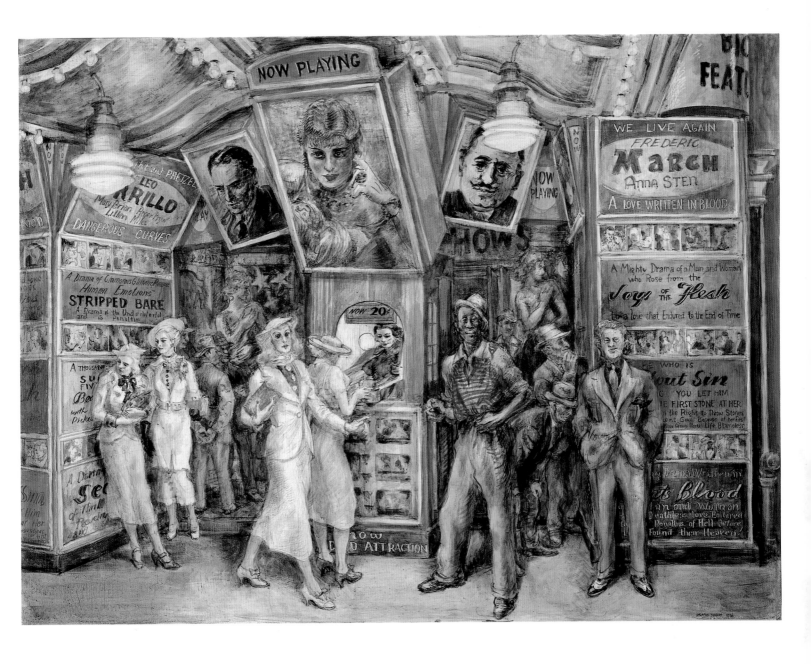

Reginald Marsh

Twenty Cent Movie, 1936

Egg tempera on composition board, 30 x
40 inches (76.2 x 101.6 cm). Purchase
37.43

Reginald Marsh's paintings and
drawings combine an almost ba-
roque drawing style with a news-
paper reporter's attention to the
minutiae of urban public life.
Filled with facts, his art is un-
abashedly topical, often based on
his own photographs and numerous
on-site sketches. Marsh's headlines,
signs, and advertisements are spe-
cific and legible while his faces and
figures are often indistinguishable.

Twenty Cent Movie, as arresting as
a boldface tabloid, presents a riot of
information and evokes a golden era
of cinematic hyperbole and Run-
yonesque characters. The double
bill of *Twenty Cent Movie* improb-
ably joins *We Live Again* (right),
an adaptation of Tolstoy's tragic
novel *Resurrection*, with an upbeat
musical comedy entitled *Moonlight
and Pretzels* (left). The blown-up
poster portraits represent the dash-
ing Frederic March and sultry Anna
Sten of *We Live Again*, and the
mustachioed character actor Leo
Carillo, whose comic mispro-
nunciations punctuated *Moonlight
and Pretzels*. The scene before
Forty-second Street's Lyric Theatre

71

looks itself like a movie still, with
stars, bit-players, and extras poised
for action. The stylish blond inge-
nue in white strolls before the street-
wise, cocked-hatted boulevardier, as
a flashily dressed, man-about-town
looks on: this trio of potential stars
in search of a plot are everyday
echoes of the three blown-up images
of the actors.

With superficial appearances more
strongly emphasized than substance,
Marsh's figures rarely reveal their
private selves. A tragic lack of con-
nection between the sexes exists in
much of his art. In *Twenty Cent
Movie*, the men are seldom attached
to the curvaceous, parading females.
Never probing human relations, Marsh
vividly catalogued an era, with all the
detail and celebration that his con-
temporary Edward Hopper left out.

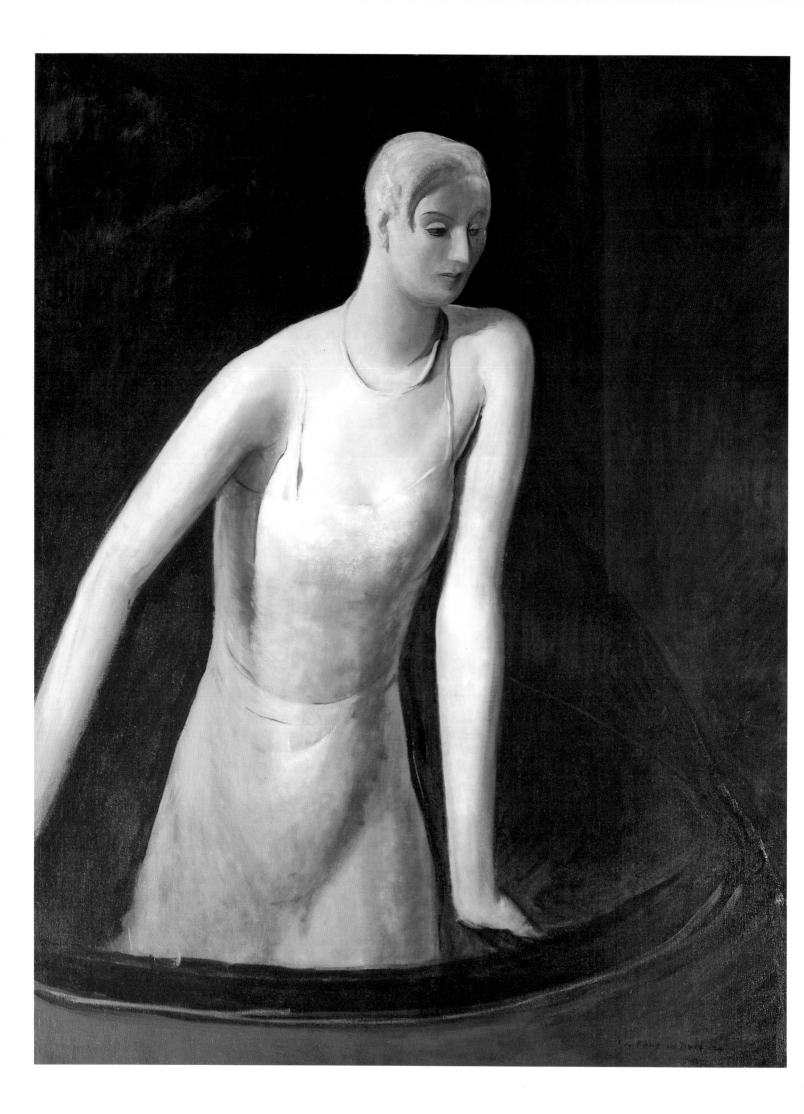

Guy Pène du Bois

Opera Box, 1926

Oil on canvas, 57½ x 45¼ inches
(146.1 x 114.9 cm). Gift of Gertrude
Vanderbilt Whitney 31.184

Guy Pène du Bois noted in his auto-
biography that early on he "found a
subject matter which was very much
to my liking at the opera house"—a
preference that dovetailed with his
job, through 1913, as music critic for
the *New York American*. His paint-
ings of opera-goers in evening dress
first drew attention to his art and one
of them provided him with his first
sale.

In December 1924, the American-
born du Bois and his family went to
live in France, where they remained
for the most part until 1930. Work-
ing outside Paris in a big studio at-
tached to his house, he felt he was
"going to paint masterpieces" and,
indeed, these years were some of the
most fruitful in his career. In 1926
Gertrude Vanderbilt Whitney, then
in Paris for the dedication of her St.
Nazaire monument, commissioned
du Bois to paint her portrait. A
small, solemn portrayal of Mrs.
Whitney alone in an opera box was
completed that year. A similar sub-
ject and sense of isolation were
monumentalized in the Museum's
larger *Opera Box*, also painted in
1926. Du Bois' alabaster amazon
looms over a darkened scene. Stand-
ing alone in a seemingly deserted
theater or rising up to view the
stage, she fills the picture. The
witty satire that characterizes most
of du Bois' portrayals of the upper
class is missing here. Somber in
mood, this solitary portrayal suggests
a spiritual void behind the facade of
wealth and leisure.

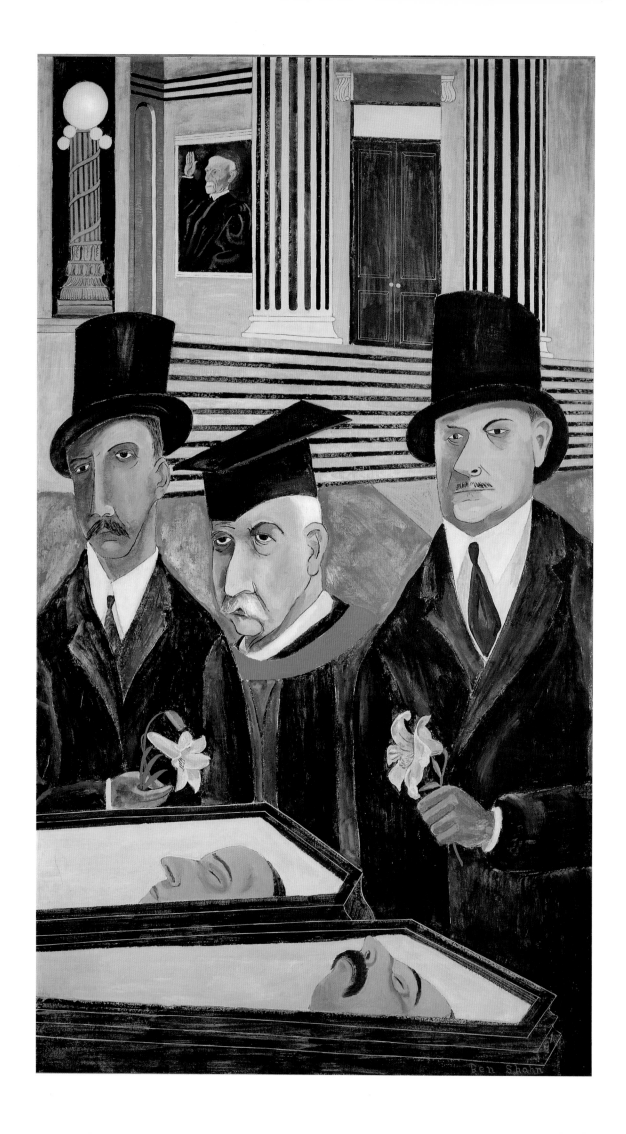

Ben Shahn

The Passion of Sacco and Vanzetti, 1931–32

Tempera on canvas, 84½ x 48 inches
(214.6 x 121.9 cm). Gift of Mr. and Mrs.
Milton Lowenthal in memory of
Juliana Force 49.22

The Sacco and Vanzetti series of
1931–32 marked Ben Shahn's
change in status from illustrator
to artist. Looking back at a crime
that had occurred over ten years
before and at its contentious after-
math, Shahn realized: "I was liv-
ing through another crucifixion.
Here was something to paint!" On
April 15, 1920, a shoe company
paymaster and his guard were
killed during a robbery of $15,000
in South Braintree, Massachusetts.
Witnesses speculated that the as-
sailants were Italian. A shoemaker,
Nicola Sacco, and a fish seller, Bar-
tolomeo Vanzetti, along with two
other Italian-Americans claimed
the car the police had connected
with the crime. Known as anar-
chists and draft evaders, Sacco and
Vanzetti were found armed and
then lied during their interrogation.
Charged with the crime, though
neither had the money or a criminal
record, they were convicted and
sentenced to death the following
summer. The case was highly con-
troversial; the judge, Webster
Thayer, was particularly criticized.
There were public pleas for pardon
when much of the evidence was
discredited. Massachusetts Governor
Alvan T. Fuller formed a review
committee, comprising Judge
Robert Grant, President A. Law-
rence Lowell of Harvard University,
and President Samuel W. Stratton

of the Massachusetts Institute of
Technology; but after consultation
with the committee, the governor
resolved the verdict was correct, and
Sacco and Vanzetti were executed
in 1927. They and others believed
they were political martyrs; their
deaths, in Vanzetti's words, were
"our career and our triumph."

Shahn made a series of twenty-
three small gouache paintings,
based on newspaper photographs,
which were exhibited in 1932 at
his second one-artist show at the
Downtown Gallery, New York, and
then at the Harvard Society for
Contemporary Art in Cambridge.
The shows were Shahn's first great
public successes. *The Passion of
Sacco and Vanzetti* and a mural
study, both combining elements of
the small gouaches, were completed
for inclusion in a contemporary
mural exhibition organized by the
Museum of Modern Art in May
1932. At the upper left of the
Museum's large-scale tempera, a
mock portrait of Judge Thayer,
taking an oath, is attached, window-
like, to a flimsy-looking courthouse.
The three members of the review
committee stand over the coffins
containing the bodies of Sacco and
the mustachioed Vanzetti.

Shahn's Sacco and Vanzetti series
was seen by the Mexican mural-
ist Diego Rivera, who hired the
younger artist to assist him with
his Rockefeller Center murals
(now destroyed). This project led
directly to the first of Shahn's nu-
merous public mural commissions,
which concluded in 1967 with the
fabrication for Syracuse Univer-
sity of a 60-foot-long mosaic mural
of the Sacco and Vanzetti story.

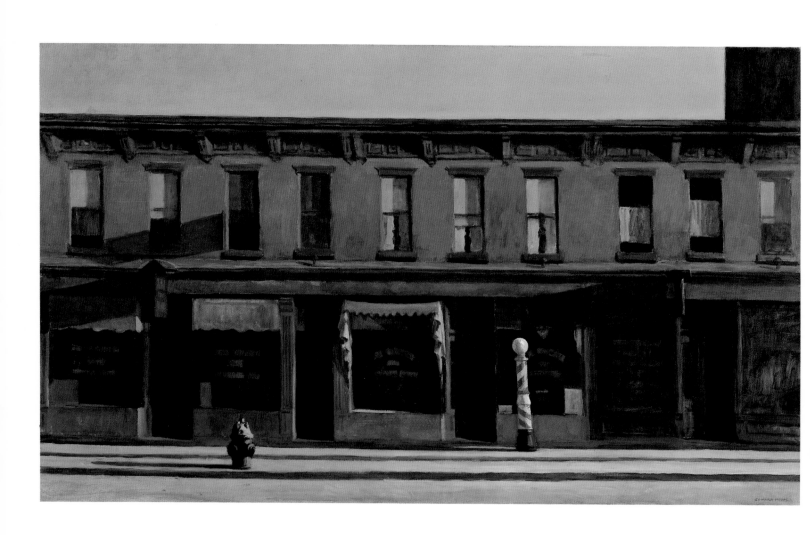

Edward Hopper

Early Sunday Morning, 1930

Oil on canvas, 35 x 60 inches (88.9 x 152.4 cm). Gift of Gertrude Vanderbilt Whitney 31.426

Early Sunday Morning was acquired by the Whitney Museum within a few months of its completion, the first Edward Hopper painting to enter the Permanent Collection. It is still regarded as one of Hopper's most evocative works, a paradigm of the solemn isolation with which he imbued his city views and of the way in which he distilled, rather than recorded, his subjects. In *Early Sunday Morning* he copied an actual row of buildings on Seventh Avenue in New York (the work was originally titled *Seventh Avenue Shops*). But Hopper strove to generalize the site, avoiding the kind of topical detail embraced by contemporaries like Reginald Marsh (p. 71). The lettering in the shop signs, for instance, is apparent, but unreadable.

Although people are nowhere to be seen, evidence of the human presence is everywhere. In the sequence of second-story windows, identical in size, each aperture has been treated differently, as if reflecting the individuality of its occupant. Hopper initially painted a figure in one of these windows, but later painted it out.

To create a dramatic play of light and shadow, Hopper took larger liberties with the original setting. The long shadow on the top of the building and the dark bands across the sidewalk suggest an impossible position for the sun on this north-south avenue. The variety of lighting on the flat, frontal row of buildings is more theatrical than real. In fact, these Seventh Avenue facades recall a theater set, designed by Jo Mielziner, for Elmer Rice's *Street Scene,* a play Hopper and his wife had attended the previous year.

Hopper's willingness to alter the photographic truths of a site reveals a concern with form no less than with content. Indeed, *Early Sunday Morning* can easily be viewed as a succession of verticals and horizontals and a frieze of contrasted shadow and light. Many of the upper windows have the appearance of miniature Mark Rothko paintings (p. 136). Given the fundamentally representational character of Hopper's art, it is ironic that his work is equally admired for its stark abstraction, painterly surfaces, and studiously constructed compositions. Hopper's power as the quintessential twentieth-century American realist is sustained by his mastery of formal pictorial construction.

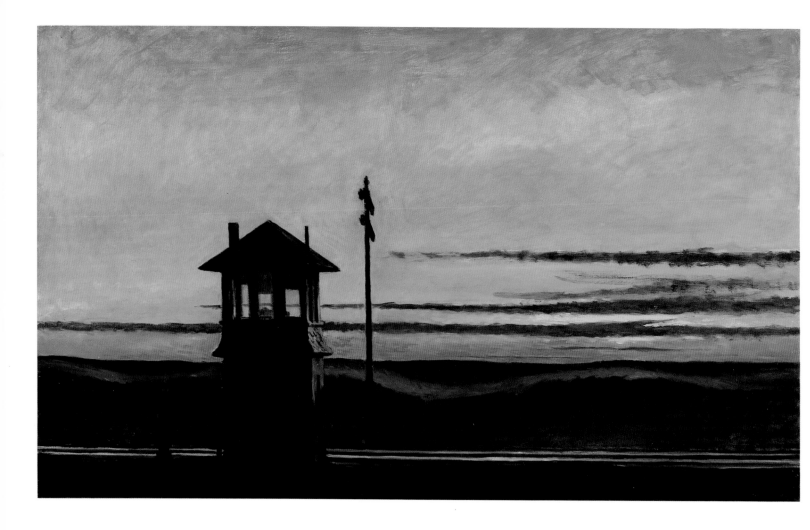

Edward Hopper

Railroad Sunset, 1929

Oil on canvas, 28¼ x 47¾ inches (71.8 x
121.3 cm). Bequest of Josephine N.
Hopper 70.1170

Seven A.M., 1948

Oil on canvas, 30 x 40 inches (76.2 x
101.6 cm). Purchase (and exchange)
50.8

Railroad Sunset was one of the
clear masterpieces among the over
twenty-five hundred paintings,
drawings, working studies, and
prints bequeathed to the Whitney
Museum by Edward Hopper's
widow in 1968. More than any other
major Hopper painting in the Per-
manent Collection, it explores the
spectacular potential of natural light.
The shift in the sky from blue
through yellow to red vividly sets
off the forlorn railroad outpost. The
railroad tracks make an unbroken
sliver of silver in the dark impene-
trability of the bottom third of the
composition. In Hopper's paintings

of the 1920s and early 1930s, figu-
ration—a requirement for the il-
lustrations by which he supported
himself until about 1925—was
usually downplayed in favor of
architectural landmarks starkly
situated against their natural sur-
roundings. The sleek continuum of
the silver tracks implies the indus-
trial and geographic mobility and
the verdant expanse of America.

From his childhood, Hopper had
been fascinated by trains, and he
always loved to travel. The year he
painted this picture he and his wife
left New York for Charleston, South
Carolina, and, in the summer, visited
Massachusetts and Maine. Trains
carried Hopper into the heartland of
America and, as in *Railroad Sunset,*

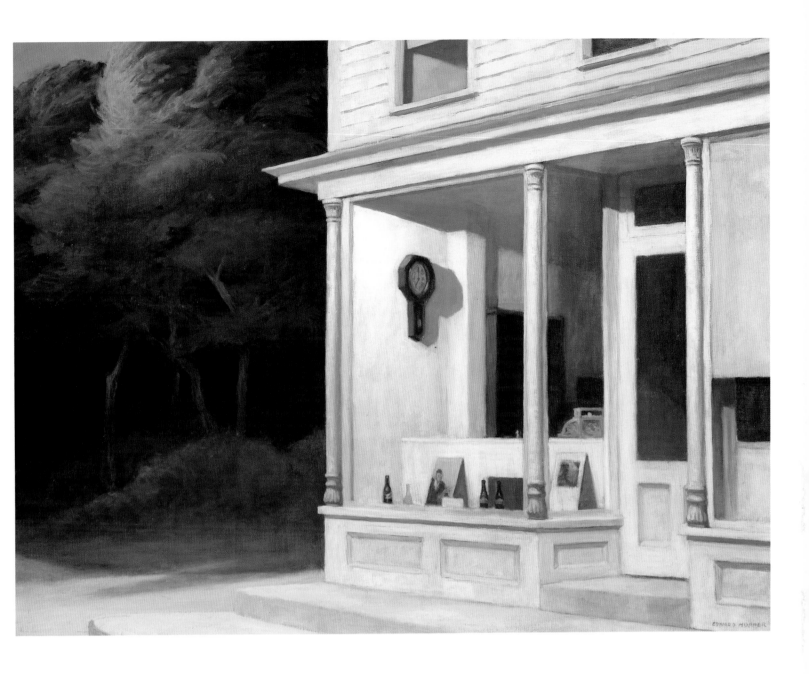

he turned his chance encounters with vernacular architecture into enduring pictorial statements.

In *Seven A.M.*, as in *Railroad Sunset* and *Early Sunday Morning*, a time of day—specifically the quality of its light—is one of Edward Hopper's principal concerns. Always a master of light, he frequently provided verbal or visual clues to what he had painted. The clock in the storefront window of *Seven A.M.* seems to be the sole active ingredient in the desolate, stilled scene. The shop window also contains one of Hopper's few still lifes. However, its impromptu grouping of a calendar, three bottles, and a photo gives no evidence of the store's function. The cash register (with a

transaction rung up) suggests interrupted commercial activity, while a drawn shade at the right and the empty shelves in the interior further obscure the source of sales. Although the fullness of summer is apparent from the clumped foliage at the left, the mood is decidedly off-season. The locale is generally representative of Cape Cod, near Hopper's summer home in South Truro, Massachusetts, where the Hoppers usually remained into November. This landscape and its special light were constant themes in his work.

As in many Hopper paintings, in *Seven A.M.* nature and townscape meet abruptly, a man-made structure hovering at the edge of the woods. The picture is a rural equivalent of the desolation in *Early Sunday Morning*, another Hopper storefront scene. *Seven A.M.*, too, once included a figure. In one of the sketches that preceded the painting, a woman peers down from a second-story window. Hopper eliminated her from the final painting and the result confirms his capacity for suggesting a story without representing any characters.

79

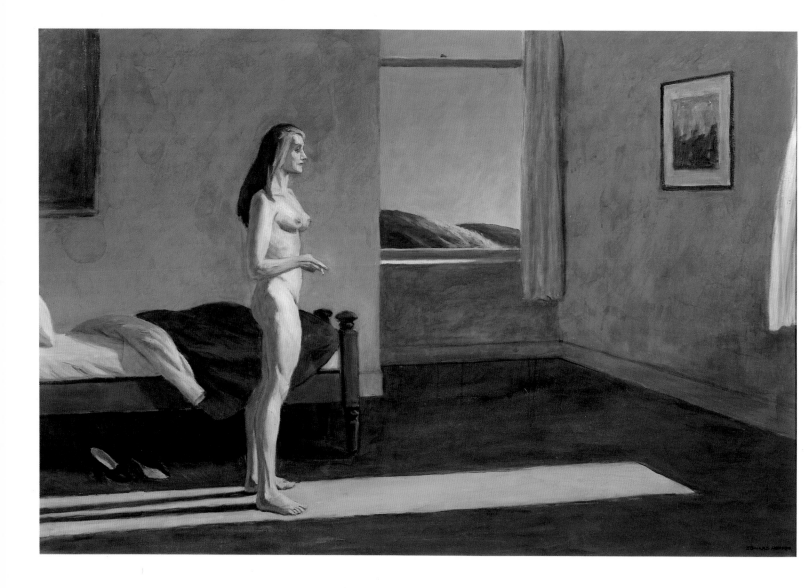

Edward Hopper

A Woman in the Sun, 1961

Oil on canvas, 40 x 60 inches (101.6 x
152.4 cm). 50th Anniversary Gift of
Mr. and Mrs. Albert Hackett in honor of
Edith and Lloyd Goodrich 84.31

Second Story Sunlight, 1960

Oil on canvas, 40 x 50 inches (101.6 x
127 cm). Gift of the Friends of the
Whitney Museum of American Art
(and purchase) 60.54

From the 1940s on, a harsh poi-
gnancy increasingly characterizes
Edward Hopper's subjects, whether
they are alone, coupled, or in a
small crowd. The figures have spe-
cific features, yet in the end read
with a generality that swiftly trans-
lates them into universals. For all
Hopper's female figures, this transi-
tion from the specific to the general
started with his wife, Jo, who posed
for all his women. Of his use of her
here, at age seventy-eight, he joked:
"That's Jo, glorified by art."

As Hopper matured he left more
and more information out of his

paintings; closing in on the psycho-
logical reality of his subjects, he re-
placed data with pathos. His rooms
were reduced to their simplest
architectural coordinates; those
details that remained only accen-
tuated the barrenness or allusive-
ness of the figures and settings—
in *A Woman in the Sun,* the pair of
black pumps that reinforces the
nudity of the smoking female, the
turned wood bedposts, the clouded
mirror, and the vaguely imaged
painting on the wall. Hopper's
subjects, as in *A Woman in the
Sun,* face the light directly and
without flinching; the sun offers
both warmth and scrutiny. Through

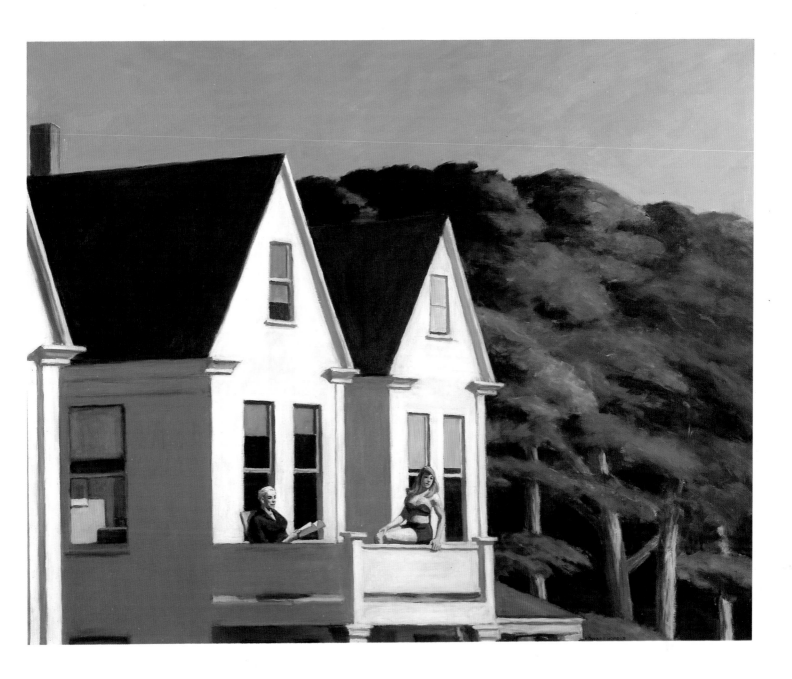

parted, windblown curtains, the light invades the room. It is seen also at a distance—through another window—as it crawls up a grassy dune. For both the woman and her environment the distance between what is inside and what is outside seems to have collapsed. Standing alone, Hopper's woman seems poised and reconciled, as if patiently awaiting a morbid annunciation.

The light-filled, isolated landscape around South Truro on Cape Cod prompted some of Hopper's most eloquent images, though not necessarily the most realistic. In *Second Story*

Sunlight, formal values seem to prevail over factual description. As Hopper explained laconically, "This picture is an attempt to paint sunlight as white with almost no or no yellow pigment in the white." At another time he noted that "I don't think there was really any idea of symbolism in the two figures. . . . I was more interested in the sunlight on the buildings and on the figures than in any symbolism." As analyzed by Hopper, the psychological content of this picture thus needs to be supplied by the viewer. The painting, one of Hopper's favorites, is a summation of his lifelong themes. The passage of beauty and

sexuality is clearly implied in the juxtaposition of the older, primly dressed duenna looking up from her paper and the scantily clad young woman, gazing beyond her. An expectant and surreal intensity suffuses the picture: the row of three houses seems to press together amid a forest of blurred trees. Painted at the end of Hopper's life, *Second Story Sunlight* is a luminous meditation upon mortality and desire.

Peter Blume

Light of the World, 1932

Oil on composition board, 18 x 20¼
inches (45.7 x 51.4 cm). Purchase 33.5

Like O. Louis Guglielmi (p. 84),
Peter Blume rejected the European
Surrealism of dreamlike imagery
oriented to the unconscious. He
presented everyday details and
ideology, not dreams and sex.

 Light of the World is among the
best known of Blume's Surrealist
canvases. It offers a rich visual riddle
about rural and urban values, cre-
ative achievements and political
tyranny, technological advances and
human docility. The pieces of the

riddle can be identified, but, in
typical Surrealist fashion, the whole
remains enigmatic. The disquieting
scene is set against an ominously
clouded sky, rocky hills, a farm, and
a small industrial complex in an area
that resembles the northwestern
Connecticut town of Sherman where
Blume and his wife settled in 1930.
In the left foreground is an archi-
tectural model based loosely on
Paris' Notre-Dame Cathedral and
at the center several plaster cornices,
all of which had been included in a
catch-all educational display at the
Metropolitan Museum of Art that
Blume had seen in the winter of
1932. Also adapted from this dis-
play are the squared-off floor pattern

and, on the circular base, the me-
chanism used to erect Cleopatra's
Needle, the obelisk in Central Park
near the Metropolitan Museum.

 Standing behind the cornices are a
woman and two men. But Blume
has identified the mustachioed fig-
ure as a blue-suited ventriloquist's
dummy, the artist's symbol for the
voiceless and impotent American
worker. The woman at left stares at
us, but the other figures (one of
them Blume's wife) are fearfully
attentive to the large, multicolor
glass light of the painting's title.
This central beacon was based on
the Highland Lighthouse on Cape
Cod. For Blume, its radio vacuum
tubes framed within crossed metal
bars seemed like a "universal eye,"
suggesting impending doom or
omnipotence.

Man Ray

La Fortune, 1938

Oil on canvas, 24 x 29 inches (61 x 73.7 cm). Gift of the Simon Foundation 72.129

From 1915 on, the American-born Man Ray was a leading figure in European vanguard art movements, especially Dada and Surrealism. Following his move from New York to Paris in 1921, he concentrated on photography, often Surrealist in subject or composition. When, in the 1930s, he enthusiastically returned to painting, it was to representations of incongruous and dream-based imagery. These paintings (and much of his photography) allied him closely with European Surrealism rather than with the more politically and socially conscious works of the American Surrealists.

The title *La Fortune* refers to good luck or wealth, but its image of a billiard table outdoors, on a dry plain with mountains in the distance, confounds easy explanation. Commenting upon the work, the artist noted: "I distorted the perspective of that table on purpose, I wanted it to look as big as a lawn. I could have had two people playing tennis on it, and I would be watching, just as I have been watching the tennis game on television. . . . I have always wanted a billiard table out in the country. . . ." The picture's stretched perspective is intensified by the triangulation of the three billiard balls on the green baize. The six differently colored clouds were, for Ray, evocative of an artist's palette.

La Fortune's idyllic billiard game in an unpeopled, peaceful, and expansive landscape may have been Man Ray's wishful response to the increasingly perilous and discordant world of Europe in the late 1930s. In fact, Man Ray fled Paris in 1940 for America. He ended up in Hollywood, where he remained throughout the war years and produced, in 1941, a second, slightly more complex, version of *La Fortune*.

O. Louis Guglielmi

Terror in Brooklyn, 1941

Oil on canvas, over composition board,
34 x 30 inches (86.4 x 76.2 cm).
Purchase 42.5

For O. Louis Guglielmi the early 1930s were "coldly sobering years," reflected in his painting by a melancholic social consciousness grafted to the neutral Precisionism his previous works had displayed. He turned to sharply delineated urban scenes presented with an arrestingly colorful palette. Protesting against an art of "super-deluxe framed wall paper," Guglielmi sought to establish a more issue-oriented and topical imagery. His Surrealism, as in *Terror in Brooklyn*, placed forlorn, despondent figures within fragments of New York City streets. He concocted such striking scenes as the women beneath the bell jar to convey the disjunctive sense of reality caused by the Depression and the onset of World War II. This image of entrapped grief and panic is among Guglielmi's most unsettling inventions. Other more disconcerting details render the terror surreal: the street light with its lamp lopped off, the beribboned pelvic bone affixed to the side of the tallest building. The car, a funereal black that matches the women's mourning garb, seems sealed off from its potential occupants. Wispy clouds streak the sky, sending an ominous message, intentionally illegible or only partially formulated, above Brooklyn.

Guglielmi portrays his deserted block of buildings twice: the particulars of the street—from the diner to the real estate office—are diminutively repeated in reverse in the background. The name of the diner is cut off, but 1941 Brooklyn telephone directories list a Kruger Restaurant on Atlantic Avenue, one of the borough's main thoroughfares. Above the doorway of the real estate office, the proprietor's name, E. Halpert, is spelled out in reverse. Edith Halpert's well-known Downtown Gallery represented Guglielmi from 1936 until 1953, giving him four one-artist shows. The equation of an art gallery with a real estate office reveals his assessment of the dubious relationship between art and commerce.

Joseph Cornell

Rose Castle, 1945

Construction in wood, paper, paint, mirror, tree twigs, tinsel dust, 11 ½ x 14 ⅞ x 4 inches (29.2 x 37.8 x 10.2 cm). Bequest of Kay Sage Tanguy 64.51

Although Joseph Cornell never visited France, he intuitively appreciated and was accepted by the French Surrealists. He immersed himself in French culture and history by scrupulous research and studiously accumulated documentation. In keeping with this process of inquiry, Cornell's encapsulated dreams and thematic assemblages were often created in groups.

Rose Castle is one of several constructions produced between 1942 and 1951 that are collectively known as the Pink Palace series. For the architectural set, all employ cut-out and mounted photostats of an engraving from Jacques Androuet du Cerceau's famous book of great French buildings, *Les Plus Excellents Bastiments de France*, published in 1576. The engraving, with its diminutive denizens and carriage, represents the Château de Madrid in Paris, a building begun for Francis I in 1528 and completely destroyed in 1793. Cornell's castle facade is set against his favored night sky. His giant tree twigs loom incongruously above the five-storied

structure. They cast crisp shadows against a reflective sheet of glass which, along with the rows of mirror-filled windows, creates an eerie atmosphere of disparity and displacement. Silvery trim lies like festive snow before Cornell's roseate shrunken world.

Cornell originally entitled the construction *Pink Municipal Building,* but he upgraded this prosaic title in 1963, after the work was bequeathed to the Museum by the artist Kay Sage, who, with her husband, Yves Tanguy, was an early supporter of Cornell's art.

Yves Tanguy

Fear, 1949

Oil on canvas, 60 x 40 inches (152.4 x
101.6 cm). Purchase 49.21

In 1923, Yves Tanguy saw a meta-
physical landscape painting by the
Italian Surrealist Giorgio de Chirico
and decided to become both an
artist and a Surrealist. By 1930 the
essential features of his style were
established: immaculate, glistening
surfaces, with smudges of color
added to his blanched palette, and
angular bone forms in an airy and
horizonless space. The terrain of
Tanguy's imagination only altered
subtly over the next twenty-five
years. Even an upheaval as major
as his immigration to the United
States in 1939 did not noticeably
change his imagery. But the events
of World War II do tempt topical
interpretations of his foreboding
scenes. Tanguy's paintings of the
war and postwar period, such as
Fear, take on a combative, apoca-
lyptic air. In the context of their
time, they become scenes of annihi-
lation. Their shiny, spiky mutants
appear as survivors of global devas-
tation and chaos.

 Armed with long white lances,
massed mammalian bone fragments
cluster vigilantly at the left and
right of *Fear*, setting a stage for the
confrontation of a seemingly mobile
black triangle and a white rectangle
poised at the center. The black
shadow of an unseen bone tower
cast at the lower center further
intensifies the painting's implication
of discordance and uncertainty.

Andrew Wyeth

Winter Fields, 1942

Tempera on canvas, 17¼ x 41 inches
(43.8 x 104.1 cm). Gift of Mr. and Mrs.
Benno C. Schmidt in memory of Josiah
Marvel, first owner of this picture
77.91

Andrew Wyeth is probably the most
willfully rural artist in twentieth-
century America. As Thomas Hart
Benton once remarked, Wyeth is
"more Regionalist" than Benton
himself. Portraying only the two
East Coast locales where he lives—
Chadds Ford, Pennsylvania, and
Cushing, Maine—Wyeth confers a
mystic charge on the familiar details
of his homes.

Winter Fields, imbued with the
bleakness of so many later Chadds
Ford views, depicts the softly rolling
hills behind his father's big studio.
Wyeth often walked in these fields
and one day came upon a dead,
frozen crow. The young artist carried
it back to his studio and twice drew

88

its stiffened form. In 1941, he
sketched a large tuft of dried winter
grass that he also found in the fields.
He combined these details in *Winter
Fields*, typically restricting himself
to the exacting medium of tempera
for the most intense compression of
his thoughts and feelings. This pic-
ture evokes not only the deadly chill
of winter, but the specter of World
War II. In this pre-figurative phase
of Wyeth's art, the horror of a dis-
tant but global conflict enters the
landscape through the image of a
dead bird in fallow fields. When
Winter Fields was exhibited at the
Museum of Modern Art in 1943, the
artist declared in his catalogue state-
ment that his aim was "not to ex-
hibit craft, but rather to submerge
it, and make it rightfully the hand-
maiden of beauty, power and emo-
tional content."

George Tooker

The Subway, 1950

Egg tempera on composition board, 18 x 36 inches (45.7 x 91.4 cm). Juliana Force Purchase 50.23

The paintings of George Tooker add a psychological intensity to the anecdotal figural style he learned at the Art Students League. His first mature works followed the private lessons he took in 1946 with former League instructor Paul Cadmus. Cadmus encouraged the younger artist to explore the theme of urban alienation.

A bland, narcissistic malaise distinguishes all of Tooker's images. Haunting messages of societal dysfunction, they often give visual form to the existential philosophy that emerged during the 1950s. In his so-called public paintings, such as *The Subway*, the impersonal settings dramatize the barely suppressed, existential terror and isolation of the anonymous, urban crowd. Even when his figures touch, there appears to be no possibility of psychic connection. Tooker described the "large modern city as a kind of limbo. The subway seemed a good place to represent a denial of the senses and a negation of life itself."

In *The Subway*, his best-known picture, an unusually crowded scene appears frozen in glazed isolation. The underground prison-labyrinth is low-ceilinged, long-corridored, and filled with jagged, claustrophobic spaces; even the figures' shadows in the central foreground form a grid enclosure that restrains their forward progress. Tooker's central female is wrapped in gray, yet her brilliant red dress implies an internalized passion.

Tooker's symbolic realism, and that of Jared French, Paul Cadmus, and Peter Blume, provided an alternative to Abstract Expressionism, which started to dominate the art scene in the early 1950s. In 1954, Tooker reworked *The Subway* composition as a set design for Gian-Carlo Menotti's opera *The Saint of Bleecker Street*.

Stuart Davis

Egg Beater, Number 2, 1927

Oil on canvas, 29⅛ x 36 inches (74 x 91.4 cm). Gift of Gertrude Vanderbilt Whitney 31.169

House and Street, 1931

Oil on canvas, 26 x 42¼ inches (66 x 107.3 cm). Purchase 41.3

Stuart Davis first painted an egg-beater in 1923, depicting it natural-istically, though upside down. John R. Lane has suggested that Davis may have been inspired by Man Ray's *Man*, a 1918 black-and-white photograph of a hanging eggbeater casting pronounced shadows on the wall. Davis' Eggbeater series began in 1927, when he nailed an egg-beater, an electric fan, and a rubber glove to a table in his studio. In neither form nor color did the first four paintings of the five that re-sulted bear the slightest resemblance to the still life (and their numbering was arbitrarily assigned thirty years later by Davis and his friend and dealer, Edith Halpert). Davis once noted that everything he did after his Eggbeater series was based on its ideas, and that with the series he crossed from naturalism to geometric abstraction. "What led to it," he later recalled, "was probably my

working on a single still life for a year, not wandering about the streets. Gradually through this concentration I focused on the logi-cal elements. They became the fore-most interest and the immediate and accidental aspects of the still life took second place."

Eggbeater, Number 2 is the least spatially complex of the works and contains the fewest linear elements. It is the series' flattest, sparest, and most uncompromising statement. The Eggbeater paintings as a group represent an aesthetic struggle; they were all the more remarkable for their adherence to advanced artistic ideas amid the general re-treat from abstraction in America in the late 1920s. Davis was not to work as abstractly again for nearly two decades.

House and Street was among the paintings of New York that Stuart Davis exhibited in his 1932 one-artist show under the heading "The American Scene." Demonstrating his return to a more direct realism following the Eggbeater series, the painting represents the intersection of Front Street and Coenties Slip in Lower Manhattan, complete with its backdrop of tenements and commercial skyscrapers. The painting's location can be confirmed in contemporaneous photographs of the site where the Third Avenue El dramatically curved toward the river. Other details of House and Street add the artist's social and political comments. For instance, the word "SMITH," larger than the street designation and the telephone company symbol, is the most forcefully decipherable element in the painting. In addition to being one of the commonest American surnames, it may refer to Alfred E. Smith, governor of New York State, celebrated Democratic reformer, and 1928 Democratic nominee for president. Smith's active political career had effectively ended in 1932, with Franklin D. Roosevelt's nomination for President. The inclusion of his name in the painting can thus be read as a parting homage, a sign of Davis' long-standing commitment to liberal American politics.

The most striking formal feature of House and Street is its split image, a compositional device that had never before appeared in Davis' work. Paintings by Matisse and Léger have been cited as precedents; to which can be added the developing technology of television, about which Davis was very enthusiastic, and the sequential images of the cinema. Whatever the inspiration, Davis' two-part study uses two dramatically angled viewpoints: on the left, an almost square, close-up facade on Front Street; on the right, the oblique frame discloses a long shot of the now-demolished Third Avenue El turning northwest at the corner of Coenties Slip and Front Street. The triangulated pier supporting the el, outside the right edge of the image, and the white curve of its track lead the viewer back into the trapezoidal image. House and Street is Davis' consummate adaptation of juxtaposition and succeeds by virtue of subtle and accomplished balance of detail and mass.

Stuart Davis

Owh! in San Paõ, 1951

Oil on canvas, 52¼ x 41¾ inches
(132.7 x 106.1 cm). Purchase 52.2

(Illustrated on p. 14)

As is the case with numerous later
Stuart Davis paintings, *Owh! In San
Paõ* builds upon the structure of
an earlier work—*Percolator* (1927,
The Metropolitan Museum of Art,
New York), the first of the Egg-
beater-period still lifes, which had
an abstracted six-cup coffee pot dom-
inating the foreground.

In 1951 Davis was asked to sub-
mit works to the São Paulo Bienal in
Brazil; it was the first time his art
was requested for an exhibition out-
side the United States. *Owh! In San
Paõ* was originally selected for the
show, though it was never actually
sent. It was initially titled *Motel*,
but in late August 1951 (after,
one may conjecture, the decision
not to show it in São Paulo) the be-
mused Davis retitled it *Owh! In Sao
Powh!*—and later changed it again
to the present spelling, with the
tilde misplaced over the "o."

Twenty-four years after *Perco-
lator*, Davis retained its composi-
tional elements, but thickened lines,
and added shapes and an overlay of
words. In *Owh! In San Paõ*, geo-
metric figures and words float about
the central, interlocked forms. A
repeated dot motif, predating the
use of enlarged Benday dots in Pop
Art (p. 176), produces a background
for one of the most striking changes:

the addition of the artist's signature,
and the words "ELSE," and "We
used to be—NOW!" Although the
application of the words was delib-
erate, Davis' poetry renders their
meanings indistinct. His own expla-
nation obscures the matter further:
for example, referring to the inclu-
sion of "ELSE" in another painting,
he stated that its content "consists of
the thought that something else
being possible there is an immediate
sense of motion as an integrant of
that thought." In simpler terms, the
"ELSE" refers to an alternative, and
Owh! In San Paõ may be seen as an
alternative version of *Percolator*.
The phrase "We used to be—NOW"
offers a concept of time that would
permit the present use of a past
image. Combining the work's title
and this phrase, Davis concocts a
nonsense poem whose two lines
connect place and time. He used
letters and numbers in the same
way he freely adopted aspects of
reality—as coordinates for artistic
practice and theory.

The Paris Bit, 1959

Oil on canvas, 46 x 60 inches (116.8 x 152.4 cm). Gift of the Friends of the Whitney Museum of American Art 59.38

Many of Stuart Davis' greatest paintings date from the 1950s, when the taut structure and intellectual content of his art were at odds with the spontaneity and emotion that prevailed in Abstract Expressionist works. Davis applied the current ideas of Gestalt psychology to unify the discrete elements and perspectives of his earlier works. In Gestalt theory, phenomena are interpreted as holistic entities rather than as aggregates of distinct elements. Davis hoped that his pictorial counterpart would net the same result—of a whole being bigger than its parts.

The Paris Bit is a pastiche of remembered Parisian architecture and street life, applied on the compositional structure of Davis' 1928 street scene with still life, *Rue Lippe*, painted in France. Davis had then described Paris in a statement that anticipates this 1959 painting: "There was so much of the past, and of the immediate present, brought together on one plane, that nothing was left to be desired." Caught in the bold linear web of *The Paris Bit*, French words —"EAU," "BELLE FRANCE," "HOTEL," letters that almost form "TABAC," and the "28" which dates his visit to Paris—join contemporary Americanisms and Davis' own private patois—"Eraser," "X," "any," "unnecessary," "PAD," and "LINES THICKEN." The now familiar script of Davis' stylized signature lies upside down as part of the composition at the bottom of the painting. The limited palette of red, white, blue, and black confers order on this most labyrinthine of his later works. In his mid-sixties, quoting his own artistic past, Davis turned a bit of personal retrospective into one of his most powerful and complex achievements.

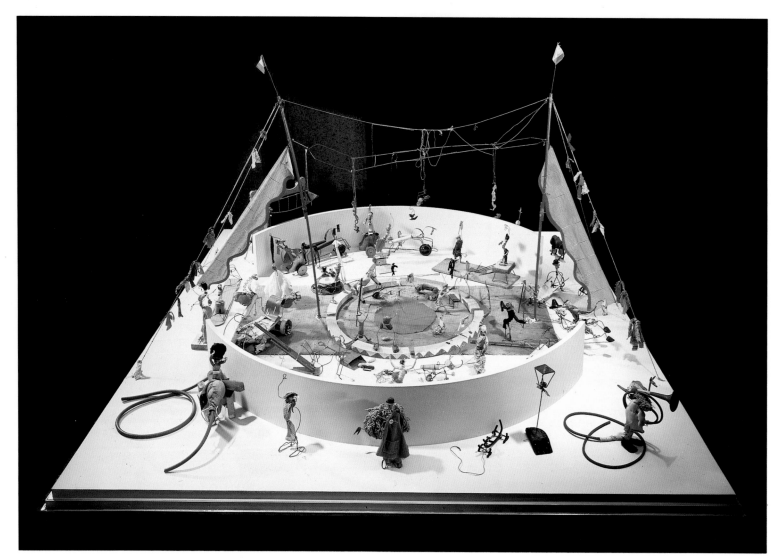

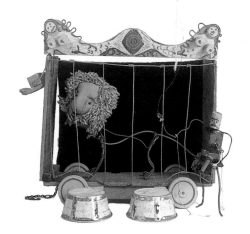

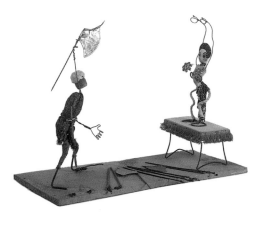

Alexander Calder

The Circus, 1926–31

Mixed media, includes wire, wood, metal, cloth, paper, leather, string, rubber tubing, corks, buttons, sequins, nuts and bolts, bottle caps, 54 x 94¼ x 94¼ inches (137.2 x 239.4 x 239.4 cm).

Purchase, with funds from a public fund raising campaign in May 1982. One half the funds were contributed by the Robert Wood Johnson, Jr. Charitable Trust

Additional major donations were given by The Lauder Foundation; the Robert Lehman Foundation, Inc.; the Howard and Jean Lipman Foundation, Inc.; an anonymous donor; The T. N. Evans Foundation, Inc.; MacAndrews & Forbes Group, Incorporated; the DeWitt Wallace Fund; Martin and Agneta Gruss; Anne Phillips; Mr. and Mrs. Laurance S. Rockefeller; the Simon Foundation, Inc.; Marylou Whitney; Bankers Trust Company; Mr. and Mrs. Kenneth N. Dayton; Joel and Anne Ehrenkranz; Irvin and Kenneth Feld; Flora Whitney Miller. More than 500 individuals from 26 states and abroad also contributed to the campaign 83.36.1–56

The Brass Family, 1927

Brass wire, 64 x 41 x 8½ inches (162.6 x 104.1 x 21.6 cm) without base. Gift of the artist 69.255

Little Ball with Counterweight, c. 1930

Sheet metal, wire, and wood, 63¾ x 12½ x 12½ inches (161.9 x 31.8 x 31.8 cm). Promised 50th Anniversary Gift of Mr. and Mrs. Leonard J. Horwich P.9.79

Roxbury Flurry, c. 1948

Painted sheet metal and wire, 100 x 96 x ⅛ inches (254 x 243.8 x .3 cm). Gift of Louisa Calder 77.85

Big Red, 1959

Painted sheet metal and wire, 74 x 114 inches (188 x 289.6 cm). Gift of the Friends of the Whitney Museum of American Art 61.46

The Cock's Comb, 1960

Painted sheet iron, 119¼ x 145¾ x 98½ inches (302.9 x 370.2 x 250.2 cm). Gift of the Friends of the Whitney Museum of American Art 62.18

In the late winter of 1925, with a press pass from the *National Police Gazette*, Alexander Calder visited the Ringling Brothers and Barnum & Bailey Circus. The fluid, stark sketches he made there over the next two weeks were the beginning of the first definable phase of his art. According to his friend James Johnson Sweeney: "The circus had already taught Calder the esthetic of the unfinished, of suspense and surprise." Within a year Calder converted his circus sketches into skeletal, but vividly descriptive, freestanding wire sculptures: the most minimal of representations were vitalized by an exuberant wit. Over the next five years, Calder twisted and attached fabric to wire and recycled everyday objects— including bottle caps and toilet bowl floats—to fashion a troupe of miniature circus performers, animals, and acts. Animated and narrated by Calder (aided by any others he could enlist, and, after 1931, by his wife, Louisa), *The Circus* was presented in both paid and free performances in Paris, New York, and elsewhere through the early 1960s. The pieces, transported in suitcases, were adjusted for various spaces and manipulated by Calder to suit different audiences. A decade after a New York presentation around 1929, attended by the novelist Thomas Wolfe, a Calder *Circus* performance was recounted, thinly veiled, in Wolfe's *You Can't Go Home Again*. Wolfe and Calder never met; Calder recalled only "some nasty remarks on my performance, included in a long-winded book."

Alexander Calder,
The Circus, 1926–31.

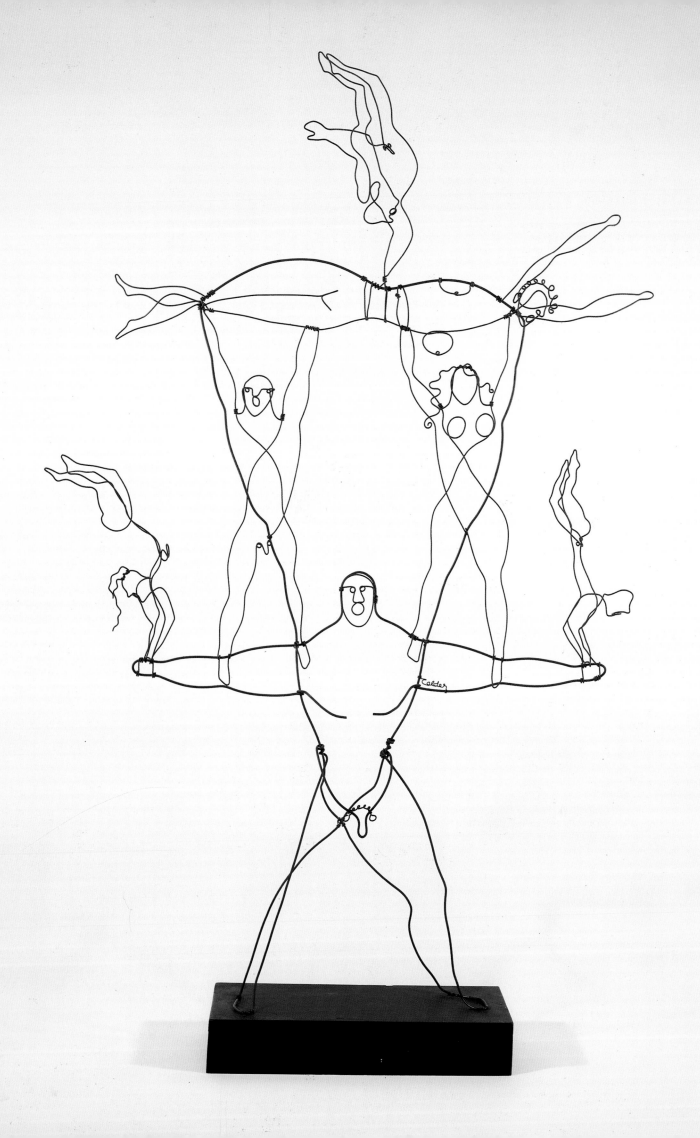

It is seldom that an artist's first work is also his most famous. Calder's *Circus*, which began as an apparatus for playful performances, has become renowned as the fundamental statement of his art. Ceaselessly active, playful, and always crowd-pleasing, *The Circus* was the catalyst for the development of Calder's aesthetic sensibility and his invention of the mobile and the stabile.

In 1929, the headline in a French journal hailed Alexander Calder's twisted and shaped animal and figure sculptures with the phrase, "Wire Becomes Statue." Calder himself once told his sister, "I think best in wire." In *The Brass Family*, Calder's exceptional skill at descriptive geometry, for which he had received the highest marks ever given at Stevens Institute of Technology, was turned to aesthetic ends. He worked in three dimensions while insisting on a planar frontality; like so many sculptors trained in painting, he still conceptualized two dimensionally.

Calder converted his passion for the circus and daredevil performance into comedy in *The Brass Family*. Improbably balanced atop a veritable giant (at whose armpit Calder started his cursive signature), the six smaller figures display the fluid and brilliant balance that epitomizes Calder's later mobiles and symbolizes his lifelong dedication to spirited human cooperation. With dexterous conception Calder draws in wire; the barest of line is orchestrated to contain space and persuasively suggest motion. The startling economy of means, however, in no way diminishes the affable good humor of the performers. Anatomically candid, this nudist acrobat family is the witty masterpiece among Calder's figurative wire works.

Alexander Calder
The Brass Family, 1927.

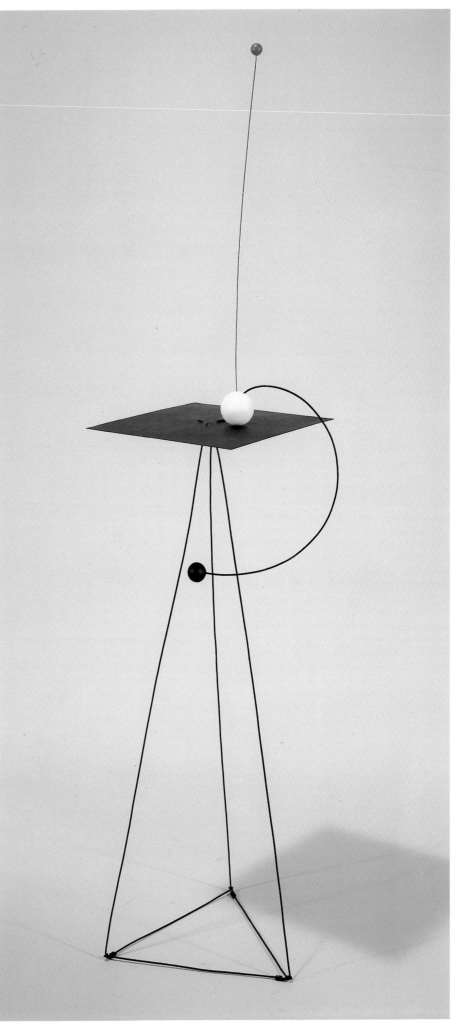

Alexander Calder,
Little Ball with Counterweight, c. 1930.

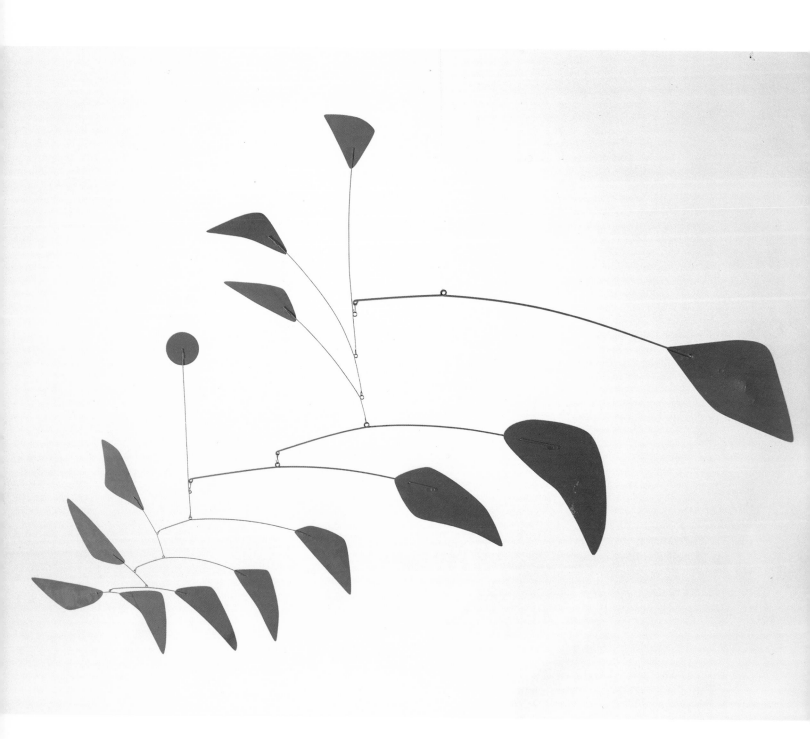

Alexander Calder
Big Red, 1959.

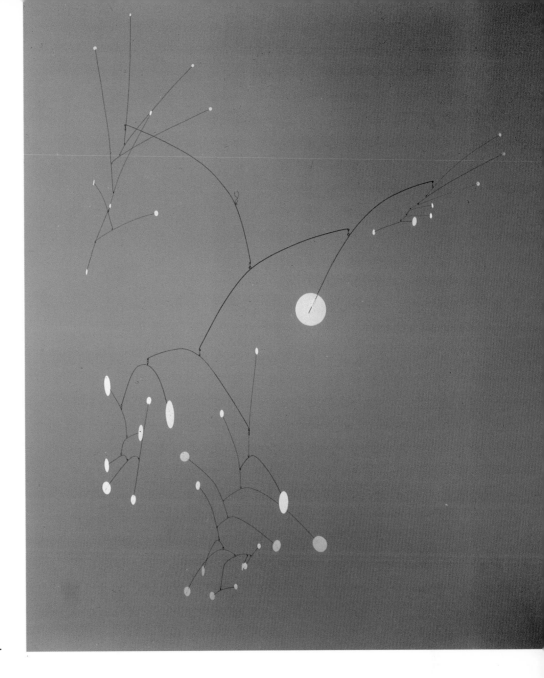

Alexander Calder
Roxbury Flurry, c. 1948.

Through the 1930s, while at work on his wire entertainers, portraits, and animals, Calder was also carving in wood. It is his essential and most creative achievement that in the constructions, mobiles, and stabiles of the early 1930s, the different qualities of line, form, and weight in these two media were combined. In such early standing mobiles as *Little Ball with Counterweight*, the energy and activity of *The Circus* performers evolved into a completely novel form of abstract wire and wood sculpture. Propelled into abstraction during his 1930 visit to Piet Mondrian's studio, Calder quickly reacted with works of astonishing invention.

In *Little Ball with Counterweight*, Calder introduces characteristic new elements: the shifts of color, the scale of the three ball elements; the knowing, off-center balance; implied motion; and interacting circles, square, and triangles. All these features communicate a bold, sophisticated non-objectivity. The tripod of wire that is both part of the work and its support solves the twentieth-century problem of liberating sculpture from a base, a solution Calder had not yet achieved earlier in *The Brass Family*. *Little Ball with Counterweight* exemplifies Calder's abstraction in an austere,

geometric phase, before he evolved the biomorphic shapes that would characterize his later work. Not surprisingly, Calder later connected the piece to his 1931 affiliation with the vanguard, Abstraction-Creation group in Paris. His association with this group signaled his immediate international acceptance.

Calder conceived his own universe of forms, a universe founded on his perception of the essential actions, structures, and principles of nature. An engineer's knowledge of modern materials, tensile strength, and the laws of balance governed the interlocking biomorphs of his stabiles and the freed, asymmetrical equilibrium of his mobiles. By suspending works such as *Roxbury Flurry* from the

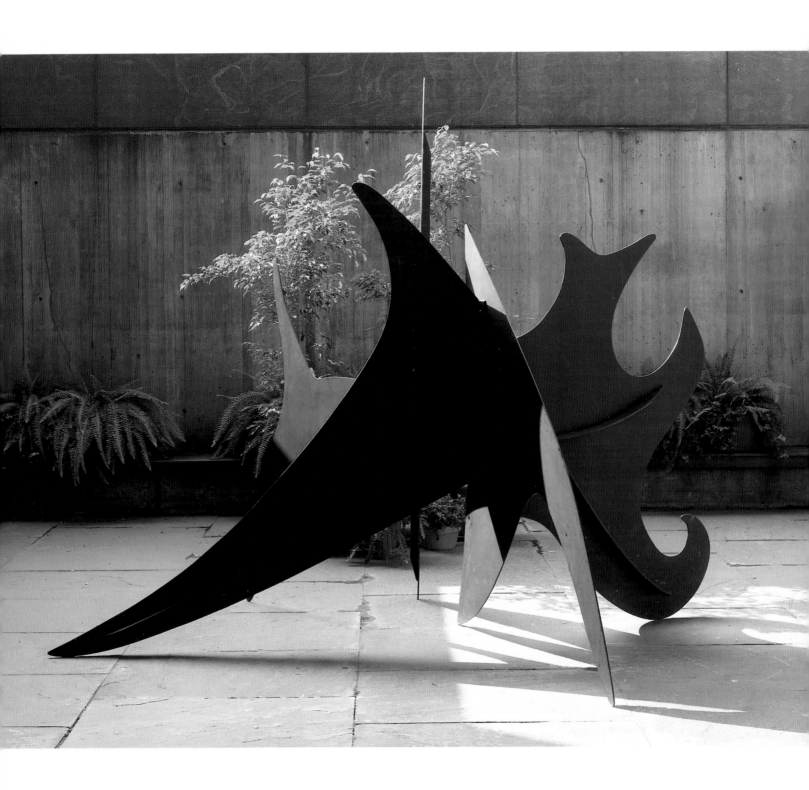

Alexander Calder
The Cock's Comb, 1960.

ceiling, Calder not only eliminated the need for a base, but brilliantly combined concepts of motion, time, and chance within a single artwork.

Though Calder's first ceiling-hung mobile dates from 1934, he did not use the form regularly until the late 1940s. During the war years, a shortage of metal had kept him from producing large-scale mobiles. By the end of the decade, however, he once more had access to quantities of sheet metal. When he again began creating mobiles, it was with a greater lyricism, a surer, more varied asymmetry, and monochromatic or limited color. Jean-Paul Sartre described Calder's postwar sculpture as "a little private celebration . . . a flower that fades when it ceases to move." Such pieces as *Roxbury Flurry* were Calder's cheerful odes to the end of global conflict. The all-white disks aptly imitate falling, swirling snowflakes.

This exceedingly complex sculpture is one of several similarly titled pieces. It was discovered in a tangle on the floor of Calder's studio in Roxbury, Connecticut. Reassembled by the artist for the Whitney Museum's 1976 retrospective "Calder's Universe," it was given to the Museum the following year by his widow.

Calder's later mobiles reveal that as his fame grew, so did the scale of his work. Requests for sculptures for imposing public and private spaces called for an amplification of his ideas. As the scale of his mobiles and stabiles increased, their number declined. The individual shapes in his larger work became more standardized, and the color range simplified—as is apparent in *Big Red*. Yet, while Calder turned for assistance to commercial fabricators for his stabiles, all but the largest of his mobiles were, as Calder emphasized in a Museum questionnaire concerning *Big Red*, still "made by the artist, by hand."

It was Calder's intention in such early abstract sculptures as *Little Ball with Counterweight* to make Mondrian's geometry "oscillate"; but in his mature mobiles, including *Big Red*, the biomorphic shapes evolved by Miró float in and punctuate space. The air-directed motion of Calder's flat, cut-out metal sections added the third dimension and compositional variability to his mobiles. Form and motion were stressed far above color. He frequently chose just the extremes of black and white for his pieces, but then turned to red, which he perceived as the color most opposed to black and white. For Calder, secondary and intermediate colors only confused the clarity and distinctness he sought for his shapes. Of his affection for red, he once admitted, "I almost want to paint everything red. I often wish that I'd been a *fauve* in 1905."

By the late 1950s, Calder turned to metal workshops in France and America to help him produce the stabiles that were being commissioned for sites around the world. Because he admired modern technology and the crisp, industrial process of fabrication, he always left visible the bolts, fittings, gussets, and ribs that connected the heavy metal sections and added detail to these massive pieces. Stabiles such as *The Cock's Comb* were produced from small maquettes, often of aluminum, which Calder reworked until he was satisfied with the design. A fabricator then enlarged the shapes into cut steel plates (or iron for *The Cock's Comb*). When the basic components were finished—*The Cock's Comb* breaks down into six separate flat metal sections—Calder returned to oversee the assembly and make final adjustments.

Calder preferred black for the large stabiles, though he sometimes used solid red, or even both colors. Black gave the sculptures a sense of impenetrable mass and teasing menace in their outdoor settings, whether the green of the countryside or the urban gray of the city. The dark organic shapes entwine, joining and separating as the viewer moves about them. Their sharp endpoints puncture space, and become whimsical presences. Like all his titles, *The Cock's Comb* is both descriptive and cheerful. It refers to a rooster's prominent jagged headdress, the kind of exuberant adornment that delighted and inspired Calder.

Isamu Noguchi

The Queen, 1931

Terracotta, 45½ x 16 x 16 inches
(115.6 x 40.6 x 40.6 cm). Gift of the
artist 69.107

Humpty Dumpty, 1946

Ribbon slate, 58¾ x 20¾ x 18 inches
(149.2 x 52.7 x 45.7 cm). Purchase
47.7

Isamu Noguchi's tenure as a studio
assistant to the sculptor Constantin
Brancusi in 1927–28 encouraged
him to explore abstraction and to
respect material itself as a basic
form of expression. During a trip
to the Orient in 1930–31, he studied
in Kyoto, Japan, with the master
potter Uno Jimnatsu. In this ancient
capital Noguchi became fascinated
with the stark forms of *haniwa*, pre-
Buddhist tomb figures of unglazed,
hollow clay. *The Queen* is the largest
of a series of terracotta pieces in-
spired by Noguchi's stay in Kyoto.

Assimilating the influence of
Brancusi and *haniwa*, *The Queen*
presents a symmetrical series of cir-
cular motifs, definable as a head
covering, head, torso and arms, and
lower body. The compact unity of
the vessel-like form is contradicted
by its obvious fragility, its uneasy
and already fractured balance of
upper and lower masses.

Although dated 1931, *The Queen*
was actually assembled in 1943
from two terracotta elements that
had been exhibited separately in
Noguchi's 1932 New York showing
of his Kyoto work. The sculpture
received its title in 1943 from his
friend Arshile Gorky, who responded
to its distinctly feminine shape. It
bears, as well, a clear resemblance

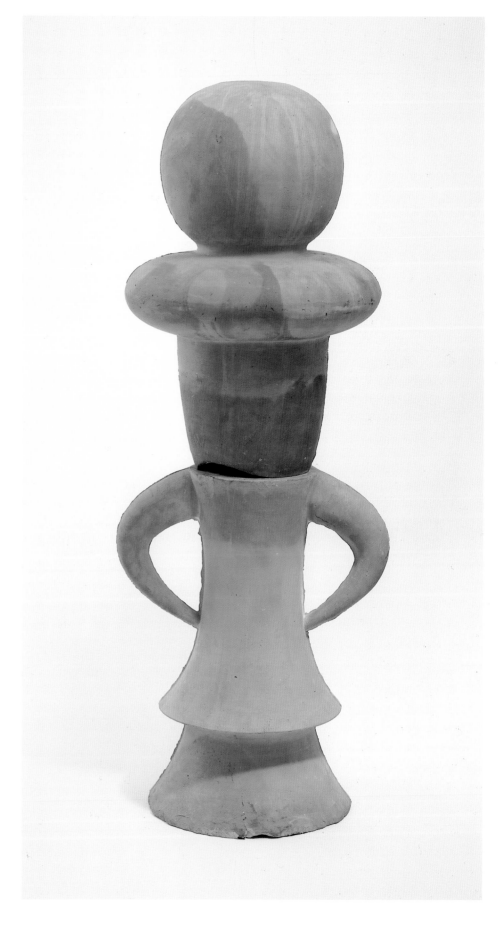

to the chess piece. Although Noguchi made a second series of clay sculptures in 1952 (again in Japan), *The Queen* remains his most commanding and masterful treatment of this material.

The refined fusion of simplicity and detail in *Humpty Dumpty* is characteristic of Noguchi's later work. *Humpty Dumpty* is one of a group of carved, ingeniously interlocking, wood, marble, and slate sculptures that he made between 1944 and 1948, many of which (though not the slate *Humpty Dumpty*) have been subsequently cast in bronze and aluminum. Noguchi has commented of his original materials that "wood and stone, alive before man was, have the greater capacity to comfort us with the reality of our being."

Noguchi chose slate because it was widely available at a reasonable cost during the postwar building boom. The whimsy of the title is unusual in Noguchi's art; it denotes not only the amplitude of the figure, but also the special challenge posed by the brittle medium of slate.

Noguchi's 1944–48 works established the basis of his mature art, an art in which the organic properties of the material determined its eventual sculptured shape. These sculptures derived in part from Noguchi's lightweight, remountable sets for *Herodiade*, a Martha Graham/Paul Hindemith dance of 1944, which prized compactness and the transformation of flat materials into volumetric shapes.

The configurations of these 1940s sculptures are curiously akin to the polished totems of some of Yves Tanguy's paintings (p. 87). The interconnective curves of *Humpty Dumpty* relate as well to the forms in paintings by Noguchi's friends Arshile Gorky (p. 105) and Willem de Kooning. However, Noguchi's intentions are distinctly removed from the Surrealism of Tanguy and the biomorphic expressionism of Gorky and de Kooning. For Noguchi sought a meditative compression and silence in his sculpture which separates, as East from West, his 1940s work from that of his contemporaries.

Arshile Gorky

*The Artist and
His Mother*, c. 1926–36

Oil on canvas, 60 x 50 inches (152.4 x
127 cm). Gift of Julien Levy for Maro
and Natasha Gorky in memory of their
father 50.17

(Illustrated on p. 10)

While best known for colorful proto-
Abstract Expressionist compositions,
Arshile Gorky's most trenchant
image is the subdued and repre-
sentational *The Artist and His
Mother*. He worked on it inter-
mittently from the mid-1920s
through the mid-1930s—during the
period when he was producing in-
creasingly abstracted still-life paint-
ings under the influence of Cézanne,
de Chirico, and especially Picasso.
Nevertheless, such paintings of
family and friends continued to play
a major role in Gorky's art until
around 1940. These portrayals
merge formalist experimentation
with a deeply emotional sensitivity.

Gorky's figure paintings are
usually quite small, but in the
two versions of *The Artist and
His Mother* (the second is in the
National Gallery of Art, Washing-
ton, D.C.), he worked on a larger
scale with complete mastery. The
Whitney Museum painting is the
first and more somber and finished
treatment of this affecting scene.
Gorky based his composition on a
photograph of himself and his
mother made in 1912 in Armenia.
It was taken for his father, who had
already immigrated to the United
States. In 1920, after his mother had
died of starvation during the years
of Turkish-Armenian conflict, the
artist and his younger sister joined
their remaining family in America.

The photograph became Gorky's
potent icon of his mother. In New
York, around 1926, he began to
transcribe the composition. Framed
by the hard geometries of the itin-
erant photographer's cloth backdrop,
with its intimation of a window, the
painting's much-worked passages of
color and softened anatomical forms
herald the abstract course of Gorky's
later art. Except for the distinct
fingers that clench Gorky's little
bouquet above his heart, the hands
are mitt-like and the figurative style
more biomorphic than naturalistic;
yet it convincingly describes the sub-
jects. The figures' stark gazes seize
the viewer. Their faces—the artist's
heart-shaped, his mother's perfectly
oval—incite sympathy, yet their
clothing and setting enshroud emo-
tion. This painting was given to the
Whitney Museum by the artist's
young daughters in 1950 in appre-
ciation of the Museum's support of
Gorky's art, which culminated in
the organization of a memorial
retrospective in 1951.

Painting, 1936–37

Oil on canvas, 38 x 48 inches (96.5 x 121.9 cm). Purchase 37.39

For Arshile Gorky, as for many other American painters of the 1930s, the still life was a primary vehicle of abstraction. The earlier works of Patrick Henry Bruce and Stuart Davis (pp. 47, 90) show how great a distance an artist could travel from the almost invariably Cubist source of inspiration. More than in other Cubist-derived still lifes, however, Gorky's adaptations took the form of interlocking organic shapes. His curvilinear confrontations with Cubism also involved obsessive compositional reworking and thematic repetition.

Centered on a demarcated table-top or within an interior space, the grouped forms of *Painting* surround a white bird-like shape with an eye and mouth. This defined, authoritative presence dominates other outlined shapes, including spear- and palette-like configurations. Such details aside, narrative reading is not possible here or in Gorky's other neutrally titled paintings of the late 1930s (unlike his later works, which yield elaborate interpretations).

The immediate purchase of *Painting* by the Whitney Museum from its 1937 Annual marked Gorky's first sale to a public institution. The work was reproduced in the prestigious journal *Cahiers d' Art* the following year. Such positive response can only have accelerated Gorky's move to the biomorphism that established the aesthetic terms for the final decade of his art.

Arshile Gorky

The Betrothal II, 1947

Oil on canvas, 50¾ x 38 inches (128.9 x 96.5 cm). Purchase 50.3

During the 1940s, Arshile Gorky made his most original artistic statement, finding the visual means to express his intense memories of Armenia, later biographical events, and the forms and processes of nature. Gorky benefited from the arrival in America of refugee European artists and intellectuals in the late 1930s and early 1940s; the presence of the Surrealists proved particularly catalytic to his art. He was included in their circle and André Breton, the "Pope" of Surrealism, lauded his ability to "decode nature to reveal the very rhythm of life." Nature for Gorky became, in Breton's words, "the eye-spring."

The period 1944–47 was the most productive one in Gorky's life. He focused on several themes, exploring them in different versions with cool intelligence and forethought, and rendering the compositions with delicate, sinuous line and floating, thinned-down, mottled color. *The Betrothal* theme exists in three large-scale paintings, several finished drawings, and numerous preparatory sketches. Though considered one of the most refined and coloristically masterful of Gorky's late paintings, *The Betrothal II* remains difficult to interpret. Its title has consistently provoked an intensely narrative

reading. A horse, a rider, and a figure carrying a spear may be discerned. The rider has a pastel-toned head; the horse, a dark head, hoof, and tail. The second figure, at the right, walks with a spear aloft. The couple's interaction has been said to equate love and sacrifice. Formally, the composition evokes the battle scenes of Paolo Uccello, the fifteenth-century Florentine painter whose compressed and luminous images were openly admired by Gorky and the Surrealists. Recently, however, a more complex and familial scenario has been proposed: that the picture enacts or represents Gorky's troubled marriage to his second wife (1941–48). Amid its jetsam of anatomical parts, the tangled relations of the artist and his wife (the mother of his two children) and possibly Gorky's father-in-law have been detected. It is a measure of Gorky's greatness that his paintings generate emphatic but disparate interpretations. Beyond such analysis, the meaning of these sleek, opalescent shapes may be found in a different marriage, that between representation and abstraction, feeling and formalism.

Richard Pousette-Dart

Within the Room, 1942

Oil on canvas, 36 x 60 inches (91.4 x 152.4 cm). Promised 50th Anniversary Gift of the artist P.4.79

Richard Pousette-Dart was the youngest of the independent American artists who, as the 1940s proceeded, shifted the center of advanced art from Paris to New York. Raised by artist-parents who were unusually supportive, Pousette-Dart began his artistic career in 1936 at the age of twenty. He initially made contoured, totemic sculptures and flattened, thickly outlined, representational paintings. Such simplified cubistic works were shown in

New York in 1941 in his first one-artist exhibition. Shortly thereafter, as seen in *Within the Room*, Pousette-Dart had evolved a calligraphic language of whirling organic forms. His active and multicolored fields of shapes anticipated the ideas of the Abstract Expressionists, with whom he was to be affiliated later in the decade.

Pousette-Dart's paintings offer an abstract pictograph of memory and feeling. He approached the canvas directly, establishing a spontaneous, sensuous rapport with his materials. He painted very thickly and he believed that his images fashioned themselves: "Painting is a creative prayer . . . a quest for reality."

Significantly, he entitled a 1943 painting *Palimpsest*—a tablet or paper upon which successive layers of script have been inscribed and then erased. The word is poetically suggestive of Pousette-Dart's creative process of compiling and altering motifs to represent his inner life.

Pousette-Dart's most compositionally complex and dense paintings date from these early years. A baroque frenzy of enclosures and apertures covers *Within the Room*, keeping the eye in motion. A white illumination surrounds these clustered ovoids and contains their complexity at the edge of cacophony. As his art later developed, Pousette-Dart's pictorial vocabulary turned from form to line to dot, from depictions to atmospheres.

Bradley Walker Tomlin

Number 2—1950, 1950

Oil on canvas, 54 x 42 inches (137.2 x
106.7 cm). Gift of Mr. and Mrs. David
Rockefeller in honor of John I. H. Baur
81.8

Bradley Walker Tomlin's career
began, as did that of other artists of
his generation, with his graduation
from Cubism. In the early 1940s, he
abandoned the Cubist still life, par-
ticularly the crowded compositions
he had favored, for pictographic
motifs, probably influenced by his
friend Adolph Gottlieb (p. 112). By

1947 representational forms had dis-
appeared from Tomlin's work, and
he painted all-over patterns of free
brushstrokes, an Abstract Expres-
sionist style, evoking his inner life
and thought process. Despite poor
health, Tomlin was startlingly pro-
ductive in the last years of his life;
1950 marked the fullest and most
ambitious achievements of his
career.

 Number 2—1950 takes as its sub-
ject mobile, bright line against
massed, darkened background.
Tomlin's thick-lined paintings differ
from those of Jackson Pollock
(p. 110), being more of a performance
than an improvisation. As Tomlin's

friend Philip Guston observed, "his
temperament insisted on the im-
possible pleasure of controlling and
being free at the same moment."
Number 2—1950 was evidently
painted in the horizontal format he
frequently used, so that its present
right side was at the bottom while
Tomlin worked. The drips from the
broad white paint strokes that origi-
nally flowed downward now flow to
the right. This assault upon gravity,
atypical within his art, accentuates
the viewer's inclination to be dis-
placed in the painting's labyrinth.
Number 2—1950 was donated to the
Whitney Museum in honor of John
I. H. Baur, former Director of the
Whitney Museum and the organizer
of the first retrospective of Tomlin's
art, held in 1957 at the Museum.

Jackson Pollock

Number 27, 1950

Oil on canvas, 49 x 106 inches (124.5 x 269.2 cm). Purchase 53.12

Jackson Pollock's abstract fusions of line, color, and movement have had a seminal influence on successive generations of artists. Since the late 1940s, his art has been considered the pivotal manifestation of Abstract Expressionism, or Action Painting, as his form of it is known. In the years following World War II, it was Pollock and his contemporaries

—among them, Willem de Kooning, Barnett Newman, Mark Rothko, Clyfford Still, and David Smith— who elevated American art to international prominence.

Number 27 (the number refers roughly to its sequence in the artist's yearly production) is situated at a midpoint in the series of drip paintings and drawings Pollock made between 1947 and 1953, which are considered his consummate achievements. He stood above an unprimed,

unstretched canvas spread out on the floor; with a paint-loaded brush or stick he proceeded to fling the paint onto the canvas surface. Skeins of paint had earlier been used by Hans Hofmann, the Surrealists, and others, but Pollock's sustained and ambitious mastery of this technique appropriated it as his own.

In Pollock's new painterly syntax, distinctions of line and mass, color and surface, figure and ground were

111

eliminated. He transformed thought and process into action by externalizing his subconscious. "I want to express my feelings rather than illustrate them," he explained. In *Number 27*, he created exquisitely balanced vistas of paint through line, distinguished by a marvelous use of bright colors within a darker tracery. Exactly what he was expressing

remains indefinable. "When I am *in* my painting, I'm not aware of what I'm doing. It is only after a sort of 'get acquainted' period that I see what I have been about. I have no fears about making changes, destroying the image, etc., because the painting has a life of its own. I try to let it come through." On another occasion, when asked by Hans Hofmann if he worked from nature, Pollock replied simply, "I am nature."

Adolph Gottlieb

The Frozen Sounds, Number 1, 1951

Oil on canvas, 36 x 48 inches (91.4 x 121.9 cm). Gift of Mr. and Mrs. Samuel M. Kootz 57.3

Unlike certain Abstract Expressionist painters, Adolph Gottlieb worked with a succession of themes and forms throughout his forty-year career. In his first mature series, Pictographs, begun in 1941, swiftly drawn figurative symbols are contained within crude grids. At a time of global war, Gottlieb, his friend Mark Rothko, and others sought sustenance and refuge in a painterly script of archaic shapes and universal archetypes. Gottlieb's next major series evoked the landscape. Between 1951 and 1957, his Grids and Imaginary Landscapes reasserted spatial depth in their gestural conjuration of land, sea, and sky. *The Frozen Sounds Number 1* was the breakthrough painting of the group. The work introduced a divided canvas in which lunar/solar shapes interact with the earth. Its five suspended paint masses in the upper part balanced a painterly, indistinct, pictographic field below. A cool whiteness constricts the activity of the shapes and lines.

This kind of two-part composition characterized the last twenty years of Gottlieb's painting. *The Frozen Sounds Number 1*, acquired by the artist's dealer, Sam Kootz, was the keystone of Gottlieb's 1952 one-artist exhibition at the Kootz Gallery in New York. *The Frozen Sounds Number 2*, a companion painting, is owned by the Albright-Knox Art Gallery, Buffalo.

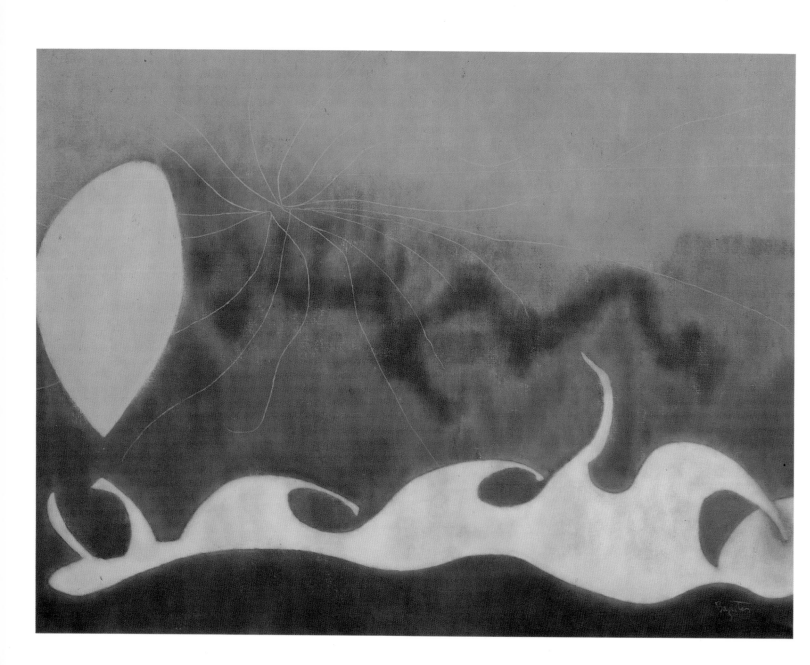

William Baziotes

The Beach, 1955

Oil on canvas, 36 x 48 inches (91.4 x 121.9 cm). Purchase 56.12

For William Baziotes painting was a quiet, calm mirror of his feelings. Working in a seclusion only penetrated by his wife, Ethel, Baziotes raised his art before him like a reflective shield. He choreographed landscape and fragmented biomorphic forms against subdued backgrounds, isolating and arresting shapes while implying hushed motion. By thinning his medium, he achieved a softened demarcation of shape and all-over, velvet smoothness.

In Baziotes' post-1950 paintings a submarine, aqueous world emerged, as in *The Beach*, where a vague, watery atmosphere contains two outlined, floating forms. Along with other New York School painters, Baziotes took his new visual metaphors and procedures from the European Surrealist art that had reached America in the early 1940s.

Through Surrealism, he introduced such effects as radiant, spidery tendrils, and employed the device of automatism to reach the subconscious. His sparer compositions took on a mysterious and evocative potency. These pictorial extensions of self were inspired by Baziotes' fascination with the archetypal formulations of Pre-Columbian and Greco-Roman art. The personal and present for him were weighted by historical continuity. As he noted, "I want my pictures to take effect very slowly, to obsess and to haunt."

Painted in his New York studio, *The Beach* combines two other locales. The dark hazy forms in the top half of the painting suggest the Berks County hills that Baziotes overlooked from the back porch of the house he retained in his native town of Reading, Pennsylvania. The cresting form at the bottom—which he described as "the dead looking fossil creature"—derived from his disagreeable memory of the landscape and shoreline of New Smyrna Beach, Florida, which he had visited in the winter of 1944.

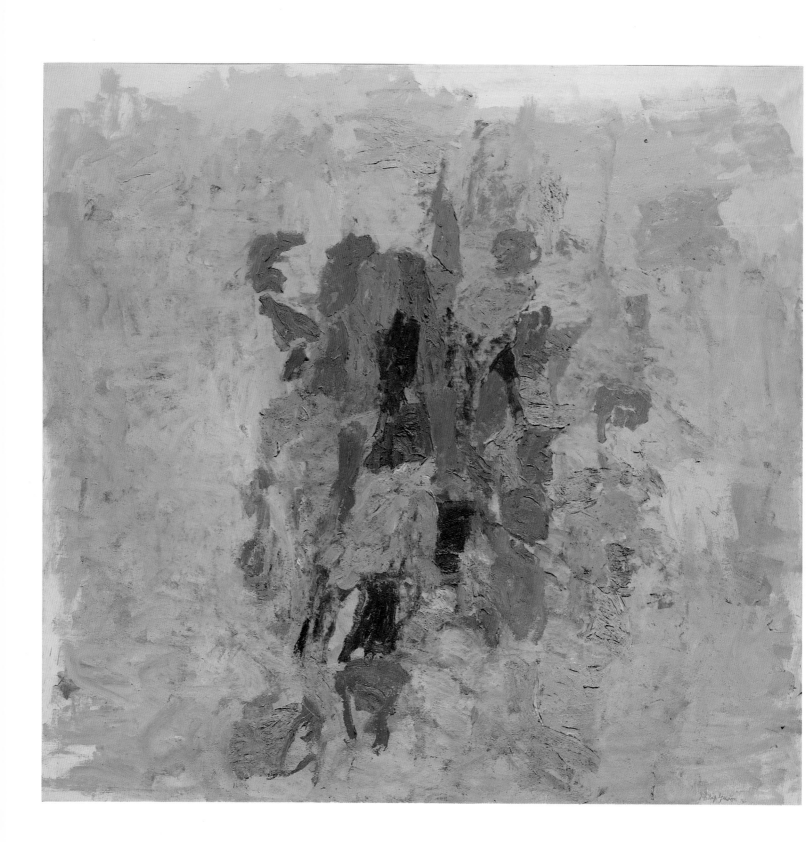

Philip Guston

Dial, 1956

Oil on canvas, 72 x 76 inches (182.9 x 193 cm). Purchase 56.44

The capacity for growth and change in American art is exemplified by the stylistic vicissitudes of Philip Guston's career—from socially conscious realism at the end of the 1940s, to Abstract Expressionism, and, finally, in the late 1960s, to representational imagery of a fervent, personal nature. Though Guston first attracted attention in the 1930s, it was his Abstract Expressionist canvases of the 1950s that ignited his reputation.

Guston later judged *Dial* to be one of the best works of his Abstract Expressionist period. Light and shimmering surface modulations enhance the thick, sensuous pigment of his gestural abstractions. With his move to the upstate New York community of Woodstock, the forms and flow of nature became his inspiration. *Dial* intimates light-dappled foliage and ripples in water, recalling Guston's special fondness for Monet's late views of Giverny and linking the painting with the *plein-air* vivacity of French Impressionism. During a 1956 visit to Guston's studio-barn, the critic Dore Ashton heard him "exclaim in an access of confidence, 'I'm in *love* with painting.'" As Ashton went on to observe, "there was no longer any barrier between him and his images. Through the paint itself, the *matter* of paint, he had been able to satisfy a need to keep in touch with the material aspect of existence."

In *Dial*, Guston's naturalism floats within his clustered, pastel sea of paint strokes. Darker multicolor masses hover at the center, their dense application nervous and suggestive. An imagery seems arrested at the edge of formulation.

The work's title serves more as a designation than a description. It likely refers to the avant-garde literary journal *The Dial*, which Guston had read avidly as a precocious high school student and later often recalled in conversation.

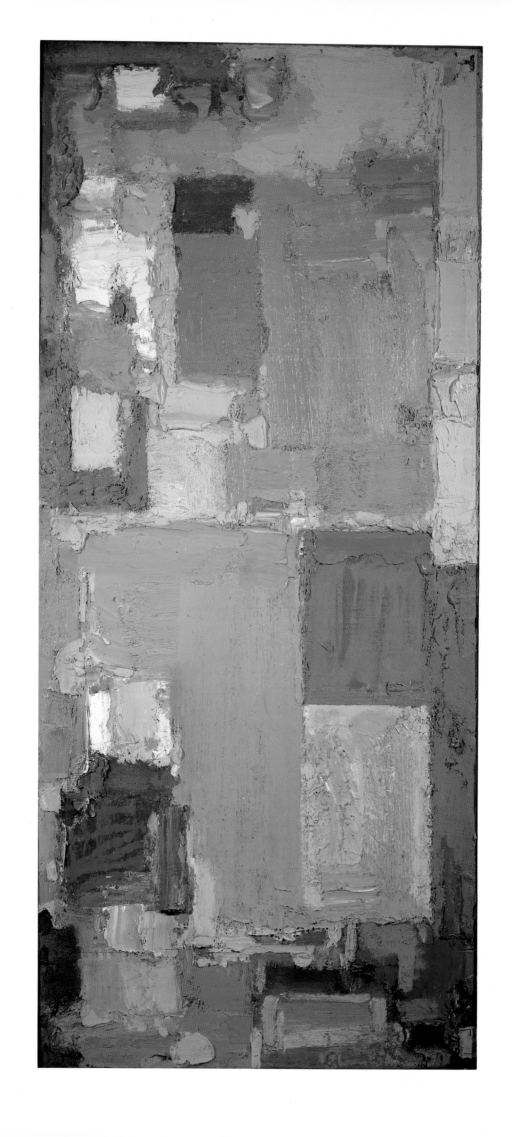

Hans Hofmann

Kaleidos, 1958

Oil on wood, 72⅛ x 31⅞ inches (183.2 x 81 cm). Promised Gift of Mr. and Mrs. Leonard Field P.20.80

Until 1958 Hans Hofmann spent much of his time teaching in universities and at his art schools, but his paintings disprove the notion that a great teacher cannot be a great artist. Hofmann's classes buttressed his art rather than overwhelmed it. Nevertheless, when he closed his art schools in New York and Provincetown in 1958, his painting did assume new authority and scale. *Kaleidos* was painted during this pivotal year and its encrusted unity of the geometric and the gestural defines Hofmann's final style. The isolated rectangle had emerged in Hofmann's art around 1954, having evolved from his geometrized townscapes and still lifes of the 1940s and early 1950s. The form is seen in *Kaleidos* in a transitional stage that retains highly gestural execution and partial formulations. Thereafter, hard-edge, floating rectangles, clustered or isolated, became Hofmann's most distinctive trademark. The sequence of merging, paint-ridged rectangles in *Kaleidos* and the work's luminous juxtapositions of green and orange express Hofmann's dictum of a "push and pull" pictorial structure. "Pictorial life is a created reality," he said, and the work's asymmetrically balanced composition and thickly tactile surface transform the rectangle into a charged and visionary experience.

Fittingly, the painting's title is an invented word related to kaleidoscope and, like it, derived from a contraction of the Greek words *kalos* (beautiful) and *eidos* (form). *Kaleidos* and *Rhapsody*, a companion painting of the same size and year, were made for Hofmann's first wife, Miz; the works were designed to hang on a pair of walls in the couple's New York apartment— hence, their unusually elongated proportions. Hofmann only released the paintings for loan and sale following Miz's death in 1963.

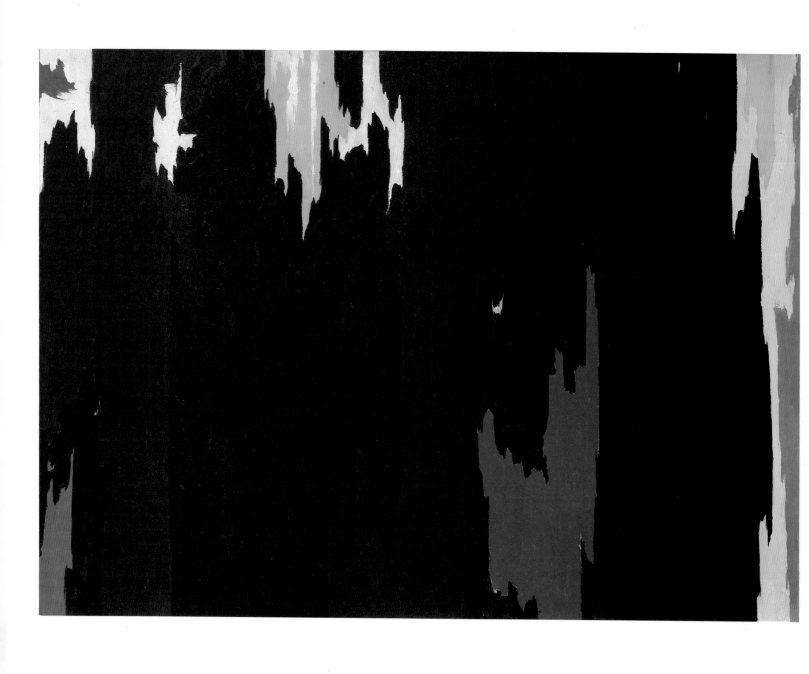

Clyfford Still

Untitled, 1957

Oil on canvas, 112 x 154 inches (284 x 391.2 cm). Gift of the Friends of the Whitney Museum of American Art (and purchase) 69.31

Clyfford Still envisioned himself as unique and olympian, and therefore disassociated himself from the other Abstract Expressionists. He kept careful control over the sale and exhibition of his works, permitting only twelve one-artist exhibitions during his lifetime. He accompanied these often epic presentations with personal explanations, frequently of an immodest, grandiose, or sanctimonious nature. This kind of commentary, coupled with the paucity of works available for exhibition, effectively inhibited critical judgment of Still's art.

Still's paintings took their mature form in the early 1940s, after which only scale and subtle distinctions of stroke and surface altered their essential character. The Whitney Museum painting, while laced with color, contains vast passages of black. Unlike Ad Reinhardt's meditative and reductive use of black (p. 149), Still's somber monochrome is athletic and sensual. Evoking the flow of water, the passage of clouds, and a mountainous terrain, his forms emerge from the mannered physicality of paint strokes and interpenetrating, jagged edges. Yet these panoramas never disclose anything but pictorial flatness. A decade later, Still reinforced this flatness by applying a thick layer of varnish, which muted and yellowed the color, neutralizing surface differences.

In 1969, Still described the Museum's *Untitled* as "one of a series of large works begun in 1944 with the metaphysical intent of transcending the authoritarian or aesthetic qualities of color, space and image. By implication, this work, as well as its antecedents, was an assault upon the concept of the picture as a value object; as a sociological or literary illustration; or as a sybaritic device. In direction this work was an affirmation of individual responsibility—a repudiation of the mechanistic ethic and technological rationale of our culture." Though he was buoyed by such effusive prose, Still's grand objective for all his paintings remained the same: "to evolve an instrument of thought which would aid in cutting through all cultural opiates, past and present, so that a direct, immediate, and truly free vision could be achieved."

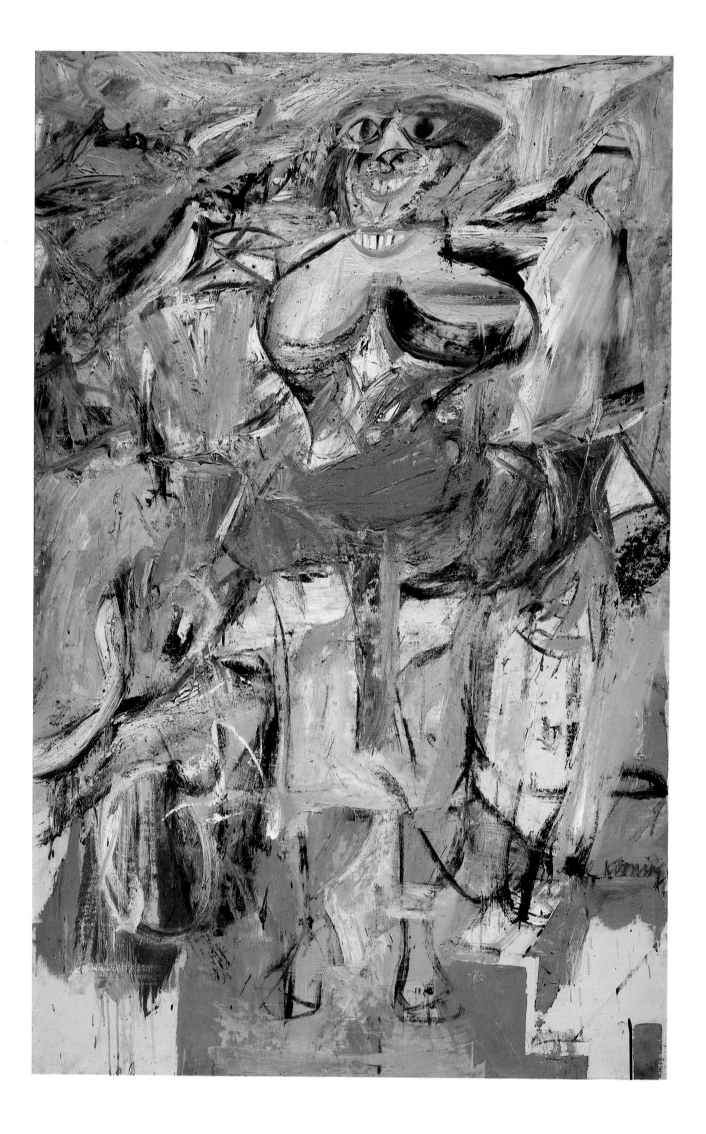

Willem de Kooning

Woman and Bicycle, 1952–53

Oil on canvas, 76½ x 49 inches (194.3 x 124.5 cm). Purchase 55.35

Between 1950 and 1953 Willem de Kooning completed the six enumerated paintings in his Woman series. When first exhibited together in 1953 they were greeted with shock and perceived as the act of a turncoat, for in the late 1940s de Kooning had made a bold break from figuration into non-objectivity, and no one expected him to return to the figure. But the Woman series presented a new kind of figuration: in a gestural abstract mode, de Kooning exploded the female form, creating an image of urgency and violence. The series seemed to demonstrate what de Kooning's colleague Mark Rothko had once contended—that for developing abstract painters "a time came when none of us could use the figure without mutilating it."

Woman and Bicycle, part of the series but not a numbered work within it, was the second largest of the group. It is notable for the clarity of the woman's features, her two mouths, and swollen breasts. The lower mouth (retained from an earlier placement) hangs like a ghoulish necklace or a souvenir of a Dracula-like attack. These frozen expressions of pleasure are arresting details within an intense and frenzied composition. The circular slashes of paint in the lower left signify the wheel and handlebar of the bicycle in the title. The Action Painting manner of execution both establishes and demolishes a dialogue between the drawn figure and the gestural ground. As Leo Steinberg described the series: "We saw not things here but events—a darting, glancing, evading, overlapping and colliding; a grammar of forms where all nouns were held in abeyance; systems of turbulence whose rate of motion was so flickering fast that the concretion of a 'thing' became unthinkable." In returning thus to the figure, de Kooning sought to explore abstraction and gesture more profoundly within a format he described as "the female painted through all the ages, all those idols." He used the future of painting to connect with its past.

Willem de Kooning

Door to the River, 1960

Oil on canvas, 80 x 70 inches (203.2 x 177.8 cm). Gift of the Friends of the Whitney Museum of American Art (and purchase) 60.63

After the Woman series, Willem de Kooning turned in the mid-1950s to larger-scaled abstractions, often based on landscapes, as the works' titles suggest. As for the human body, "by the spring of 1955," Thomas B. Hess observed, it "was engulfed in the new forms, as a jungle will obliterate a shrine."

Such emblematic expressions as *Door to the River* were built with large paint strokes that became structural, their freedom always shaped with clarity and conviction. Along with Franz Kline (p. 126), whose art in this decisive era de Kooning's most closely resembles (and may even be said to replicate in color), de Kooning brought certitude to gestural abstraction. Between the birth of his only child, Lisa, in 1956 and his move in 1963 from New York to The Springs, Long Island, he completed some of his most authoritative, dramatic, and colorful works.

Door to the River was painted in New York, midway between these central events in de Kooning's life. Within a few months of its completion, it was acquired by the Museum directly from the artist. The blue band of the river flowing in from left, near the bottom, the framed, off-center doorway, the yellow sunlit infusion and its Rubensian pink flourishes orchestrate this strikingly simplified composition. A sense of majestic other-worldliness is implied in the painting's bold aperture that floats amid vibrant space. Absolutely resolved in its execution, *Door to the River* neither bears the marks of the continual reworking of earlier paintings nor displays the agitation and coloristic turbulence of his later work.

Franz Kline

Mahoning, 1956

Oil on canvas, 80 x 100 inches (203.2 x 254 cm). Gift of the Friends of the Whitney Museum of American Art 57.10

Produced in the middle of the 1950s, at a halfway point in Franz Kline's mature work, *Mahoning* is a summary presentation of his stark mode of artistic expression. Beginning in 1949 Kline worked abstractly in heroic scale, applying bold brushstrokes of black. Having previously painted figuratively and with muted colors, Kline now created black-and-white reductions that he insisted were "not symbolism any more than . . . calligraphy." Kline's paintings seem to extrapolate and enlarge details of Willem de Kooning's concurrent black-and-white drawings and paintings. "It wasn't," he explained, "a question of deciding to do a black and white painting. I think there was a time when the original forms that finally came out in black and white were in color, say, and then as time went on I painted them out and made them black and white."

Kline's magnified, geometric constructs have the sweeping, gestural character of other Abstract Expressionist paintings. Kline, however, sought not the mobility, delicacy, and all-over effect of Jackson Pollock's compositions (p. 110), but fixity and succinct pictorial statement. The muscular finality of Kline's 1950s black-and-white paintings and the surety of their linear components derived from his incessant inclination to draw; his seemingly instinctive brushstrokes owe their character to practiced repetition.

As in *Mahoning*, in Kline's best works the black motif touches at least two sides of the canvas. Thus grounded, the girder-like transverses of *Mahoning* become architectonic. The controlled space and dynamism in such resolute black-and-white statements illustrate Kline's enthrallment with factory and urban structures. Born in an industrialized region of Pennsylvania, Kline often returned there and titled many of his paintings after the area. Mahoning is an Ohio county near the western border of Pennsylvania, in what was then a center of American steel production and industrial might.

Mark di Suvero

Hankchampion, 1960

Wood and chains, 77¼ x 149 x 105 inches (196.2 x 378.5 x 265.7 cm). Gift of Mr. and Mrs. Robert C. Scull 73.85

Franz Kline's bold, black lattices (p. 126) are the acknowledged precursors of Mark di Suvero's sculpture. Di Suvero's open-form, three-dimensional diagonals and large scale bespeak a heroic expansiveness. *Hankchampion* was the major work in his first solo show—which the critic Sidney Geist hailed as the most moving one-artist exhibition of sculpture in New York since Constantin Brancusi's in 1933. The piece was a salutation to di Suvero's younger brother Henry ("Hank") who, along with other artists and friends, had assisted di Suvero in his remarkable recovery from a crippling, near-fatal accident in March 1960.

The weathered timber beams of *Hankchampion* were salvaged from di Suvero's Fulton Street neighborhood in Lower Manhattan. The use of such materials was in keeping with the artistic practice of recycling urban detritus, common during the late 1950s and early 1960s. In *Hankchampion*, beams that once supported a building now freely structure space. The sculpture's complex of triangles and parallelograms, bolted together, formulates and breaks up as one walks about it. Chain swags (originally of rope) jauntily festoon the massive, multi-directional composition. Like the larger works of Alexander Calder, from whom he was later to borrow the idea of motion in sculpture, di Suvero's assertive and increasingly large-scale sculptures require public spaces. *Hankchampion* is among his first pieces on this scale and heralds his present position as one of the foremost sculptors of monumental public works.

Louise Nevelson

Dawn's Wedding Chapel II, 1959

Painted wood, 115⅞ x 83½ x 10½ inches (294.3 x 212.1 x 26.7 cm) with base. Gift of the Howard and Jean Lipman Foundation, Inc. 70.68

The wood elements of Louise Nevelson's assemblages of the 1950s recall her father's occupation as a builder and owner of a lumber yard. However, their Cubist form documents her study in Munich in 1931 with Hans Hofmann. Although her attendance at the Hofmann school was brief, it initiated her lifelong commitment to multi-faceted Cubist structure. Her work in the following year with the Mexican muralist Diego Rivera taught her that art could have monumental scale and still be an integral part of life.

By the mid-1950s, Nevelson's art attained its ultimate form. Her complex presentation of turned and fragmented wood shapes set organic, urban remnants within a rigorously hard-edge aesthetic. Nevelson gathered her materials from the cast-off lumber of a rapidly rebuilding city. Like her friend the composer John Cage and the painter Robert Rauschenberg, she recycled ordinary materials (or sounds, in the case of Cage) into an aesthetic that stressed chance and variability.

In 1959, Nevelson was invited to participate in the landmark exhibition "Sixteen Americans" at the Museum of Modern Art in New York. She titled her ambitious assemblage of sculptures for this show *Dawn's Wedding Feast*. Whereas before she had unified the disparate elements of her art through a monochrome of black paint, *Dawn's Wedding Feast* is coated with a brilliant white. Having considered herself an "architect of shadow," she now became an "architect of light." With its association of cleanliness, openness, and affirmation, *Dawn's Wedding Feast*, in Nevelson's words, was "a white wedding cake. A wedding mirror. A pillow . . . a kind of fulfillment, a transition to a marriage with the world." *Dawn's Wedding Chapel II* is composed of several reassembled and reshuffled sections of this larger ensemble. A purified altar of urban detritus, it is a revised and symmetrical souvenir of one of Nevelson's pioneer environmental projects.

John Chamberlain

Velvet White, 1962

Welded automobile metals, 81½ x 61 x 54½ inches (207 x 154.9 x 138.4 cm). Gift of the Albert A. List Family 70.1579

During the 1960s, sculptors such as Mark di Suvero and Louise Nevelson (pp. 128, 130) routinely employed materials which had previously been considered inappropriate for high art. John Chamberlain's decision in 1960 to make crushed automobile metal his medium of expression joined means and end. Although he would go on to manipulate polyurethane foam, galvanized steel boxes, Plexiglas, and even paper bags, his art is most identified with crushed automobile parts. This scrap metal is the most symbolic of all American industrial products, but for Chamberlain it was initially a matter of working with an appealing yet inexpensive material. In retrospect, however, it is apparent that he, like contemporaneous Pop artists, was taking an American icon, here semi-demolished, and presenting it as both art and indictment.

As implied in the title *Velvet White*, seemingly obdurate automobile metal could assume sensuous configurations; Chamberlain's adept manipulation turns metal to fabric. Color in such an early work as *Velvet White* is intrinsic, not additive, to form. Chamberlain's treatment of metal becomes a three-dimensional actualization of Willem de Kooning abstractions (p. 124). Yet unlike the planar work of David Smith (p. 142), the best-known sculptor connected to Abstract Expressionism, Chamberlain's sculptures always function in the round.

Barnett Newman

Day One, 1951–52

Oil on canvas, 132 x 50¼ inches (335 x 127.6 cm). Gift of the Friends of the Whitney Museum of American Art (and purchase) 67.18

In 1948, Barnett Newman began to develop a definitive format for his painting: stark expanses of serene, unbroken color, sometimes with ragged-edge stripes of another color ("zips," as he called them) at the peripheries or down the center. Without a clear subject or implications of depth, these paintings could be read as expressions of infinity and expanse. Newman's own comments in 1948 supported the identification of his reductive abstraction with an austere religion of emotion: "We are reasserting man's natural desire for the exalted, for a concern with our relationship to the absolute emotions. We do not need the obsolete props of an outmoded and antiquated legend. . . . We are freeing ourselves of the impediments of memory, association, nostalgia, legend, myth, or what have you, that have been the devices of Western European painting. Instead of making *cathedrals* out of Christ, man, or 'life,' we are making it out of ourselves, out of our own feelings. . . ." The process of primal creation, the nothingness before matter, is clearly inferred by the title and visual terms of *Day One*.

By the early 1950s, Newman was imposing a cathedral-like scale as well as content on his paintings. These new epic works were too large to fit in a commercial gallery and as yet of no interest to museums. Newman nevertheless produced several series of such overscaled works. In 1951–52 he created a quartet of interrelated paintings, each 132-by-50 inches: *Day Before One, Day One, Ulysses,* and *Prometheus Bound. Day Before One* and *Day One* were paired, the former predominantly blue, the latter orange. Their complementary relationship is enhanced by alternative compositional solutions: Newman placed thin bands of color at the top and bottom of *Day Before One* and at the sides in *Day One*. A human presence is asserted at the bottom left of the painting through Newman's awkwardly scripted name and *Day One*'s date of execution.

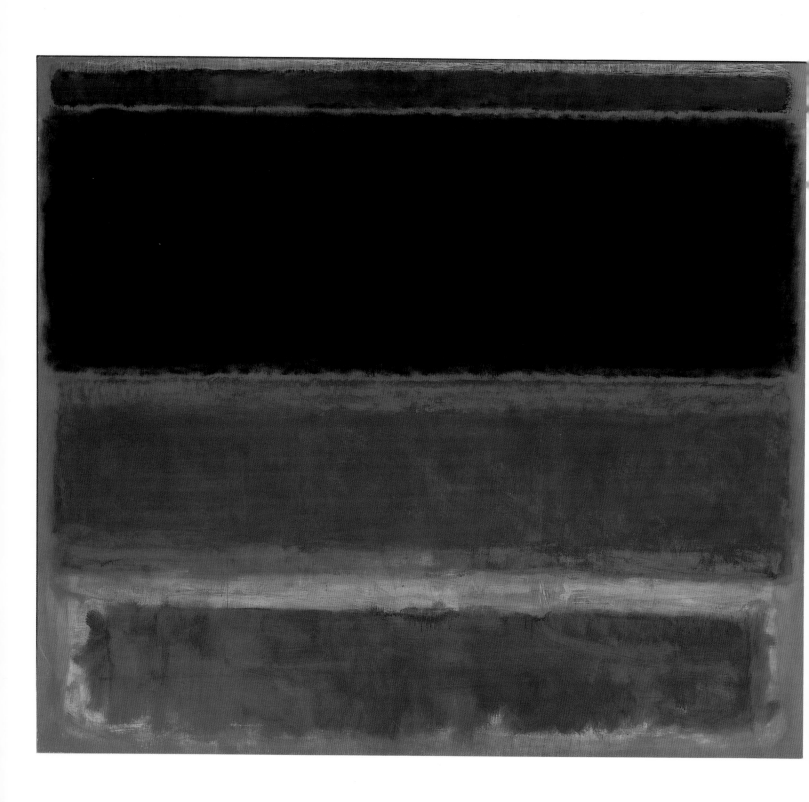

Mark Rothko

Four Darks in Red, 1958

Oil on canvas, 102 x 116 inches (259.1 x 294.6 cm). Gift of the Friends of the Whitney Museum of American Art, Mr. and Mrs. Eugene M. Schwartz, Mrs. Samuel A. Seaver, Charles Simon (and purchase) 68.9

By 1949, Mark Rothko established what became his characteristic format: single or stacked blocks or bands of mottled color afloat in harmonious fields. In their horizontality, these shapes imply a stark landscape that was at first exuberant in color and ultimately became somber. By 1957 a mournful palette of dark red, maroon, and black rectangular shapes frequently extended across even larger canvases. Around the time of *Four Darks in Red*, Rothko was also at work on a commission to make murals for a room at a New York restaurant. In this project, expansive scale became routine. But the perverse challenge of creating decor for dining eventually angered Rothko to the point where he abandoned the project—but not the succession of major paintings he had produced in connection with it, paintings marked by an increasingly dark tonality. Rothko had earlier characterized his paintings as facades; with the breadth and uniformity of *Four Darks in Red*, his paintings came to command the viewer's entire field of vision.

Rothko had always wished the viewer to be encompassed within his painting and the larger scale and palpitating color were intended to elicit an outpouring of feelings. In *Four Darks in Red* the widest and weightiest dark color block is at the top and a roseate glow flames from below. This basic reversal of visual gravity pinions the viewer to the impassive neutrality at the center. Ultimately, the subject of *Four Darks in Red* is the space and luminosity that flow around and within the painting's five horizontal bands. Rothko found means to make color alone the voice of mood and emotion.

Cy Twombly

Untitled, 1969

Oil and crayon on canvas, 78 x 103 inches (198.1 x 261.6 cm). Gift of Mr. and Mrs. Rudolph B. Schulhof 69.29

Cy Twombly's art, like that of Franz Kline (p. 126), with whom he studied in 1951 at Black Mountain College, has evolved into a language of line. Always more drawn than painted, Twombly's work trades Kline's structural clarification for a field of seemingly impromptu, fluid graphic marks. As Roland Barthes wrote in the catalogue for Twombly's 1979 retrospective at the Whitney Museum, the artist has achieved "an incessant victory over the stupidity of strokes."

With his so-called Blackboard paintings of 1966–71, Twombly counterbalanced concept and chance, process and finality. Their chalky white delineations against a bluish-gray background moved from pure script marks to graphic formulas. In *Untitled,* Twombly began with the barest of outlines—incised white rectangles on a light ground—from which a fabulously suggestive web of strokes sprung into being. Possibly derived from the mechanism of a water chart (the words are scrawled near the top, right of center), the cascade of measurement-laden lines is deliberative yet wildly free. The number progressions of Twombly's charts and the alphabet letters suggest arcane references, yet this elusive blackboard lecture, which reads from right to left, cannot move beyond the eye to the mind. When pushed further, his messages break down; the erased notations seem essential to follow the meaning of what remains inscribed. The accelerating, flowing rectangles successively dissolve in their descent from right to left. Twombly's simplifications—the reductive quotient of line against monotone background—ally him with Minimalism at the same time that the gestural character of his works defines him as a belated Abstract Expressionist. In an effort to carry forward his Abstract Expressionist past, Twombly conjoined terse, expressionistic grafitti with charged vacancy. He establishes the act and process of language and script as more important than what is actually said.

David Smith

Hudson River Landscape, 1951

Welded steel, 49½ x 75 x 16¾ inches (125.7 x 190.5 x 42.5 cm). Purchase 54.14

Running Daughter, 1956

Painted steel, 100½ x 36 x 17 inches (255.3 x 91.5 x 43.2 cm). 50th Anniversary Gift of Mr. and Mrs. Oscar Kolin 81.42

During the 1930s, David Smith's working procedure was influenced by the welded metal sculptures of Picasso and Julio Gonzalez. In 1946 Smith turned to the landscape as inspiration for his abstract yet referential, painted steel sculptures. *Hudson River Landscape,* his final and most ambitious treatment of the theme, is notable for its virtuoso welding, large scale, and exuberant description of details. Its source was the riverside stretch of the New York Central Railroad between Poughkeepsie and Albany. Smith saw this particular segment on his frequent journeys between New York City and his property in Bolton Landing, New York, near Lake

George. He had purchased this retreat in the foothills of the Adirondacks in 1929 and lived there from 1940 (when he renamed it Terminal Iron Works) until his death in 1965.

Made in Bolton Landing in late spring, *Hudson River Landscape* includes recognizable clouds, railroad tracks, and a stepped terrain; the spring-thawed, ice-laden Hudson River is airily frozen in steel. The sculpture's line moves swiftly in space with the animation and energy of the Abstract Expressionist painting then developing. Though over 16 inches deep, the sense of depth is minimized by the planarity with which Smith sketched the scene. The sculpture's outlined, rectangular format recalls his training as a Cubist painter.

In 1958 Smith provided his own comments on the work: "This sculpture came in part from dozens of drawings made on a train between Albany and Poughkeepsie, a synthesis of ten trips over a 75 mile stretch. Later, while drawing, I shook a quart bottle of India ink and it flew over my hand. It looked like my river landscape. I placed my hand on paper. From the image that remained, I travelled with the landscape, drawing other landscapes and their objects, with additions, deductions, directives, which flashed unrecognized into the drawing, elements of which are in the sculpture. Is my sculpture the Hudson River? Or is it the travel and the vision? Or does it matter? The sculpture exists on its own; it is an entity."

In 1956, Smith described the kinship between Julio Gonzalez and the Barcelona architect Antonio Gaudi as based on a shared "feeling of flying form and unorthodox balance." Such principles, and Smith's own use of scrap metal, gain special pertinence in relation to *Running Daughter*. Having previously worked with still-life and landscape modes, in the final fifteen years of his life Smith produced numerous sculptures devoted to abstracted figuration. *Running Daughter* began with a treasured, blurred photo of Rebecca, the eldest of his two daughters, running across the grass. In the finished sculpture, which emulates the spirit of the photo, the girl's left leg is raised in motion, and the forward thrust of her body, with its lithe torque, is clearly evoked. The linear sweep of metal that supports the left leg also propels the sculpture forward. For the buttocks, Smith bent one of the tank or boiler plates he had especially produced for his sculptures. The flag-like scrap of metal at the top becomes a head. The figurative associations in Smith's sculpture are always suggested, never declared—a practice that keeps his work of this period from becoming too playfully cartoonish.

David Smith

Lectern Sentinel, 1961

Stainless steel, 101¾ x 33 x 20½ inches (258.5 x 83.8 x 52.1 cm). Gift of the Friends of the Whitney Museum of American Art (and purchase) 62.15

Lectern Sentinel was made during David Smith's prolific final years; in 1961 he produced over thirty major sculptures, numerous spray paintings, and, as was his practice, a multitude of drawings. He conceived and executed many of his post-1950 sculptures in groups, and in 1961 he worked on, among others, his Albany, Circle, and Zig series. This year also marked the start of what were to become his Cubi sculptures, a series to which *Lectern Sentinel* is a more complex and flatter antecedent. It is the third of his final four variations on the Sentinel theme and its preparatory sketch dates from mid-December of 1961. Five earlier, enumerated Sentinels (1957–59) are more clearly figurative in the mode of Smith's *Running Daughter* (p. 141). The effect of the final 1961 Sentinels is as real as it is titular: they are upright, watchful, and mute presences. Fabricated in stainless steel, they have a cleaner, more objective stance than their scrap metal predecessors. Their frontal planarity may be equated with the muted geometries of Picasso's elongated Cubist figures: depth is never emphasized, only flatly speculated upon. *Lectern Sentinel* consists of a jaunty pile-up of attached rectangular plates standing on two angled plates, which rest in turn on a thicker base plate. As with the other later Sentinels, its airy elements are capped with a circle-head.

For his first unpainted, stainless steel pieces, Smith used a high-speed disk grinder (originally employed to clean metal) to achieve his swirling burnished surface. *Lectern Sentinel* is thus ornamented, but only to visually lighten its weight and enliven the rigid rectilinearity of the plates. The configuration of *Lectern Sentinel* resembles a cascade of books and the stand of a lecturer, while the work's title retains a reference to early attenuated guardian figures. The emotional content, however, lies elsewhere, for Smith soldered inside its base "I greet you. Becca—Dida." Similar messages to his children, Rebecca and Candida (from whom he had recently been separated by his divorce from their mother), are to be found on numerous other sculptures of this period, often less secretly. They quietly betray an emotional outreach and psychological pathos which, despite the works' geometric abstractions, confirm Smith's continued ties to Abstract Expressionism.

Burgoyne Diller

Third Theme, 1946–48

Oil on canvas, 42 x 42 inches (106.7 x 106.7 cm). Gift of Miss May Walter 58.58

Burgoyne Diller began working in a geometric non-objective style in the 1930s, an era when representational forms—Social Realism and Surrealism—dominated American art. He continued to pursue his strict formalism into the 1950s, the period of emotionally focused Abstract Expressionism. Diller was the first American painter to adopt Mondrian's Neo-Plasticist ideas, and his

art became increasingly simplified, iconic, and symmetrical. These characteristics eventually created a bridge to the reductive clarity of Minimalism in the 1960s; it was at this time that the first sustained recognition of Diller's art took place, although by then he was perceived as a historic figure.

During the 1960s, Diller categorized all his work of the previous thirty years into three numbered groups. The First Theme, which is closest to Minimalism, emphasizes rectangles arranged without a grid structure. In the Second Theme paintings, the rectangles cross to form single grids. In the Third Theme, including this painting,

Diller presents an elaborate grid structure, most conspicuously like Mondrian's late work. This Third Theme, the least common of the three, originated toward the end of the 1930s, and was most frequently employed in the 1940s, when Mondrian's late compositions—produced in America—were at the height of their influence. The Third Theme paintings were accompanied by numerous study drawings and preparatory collages. Architectonic rhythms of color, especially in this example, seem to ascend and descend against their white ground. The complex interplay of the unaligned and variously sized blue, red, yellow, and white rectangles within the black verticals testifies to Diller's careful preparation and meticulous composition.

Fritz Glarner

Relational Painting,
1949–51

Oil on canvas, 65 x 52 inches (165.1 x
132.1 cm). Purchase 52.3

Within two years of his arrival in
the United States in 1936, the Swiss-
born Fritz Glarner became associated
with the American Abstract Artists
group (A.A.A.). In America, his art
matured as his geometric still-life
reductions assumed a purer recti-
linearity that allied him with the ad-
vanced abstractionists of the A.A.A.
In 1941 Glarner made the first of
his Relational Paintings, the series

that occupied him until his death
thirty-one years later. In concept the
Relational Paintings owe their in-
spiration to the Neo-Plasticism of
Theo van Doesburg and Piet Mon-
drian—especially to Mondrian,
whom Glarner came to know fol-
lowing the Dutchman's move to
America in 1940.

 After 1943, Glarner was satisfied
with the development of his style,
and there were no further dramatic
changes in his art. Only scale and
the occasional use of round can-
vases varied the form of his ex-
pression. The individuality of the
Relational Paintings lies in the
subtle ways slanted or oblique forms

are placed and how they charge the
pictorial axis with rhythmic tension.
With one exception, the Whitney
Museum's *Relational Painting* was
Glarner's largest exploration of the
theme to that time; other than his
several public murals, he rarely
worked on such a large scale again.
The limited color range and use of
gray in *Relational Painting* char-
acterize the entire series. The shades
of gray surrounding red, yellow, and
blue quadrilaterals offer greater
compositional complexity than such
an ostensibly related work as Bur-
goyne Diller's *Third Theme*. As one
moves from top to bottom, the com-
ponent forms become smaller, and
the greater masses at the top are
balanced by detail and density below.

Ad Reinhardt

Number 30, 1938

Oil on canvas, 40½ x 42½ inches
(102.9 x 108 cm). Promised Gift of
Mrs. Ad Reinhardt P.31.77

Because few of Ad Reinhardt's early works are extant, it seems as if he attained immediate artistic maturity. The first group of works to survive in significant number—those of the late 1930s—reveal that his art had already evolved into a system of hard-edge, discretely colored, and interlocking shapes. It was this aesthetic, in a radically reductive form and motivated by a different ideology, that would characterize the final, post-1950 phase of his career.

In 1938, after experimenting with carefully composed, cut-paper studies, Reinhardt completed *Number 30*, the most assured and zestful of his first series of paintings. His sharply variegated, bright blocks and circles of hot color engage the eye with their asymmetrical balance. Within the vocabulary of American geometric abstraction of the late 1930s, the non-objective elements of *Number 30* overlap and lock together at acute angles, expressing a distinctly flat pictorial statement.

Reinhardt's work in this period is often only subtly distinguishable from that of his colleagues in the American Abstract Artists group. George L. K. Morris, the group's most articulate member, attributed the similarity of these works to their indigenous origins: "Any one who knows America can see that the tone and color-contrasts are quite native, that the cumulative rhythmic organization resounds from an accent which could have originated in America alone." Works of the quality of *Number 30* found no purchasers at the time they were produced. Only in the 1960s, when the formalist principles of Minimalism took hold, did critics and the public come to appreciate the complex and bright consonance of these earlier geometric abstractions.

Ad Reinhardt

Number 17, 1953

Oil and tempera on canvas, 77¾ x 77¾ inches (197.5 x 197.5 cm). Purchase 55.36

Abstract Painting, Number 33, 1963

Oil on canvas, 60 x 60 inches (152.4 x 152.4 cm). 50th Anniversary Gift of Fred Mueller 80.33

A decade and a half after his early geometries (p. 146), Reinhardt became engaged "in painting as a 'field' of color, or as a 'total image.'" Greater logic began to rule his work, although it was a logic less strictly goverened by the symmetry and monochrome that characterize his later paintings. *Number 17* is one of these transitional works: a square canvas with an upright central rectangle surrounded by asymmetrically placed squares and rectangles of different, but closely related, colors. Reinhardt insisted of *Number 17* that it had "no concern especially with light, form or space divisions or relationships, nor with color contrasts." Yet even a cursory examination of the

148

painting confirms that, contrary to Reinhardt's declarations, meticulous attention was directed to spatial relationships and coloristic balance.

Such attention was surely encouraged by Reinhardt's regular contact with Josef Albers, the artist then most deeply engaged in theories of color in non-objective geometric art (p. 154). In the winter and spring of 1952–53, Reinhardt taught at Yale University, where Albers was director of the School of Art. In *Number 17*, Reinhardt responded to Albers' light-infused systematic variations on stacked squares with his own brooding and adjacent rectangles.

For all the apparent geometries in Reinhardt's *Number 17*, the arrangement, color, and scale of his rectangles were still personal and spontaneous. In order to eliminate

such subjective compositions and to
systematize his art, around 1953
Reinhardt began to limit his paint-
ings to variations on a single color
—variations of blue, red, and black
—within a multiple-square format.
By 1960 he was producing only the
symmetrical black paintings, such as
Abstract Painting, Number 33, that
concluded his career. Other Ameri-
can artists had previously made es-
sentially black paintings. But no one
before had set out so earnestly to
create, in Reinhardt's own words,
"the last painting which anyone can
make." In his twenty-five 60-by-
60-inch black paintings, Reinhardt
pursued an art of subtle color muta-
bility within a strict, unvarying com-
positional format and size that used
a 9-square structure. Controversy
has surrounded these ultimate works,
dominated, characteristically, by

Reinhardt's writings. He had repre-
sented his painting as an "unma-
nipulated and unmanipulatable,
useless, unmarketable, irreducible,
unphotographable, unreproducible,
inexplicable icon. A non-entertain-
ment, not for art commerce or mass-
art publics, non-expressionist, not
for oneself."

Despite the strength of these
claims, many of them have been
invalidated: the black paintings have
become exemplars of postwar Ameri-
can art. If at first they confounded
their audience, they soon won accep-
tance. In pushing toward an extreme
position and narrowing the terms of
his art, Reinhardt seemed to have
opened these paintings to wide-

ranging speculation, and manifold
analyses of their political, spiritual,
and artistic implications. But the
boundaries of critical discussion may
best be summarized in the words of
Frank Stella, an artist who admired
Reinhardt's work deeply enough to
acquire one of the series for himself:
"If you don't know what they're
about you don't know what painting
is about."

The Black paintings call into
question the goals of much previous
art and provide a sturdy platform
for the Minimalist and Conceptualist
art that emerged in the 1960s and
1970s. But on its own terms Rein-
hardt's greatest achievement resides
in the unrelenting, meditative, and
quiescent surfaces of these final
paintings. Beyond meaning, they
mandate sustained attention—the
disclosing of darkness.

Ellsworth Kelly

Atlantic, 1956

Oil on canvas, 2 panels, 80 x 57 inches
each (203.2 x 144.8 cm). Purchase 57.9

Ellsworth Kelly's work can always
be connected with visible reality,
but his abstractions strip away the
source of all perspective, narrative
association, and emotional content.
His meticulously hard-edge paint-
ings and sculptures offer only flat
unmodulated color, simple shape,
and planar frontality. In this way,
Atlantic converts a commonplace
observation into a radical abstrac-
tion. The white curved forms of
Atlantic derive from the shadows
that fell across the opened pages of a
paperback book. While he was riding
a bus in 1954, Kelly quickly copied a
succession of these paired shadows
onto the facing pages of a sketch-
book; the shadows curved with the
swell of the book. These comple-
mentary forms were more carefully
redrawn in a blank notebook that
became a source of pictorial compo-
sitions.

Two years later, the idea was
realized in a small (24-by-34-inch)
oil study from which *Atlantic* was
made. In 1955, Kelly had worked
with black shapes on a white ground.

Atlantic reversed the relationship,
rendering white shapes on a black
ground, so that the shadows are
described in white. The bipartite
construction of *Atlantic* suggests the
composition's source in a book
spread, although Kelly frequently
uses the device of abutted yet sepa-
rate canvas panels to differentiate
color and form.

Atlantic is the largest of Kelly's
black-and-white canvases of the late
1950s, made before he reintroduced
a wide spectrum of colors into his
art. In this painting Kelly also re-
turned to the curve, which he was
to use through the mid-1960s, and
periodically thereafter. *Atlantic*,
purchased in 1957, was the first
work by Ellsworth Kelly to be
acquired by a museum.

Agnes Martin

Milk River, 1963

Oil on canvas, 72 x 72 inches (182.9 x 182.9 cm). Larry Aldrich Foundation Fund 64.10

Agnes Martin's mature paintings have consistently dealt with repetitive linear motifs within spatially flat, square, 6-foot formats. By 1960 her work challenged the gesturalism of Abstract Expressionism, the blankly impersonal images emerging from Pop Art, and the neutral formalism of much of the period's abstraction. Such early 1960s paintings as *Milk River*, though geometrically composed and systematic, are resolutely handmade and derive from an impulse to draw. The subdued line and color, presented in large scale, intentionally summon the viewer to intimate, careful confrontation.

Milk River, with its double border, is unique in Martin's oeuvre. Its second "frame" of mottled paint cushions the transition from the darker canvas to the interior white. This inner square is horizontally banded with red pencil lines. Drawn with a taut string as a guide, the line is incised into the thin layer of white. Each line is slightly different in emphasis and weight. Martin's paintings and drawings are not, therefore, as Minimal as they first appear; rather, they embrace a more sensate lyricism. As the title of a later exhibition described her, she is a "romantic Minimalist." Martin herself has best articulated her attitude to Minimalism: "the minimalists are idealists . . . they're non-subjective. They want to minimalize *themselves* in favor of the ideal. Well, I just can't. . . . You see, my paintings are not cool."

The subtle modulations of line in *Milk River*, the irregular edges of the rectangles within the square format, and the attention focused on the physicality of the canvas ground, all open the "perfection" of Martin's systems to contradictions. These small, minutely gestural denials of the ostensible system and grid animate her works. At the core of Martin's intention is an almost mystical spiritualism and bond with the viewer.

Josef Albers

Homage to the Square: Gained, 1959

Oil on board, 40 x 40 inches (101.6 x 101.6 cm). 50th Anniversary Gift of Fred Mueller 79.36

From his early training in stained-glass design in his native Germany, Josef Albers perceived an artwork as a configuration of compositionally interlocking, meditative forms. He sought an art that carried the notion of "icons" into the twentieth century. This focus received its fullest expression in his Homage to the Square series, begun in the summer of 1949. Thereafter, as he worked through innumerable variations, all his paintings carried on a dialogue with each other. The Homage series ranges in size from 12 to 48 inches, with colors taken straight from the tube, and thinly applied on fiber-board panels. Albers here was less interested in paying homage to a primary geometric shape than in using overlaid squares as windows for his real concern, the interaction of color. Using three or four colors, the four basic configurations of the Homage series explore the discrepancy between the physical and psychic effect of color upon the viewer. As in *Homage to the Square:*

Gained, Albers could make different colors interact compatibly. "Color, in my opinion, behaves like man—in two distinct ways: first in self-realization and then in the realizations of relationships with others. In my paintings I have tried to make two polarities meet—independence and interdependence. . . ."

Through Albers' teaching, writings on art, and his codified, repetitive formats, his concepts had an enormous influence on Color Field painters and Minimalists. The short-lived Op (Optical) Art movement also borrowed Albers' insights into color and formal interaction. The Homage to the Square series even offers a fascinating compositional anticipation of Jasper Johns' *Three Flags* (p. 170).

Brice Marden

Summer Table, 1972

Oil and wax on canvas, 3 panels, 60 x
35 inches each (152.4 x 88.9 cm). Pur-
chased with the aid of funds from the
National Endowment for the Arts
73.30

Brice Marden's paintings have
elicited adjectives like "reductive,"
"minimal," and "stark." Their
multiple rectangles of subdued color
appear emptied of conventional con-
tent and reference. Following a
precedent established by Ellsworth
Kelly, each color is assigned its own
panel and the panels are then at-
tached, as in *Summer Table.* Marden

deliberately builds up his wax-and-
turpentine medium to create a matte
but luminous surface. In *Summer
Table* he also leaves an unpainted
strip at the bottom, a device learned
from Jasper Johns. This strip, with
its incidental drips of paint, recalls
the painting's process and history.

Despite Marden's seeming affinity
with the Minimalists, it is the Ab-
stract Expressionists, especially
Barnett Newman and Mark Rothko
(pp. 134, 136), to whom he is heir.
Through color and the rigor of his
format, he has sought to render
emotion and to seek an equivalent
to personal and universal experiences.
As Marden explains, "I try to give
the viewer something to which he

will react subjectively. I believe
these are highly emotional paintings
not to be admired for any technical
or intellectual reason but to be felt."

Marden thus considers the values
of his paintings to be traditional,
and his references, frequently as-
serted in his titles, are to place,
person, and incident. In the tri-
partite format of *Summer Table,*
scene, light, and time are trans-
fixed. The painting's panels convey
for Marden the memory of glasses
of cool liquid on a table in the gar-
den of a house he often visits on the
Greek island of Hydra. The summer
light there is, for Marden, "intenser,
clearer, and less shrouded" and its
modulations against a backdrop of
the garden's plants and the sea
beyond are compressed into the
painting's three panels.

Frank Stella

Die Fahne Hoch, 1959

Enamel on canvas, 121½ x 73 inches (308.6 x 185.4 cm). Gift of Mr. and Mrs. Eugene M. Schwartz and purchase through the generosity of the John I. H. Baur Purchase Fund, Charles and Anita Blatt Fund, Peter M. Brant, B. H. Friedman, Gilman Foundation, Inc., Susan Morse Hilles, The Lauder Foundation, Frances and Sydney Lewis, Albert A. List Fund, National Endowment for the Arts, Sandra Payson, Philip Morris Incorporated, Mr. and Mrs. Albrecht Saalfield, Mrs. Percy Uris, and Warner Communications Inc. 75.22

(Illustrated on p. 6)

By the time Frank Stella graduated from Princeton University in 1958, he was determined to create an art that could be read not as a record of the artist's emotions and personal history, but as an objective, intellectual structure. Stella's repudiation of Abstract Expressionism—and immediate anticipation of Minimalism—is clear from a statement he made later: "My painting is based on the fact that what can be seen is there. . . . If the painting were lean enough, accurate enough or right enough, you would just be able to look at it. All I want anyone to get out of my paintings, and all I ever get out of them, is the fact that you can see the whole idea without any confusion. . . . What you see is what you see."

The first series of works Stella produced (1958–59) were twenty-three large-scale Black Paintings, including Die Fahne Hoch. They were stripped of all representational allusions; thin white lines on a black ground form either rectilinear or diamond patterns. The lines are not applied, but created by the narrow spaces of white canvas Stella left between the black stripes.

The German title Die Fahne Hoch literally translates as "the banner (or flag) raised." It was taken from the first phrase of the so-called Horst Wessel song, the marching anthem of the Nazi youth organization.

Despite this connection to Nazi Germany, it seems Stella was more concerned with suggesting the sense of a heightened fervor born of a new ideology—in his case, an aesthetic one. Indeed, another connection immediately arises—to Jasper Johns' re-presentations of the American flag, begun in 1954 and culminating in 1958 with Three Flags (p. 170). Die Fahne Hoch, with its serial stripes and repeated right angles, has much that evokes Johns' painting. But in Die Fahne Hoch, the non-referential objectness of the painting takes precedence. It is for this reason that the stretchers are unusually thick and the painting is frameless. Die Fahne Hoch's coloration and elongated cross motif also connect it with Ad Reinhardt's last paintings (p. 149). Like Reinhardt's abstractions, Stella's Black Paintings, which seemed drained of meaning when originally made, have now taken on a stark, religious presence, and have become cornerstones of a new pictorial ideology.

Gran Cairo, 1962

Synthetic polymer on canvas, 85½ x
85½ inches (217.2 x 217.2 cm). Gift of
the Friends of the Whitney Museum of
American Art 63.34

Gran Cairo is an offshoot of a paint-
ing in Frank Stella's 1961 Benjamin
Moore series, a work in which he
first used concentric squares. Gener-
ically titled after the commercial
paint company that produced the
colors Stella used—unmixed and
directly out of the can—the Ben-
jamin Moore series continued the
strict, rectilinear formalism of such
Black Paintings as Die Fahne Hoch
(p. 10). In both the Benjamin
Moore series and Gran Cairo, pic-
torial device and physical support

are succinctly fused. Gran Cairo is
one in a separate series of six multi-
color Concentric Square paintings.
The motif clearly originates in Josef
Albers' Homage to the Square paint-
ings (p. 154), but the spatial com-
plexity of Stella's Concentric Squares
owes more to Jasper Johns' Three
Flags (p. 170). The overall effect of
Stella's fifteen bands of color, each
bordered with white stripes, is, as
Robert Rosenblum wrote, "of ex-
panding or contracting bellows that
ambiguously shift from convexity
to concavity while clinging still to
the flat plane. . . ."

In the Concentric Squares, elabo-
rate polychrome entered Stella's art
for the first time. The programmatic,

complementary color sequences of
Gran Cairo—red, orange, gray,
blue, and green—shift twice. Be-
tween 1966 and 1978, Stella re-
turned to the motif in four series of
paintings and in 1972–73 made
offset lithographs of all six of his
original 1962 Concentric Square
series, including two variants on
Gran Cairo.

The painting's title derives from
the name of a large Indian settle-
ment on the Yucatan coast that was
plundered by the Spanish in 1517.
Inland from this town, the Euro-
peans first encountered the stepped
pyramids of Pre-Columbian cultures.
The repetitive geometry of Stella's
concentric squares subtly invokes
these ancient structures.

Frank Stella

Dove of Tanna, 1977

Mixed media on aluminum, 154 x 225 x 36 inches (391.2 x 571.5 x 91.4 cm). Partial and Promised Gift of Mr. and Mrs. Victor W. Ganz P.25.83

Silverstone, 1981

Mixed media on aluminum and fiberglass, 105½ x 122 x 22 inches (268 x 309.9 x 55.9 cm). Purchase, with funds from the Louis and Bessie Adler Foundation, Inc., Seymour M. Klein, President; the Sondra and Charles Gilman, Jr. Foundation, Inc.; Mr. and Mrs. Robert M. Meltzer; and the Painting and Sculpture Committee 81.26

After 1970 Stella made the first of a series of astonishing about-faces. He abandoned the flat pictorial surface, a move announced in the bas-relief Polish Village series (1970–74). After 1975 such reductive, geometric configurations gave way to hand-drawn, garish colors painted on metal sheets fastened together to create full reliefs. In the Exotic Bird series (1976–80), Stella established for his art a new order of priorities, placing instinct ahead of intellect. *Dove of Tanna* is the nineteenth of twenty-eight works in the series, all titled after extinct and vanishing species of birds.

Despite the expressive frenzy of *Dove of Tanna*, the underlying

process was careful and deliberate. After preparatory drawings, Stella made each piece in three different scales—a small maquette and two subsequent versions, respectively 3 and 5.5 times bigger than the maquette. The Museum's *Dove of Tanna* is the largest version of the composition and among the largest of the Exotic Bird works.

Whereas Stella had once sought to negate illusionism by insisting on the inherent flatness of the picture surface, he now violated that surface with metal relief segments that project forward and backward. Yet there is a constant play between two and three dimensions. Stella coated the paint surface with ground glass, and the sparkling, metallic finish that results freezes the effect of movement in space. This frozen

two-dimensionality is, however, brilliantly contradicted by Stella's use of French-curve forms in the relief segments. These segments transform the flatness of real French curves—the templates used by draftsmen—into the very components that generate physical and illusionistic space.

From a historical point of view, *Dove of Tanna* is a raucous blend of Jackson Pollock, Willem de Kooning, and David Smith. Stella, whose Black Paintings signaled the end of Abstract Expressionism, has returned to a spurned source.

In Circuits (also known as Roadways), Stella's 1981–83 series of paintings, he again made preparatory drawings followed by three-dimensional maquettes from which larger versions (3 and 4.75 times bigger) were fabricated. The Whit-

ney Museum's *Silverstone*, enlarged 4.75 times from its maquette, is the sole Circuit painting for which Stella has produced three of these largest-scaled versions.

Though all of these object/paintings have identical configurations, each achieves a remarkable degree of individuality through different color and surface treatments. *Silverstone*, among the earliest compositions in the twenty-two-part series, shares the rectilinear containment found in the earlier Exotic Bird series, such as *Dove of Tanna*. But about a third of the way through the Circuits series, Stella abandoned the traditional painting rectangle. The motifs thereby acquired greater freedom and their components interlace in open space.

The Circuits embody Stella's fascination with competition and speed, especially with car racing. The sleek contours of the automobile and its celebration of motion find fluid expression in his machine-like metal relief cut-outs. He named the twenty-two Circuit motifs after automobile racetracks. (*Silverstone* is the name of a popular English track.) The holiday atmosphere of a racetrack, its curves and straightaways, fiery danger, and dazzling speed found provocative realization in these apparent abstractions. Stella's artistic identification with automobile racing began in 1960 when he titled one of his Aluminum series paintings *Marquis de Portago*, after a famous race car driver. In 1980 he completed a set of prints dedicated to the memory of the race car driver Ronnie Peterson.

Morris Louis

Tet, 1958

Synthetic polymer on canvas, 95 x 153 inches (241.3 x 388.6 cm). Purchase with funds from the Friends of the Whitney Museum of American Art 65.9

Numerous contemporary American abstract painters have worked in series, especially during the 1960s. Concentrating on a particular format, they advanced through an extensive range of coloristic and compositional variations. Morris Louis' mature work, which began in the 1950s, anticipates the serial paintings of later abstractionists. He started with the Veil paintings, such as *Tet*, and moved on to three other basic formulations, Florals, Unfurleds, and Stripes. The Veil series, begun in 1954, was taken up again in 1957–59. Like the concentric circles of his close friend Kenneth Noland (p. 162), Louis' Veils have won him the greatest renown and exemplify his achievements as a colorist. Here, and in all of his later paintings, unsized and unprimed canvases are masterfully stained with highly diluted plastic-based paint. Louis' decorative hues flow into the canvas with a freedom inspired by his encounter in 1953 with the paintings of Helen Frankenthaler (p. 164), of whom he later professed: "She was a bridge between Pollock and what was possible."

Louis' heroic scale echoes that of the first Abstract Expressionists, but he discarded their painterly gesture. What he retained in his tidal pools of commingled color was their search for the sublime, expecially as seen in the abstract imagery of Clyfford Still and Mark Rothko (pp. 120, 136). The blue-green fanned washes of *Tet* are also reminders of the enormous influence during the 1950s of Monet's late and verdantly lyric evocations of his garden at Giverny.

Upon his death at forty-nine, Louis left a large number of untitled, unsigned, unstretched, and undated canvases, often lacking instructions about their orientation. His clear message was that the creative process is fostered by chance. After his death these matters of date and orientation had to be resolved. Some of the Veil series, for example, are presented, unlike *Tet*, with the bottom, cap-like elements at the top of the work. Louis was seemingly more interested in the transit of paint and color than in the direction of that transit. The specific title of the Whitney Museum picture, signifying the ninth letter of the Hebrew alphabet, comes from the posthumous designations assigned by Clement Greenberg, the noted critic and Louis' close friend, adviser, and artistic executor.

Kenneth Noland

Song, 1958

Synthetic polymer on canvas, 65 x 65 inches (165.1 x 165.1 cm). Gift of the Friends of the Whitney Museum of American Art 63.31

From 1958 to 1964, Kenneth Noland was preoccupied with the motif of concentric circles, a theme that constitutes his first, and best-known, painting series. Having studied with Josef Albers, Noland brought to his circle motif some of the obsessive attention his teacher had reserved for stacked or concentric squares (p. 154). Yet Noland's circles, painted in plastic-based paint on unsized and unprimed canvas, always display, even at their most controlled, a color saturation and gestural application that allies him more profoundly with the Abstract Expressionists—with the direct energy of Jackson Pollock and the decorative lyricism of Helen Frankenthaler and Morris Louis (pp. 110, 164, 160). Noland and Louis had been friends in the 1950s, when both were living in Washington, D.C.

Noland's emanations of light recall the circular banding seen in the 1930s landscape abstractions of Arthur G. Dove (p. 39), represented in depth at Washington's Phillips Collection. However, Noland trades natural description for formalist color harmony and simplification. As in Song, he isolates his circles, usually within a square, with the unpainted periphery containing his chromatic rings. The execution of Song appears to be speedy. The incidental dots of blue and red in the unprimed area document the velocity with which he painted the bands.

Helen Frankenthaler

Flood, 1967

Synthetic polymer on canvas, 124 x 140 inches (315 x 355.6 cm). Gift of the Friends of the Whitney Museum of American Art 68.12

In 1952, Helen Frankenthaler developed a procedure for staining raw canvas with large expanses of color, a technique that influenced numerous artists, including Kenneth Noland and Morris Louis (pp. 162, 160). Her contribution is important both as a method and as a confirmation of a new mentality about picture-making, one that equated process and content. If the works of her mentor Jackson Pollock (p. 110) merge drawing and painting, Frankenthaler's compositions fuse watercolor and painting. With the canvas on the floor and the paint applied from above, as in Flood, Frankenthaler's thinned color transformed the inherent spontaneity and chromatic intensity of watercolor into a grand, operatic occasion. Though Flood is abstract, it clearly can be related to a simplified landscape, with layers of sky, cloud, mountain, forest, and water. Frankenthaler's zones of color, in addition, evoke different emotional states, billowing surges of feeling in an all-consuming fusion of color and form. Her aim is similar to Mark Rothko's (p. 136)— to use hue and basic shape to convey nuances of place and emotion.

Flood's few color forms expand across the canvas so that no central, dominant image is present; the composition reads simply as a filled-up flat surface. The broad, cosmic character of Frankenthaler's paintings of this period is concisely captured in the description she provided for the Museum's records on Flood: when "forced to associate, [I] think of my pictures as explosive landscapes, worlds and distances, held on a flat surface."

Milton Avery

Dunes and Sea II, 1960

Oil on canvas, 52 x 72 inches (132.1 x 182.9 cm). Promised 50th Anniversary Gift of Sally Avery P.14.80

Although in many ways an abstract painter, Milton Avery remained committed to depicting the world around him. The coastal landscape of Cape Cod, where he spent several summers, inspired many of his most felicitous compositions. By omitting distracting detail, he could simplify and reduce the forms and interlock open passages of color.

In 1957, Avery spent the first of four summers in Provincetown, Massachusetts, at the end of Cape Cod. His wife, Sally, felt that this landscape—with its dramatic and beautiful confrontation of sand and sea—most stimulated his creativity. These Provincetown views of beach, water, and sky prompted Avery's largest scale and most refined handling of color and form, as in *Dunes and Sea II*. In such late works abstract values—bold, infused color and stark spatial juxtapositions—predominate. *Dunes and Sea II* was one of the increasingly abstract images that earned the respect of Mark Rothko, Avery's colleague and friend, and linked Avery's representational style to that of the New York School abstractionists and Color Field painters.

Working in his usual manner, Avery produced a half-scale gouache-on-paper study before painting *Dunes and Sea II*. In this study, made during his final summer in Provincetown, the sky and border between sand and sea are blue, not the gray and green they became in the final version, painted in his New York studio-apartment. Both works nevertheless show the same economy of means—a rough sea, set forth in strokes of black and blue, the dune's edge, reduced to a serpentine band, and the sand simplified into two muted tonalities. The Whitney Museum painting is the second of two Provincetown canvases, bearing the same title, but otherwise unconnected.

Richard Diebenkorn

Ocean Park #125, 1980

Oil on canvas, 100 x 81 inches (254 x 205.7 cm). Gift of an anonymous donor (by exchange), Charles Simon Purchase Fund, and purchase, Painting and Sculpture Committee 80.36

Richard Diebenkorn's continuing series of Ocean Park paintings, titled after the seaside area of Santa Monica in which he lives and works, isolates and abstracts the simplified views out of windows that had appeared in his interior representations of the late 1950s and the 1960s. In his Ocean Park paintings—tonal renditions of Southern California light and topography—traces of underpainting allow the works' process and alterations to be seen. Drawing—the merest straight and diagonal delineations—structures his oil-washed and discrete canvas surfaces. As if shadows could leave stains, the whitened color areas seem to make light palpable. Diebenkorn translates the Southern California fascination with light and calm into a laconic and pleasurable pictorial expression. Like closely observed weather, the buoyant, luminous scene outside his studio windows invites introspection.

Begun in 1967, Diebenkorn's sequentially numbered Ocean Park paintings (and the many studies, drawings, and prints that accompany them) have undergone distinct shifts: structure has become more subtle; space has flattened out; color is less varied and more muted, and a general all-over lightness prevails. When stronger color is used, its potency seems diluted. For example, the balmy blue expanses of *Ocean Park #125* almost make the eye forget the elongated rectangle of black, with its racy red stripe, that rests across the top of the composition. A little flame of yellow is the most active color incident among Diebenkorn's subdued rectangles. Sustained good nature, not the pathos found in Mark Rothko's layered rectangles (p. 136), is the predominant mood of Diebenkorn's Ocean Park paintings.

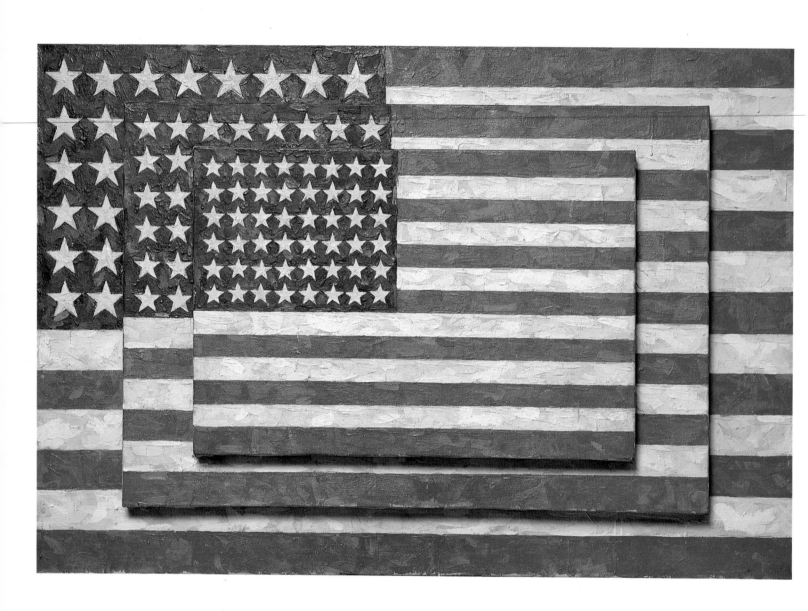

Jasper Johns

Three Flags, 1958

Encaustic on canvas, 30⅞ x 45½ x 5 inches (78.4 x 115.6 x 12.7 cm). 50th Anniversary Gift of the Gilman Foundation, Inc., The Lauder Foundation, Mr. A. Alfred Taubman, an anonymous donor (and purchase) 80.32

The mature work of Jasper Johns began in 1954 with his appropriation of the American flag as his prime pictorial motif. The single flag, and later the target, numbers, and the alphabet, became the essential subject matter of these early years of his art. By treating the flag outside of its traditional context, he divested it of symbolic associations. The visual components of the flag became data for examining perception, ambiguity, and the meaning of art itself. In the gestural paint strokes of Johns' flags, the vocabulary of geometry—triangulated stars and rectangular stripes—reentered American art. The combination of painterly surface richness (produced by his encaustic medium) with the quintessential American icon signaled the transition from Abstract Expressionism to Pop Art.

When queried about the source of his subject matter, Johns responded that he had dreamed he was painting a large flag. What he then painted was not the wavy, wind-blown banner seen on flagpoles and in patriotic parades, but the flat, rigid flag characteristic of American folk art and craft. But this decision had less to do with evoking American folk tradition than with transforming a charged national symbol into a compositional proposition, an ambiguous, aesthetic object.

Johns' single-flag images never suggest spatial depth. They defy the usual pictorial structure of figure against ground. In the tri-leveled *Three Flags,* the culminating work of this first period of Johns' art, the flag subject becomes its own ground. Moreover, the trio of flags—each one successively diminished in scale by about 25 percent—projects outward, contradicting classical perspective, where the rearmost flag would be smaller than that at the front. Johns' flags now seem to have heralded Minimalism. Their emphasis on design over subject, serial progression, and repetition laid the foundation for the works of Frank Stella and Donald Judd (pp. 10, 207). Johns' continuing and obsessive exploration of his motifs and his transformation of the ordinary into the enigmatic have proved crucial to the development of American art.

Jasper Johns

Racing Thoughts, 1983

Encaustic and collage on canvas, 48 x 75⅛ inches (121.9 x 190.8 cm). Purchase, with funds from Leo Castelli, the Equitable Life Assurance Society of the United States Purchase Fund, Sondra and Charles Gilman, Jr. Foundation, Inc., S. Sidney Kahn, The Lauder Foundation, and the Painting and Sculpture Committee 84.6

In the quarter century between *Three Flags* (p. 170) and *Racing Thoughts*, Jasper Johns added layers of poetic allusion and bold stretches of abstraction and autobiographical episode to his initial treatment of commonplace emblems. During the 1970s, he also introduced a hatched, parallel, paint stroke motif, a rigorous structuring device not unlike that obtained through his initial use of flags, targets, letters, and numbers. In 1981, Johns' paintings underwent a radical shift. He restored representational imagery, but as a compilation of seemingly disconnected images and personal references—his racing thoughts.

The right half of the Whitney Museum's *Racing Thoughts* presents the interior of Johns' country bathroom, filled with his actual possessions. Displayed on the top of a clothes hamper is a pot by the turn-of-the-century ceramicist George Ohr and an English commemorative vase with the profiles (in negative) of Queen Elizabeth and Prince Philip. (In 1972, Johns made two lithographs in which confronted profiles of Picasso were likewise turned into a goblet.) Barnett Newman's lithograph *Untitled* (1961) hangs above the tub. It overlaps a Swiss sign that warns, in German and French, of falling ice. Johns admired the sign for the manner in which the jawbone double functions as the crossed bones of poison and death. Its concern for falling "glace" —the sign's legend "continues" at the left edge of the picture—evokes as well his fascination with Marcel Duchamp's *The Large Glass*. Also in this section is an iron-on decal of Leonardo da Vinci's *Mona Lisa*, "attached" to the canvas with illusionistically painted tape. This tape, a nail and its cast shadow, and other deceptively real motifs recall the nineteenth-century American trompe l'oeil tradition of John F. Peto. Peto's well-known still life of about 1900, *The Cup We All Race 4*, may provide another explanation for Johns' title.

A ghost-like pair of pants hangs from the wood-grained brace of the bathroom's open door, suggesting that their wearer is about to enter or has entered the filling tub. But the clearest subject of the left half of *Racing Thoughts* is friendship. Tacked down next to the pants is a portrait of Johns' long-time dealer and friend, Leo Castelli. But it is not a portrait in the conventional sense. Johns based his likeness on an old passport photograph that had been turned into a jigsaw puzzle. Castelli's image hangs on a wall of interlocking, hatched shapes—a variation of the linear motif that had characterized Johns' paintings of the 1970s. At first, the outlined forms seem to represent broken pieces of wood assembled to form the bathroom door; but, in fact, they constitute an abstracted, upside-down transcription of the web-footed demon in the lower left corner of Matthias Grünewald's *Temptation of St. Anthony* from the Isenheim Altarpiece (c. 1512–15).

Beyond such conundrums, Johns bends pictorial flatness through the placement of his letters: the stenciled title at the top and the warning on the Swiss sign break off at right and are completed at left. Whereas the unequivocally flat subject of *Three Flags* is turned by reduction and superimposition into sculpture, the letters in *Racing Thoughts*, when read for meaning, make the flat surface as circular and continuous as Johns' thought process.

Andy Warhol

Green Coca-Cola Bottles, 1962

Oil on canvas, 82½ x 57 inches (209.6 x 144.8 cm). Purchase with funds from the Friends of the Whitney Museum of American Art 68.25

Ethel Scull 36 Times, 1963

Synthetic polymer paint silkscreened on canvas, 79¾ x 143¼ inches (202.6 x 363.9 cm) overall. Partial and Promised Gift of Ethel Redner Scull 85.30a–jj

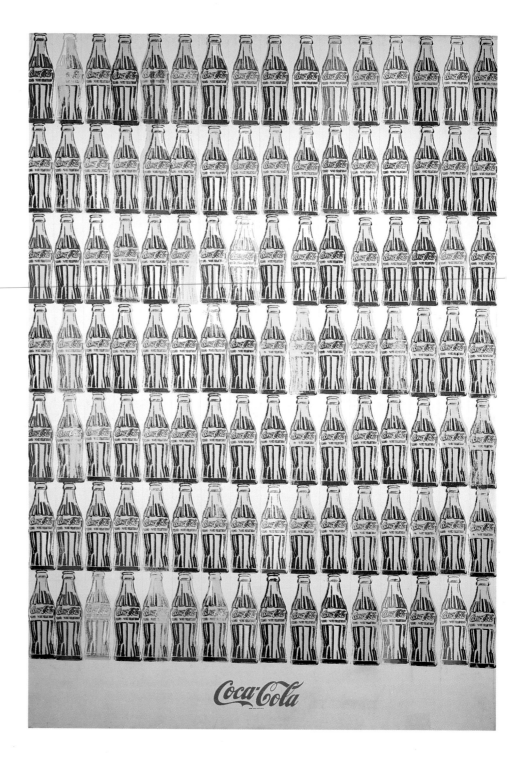

Andy Warhol's silkscreen paintings of the early 1960s replace the emotive and personal gestures of Abstract Expressionism with machine-produced, standardized techniques and images. From Brillo boxes to dollar bills to media personalities, Warhol's art of this period revolves around consumer culture. Keyed as much to sociology as to aesthetics, it defined the new Pop Art.

In the summer of 1962 Warhol first appropriated the commercial silkscreen technique to reproduce images of contemporary society already familiar from the mass-communications and advertising media. His preference for secondary sources—for the reproduction or packaging rather than the substance—champions the commonplace and commercial over the rare and artistic. Warhol's standardized battalion of 112 Coca-Cola bottles, within their discrete, graphite Minimalist grid, reflects blandly upon mass production, abundance, and monopoly. As Warhol wrote later: "A Coke is a Coke and no amount of money can get you a better Coke than the one the bum on the corner is drinking. All the

Cokes are the same and all the Cokes are good. Liz Taylor knows it, the President knows it, the bum knows it, and you know it." In 1962 Warhol completed a group of silkscreened paintings of Coca-Cola bottles, each painting with a distinct character and color. In the naturalistic *Green Coca-Cola Bottles,* the script trademark printed at the bottom is as prominent as the parade of bottles above. Green and black

silkscreens of Coca-Cola's award-winning bottle design are imprinted in variously weighted and inked impressions. As a result, the bottles appear handmade and individualized, as well as streamlined and mass-produced. Warhol's nihilistic and paradox-ridden aesthetic encourages such double readings; the early work of the artist who wants to be a machine ends up expressing subtle and variable gestures.

Ethel Scull 36 Times is probably the first of Warhol's commissioned

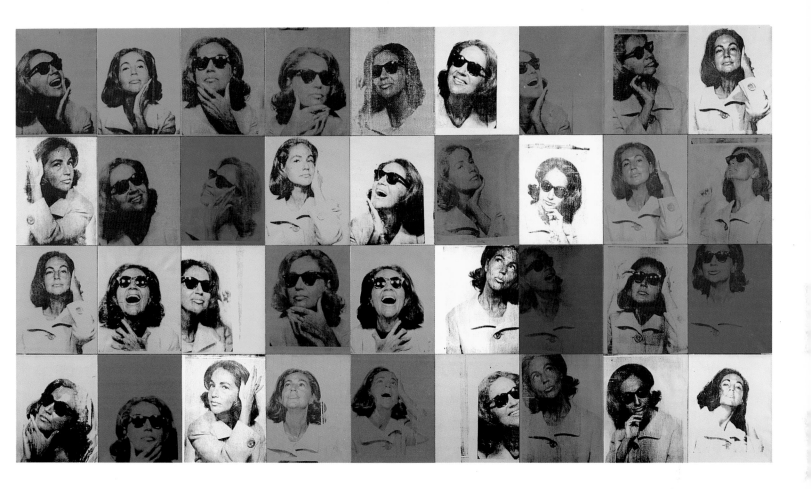

portraits; it is also the largest and most compelling. His repeated image, silkscreen portraits transformed people into products; household names were no different from household goods. He began in 1962 with movie stars; the following year Warhol gave the art collector celebrity treatment.

Ethel Scull and her former husband, Robert, were, in Warhol's own estimation "big—very big, the biggest—collectors of Pop Art . . . the Sculls more than anyone else came to symbolize success in the art scene at the collecting end." Having already purchased several paintings directly from the artist's

studio, in 1963 the Sculls commissioned Warhol to make Ethel's portrait. Uninterested in using existing photographs for the silkscreens, he fortified himself with quarters and took Mrs. Scull to a photo booth in a Times Square arcade. There she "posed" for more than a hundred shots. Unlike Warhol's previous "product" series, the Scull portrait presents different views of the same subject. At first glance, the portrait seems to offer thirty-six different views; in fact, a pose is occasionally seen twice, differentiated by color, flipped, or dropped

registration. The Scull portrait was completed the same year as Warhol's initial activity as a filmmaker and its staccato sequence is appropriately cinematic. Mrs. Scull is portrayed as a collection of poses, a dictionary of moods—thoughtful, seductive, vacuous, exuberant. She wears her dark glasses like a celebrity and her hand moves about her face theatrically. With the lacquered affectations of casual chic, Ethel Scull, dressed in an Yves Saint-Laurent-for-Christian Dior suit, defines an era. Warhol's commissioned portraiture of the rich and aspiring—the light industry of his Factory studio during the 1970s—has seldom been bettered.

175

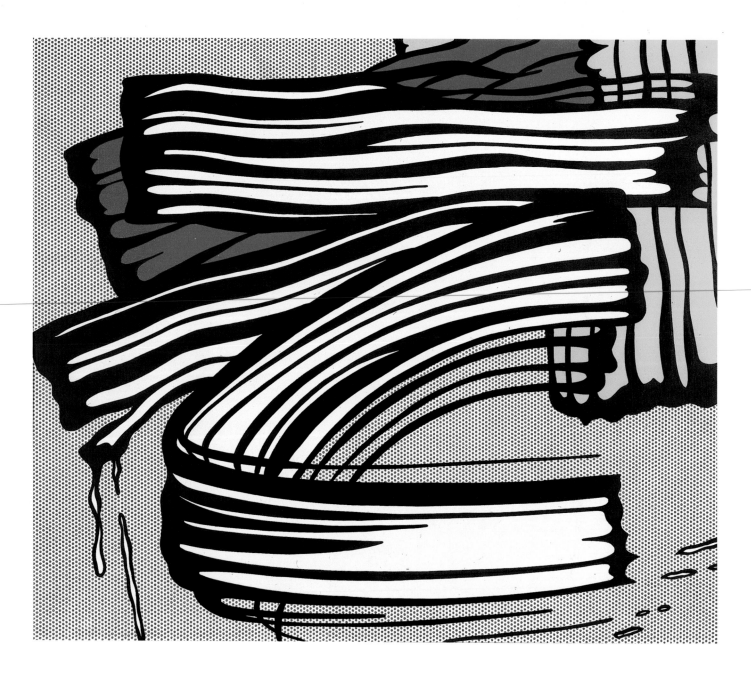

Roy Lichtenstein

Little Big Painting, 1965

Oil on canvas, 68 x 80 inches (172.7 x 203.2 cm). Gift of the Friends of the Whitney Museum of American Art 66.2

Still Life with Crystal Bowl, 1973

Oil and magna on canvas, 52 x 42 inches (132.1 x 106.7 cm). Gift of Frances and Sydney Lewis 77.64

Around 1960, Roy Lichtenstein tired of the stylized Cubist and Abstract Expressionist lodes he had been mining for a decade and, in a radical shift, embarked on an ironic, impersonal, and mechanistic realism. His straightforward depictions of cartoon figures—Donald Duck, Mickey Mouse, and Popeye—were followed by magnified images of comic-strip scenes and commonplace objects, all represented on a ground of painted dots imitative of the Benday dots that create color and form in printed comics. By the mid-1960s, Lichtenstein, like other Pop artists, was recycling the works of earlier masters

—in his case, Cézanne, Picasso, Mondrian, Monet and, later, Matisse and the Surrealists.

In 1965, Lichtenstein boldly assaulted the Abstract Expressionist painting he had earlier embraced. Such works as *Little Big Painting* mock Abstract Expressionism by offering a mannerist version of this supposedly spontaneous and personal style. As with other restatements in the series, Lichtenstein applied paint strokes on clear acetate sheets, which were then projected and transferred onto canvas. Abstract Expressionism's assertion that the creative act is a struggle between the artist and the realization of the work is casually and drolly sabotaged by the mechanical character of Lichtenstein's floating,

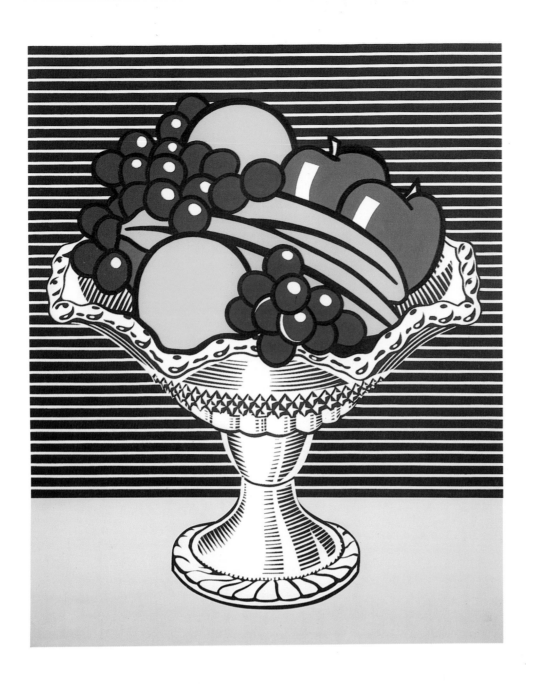

dripping, solid-toned slashes of pigment. His isolated and magnified brushstrokes are painted in a severely simplified palette. *Little Big Painting* commercializes and stylizes the emotional and spiritual energy of Abstract Expressionism—particularly the painting of Willem de Kooning and Franz Kline (pp. 124, 126)—with the precision and wit that marks the artist's general attitude toward subject matter.

In Lichtenstein's first forays into still life (1961–63), he placed isolated product advertisements and commonplace objects—a ring, a roto-broil unit, a slice of pie, a golf ball—against a backdrop of minute

Benday dots. From 1972 to 1974, he undertook a second group of still-life paintings, this time with more complex arrangements that were closer to the conventional treatment of the still-life theme—groupings of objects in interior space. *Still Life with Crystal Bowl* is a singular example within this series. Against its black-and-white banded background, luscious, colorful fruits, with gleaming white accents, cluster in an ornate black-and-white cut-glass compote. No dots surround the

compote, only the somber, striped background, the blank, off-white intimation of a tabletop which fills the bottom quarter of the painting. The allusion here is not to media imagery or other manifestations of Pop culture, but to the iconic plainness and factuality of American folk art. Although Lichtenstein produced many still lifes after 1974, these later works focused on Cubist, Purist, Surrealist, and brush-stroked interpretations of the theme. *Still Life with Crystal Bowl* presents Lichtenstein at his most rigorous and least ironic.

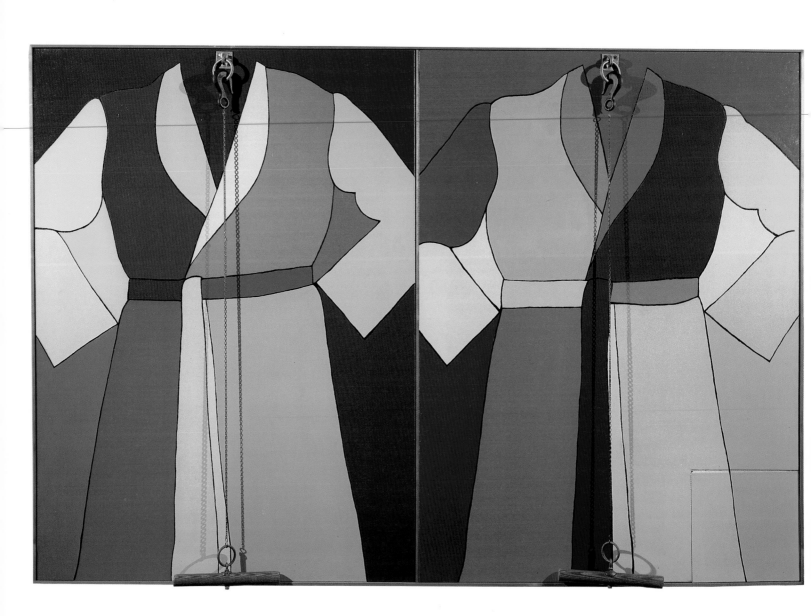

Jim Dine

Double Isometric Self-Portrait (Serape), 1964

Oil with objects on canvas, 56⅞ x 84½ inches (144.5 x 214.6 cm). Gift of Helen W. Benjamin in memory of her husband Robert M. Benjamin 76.35

In 1963, inspired by a *New York Times* advertisement for a bathrobe, Jim Dine started a series of self-portraits using the bathrobe as his symbolic surrogate. This series represented his first break with the intense, expressionistic approach that had characterized his participation in Happenings and his environmental installations. By the mid-1960s, more conventional attitudes took precedence in his art, and traditional media—painting, drawing, and printmaking—became, and remained, Dine's primary vehicles of expression.

Dine's choice of the robe-as-portrait implies a self-image that is domestic, private, and leisurely. Informal, yet discreet, these depictions are limited to a loosely wrapped body and an unseen head and hands. Of his six major robe paintings of 1964, *Double Isometric Self-Portrait (Serape)* is the one that stresses color variation: the same palette appears in both panels, but the arrangement of the colors is shifted. Dine uses the robes here as Josef Albers used the square (p. 154); but Dine's formalism is diverted to autobiography. The painting's title invokes the traditional Mexican-American poncho with its bright, geometric design, while the two wood and chain pulls —isometric exercise devices— anchored atop the robe suggest a concern for fitness. Since the two panels are also of equal dimensions,

the original meaning of isometric is reinforced. The separate rectangle in the bottom corner of the right panel is enigmatic; the artist himself no longer recalls why it was made. It may have been Dine's subtle gesture of homage to Jasper Johns, who had earlier used this device to emphasize the flatness of the picture plane and to assert line as construction rather than draftsmanship.

Dine's other 1964 robe paintings situate their subject in a more complex space and, in certain cases, depict the robes with a painterliness that anticipates the artist's later return to a more gestural style. The first group of robes, however, affirms that by the mid-1960s, Dine had discarded the socio-cultural aspect of Pop Art. By 1970, he confessed that "I'm really only interested in being a biographer of myself." Dine's headless and limbless robes plumb the psychology of depiction; masks of incorporeality, his robes portray the self as complete within its cloaked enigma.

Claes Oldenburg

Soft Toilet, 1966

Vinyl filled with kapok, painted with liquitex, and wood, 52 x 32 x 30 inches (132.1 x 81.3 x 76.2 cm). 50th Anniversary Gift of Mr. and Mrs. Victor W. Ganz 79.83

In the late 1950s and early 1960s, Claes Oldenburg produced objects and environments crudely formed from the detritus of city life. By the mid-1960s, his art took on a more finished, almost elegant, expression. He never ceased being fascinated with everyday objects, but these objects came to assume a monumental stature. And whereas his earlier subjects were mostly clothes and foodstuffs, Oldenburg now invaded the American home. He scrutinized kitchen appliances, the bedroom, and the bathroom— the bathroom being a subject frequently chosen by Pop artists since 1960 to assault conventional good taste.

In 1965, Oldenburg first made sculptures of a toilet, a sink, and a bathtub, based upon the fixtures in his East Fourteenth Street studio. As was typical of his working method at the time, he made cardboard, canvas, and vinyl and kapok-filled versions of the subject. The toilet exists as a rigid, annotated cardboard cut-out, as a scruffy, ghost-like fabric presence, and in this slack, shiny, vinyl-covered formulation. *Soft Toilet*, like other works in the series, evolved from drawings. The sculpture's softness and the sprawled flow of form retain something of Oldenburg's relaxed preparatory studies. In one of these drawings, Oldenburg's magpie sensibility equated the shape of the toilet's base with Cézanne's painting *Mont Sainte-Victoire* and with the outline of the city of Detroit.

Oldenburg's method of presentation makes the viewer reconsider the toilet. His use of vinyl turns the hardness of porcelain soft and flabby, while retaining porcelain's glossy sheen. Salvador Dali made time droop and slither with his collapsed watch image, but something more comic and visceral occurs when the toilet is so transformed. *Soft Toilet* revamps a staple of human sanitation into a sagging, droll essay on the oval. The sculpture's natural weight is such that a metal bar had to be added to keep the piece upright. The toilet's lid is clipped to this bar, exposing the bluish swirls of vinyl water in the bowl and tank. Time has altered the shock of Oldenburg's subject into a healthy respect for its aesthetic wit, deft construction, and pleasing materiality. *Soft Toilet* was first featured in the artist's 1966 exhibition at the Sidney Janis Gallery, New York, where it was reserved for purchase by the Whitney Museum. The Museum changed its mind, however, owing to the work's subject matter: fifteen years later, *Soft Toilet* was enthusiastically received as a gift from the collectors who had taken advantage of the Museum's initial doubt.

H. C. Westermann

Antimobile, 1966

Laminated plywood, 67¼ x 35½ x 27½ inches (170.8 x 90.2 x 69.9 cm) with base. Gift of the Howard and Jean Lipman Foundation, Inc. 69.4

Like Lucas Samaras, H. C. Westermann is one of the great mavericks among twentieth-century American artists. Inventive, irreverent, and idiosyncratic, his art cannot be categorized with any of the succession of movements that span his tragically abbreviated twenty-year career. Living in Chicago and, more briefly, in San Francisco, Westermann left a legacy of hybrid Surrealism that thereafter characterized the work of artists in these cities. Although related by obsession with craft and Surrealist heritage to the great assembler Joseph Cornell (p. 86), Westermann is as down-to-earth as Cornell is fantastic and as blunt as Cornell is refined.

Westermann's objects are both cultural barometers and crucibles of his artistic and personal chronology. Although some Westermann sculptures can be grouped thematically, he never worked in series. Each piece addresses very particular, if enigmatic, circumstances. Westermann sequestered himself in his well-equipped woodworking shop to tackle the subjects of war, mortality, sexuality, language, knowledge, and perception. In *Antimobile* his adoration of wood achieves one of its most monumental and fervent expressions. As in several other pieces of the early and mid-1960s, Westermann here treats wood laminates as if they were elastic. This taut construction is fabricated in Douglas fir and marine plywood; the axle of the wheel is a ball bearing-encased

bicycle pedal. *Antimobile* has been explained by Westermann's longtime ally and explicator Dennis Adrian as an antithetical response to the mobiles of Alexander Calder (p. 98): it is solidly based and cumbrously three-dimensional, not airily suspended and drawn in wire. With its misshapen and paralyzed steering wheel and such eccentric, flippant details as a diminutive,

wing-bolt crown, *Antimobile* conjures up an impotent machine, one that inhibits function and idolizes craft. As Westermann commented, "everything is on wheels nowadays . . . a hundred million cars . . . and everything turns and it's all a bunch of junk. . . . I wanted to make something that was just completely anti-wheel, antimobile."

Lucas Samaras

Untitled Box No. 3, 1963

Wood, pins, rope, and stuffed bird, 24½ x
11½ x 10¼ inches (62.2 x 29.2 x 26 cm).
Gift of the Howard and Jean Lipman
Foundation, Inc. 66.36

In the early 1960s, having been
active in Happenings, Lucas
Samaras began to make art objects
keyed to theatrical, ritualistic
presentations. Specializing in the
id, he inaugurated an art of public
auto-psychoanalysis and narcissis-
tic display. Samaras' daggered sensi-
bility best operates on an intimate
scale. The small size of his box
constructions and their combinations
of familiar, often household, objects
never physically overwhelm, but
confront the viewer cerebrally and
psychologically. Of all his thematic
cycles, the over one hundred box
constructions he has created since
1960 have most disturbingly dis-
played his perversity and omnivorous
appropriation of materials. Between
1963 and 1966, he devoted his full
energy to these reliquaries. He
filled and adorned them with mixed
media and bric-a-brac. As a group,
the boxes marry contradictions:
simple and adorned, container and
contained, neutral and charged, shut
and open. As Samaras put it: "Box
is a lovely principle that carries a
lot of symbolic beans."

For Samaras, the box "suggesting
architecture and all sorts of satyric
psychological complications . . .
provided me with a geometric struc-
ture that I could re-camouflage. . . .
when I started covering them with
pins, wool, jewels, I subverted
their geometry—buried it—and
gave myself an opportunity to use

and introduce ordinary yet strange
substances that had the capacity to
keep my mind glued to their
appearance."

While ostensibly manipulable
and portable, Samaras' box assem-
blages are too fragile and menacing
to use or even handle frequently.
As in *Untitled Box No. 3*, all function
is thwarted. This box is the least
self-contained of the 1963–66 series.
Twine, string, and rope cascade
at its base; its content is more ex-
terior than interior. All that can be

seen in this box is a stuffed bird
that serves, along with several pins,
to hold it open. This immortalized
mocking bird, with its beady eyes
glowing, barely discloses the interior
darkness. Within the black, impene-
trable void, Samaras' nest turns cage
to coffin. His small, busy containers
differ markedly from the large,
pristine boxes then being produced
by the Minimalists. His boxes are, in
contrast, private and autobiograph-
ical, unequivocally fashioned by the
artist's own hand and psyche. In
them art and obsession converge.

Lucas Samaras

Chair Transformation
Number 3, 1969–70

Acrylic on wood, 43 x 20 x 29¾ inches
(109.2 x 50.8 x 75.6 cm). Promised
50th Anniversary Gift of Mr. and
Mrs. Wilfred P. Cohen P.1.80

Chair Transformation
Number 6, 1969–70

Wool, string, brass, and wire, 33½ x
12 x 12 inches (85.1 x 30.5 x 30.5 cm).
Gift of the Howard and Jean Lipman
Foundation, Inc. 70.1570

Chair Transformation
Number 8, 1969–70

Plaster, cloth, wire, and tin foil, 32½ x
22 x 22 inches (82.6 x 55.9 x 55.9 cm).
Gift of the Howard and Jean Lipman
Foundation, Inc. 70.1571

Chair Transformation
Number 12, 1969–70

Synthetic polymer on wood, 41½ x 36 x
13 inches (105.4 x 91.4 x 33 cm). Gift
of the Howard and Jean Lipman Foun-
dation, Inc. 70.1573

Chair Transformation
Number 16, 1969–70

Synthetic polymer on wood, 30 x 15 x
28 inches (76.2 x 38.1 x 71.1 cm). Gift
of the Howard and Jean Lipman Foun-
dation, Inc. 70.1574

Chair Transformation
Number 25A, 1969–70

Plastic and wire, 42 x 20 x 22 inches
(114.3 x 50.8 x 55.9 cm). Gift of the
Howard and Jean Lipman Foundation,
Inc. 70.1575

Chair Transformation
Number 10A, 1969–70

Formica, wood, and wool, 38 x 20 x 20
inches (96.5 x 50.8 x 50.8 cm). Gift of
the Howard and Jean Lipman Foun-
dation, Inc. 70.1572

Samaras created twenty-five full-scale Chair Transformations in 1969 and 1970. They follow similar "transformations" of boxes, eyeglasses, knives, scissors, and flowers and a few smaller-scale forays into the chair. Samaras had begun to conceive of this subject for sculpture in a group of 1964 drawings. This ensemble most ambitiously demonstrates his resourceful imagination and insatiable need to requisition and redefine utilitarian conveniences. Like Claes Oldenburg (p. 180), Samaras represents implements of domestic life, but Samaras trades Oldenburg's socio-cultural commentary for a perverse, witty parade of materials. From steel to plastic flowers to paper, Samaras ignored few materials or styles. His function-denying seats are essays in stylistic conjunction and the diversity of materials. The eclecticism of the sources he draws upon is apparent in the over eighty influences he cited for the series. The extent of his stylistic references, even among the seven examples owned by the Museum (the largest number under a single ownership), is astonishing and reinforced in their interactive installation. Pointillism, Expressionism, and Minimalism are all sedentarily dispatched.

From the complex Constructivism of *Chair Transformation Number 3* to the delineated delicacy of *Chair Transformation Number 8*, Samaras' attention to craft is evident. The stodgy geometry of *Chair Transformation Number 3* is a foil for the extravagant sentimentality of *Chair Transformation Number 25A*. An austere configuration of triangle, square, rectangle, and circle occurs in *Chair Transformation Number 16*, the most potentially harmful to the possible user. Samaras called his chairs "propaganda for my psyche," referring to their function as expressive vehicles for his perverse sensibility. But beyond such idiosyncrasy, the chairs and Samaras' other Transformation pieces declare a larger ambition: to "negate," as he said, "the possibility of a single Platonic ideal acting as measure for any physical thing."

Edward Kienholz

The Wait, 1964–65

Tableau, 80 x 148 x 78 inches (203.2 x 375.9 x 198.1 cm). Gift of the Howard and Jean Lipman Foundation, Inc. 66.49

Social agitant and promoter of the banal, Edward Kienholz believes that the human condition and its cultural setting can only be comprehended through the commonplace, the discordant, and the discarded. Beginning in the late 1950s, his art took the form of repulsively attractive, found-object assemblages; in 1961 he made the first of his topical environmental assemblages. Among other issues, sex, existential boredom, patriotism, and the treatment of the insane were trenchantly exposed.

The Wait investigates the plight of the aged. Gruesome and stark, it is among Kienholz's best-known— and most morbid—pieces. A female figure, embalmed in plastic coating and constructed of cow bones (and a deer skull for the back of her head), sits at the center of a maudlin interior. A matriarch of obsolescence, she lives in a cell of memory. Her attendants are a broken lamp beneath a tattered shade and the feeble chirps and fettered flight of a caged, live parakeet. Her youth is recalled in the bottled photograph of an innocent, late adolescent face that serves as her head. She is adorned with a grim and heavy necklace of sixteen glass jars containing crosses and golden figurines; the events of her past remembered in these containers begin, as Kienholz has described, "with her childhood on a farm and move on to girlhood, waiting for her man, marriage, bearing children, being loved, wars, family, death and then senility, where everything becomes a hodgepodge." In this vision of imminent death, even the most common domestic activities, crocheting and sewing, must be set aside. Kienholz's figure, trapped in her decay, clings to the company of her flea-bitten, stuffed cat. His works, quite unlike any sculpture being made at the time, injected emotion and moral indignation into American art. *The Wait* is far more pitiless than Duane Hanson's later treatment of a seated woman, with her pet animal in a carpeted interior (p. 194). Beyond compassion and verisimilitude, it is unmasked indignation that incites Kienholz to visual rage.

Larry Rivers

Double Portrait of Berdie, 1955

Oil on canvas, 70¾ x 82½ inches (179.7 x 209.6 cm). Anonymous Gift 56.9

Beginning in 1953, Larry Rivers sought an alternative to the Abstract Expressionist style in which he had been trained. He found it in a highly personal form of figuration—portraits of family and friends. Over the next few years, Rivers made portraits of his first wife, his sons, his close friend Frank O'Hara, and his mother-in-law, Bertha (Berdie) Burger.

From 1950 until her death in 1957, Berdie lived with Rivers (who was estranged from her daughter) and his two sons, supporting them in the financially pressed early years of Rivers' career. Of all his models, Berdie was Rivers' favorite, no doubt because she was, in his words, "available and quiet." She was also "monumentally permissive—like a classic dream of a mother. . . . she went to the bathroom, ate and slept. Everything else was what did *you* want to do." The poet-curator Frank O'Hara described her as "a woman of infinite patience and sweetness . . . she held together a Bohemian household of such staggering complexity that it would have driven a less great woman mad."

Among Rivers' various paintings, drawings, and sculptures of his beloved mother-in-law, the Whitney Museum's *Double Portrait of Berdie* is the most monumental assessment of her. She was reluctant to disrobe for this view and, while the portrayal of her full and aging figure is unstinting, an affectionate regard and lyric looseness suffuses the work.

Double Portrait of Berdie has all the marks of conventional portraiture. Rivers paid careful attention to anatomical accuracy and to the details of the setting—the rug, bedspread, and still life on canvas at rear. But there are other features that signal a different intent: the revelation of the process of painting, of the artist at work. Berdie appears twice, as if Rivers were trying out different poses (a thematic variation that may also stem from his experience as a jazzman). The foreground space slants forward precipitously as a thin wash of paint reasserts the canvas surface; the bed's headboard and other areas dissolve in midexecution. The working life of the artist is further suggested by the preparatory sketch of Berdie tacked to the wall at upper left and by the still life in progress.

Double Portrait of Berdie, produced during the heyday of Abstract Expressionism (p. 126), reaffirms the undisguised figurative mode and heralds its potent return in the 1980s.

Alfred Leslie

Alfred Leslie 66/67,
1966–67

Oil on canvas, 108 x 72 inches (274.3 x 182.9 cm). Gift of the Friends of the Whitney Museum of American Art 67.30

In 1962, Alfred Leslie ended the accomplished Abstract Expressionist phase of his career and, with a convert's dedication, devoted himself to representation. A year later, he embarked on a series of enormous black-and-white portraits, at first using photographs as models. Leslie saw portraiture as a vehicle for expressing higher, more tradition-bound truths. The genre, he said, "demanded the recognition of individual and specific people, where there was nothing to be looked at other than the person—straightforward, unequivocal, and with a persuasive moral, even didactic, tone." To do so, he "eliminated color, line, space, perspective, light, drawing, and composition as nearly as [he] could . . . [and] increased the size of the paintings so that there could be no question but that they were meant for public viewing and an institutional life and service." Leslie's scale was a legacy of his Abstract Expressionist work, but his technical emphasis and the expressionless demeanor of his subjects link him more comfortably with the formalist mode that prevailed during the 1960s. Leslie hoped, with an idealism that may now be equated with the 1960s, to upgrade the conduct of the viewer; he posited that the earnest concern he took with each picture might translate into a morally elevated sense of self for the viewer.

In October 1966 a fire in Leslie's New York City studio-loft destroyed twenty years of work. The Whitney Museum self-portrait, painted after the fire, remains one of the few works that exemplify his concerns of the mid-1960s, by which time he no longer used photographs. In its frontal, artificially illuminated factuality, an understandably grave artist faces his public. A huge, bluntly confrontational expanse of flesh and mute expression meets the viewer's gaze: dirty shirt wide open, paint-splattered pants stretched by the hands in the pockets, the fly broken. This representation of a working artist is massively self-assured and emotionally self-centered. But since the figure is set against a dark gray background, the painting is more about presence than psychology. *Alfred Leslie 66/67* establishes a stance that makes the broken fly and fastener on the pants seem as significant as the artist's head.

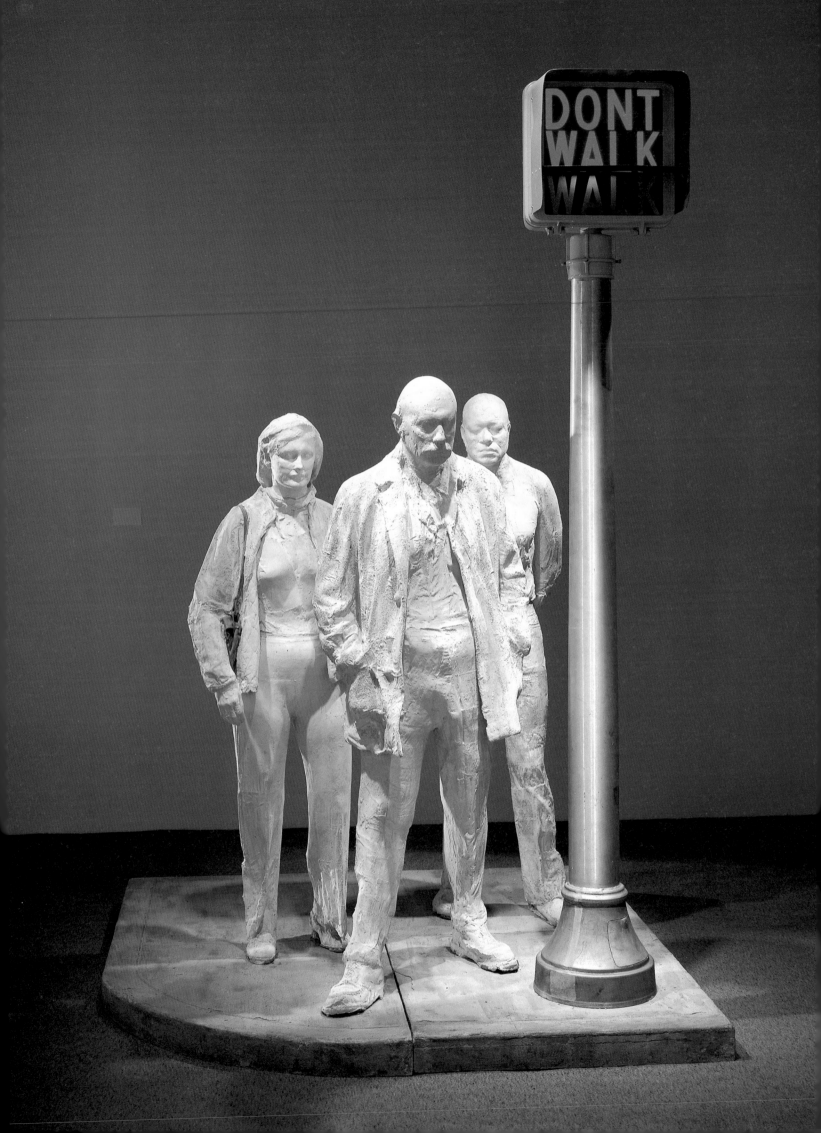

George Segal

Walk, Don't Walk, 1976

Plaster, cement, metal, painted wood, and electric light, 104 x 72 x 72 inches (264.2 x 182.9 x 182.9 cm). Gift of the Louis and Bessie Adler Foundation, Inc., Seymour M. Klein, President; the Gilman Foundation, Inc.; the Howard and Jean Lipman Foundation, Inc.; and the National Endowment for the Arts 79.4

Like many successful sculptors, George Segal began as a painter, and the rough-hewn surfaces of his sculptures recall the painterly brush-strokes of his early expressionistic canvases. In his sculpture, Segal never uses actual flesh tones, but paints his plaster figures white or, more recently, one of several non-naturalistic colors. Unlike Duane Hanson's solitary tableaux vivants (p. 194), which fool the eye through their craft and verisimilitude, Segal's pieces are apparitional, tapping the world of dreams and memories. Moreover, though he casts directly from models, the bulk, whiteness, and even the attitudes of his figures immediately transcend specificity. His wife's brother-in-law, for instance, modeled for the central pedestrian of *Walk, Don't Walk*, but the neutrality of the plaster cast and of the setting transforms him into an urban archetype.

Segal's blend of the specific and the universal, the real and the dreamlike, is achieved through the inclusion of actual objects, such as the streetlight and woman's purse in *Walk, Don't Walk*. Indeed, these objects often provided the inspiration for the sculpture. In *Walk, Don't Walk*, it was the functioning pedestrian streetlight that suggested this study of urban patience and regimentation. The light keeps flashing alternate commands, but Segal's crowd of three remains anchored and unmoving on the curbside. By thus immobilizing people in their environment, Segal transforms a metropolitan commonplace into a fragmentary, existential episode. His art, he has asserted, is predicated on freezing "a moment that contains a whole autobiography."

Segal's sculptures occasionally treat political, mythological, or religious subjects, but his prevalent theme, as in *Walk, Don't Walk*, is the recording of telling and allusive incidents and gestures from ordinary life. The procedures of his casting process require his models to close their eyes; the trance-like inwardness that results emphasizes the figures' ethereality and psychic displacement. A poet of the mundane, Segal isolates and confirms what can readily be seen, but is seldom observed.

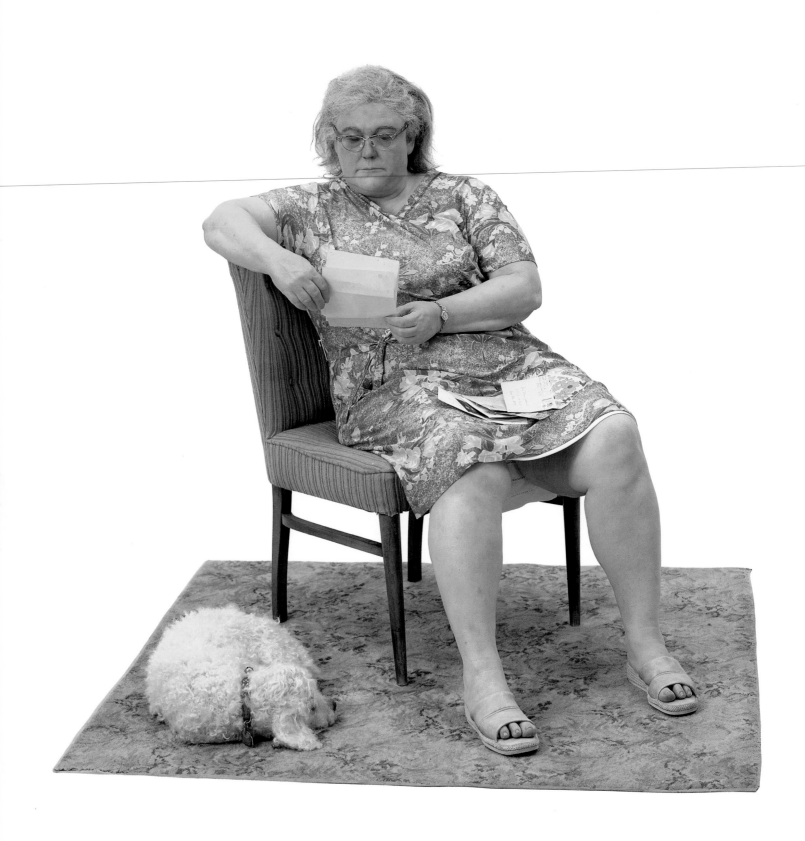

Duane Hanson

Woman with Dog, 1977

Cast polyvinyl, polychromed in acrylic, with mixed media; life size. Gift of Frances and Sydney Lewis 78.6

Interviewed in 1970, four years after beginning the first of his extraordinarily lifelike figurative sculptures, Duane Hanson remarked that "realism is best suited to convey the frightening idiosyncracies of our time." Hanson's idealism and social consciousness, like America's, has softened somewhat in the intervening years. Whereas in the 1960s he depicted the victims of poverty, war, and violence, he currently commemorates what Thoreau called the "quiet desperation" in ordinary lives. Now the pathos of aging, of being unemployed, or feeling unwanted and alone are Hanson's chief concerns.

Hanson's casting technique yields a greater realism than that of George Segal (p. 192), whose plaster figures first inspired him. Although Hanson's figures are also cast from life, he fills molds with plastic alloys, then paints the seamed figures, weaving human and artificial hair into the cast and using plastic eyes.

He outfits the figures to convey his message and spends as much time selecting the right clothing and props as he does forming the bodies.

On first encounter, *Woman with Dog*, like all of Hanson's figures, is accepted as a genuine human presence. She sits on a vinyl-covered chair that rests on a dingy carpet and calmly reads a letter, with her pet dog for company. Hanson's models for *Woman with Dog* were a housewife from Fort Lauderdale, near where he lives, and his brother's pet poodle. The figure of the dog is complete with the poodle's actual hair clippings.

After the fabricated nature of *Woman with Dog* is recognized, however, a new kind of fascination takes hold. By its very setting in a museum, Hanson has rendered the commonplace uncommon. His stated intention for the piece was to present "a credible, unpretentious working class type of woman at mail time enjoying the fellowship of a friendly letter and her pet dog." But his super-realism catches and retains the viewer's eye through the simple humanity of his subject. Hanson has established a new and deeply humanistic kind of voyeurism.

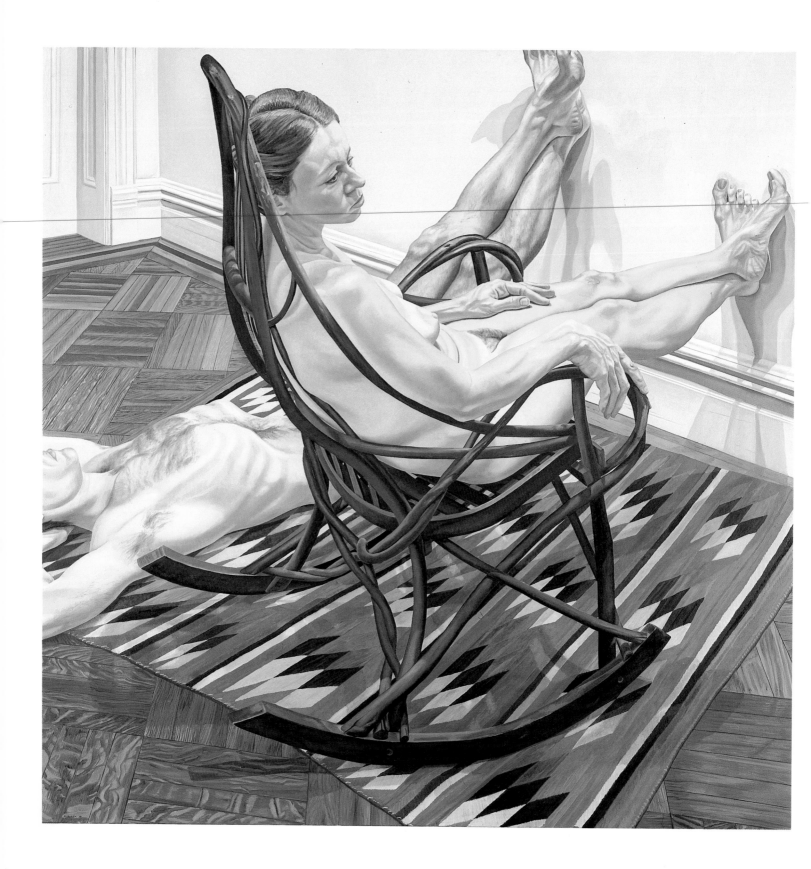

Philip Pearlstein

Female Model on Adirondacks Rocker, Male Model on Floor, 1980

Oil on canvas, 72 x 72 inches (182.9 x 182.9 cm). Gift of the Friends of the Whitney Museum of American Art (by exchange), and purchase, Painting and Sculpture Committee 80.39

Since 1960, carefully executed nudes in interiors have been the subject of Philip Pearlstein's art. Arranging his figures in strong diagonals, Pearlstein turns the dynamic Abstract Expressionist lines of Franz Kline (p. 126) into flesh. At the same time, he proposes a radical representation of the figure: he depicts his models as he would still-life objects. They are devoid of any humanistic sensibility or—despite their nudity—erotic content. This psychological emptiness is asserted physically by their cropped bodies, awkward, life-class poses, and disconnected pairings. Their mutual isolation is so complete as to suggest sexual alienation, in keeping with the aura of disinterest and lassitude that hangs about them. These professionals seem selected for their stalwart but blank ordinariness— never noticeably too young or too old, too thin or too fat, too attractive or too ugly.

Pearlstein appears to have greater affection for the decorative props. In *Female Model on Adirondacks Rocker, Male Model on Floor*, it is these accoutrements which project individualistic and compelling presences. The rustic upstate New York rocking chair and the staccato rhythms of the Navaho blanket, set up in the corner of Pearlstein's New York studio, are the liveliest aspects of the painting. This emphasis on props is abetted by the sexual neutrality of the figures. As Pearlstein described his dispassionate assessment of the human body, "I am the I.R.S. man of a few of the bodies that inhabit New York City and visit my studio periodically."

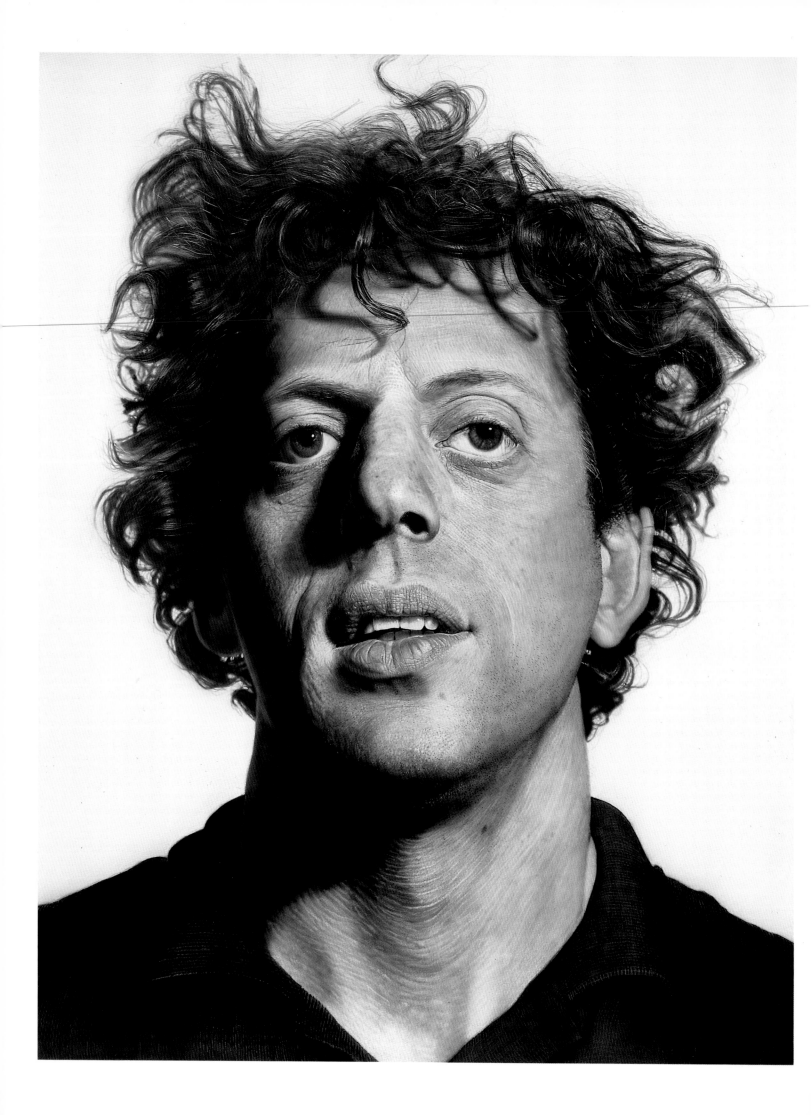

Chuck Close

Phil, 1969

Synthetic polymer on canvas, 108 x 84 inches (274.3 x 213.4 cm). Gift of Mrs. Robert M. Benjamin 69.102

By the end of the 1970s, numerous painters were making the photograph the undisguised source of their imagery. For Chuck Close, even more than for Richard Estes (p. 200), replicating the camera's facsimile of reality defined his impersonal, process-oriented style. The isolated face and neck—amplified, centered, and symmetrically placed—have been Close's subject for over fifteen years. In his inaugural series of eight identical, large-scale black-and-white paintings of 1968–70, one of which was *Phil*, Close knew in advance exactly what the finished paintings would look like. He started with photographs he took himself, drew grids over them, and then, using an airbrush, blew up and transferred the image fragment in each grid to the canvas. He was fascinated by the neutrality and finality of the camera lens—so different from the human eye, which constantly refocuses and judges as it surveys. "The camera," Close remarked, "is not aware of what it is looking at. It just gets it all down."

For their verisimilitude, their lack of any obvious sign of their maker's hand, and their monumental scale, Close's early paintings inspire general awe and then intimate inspection. All depict his family or close associates. Although he later explained that he would not want to spend so much time with the face of someone he did not like, the quality of the photograph, as much as the friendship, determines which of his snapshots gets turned into art. Close prizes information above psychological interpretation. He considers his works paintings, before he perceives them as portraits. Through the process of magnification, the features of Close's subjects, sharply defined up close and blurred in the distance, read more like landscape contours than physiognomic components. As Lisa Lyons has pointed out, "The paradoxical character of Close's paintings—a delicate balance between description and abstraction—is their strength." The subject of the Museum's painting is the composer Philip Glass, whose face appears in the same photo the artist used as the basis of many subsequent works. A connection can be made between Close's obsessive and stringent methodology and the early musical ideas of Glass, which are at once reductive and, through layered construction and repetition, aesthetically mesmerizing.

Richard Estes

Ansonia, 1977

Oil on canvas, 48 x 60 inches (121.9 x 152.4 cm). Gift of Frances and Sydney Lewis 77.33

Since the late 1960s, Richard Estes has led the movement known as Photo-Realism, a revival of realistic imagery based on photographs of sharply focused urban (and suburban) scenes. Estes works from his own photographs, drawing the image directly onto the canvas without the aid of a projector. All his city views, whether of Paris, Venice, or New York, are concerned with the invention and solution of formal problems. For this reason, he can paint the city as easily living in Maine, where he now spends part of the year, as in Manhattan, where he has lived since 1959. "I don't enjoy looking at the things I paint," he explained, "so why should you enjoy it? I enjoy painting it because of all the things I can do with it. I'm not trying to make propaganda for New York, or anything. I think I would tear down most of the places I paint. . . . places and things can if you look at them objectively as forms and colors divorced of their function, or threat or whatever, provide unexpected possibilities for painting . . . the closer I can get to reconstructing the scene the more exciting it is rather than simply using it as a springboard toward some sort of self expression."

Estes' "reconstruction" of the scene in *Ansonia* presents an uncharacteristically tidy, litter-free, and unpopulated view of the Upper West Side of New York City, not far from the artist's apartment.

Looking north from the northeast corner of Sixty-ninth Street and Broadway, there appears in the distance the ornamented towers of the Ansonia Hotel. A white billboard has had its advertisement discreetly deleted. Small writing on the side of the bus proclaims, "Taste is everything—Taste is everything"—a message that underscores the discrimination required for successful Photo-Realist painting (Estes at one point even considered using this slogan as a title).

Estes' edited view of reality is taken from two principal vantage points. At the left of the picture, the area between McDonald's and the street-crossing sign derives from a photograph Estes took half a block below the corner of Seventy-first Street and Broadway. In the painting, this view is shown artfully but not realistically reflected in the window of the flower shop. In front of the flower store Estes took the second photograph that defines the structure of the painting to the right of the church. As is usual for Estes, *Ansonia* is cleverly signed within the composition: in this case, on the marquee by the entry to the church.

Robert Morris

Untitled (L-Beams), 1965

Stainless steel, 3 beams, 96 x 96 x 24
inches each (243.8 x 243.8 x 61 cm).
Gift of Howard and Jean Lipman
76.29

Since the early 1960s, Robert Morris
has been involved in a wide range of
avant-garde styles and sensibilities,
from Pop to Process and Perform-
ance art, to Minimalism, Conceptu-
alism, Earth Works, and apocalyptic
Neo-Expressionism. *Untitled (L-
Beams)* is the most significant of his
Minimalist pieces. In his "Notes on
Sculpture" (1966–69), Morris estab-
lished a critical description for Mini-
malism: "There is some justification
for lumping together the various
focuses and intentions of the new
three-dimensional work. Morpholog-
ically there are common elements:
symmetry, lack of traces of process,
abstractness, non-hierarchic distribu-
tion of parts, non-anthropomorphic
orientations, general wholeness. . . .
[The new work] does not refer to past
sculptural form. Its referential con-
nections are to manufactured objects
and not to previous art."

Untitled (L-Beams) bears the date
1965, although the Museum's paint-
ed stainless steel version was not fab-
ricated until 1971. In 1965 Morris
gave form to his published princi-
ples by conceiving nine identical L-
beams, to be painted pale, matte
gray. He then reduced the number
of planned units to two, and con-
structed a plywood version (1965). A
year later, he produced a fiberglass
edition and, in 1970, a stainless
steel edition in which he sand-
blasted the steel to achieve a matte
gray surface.

At this time Morris decided to add
another L-beam, changing the piece
to a three-unit configuration. Hav-
ing the piece in three units allowed
him to present all three possible po-
sitions of the parts: lying on a side,
standing on an end, and resting on
the two inside corner edges. The
position of each element was deter-
mined during fabrication. The un-
seen, bottom sides of the lying and
standing elements were left incom-
plete to cut down on weight and
materials; to ensure stability, fin-
like protrusions were added to the
inverted-V element. Unlike the
earlier plywood and fiberglass
versions, the elements were not
interchangeable, thus the factor of
variability was eliminated. Yet the
L-beams can still be situated in
varying relationships to each other,
a decision made by the curator
during each installation. With such
variable placements and no prede-
termined viewing perspective,
Untitled (L-Beams) functions as an
environment as much as a sculptural
object or monument.

Robert Smithson

Non-site (Palisades— Edgewater, N.J.), 1968

Painted aluminum, enamel, and stone, 56 x 26 x 36 inches (142.3 x 66 x 91.5 cm), plus map and description of site. Gift of the Howard and Jean Lipman Foundation, Inc. 69.6a–b

Robert Smithson's eleven extant Non-site pieces of 1968 are among his most potent fusions of object and idea. The Non-sites established, in a conventional sculptural format, his polemical art of confrontation between man and the landscape that was later to assume giant scale in his massive earthworks such as *Spiral Jetty*. In a general description of the Non-sites, Smithson remarked, "My Non-sites take the outdoors and bring it inside in containers." As he noted on the documentary sheet that is always installed near the sculpture of *Non-site (Palisades-Edgewater, N.J.)*, "Instead of putting a work of art on some land, some land is put into the work of art." For the Non-sites, Smithson placed stone or soil in Minimalist metal bins.

The Whitney Museum *Non-site* was the last of Smithson's first four Non-sites from sites in his native New Jersey. Visible through the open container and painted a vivid sky or sea blue, artfully stacked "trap" rock (from the Swedish word for "stairs") forms a frozen cascade in space. Smithson's collection site was an abandoned trolley line that ran between the old Palisades Amusement Park and the Edgewater ferry boat slip on the New Jersey side of the Hudson River. He was particularly pleased that this specific *Non-site* was acquired by the Whitney Museum. He hoped that a tour of the site, which is now an apartment complex, might be arranged for Whitney Museum members, during which "each member would be entitled to collect one piece of rock."

Richard Serra

Prop, 1968

Sheet: lead antimony, 60 x 60 inches
(152.4 x 152.4 cm). Pole: lead antimony,
96 inches high (243.8 cm). Gift of the
Howard and Jean Lipman Foundation,
Inc. 69.20

By 1967, at the age of twenty-eight,
Richard Serra had established him-
self as one of the seminal Post-
Minimalist sculptors. His work, like
that of Jackie Winsor (p. 209), began
through an involvement with eccen-
tric materials and an emphasis on
process, concerns powerfully intro-
duced into sculpture by Eva Hesse
(p. 206). In 1968, however, Serra
returned to a more strictly reductive
format. Such works as *Prop* ener-
gize Minimalist geometry by dram-
atizing the conditions of equilibrium
and interdependence. Serra made
numerous Prop sculptures in 1968–
70, but considered the Whitney
Museum example to be "the gener-
ative prop of a series utilizing vari-
ous plates and poles of different
dimensions and focusing on the logic
of the material under tension."

Anchored to the floor, a rolled-up,
8-by-8-foot lead sheet tightly pin-
ions a flat 5-by-5-foot square against
the wall. Line, square, and—in side
view—triangle converge in a dy-
namic interaction of wall and floor.
The fundamental properties of
lead—weight and pliability—are
acknowledged in the propping and
rolling of the material. (It has
since become necessary to tack the
top of the square to the wall because
the lead-antimony alloy no longer
stays flat.) In the square, Serra also
offers a sly reference to the picture
plane being supported by sculpture.
The lead's smooth yet varied sur-
face, visible in the flat square, pos-
sesses a mottled sheen that adds a
lyric surface to a simple exposition
of interdependence.

Eva Hesse

Sans II, 1968

Fiberglass, 2 sections, 38 x 170¾ x 6⅛
inches (96.5 x 433.7 x 15.6 cm) overall.
Gift of the Albert A. List Family and
Dr. and Mrs. Lester J. Honig 69.105

Between 1965 and her death in
1970, Eva Hesse produced a small
yet seminal corpus of sculpture. She
had spent the early part of her ca-
reer as a painter, and a painterly
concern with surfaces and with the
effect of color on form characterizes
her sculpture. Its reliance on chance,
impromptu materials, and hand-
made eccentric construction placed
her in the vanguard of Post-Mini-
malist sculpture. The Museum's
Sans II is from the second work in a

trio of paired rectangular progres-
sions made between 1967 and 1969.
These compositions resemble shallow,
enlarged ice trays, and derive from
the Minimalist simplicity of Carl
Andre, Donald Judd, and
Sol LeWitt. While *Sans I* and
Sans III move down the wall and
across the floor, *Sans II* hangs on a
wall. But the irregularity of manu-
facture in all three Sans pieces, the
works' fluted edges, and clouded
transparencies challenge the conven-
tional machine-made reductiveness
of Minimalism.

The repetitive parts of *Sans II*
were produced by using a gum rub-
ber mold, created from a plaster
model, to form its five, twelve-
compartmented fiberglass sections.
As suggested by their titles, the Sans
works were made without the ec-

centric, freestanding structure of
much of Hesse's other sculpture.
Sans II links the concerns of a painter
and a sculptor. As Lucy Lippard has
observed, the work is a "triumph be-
tween the frontality of painting and
the subtlety of surface possible only
in three dimensions."

The Whitney Museum owns two
of five *Sans II* sections. The piece's
entire vertebrate expanse has only
been shown once, at Hesse's Novem-
ber 1968 Fischbach Gallery show in
New York. After this presentation,
it was broken up for sale to five dif-
ferent owners, two of whom donated
their sections of the work to the
Whitney Museum. In its current
version, the piece's serial repetition
is thus compromised. For Hesse, as
with such later admirers of her
work as Jackie Winsor, repetition
builds strength: "If something is
meaningful," Hesse said, "maybe
it's more meaningful said ten times."

Donald Judd

Untitled, 1965

Aluminum, 8¼ x 253 x 8¼ inches (21 x 642.6 x 21 cm). Gift of the Howard and Jean Lipman Foundation, Inc. 66.53

Machine-made, self-referential, and geometric, the sculpture of Donald Judd is emblematic of the formalism of the 1960s. In a decade whose stylistic advances often proceeded from sculpture rather than painting, Judd, along with Carl Andre, Robert Smithson, and Robert Morris (pp. 202, 204), established a new, reductive mode. Their sculptures took material itself and serial progression as subject matter. By 1961, Judd began to produce eccentric but increasingly purified geometric sculpture.

In 1964, he made his first major lateral wall reliefs, a continuing series that includes the Whitney Museum's 1965 work. These sculptures, along with rectangular floor pieces and vertically stacked wall boxes, are Judd's primary sculptural configurations. All discarded the traditional notion that sculpture should rest on a base.

For *Untitled*, Judd paired an unpainted, matte-finished hollow transversal beam with painted, shiny, encased L-shaped brackets. These reddish-purple support elements set up an apparently irregular sequence of solids and voids. In fact, Judd set the lengths of the ten metal rectangles and their intervals with mathematical exactitude, each rectangle alternately augmented and diminished according to a predetermined system of proportions. Because the piece is lit from above, the shadows cast by the rectangles establish a second, even more complex, visual component. Using a formula that is at once precise and witty, Judd produced a rich interplay of surface, mass, color, negative space, and shadow.

Judd's non-naturalistic and quirky choice of color, the sensuousness of his materials, and the complexity of his composition seem to refute the reductive Minimalism with which the work is so routinely identified. Judd's geometry stresses an act of seeing unencumbered by any representational or narrative connection. Color, interrelation, and precision command the viewer's attention.

Richard Tuttle

Drift III, 1965

Painted wood, 24¼ x 52¾ x 1¼ inches (61.6 x 134 x 3.2 cm). Purchase, with funds from Mr. and Mrs. William A. Marsteller and the Painting and Sculpture Committee 83.18

In Richard Tuttle's first publically exhibited work (1965), he presented flat object-paintings which, by their irregular shape and apparently arbitrary installation (on either the floor or the wall) introduced a radical, hybrid medium. He began the constructions with cut-out drawings on large sheets of brown kraft paper, which served as templates for identical, quarter-inch plywood sections. These were joined around their edges with stripping painted the same color as the face of the work.

Tuttle created about 130 of these single- or dual-sectioned pieces in 1964 and 1965, but he later destroyed most of them. The remaining works, *Drift III* among them, chart a remarkably subtle interaction between color and form. Adjacency, edge, and balance are the real subjects of the works. Although Tuttle employs a spare, Minimalist vocabulary, his pieces are distinctly poetic

and personal. The edges are never quite straight and the buoyantly pastel palette is both restrained and eccentric.

Drift III is the third in a series of five wall-mounted pieces, related only by title, which conclude the first phase of Tuttle's art. The designation of the series has a biographical source. Following his postgraduate study at Cooper Union, Tuttle briefly joined the Air Force. The shapes of the Drift series, he explained, reminded him of tinted clouds. Moreover, his fascination with motion and buoyancy finds an artistic equivalent in the apparently impromptu and off-balance placement of his objects on the wall.

Jackie Winsor

Bound Logs, 1972–73

Wood and hemp, 114 x 29 x 18 inches
(289.6 x 73.7 x 45.7 cm). Gift of the
Howard and Jean Lipman Foundation,
Inc. 74.53

From 1967 to 1976, hemp, rope, and
twine were the materials of many
of Jackie Winsor's sculptures. Her
twine-wrapped boles such as *Bound
Logs* constitute her most intransi-
gent reaction to Minimalism—to the
impersonality of machine fabrication
and the conventional definitions of
artistically acceptable materials.
Winsor craftily naturalized the
Minimalist vocabulary. Her earliest
work used hair-like extrusions; in
time, these became hefty braids of
rope. Clearly hand-executed, the
additive activity of binding and
wrapping was Winsor's gesture of
fabrication. The crude carpentry of
Bound Logs is covered with string. A
collection of twine—the symbol of
miserly frugality—is squandered
obsessively and without function.
The slow coiling process turns task
to ritual.

 Through the early 1970s, a pro-
gression of nearly a dozen string,
wire, and wood pieces included out-
door installations and an indoor
grid of forty-nine entwined upright
sticks. *Bound Logs* is the tallest of
Winsor's indoor pieces. Wall-bound,
the sculpture is adjacent to the
space but is neither contained nor
surrounded by it. Its legacy of Min-
imalist symmetry is contradicted by
its personal manufacture, eccen-
tric proportion, and complex detail.
The rugged materiality of *Bound
Logs* is underscored by its installa-
tion in a pristine museum setting.
Ironically, however, the original
natural state of the logs was sadly
short-lived. The bound tree trunks
are now rotting from within, and
conservation—gluing and nailing
of the bark—has been required to
keep the bark attached to its
shrinking core.

Lines to Points on a Grid, fourth wall.

Sol LeWitt

Lines to Points on a Grid: 24 Lines from the Center; 12 Lines from the Center of the 4 Sides; 12 Lines from Each Corner; 24 Lines from the Center, 12 Lines from the Center of the 4 Sides, 12 Lines from Each Corner, 1976

6-inch pencil grid and white crayon lines on black walls; installation variable up to four walls; dimensions of walls and line lengths variable. Gift of the Gilman Foundation, Inc. 78.1

When not installed on the wall, Sol LeWitt's wall drawings exist solely as typewritten formulas and documentary photos. The Museum purchased a set of instructions—and with it the right to show and lend the work. LeWitt oversaw the first installation, but subsequent showings have been drawn by associates of the artist or Museum employees, who realize LeWitt's instructions, which are precise but leave room for variation. "The idea," as LeWitt noted, "becomes a machine that makes the art."

LeWitt's radical expansion of the meaning of drawing began in 1968, four years after he had established himself as an important Minimalist sculptor with his machine-made, repetitive, white cubic pieces. Unlike the perspective views he had drawn on paper for these pieces, the wall drawings were easily reproducible and boldly public. By deciding to make the wall his support, LeWitt eliminated all three-dimensional reference. The crisp lineation of *Lines to Points on a Grid* criss-crosses the wall surface without regard to perspective and depth. Inseparable from the wall, the lines establish an absolute two-dimensionality, yet their black ground connotes limitless space.

Lines to Points on a Grid can be drawn as a single wall or as many as four walls, which is the optimum room ensemble. It is begun by painting the walls a flat black and marking a 6-by-6-inch pencil grid upon them. The white lines must always end at the corner of one of the 6-by-6-inch squares. As is indicated by the full title of the work, one wall has twelve lines that emanate from the four corners, another is covered with twelve lines that fan out from the center point of each side of the wall; the third wall consists of twenty-four lines radiating from the center of the wall; the final wall merges all of these instructions. Originally drawn on the walls in easily smudged chalk, the lines are now installed in wax crayon. When all four walls are used, the experience of *Lines to Points on a Grid* is a galactic explosion of intricate lines, all the while bound by logic.

Lines to Points on a Grid, detail

Dan Flavin

Untitled (for Robert, with fond regards), 1977

Pink, yellow, and red fluorescent light, 96 x 96 inches (243.8 x 243.8 cm). Gift of the Howard and Jean Lipman Foundation, Inc. (by exchange), Peter M. Brant (by exchange), and the Louis and Bessie Adler Foundation, Inc., Seymour M. Klein, President 78.57

The mechanical appearance of Dan Flavin's art masks his beginnings as an expressionist painter and draftsman. His earliest work was characterized by a lush sentiment that now only surfaces in his colors and in the personal dedications added to many of his untitled designations. Flavin appropriated the fluorescent light tube as his medium in 1961. The pieces performed both as painting and sculpture, infusing surrounding space with glowing color. Flavin called his early light pieces "icons," but also confessed that "they are dumb—anonymous and inglorious . . . as mute and indistinguished as the run of our architecture."

Flavin's fluorescent works quickly developed from cool white, singular configurations to space-altering illuminations of multi-colored ethereality. With their increased scale and luminosity they established a territorial imperative, transforming not only the surrounding space but any art installed nearby. As early as 1963, Flavin's pieces often traversed corners, in a way that visually altered the proportions of the room.

Untitled (for Robert, with fond regards) is one of his more elaborate corner grid configurations. The Museum's 8-by-8-foot example is fabricated in an edition of three (a group of 4-by-4-foot versions have also been made). In the larger scale, the almost palpable pools of lights seem to make the room's corner disappear. Flavin supplied his own description of the work's virtues, citing its "rich contrast, front over rear, and an optical interplay, pink on yellow backgrounded by the red, all modified by reflected color mixes and shadows of the grid structure itself. As an ensemble, this intense fluorescent light use/abuse seems to me to be rare in my production." As is Flavin's practice, the work is dedicated to a friend, in this case, Robert Skolnick, a former longtime assistant, who had previously been an installer of art at the Whitney Museum.

Joel Shapiro

Untitled, 1980–81

Bronze, 52⅞ x 64 x 45½ inches (134.3 x 162.5 x 115.6 cm). Purchase, with funds from the Painting and Sculpture Committee 83.5

Joel Shapiro emerged as a major Post-Minimalist sculptor in 1971, when he abandoned abstraction for simplified, miniaturized representations—a bridge, a chair, a horse, and, in his most extensive exploration of a form, the house. For Shapiro these dense, geometric shapes compressed basic personal truths; for his audience they likewise tapped resonant psychological chords. The minuteness of their scale, demanding a close and careful viewing, encouraged pause; it made, for instance, the idea of a house, not a house itself, the subject of the work.

Shapiro turned to the figure for the first time in 1976, with a group of stick men whose simplicity conceals their contradictory character: at once cumbrous and graceful, wooden and metallic, hard and soft, representational and non-objective, but always active and energized. The Whitney Museum's *Untitled* is one of four bronze casts of a configuration originally made in wood. With this work, Shapiro also moved away from the miniaturization for which he had become celebrated. The small scale that had first attracted attention to his art now appeared to limit his range. In a historical context, his big figures can be read as witty descendants of the more figurative members of David Smith's Cubi series or even Smith's *Running Daughter* (p. 141).

The almost life-size, bronze figure of *Untitled* retains the grained, modulated surface of the wood from which it was directly cast, and hence the sawed irregularities and pounded softness where the nails were driven in. Its original construction with nailed 4-by-4-inch beams seems casual and undistinguished, but in bronze its precarious balance adds grace and motion. Bowed yet defiant, the figure maintains an impossible posture with élan. Shapiro's description of this work best defines its multivalent, Post-Minimalist character: "I am interested in those moments when it appears that it is a figure and other moments when it looks like a bunch of wood stuck together —moments when it simultaneously configures and disfigures. . . . I'm more interested in how one thinks about something than in what something looks like. I am interested in what a house or a figure might mean, or what it means to me. I am interested in my capacity to refer to it in terms of sculpture, but not to illustrate it or describe it."

Artists' Biographies and Bibliographies

Josef Albers

Bottrop, Germany, 1888–
New Haven, 1976

In 1915, after attending teachers training schools and teaching primary school, Josef Albers was certified as an art teacher in Berlin. Five years later, after further study at art schools in Essen and Munich, he entered the Bauhaus in Weimar. The designs he produced there—mostly in stained glass—grew increasingly geometric through the 1920s, reflecting the influences of Constructivism and de Stijl. By 1925, Albers had become a professor at the Bauhaus (then in Dessau) and was designing typography and furniture.

When the Bauhaus closed in 1933, Albers immigrated to the United States. He was appointed head of the art department at the new, experimental Black Mountain College in North Carolina, where he remained until 1949. From 1950 to 1958, he served as director of the Yale University School of Art. He wrote many books and essays on his artistic theories; these studies, combined with his active teaching career, exerted a profound influence on younger artists.

Albers' chief contribution to twentieth-century art was his assertion of color as the primary pictorial element, an element in no way subordinate to form. He generally produced paintings and prints in series, the most famous of which is the Homage to the Square, begun in 1949. These simple geometric compositions consist of squares nestled within squares, usually in different values of the same color. The calculated distinctions between these values, however, yield three-dimensional effects. A color appears to recede or project because our perception of it is determined by the intensity of neighboring colors.

Albers called this perceptual process "The Interaction of Color"—the title of a fundamental book on color theory he published in 1963.

From 1936 on, Albers had numerous one-artist exhibitions of his glass works and paintings in both American and European galleries. His first important museum retrospective took place in 1956 at the Yale University Art Gallery, and he participated in many Whitney Museum Annual Exhibitions in the late 1950s and early 1960s. The Museum of Modern Art, New York, organized an exhibition of the Homage to the Square series that traveled to museums in the United States, Mexico, and South America (1965–67). In 1971 a retrospective of his prints and paintings was presented at the Metropolitan Museum of Art, New York, the first retrospective there accorded to a living artist.

George Heard Hamilton, *Josef Albers: Paintings, Prints, Projects,* exhibition catalogue (New Haven, Connecticut: Yale University Art Gallery, 1956).

Josef Albers, *Interaction of Color* (New Haven, Connecticut: Yale University Press, 1963).

Werner Spies, *Albers* (New York: Harry N. Abrams, 1970).

Henry Geldzahler, *Josef Albers at The Metropolitan Museum of Art: An Exhibition of His Paintings and Prints,* exhibition catalogue (New York: The Metropolitan Museum of Art, 1971).

Fronia Wissman and Gene Baro, *Paintings by Josef Albers,* exhibition catalogue (New Haven, Connecticut: Yale University Art Gallery, 1978).

Nicholas Fox Weber, *Josef Albers: His Art and His Influence,* exhibition catalogue (Montclair, New Jersey: Montclair Art Museum, 1981).

Milton Avery

Sand Bank, New York, 1885–
Bronx, New York, 1965

While supporting himself with factory jobs, Milton Avery studied life drawing and painting at the Connecticut League of Art Students in Hartford (enrolling sometime between 1905 and 1911). In 1917 he began working nights in order to paint in the daytime. The following year he transferred to the School of the Art Society of Hartford.

Avery's landscapes and seascapes of the early 1920s use the heavy impasto, light palette, and atmospheric mistiness of the American Impressionists Ernest Lawson and John Henry Twachtman. With his move to New York in 1925, where he encountered the work of Matisse and the pre-Cubist work of Picasso, Avery began to simplify forms into broad areas of close-valued color. Although Avery's art became increasingly abstract, he never abandoned representational subject matter, painting figure groups, portraits, still lifes, landscapes, and seascapes. His mature style, developed by the mid-1940s, is characterized by a reduction of elements to their essential forms, elimination of detail, and surface patterns of flattened shapes, filled with arbitrary color in the manner of Matisse.

Early in Avery's career, when Social Realism and American Scene painting were the prevailing artistic styles, the semi-abstract tendencies in his work were viewed by many as too radical. In the 1950s, a period dominated by Abstract Expressionism, he was overlooked by critics because of his adherence to recognizable subject matter. Nevertheless, his work, with its emphasis on color, was important to many younger artists, particularly to Mark Rothko, Adolph Gottlieb, Barnett Newman, Helen Frankenthaler, and other Color Field painters.

Avery had frequent one-artist gallery exhibitions beginning in the early 1930s. His first museum exhibition took place in 1943 at the Phillips Memorial Gallery in Washington, D.C. In 1952, the Baltimore Museum of Art held a retrospective, followed by another in 1960, organized by the American Federation of Arts and held at the Whitney Museum of American Art in New York. Major posthumous retrospectives were presented in 1969 by the National Collection of Fine Arts, Washington, D.C., and in 1982 by the Whitney Museum.

Hilton Kramer, *Milton Avery: Paintings, 1930–1960* (New York: Thomas Yoseloff, 1962).

Adelyn D. Breeskin, *Milton Avery,* exhibition catalogue (Washington, D.C.: National Collection of Fine Arts, Smithsonian Institution, 1969).

Bonnie Lee Grad, *Milton Avery* (Royal Oak, Michigan: Strathcona Publishing Company, 1981).

Marla Price, *Milton Avery: Early and Late,* exhibition catalogue (Annandale-on-Hudson, New York: Edith C. Blum Art Institute, Milton and Sally Avery Center for the Arts, Bard College, 1981).

Barbara Haskell, *Milton Avery,* exhibition catalogue (New York: Harper & Row in association with the Whitney Museum of American Art, 1982).

William Baziotes

Pittsburgh, Pennsylvania 1912–
New York City, 1963
The son of Greek parents, William
Baziotes grew up in Reading, Penn-
sylvania. Between 1931 and 1933,
while working for the Case Glass
Company, he attended evening
sketch classes. His close friend the
Reading poet Byron Vazakas in-
troduced him to the poetry of
Baudelaire and other Symbolists,
which remained a lifelong source
of inspiration for the artist. Settling
in New York in 1933, Baziotes
studied until 1936 at the National
Academy of Design, primarily with
the realist painter Leon Kroll.

Around 1940, Baziotes was one of
the first New York artists to become
acquainted with the Surrealist emi-
grés, Matta, Gordon Onslow-Ford,
and Kurt Seligmann; he also shared
a studio with Jimmy Ernst. By this
time he was experimenting with
Surrealist automatic techniques
and incorporating biomorphic
imagery into the shallow Cubist
formats of his paintings. Baziotes
was one of the few Americans in-
vited by André Masson to partici-
pate in a major Surrealist exhibi-
tion, "First Papers of Surrealism,"
at the Whitelaw Reid Mansion in
New York in 1942. Two years
later, he had his first one-artist
exhibition at Peggy Guggenheim's
Art of This Century Gallery in
New York.

Nineteen forty-six marks the be-
ginning of Baziotes' mature paint-
ing style. The Cubist structure was
abandoned in favor of simpler com-
positions in which several large bio-
morphic shapes, often accompanied
by meandering calligraphic lines,
appear to float in fields of soft,
glowing color. Baziotes shared
fully the Abstract Expressionists'
emphasis on intuitive execution;
his paintings, however, are charac-
terized by a quiet lyricism, unlike
the energetic canvases of the Ab-
stract Expressionists.

From 1945 on, Baziotes had fre-
quent one-artist gallery shows in
New York, and was included in
most Whitney Museum Annuals
through 1961. In 1948 Baziotes,
Robert Motherwell, Mark Rothko,
and David Hare founded the short-
lived Subjects of the Artist School
in New York, a loosely organized
art school devoted to the open ex-
change of ideas between faculty and
students. Two years after Baziotes'

death in 1963, the Solomon R.
Guggenheim Museum in New York
presented a memorial exhibition of
his work, and a major traveling
retrospective was organized in 1978
by the Newport Harbor Art Muse-
um, Newport Beach, California.

Lawrence Alloway, *William
Baziotes: A Memorial Exhibition*,
exhibition catalogue (New York:
The Solomon R. Guggenheim
Museum, 1965).

Irving H. Sandler, "Baziotes:
Modern Mythologist," *Art News*,
63 (February 1965), pp. 28–30,
65–66.

Mona Hadler, "William Baziotes:
A Contemporary Poet-Painter,"
Arts Magazine, 51 (June 1977),
pp. 102–10.

Barbara Cavaliere and Mona Had-
ler, *William Baziotes: A Retro-
spective Exhibition*, exhibition
catalogue (Newport Beach, Califor-
nia: Newport Harbor Art Museum,
1978).

George Bellows

Columbus, Ohio, 1882–
New York City, 1925

After attending Ohio University
(1901–04), George Bellows enrolled
in the New York School of Art,
where he came under the influence
of Robert Henri. The two artists
developed a lifelong friendship
and Henri's ideas had a lasting
impact on Bellows' work.

By 1906, Bellows had settled into
his own New York studio and had
begun to exhibit his work. A sports
enthusiast, he made money playing
baseball in his spare time. Although
he was not a member of The Eight,
he shared their commitment to can-
did portrayals of urban life. Never-
theless, in 1909, he was elected an
associate member of the conser-
vative National Academy of Design,
its youngest member ever. Bellows
participated in and helped to or-
ganize both the 1910 "Exhibition
of Independent Artists" and the
1913 Armory Show. He also helped
to found, in 1916, the Society of
Independent Artists, and joined the
art staff of the Socialist maga-
zine *The Masses*, under John Sloan.
Beginning in 1910, Bellows also
taught occasional terms at the Art
Students League.

Despite Bellows' involvement
with the more progressive art
forces of his day, his own work was
conservative and strictly represen-
tational. He was a prolific painter
and the range of his subject matter
is enormous: seascapes from his
many Maine summers, New York
City street scenes, portraits, female
nudes, circuses, prayer meetings,
groups of children swimming, and
his famous prize fighters. He em-
ployed a dark, subdued palette for
portraits and other indoor scenes,
but often accented them with
brightly colored details, while the
colors in his outdoor paintings were
richer and bolder. Early in his
career Bellows characteristically
rendered his subjects with broad
rough strokes, which became less
evident in his later paintings.

Bellows exhibited widely and sold
many of his paintings during his
lifetime. In 1916, he became in-
terested in lithography and was
equally successful in this medium.
Bellows was the recipient of many
awards and honors. New York's
Metropolitan Museum of Art spon-
sored a memorial exhibition of his
work in 1925. A major retrospective
was held in 1956 at the National
Gallery of Art in Washington, D.C.

Henry McBride, *George Bellows:
A Retrospective Exhibition*, exhibi-
tion catalogue (Washington, D.C.:
National Gallery of Art, 1957).

Charles H. Morgan, *George Bellows,
Painter of America* (New York:
Reynal and Company, 1965).

Donald Braider, *George Bellows and
the Ashcan School of Painting*
(Garden City, New York: Double-
day & Company, 1971).

Mahonri Sharp Young, *The Paint-
ings of George Bellows* (New York:
Watson-Guptill Publications, 1973).

Margaret C. S. Christman, *Portraits
by George Bellows*, exhibition cata-
logue (Washington, D.C.: Smith-
sonian Institution Press for the
National Portrait Gallery, Smith-
sonian Institution, 1981).

E. A. Carmean, Jr., John Wilmerd-
ing, Linda Ayres, and Deborah
Chotner, *Bellows: The Boxing Pic-
tures*, exhibition catalogue (Wash-
ington, D.C.: National Gallery of
Art, 1982).

Thomas Hart Benton

Neosho, Missouri, 1889–
Kansas City, Missouri, 1975

Thomas Hart Benton attended the
Art Institute of Chicago (1906–07)
before making the traditional art-
student pilgrimage to Paris. Benton
lived in Paris between 1908 and
1911, and studied briefly at the
Académie Julian and at the Acad-
émie Colarossi. His early work re-
veals his experimentation with
Impressionism and Post-Impression-
ism, and particularly the influence
of Cézanne. Benton became a
friend of the Synchromist Stanton
Macdonald-Wright, and by 1914–
15 he was producing abstract and
representational paintings in a
Synchromist style.

Around 1916, however, Benton's
interest in abstraction and other
avant-garde issues lessened. He be-
gan to fill his compositions with rec-
ognizable American imagery, and
eventually became known, along
with John Steuart Curry and Grant
Wood, as one of the foremost Re-
gionalist or American Scene paint-
ers. Throughout his career, murals
were the major vehicle for this
effort. American history and con-
temporary American life—labor,
business, technology, and leisure—
became the subjects for the many
murals Benton was commissioned to
execute in the 1930s for American
colleges, governmental buildings,
and libraries. He employed a nar-
rative format in these works, his
figures, and occasionally certain
motifs, recalling those of the Old
Masters he had studied.

Although Benton considered New
York his home between 1912 and
1935, he traveled widely through-
out the United States, gathering
material for his murals and other
paintings. From 1926 to 1935, he
taught at the Art Students League
in New York. In 1935, with a com-
mission to execute murals for the
Missouri State Capital in Jefferson
City and an appointment as Di-
rector of Fine Arts at the Kansas
City Art Institute, Benton moved
to Kansas City, Missouri, where he
remained until his death.

Benton began an affiliation with
the Associated American Artists
Gallery in New York in 1936.
Major exhibitions of his work were
organized by the Art Museum of
the New Britain Institute, Con-

necticut (1954), and the Rutgers University Art Gallery, New Brunswick, New Jersey (1972). In 1980, the Spencer Museum of Art, the University of Kansas, at Lawrence, presented an exhibition of selections from the Benton estate.

Thomas Hart Benton, *An American in Art: A Professional and Technical Autobiography* (Lawrence, Kansas: The University Press of Kansas, 1969).

Phillip Dennis Cate, *Thomas Hart Benton: A Retrospective of His Early Years, 1907–1929*, exhibition catalogue (New Brunswick, New Jersey: Rutgers University Art Gallery, 1972).

Matthew Baigell, *Thomas Hart Benton* (New York: Harry N. Abrams, 1973).

Wilma Yeo and Helen K. Cook, *Maverick with a Paintbrush: Thomas Hart Benton* (Garden City, New York: Doubleday & Company, 1977).

Elizabeth Broun, Douglas Hyland, and Marilyn Stokstad, *Benton's Bentons: Selections from The Thomas Hart Benton and Rita P. Benton Trusts*, exhibition catalogue (Lawrence, Kansas: Helen Foresman Spencer Museum of Art, 1980).

Polly Burroughs, *Thomas Hart Benton: A Portrait* (Garden City, New York: Doubleday & Company, 1981).

Oscar Bluemner

Hannover, Germany, 1867– South Braintree, Massachusetts, 1938

Between 1886 and 1892, Oscar Bluemner attended technical high schools in Hannover and Berlin, Germany. He held two jobs as an architect before immigrating to the United States in 1892. For the next eight years, Bluemner moved between Chicago and New York, working on a variety of architectural projects. By 1900, he was married and settled in the New York City area, where he would live until 1926.

Bluemner painted and sketched landscapes in Germany and America. His 1910–11 color drawings of New Jersey and New York scenes display a chromatic vibrancy equal to that of the Post-Impressionists, especially van Gogh. In 1912, Bluemner gave up architecture to devote all his energies to painting. That same year, during a seven-month stay in Europe, he had his first solo exhibition in Berlin.

During 1914–15, back in America, Bluemner radically transformed his artistic conceptions and techniques, incorporating simplified architectural and landscape forms into interlocking architectonic grids of color planes; the result is brilliantly prismatic. Although the use of bright color in these works resembles that of the Synchromists and Orphists, Bluemner claimed the early nineteenth-century color theories of Goethe were more influential. The paintings were included in Bluemner's first American one-artist exhibition, in 1915 at Alfred Stieglitz's 291 Gallery. Bluemner's work was included in the famous "Forum Exhibition of Modern American Painters" at the Anderson Galleries in New York (1916), as well as in group exhibitions at the Montross and Stephan Bourgeois galleries in New York in the late 1910s and early 1920s.

In 1926 Bluemner moved to South Braintree, Massachusetts. In his late work, he abandoned the geometric grid format and his landscapes became more naturalistic. He developed a system, based in part on Goethe's principles, that ascribed meanings to specific colors, and thus fully realized the emotive symbolism he had always sought.

In 1938, bedridden and in great pain as the result of an automobile accident, Bluemner took his own life. There were several posthumous exhibitions of Bluemner's work in New York galleries in the 1940s and 1950s. There were no major exhibitions, however, until 1967, when the Fogg Art Museum, Harvard University, organized a retrospective. In 1980, the Hirshhorn Museum and Sculpture Garden in Washington, D.C., organized another retrospective.

Clemency Coggins, Martha Holsclaw, and Martha Hoppin, *Oscar Bluemner: American Colorist*, exhibition catalogue (Cambridge, Massachusetts: Fogg Art Museum, Harvard University, 1967).

Alfredo Valente and John Davis Hatch, *Oscar Bluemner: Paintings, Drawings*, exhibition catalogue (New York: New York Cultural Center in association with Fairleigh Dickinson University, 1969).

Frank Gettings, "The Human Landscape: Subjective Symbolism in Oscar Bluemner's Painting," *Archives of American Art Journal*, 19 (1979), pp. 8–14.

Judith Zilczer, *Oscar Bluemner*, exhibition catalogue (Washington, D.C.: Smithsonian Institution Press for the Hirshhorn Museum and Sculpture Garden, 1979).

Ramapo College Art Gallery, *Oscar Bluemner: The New Jersey Years; Drawings and Watercolors, 1916– 1926*, exhibition catalogue (Ramapo, New Jersey: Ramapo College, 1982).

Peter Blume

Smorgon, Russia, 1906–

Peter Blume spent his boyhood in Brooklyn, New York, where he had immigrated from Russia with his parents in 1911. Between 1921 and 1924 he studied art in New York at the Educational Alliance, the Beaux-Arts Institute of Design, and the Art Students League. Blume joined the Charles Daniel Gallery in New York in 1925 and had his first one-artist exhibition there in 1930. His painting of the late 1920s, with its emphasis on cleanly rendered architectural forms, is closely related to the style of the Precisionist artists then associated with the Daniel Gallery. In some of his early works, however, Blume was already introducing the curious, Surrealist juxtapositions of recognizable but unrelated objects and figures that have remained central to his art. Blume's precocious debut on the international art scene took place in 1934, when his characteristically surreal *South of Scranton* (1931) won First Prize at the Carnegie International Exhibition of Paintings in Pittsburgh.

Blume toured the Eastern United States in the late 1920s; Europe in 1932 as a Guggenheim Fellow; Mexico in 1949; Italy in the 1950s and again in the early 1960s (he was an Artist-in-Residence at the American Academy in Rome in 1956 and 1962); and the South Pacific in 1954. References to the art and architecture, political events, and landscape of these areas have appeared repeatedly in his work. While Blume's paintings elude complete interpretation, certain motifs that occur with frequency—crumbling architecture and excavation of the earth— suggest a concern with the decay and regeneration of civilization. Blume's painting style has always been characterized by a meticulous rendering of forms, similar not only to Precisionism but also to paintings by the fifteenth- and sixteenth-century Flemish and Italian masters he admires.

Blume participated in the first Whitney Museum Biennial Exhibition of Contemporary American Painting in 1932 and in subsequent Whitney Museum Exhibitions. Between 1947 and 1964, he had several one-artist exhibitions at the Durlacher Brothers Gallery in New York. In 1964, the Currier Gallery of Art, Manchester, New Hampshire, and the Wadsworth Atheneum, Hartford, Connecticut, together organized the first museum retrospective of Blume's paintings. In 1972 Blume began to produce a series of sculptures entitled *Bronzes About Venus*, which explore the theme of the Greek goddess as the embodiment of feminine beauty and sensuality. In 1976, Chicago's Museum of Contemporary Art held a retrospective of his painting and sculpture.

Robert Ulric Godsoe, "Peter Blume —A New Vision," *Creative Art*, 10 (September 1932), pp. 11–15.

Thomas B. Hess, "Blume: Obsessed Realist," *Art News*, 47 (January 1949), pp. 22–23.

Charles E. Buckley, *Peter Blume: Paintings & Drawings in Retrospect, 1925 to 1964*, exhibition catalogue (Manchester, New Hampshire: The Currier Gallery of Art, 1964).

Dennis Adrian and Peter Blume, *Peter Blume*, exhibition catalogue (Chicago: Museum of Contemporary Art, 1976).

Patrick Henry Bruce

*Long Island, Virginia, 1881–
New York City, 1936*

Between 1897 and about 1902,
Patrick Henry Bruce worked for a
Richmond real estate firm and at-
tended evening classes at the Rich-
mond Art Club. He also enrolled in
mechanical drawing classes at the
Virginia Mechanics Institute in
Richmond (1900–01). Bruce left
for New York in 1902 to study
with William Merritt Chase and
Robert Henri at the New York
School of Art. In late 1903 or early
1904, he moved to Paris, where he
lived for most of the rest of his life.
At first, he continued producing the
Henri-style portraits and figure
studies he had painted in New
York, but between 1907 and early
1912, Bruce studied with Matisse
and through him came to under-
stand Cézanne. Bruce developed an
accomplished Cézannesque style,
painting only still lifes and ex-
hibiting infrequently.

In 1912, Bruce met Robert and
Sonia Delaunay, whose color the-
ories were the primary inspiration
for his six highly abstract *Compo-
sitions*—the only extant work of
1912–15. These paintings repre-
sent Bruce's initial attempts to
create volume through the inter-
action of color planes; they share
with Cubism a tension between
illusionism and the flatness of the
picture plane. The *Compositions*
were included in Bruce's 1917 exhi-
bition at the Modern Gallery in
New York—his second and last one-
artist exhibition during his lifetime.

Between 1917 and the end of his
life, Bruce developed his own
architectonic still-life style: the
organization of flat planes of bright
color into geometric volumes con-
structed through mechanical draw-
ing. Because of Bruce's increasingly
reclusive existence, his activities in
the 1920s and 1930s largely remain
a mystery. Around 1920, Bruce's
wife, tired of their poverty and her
husband's self-imposed isolation,
returned to the United States, taking
their son with her. Bruce returned
to America in 1936, and a few
months later committed suicide.

Bruce's artistic contributions
have gone unrecognized, in large
part because only a fragment of
his total oeuvre remains. Not until
the 1965 exhibition "Synchro-
mism and Color Principles in
American Painting, 1910–1930,"
at M. Knoedler & Co., New York,
was there a full appreciation of his
art. In 1979, the Museum of Mod-
ern Art in New York and the Mu-
seum of Fine Arts in Houston
together sponsored the first retro-
spective of Bruce's work.

William C. Agee, *Synchromism and
Color Principles in American
Painting, 1910–1930*, exhibition
catalogue (New York: M. Knoedler
& Co., 1965).

William C. Agee, "Patrick Henry
Bruce: A Major American Artist of
Early Modernism," *Arts in Virginia*,
17 (Spring 1977), pp. 12–32.

Gail Levin, *Synchromism and
American Color Abstraction, 1910–
1925*, exhibition catalogue (New
York: George Braziller in associ-
ation with the Whitney Museum of
American Art, 1978).

William C. Agee and Barbara Rose,
*Patrick Henry Bruce, American
Modernist*, exhibition catalogue
(New York: The Museum of Mod-
ern Art; Houston: The Museum of
Fine Arts, Houston, 1979).

Charles Burchfield

*Ashtabula Harbor, Ohio, 1893–
Buffalo, New York, 1967*

As a child in Salem, Ohio, Charles
Burchfield spent a great deal of
time observing and recording
nature. This preoccupation, com-
bined with his later indifference to
avant-garde artistic developments,
resulted in a highly individualistic
art inspired by nature. Burchfield
studied at the Cleveland School of
Art (1912–16) and had an unhappy,
short stint at New York's National
Academy of Design—one day of
life-class there convinced him that
school was not what his art needed.
He returned to his old job at a fac-
tory in Salem in late 1916, painting
in the evening, on lunch hours,
and during vacations.

In 1921, Burchfield secured a
job as an assistant designer in a
Buffalo wallpaper company. His
earlier celebrations of nature gave
way to somber depictions of the
small-town scene. Buffalo pro-
vided subject matter—rows of
working-class houses, railroads,
docks, bridges, and bleak weather—
for these lonely, often figureless
compositions. It is this work
that has led critics to regard
Burchfield as a precursor of Amer-
ican Scene painting.

Burchfield exhibited with the
Montross Gallery in New York
from 1924 to 1929 and after that
regularly with New York's Frank
K. M. Rehn Gallery. During the
late 1920s, he grew increasingly
dissatisfied with his job at the wall-
paper company, and in 1929, al-
though he had five children to
support, resigned the position.

A 1939 Rehn Gallery exhibition
of some of his early watercolors
prompted Burchfield to reexamine
these first efforts. By 1943 he had
returned to portraying nature with
the romantic spirit of his early
years. As a mature artist, he re-
worked and amplified many of
these first compositions, adding
bold undulations that recall, but
were not influenced by, the Futur-
ists' ray lines. These larger works of
the 1940s are less realistic, showing
a mystical view of nature more
passionate than anything he had
ever previously produced.

In his later years, Burchfield was
the recipient of many honorary
degrees and awards and was asked
to sit on many juries. He had one-
artist exhibitions at the Museum of
Modern Art (1930), the Albright
Art Gallery in Buffalo (1944), the
Whitney Museum of American Art
(1956), and many at the Rehn
Gallery. Between 1949 and 1953,
Burchfield taught at the Univer-
sity of Minnesota, the Art Institute
of Buffalo, Ohio University, and the
Buffalo Fine Arts Academy. In
1966, the Charles Burchfield Cen-
ter was established at the State
University of New York, College
at Buffalo.

John I. H. Baur, *Charles Burchfield*
(New York: Whitney Museum of
American Art and the Macmillan
Company, 1956).

Joseph S. Trovato, *Charles Burch-
field: Catalogue of Paintings in
Public and Private Collections*
(Utica, New York: Munson-
Williams-Proctor Institute, 1970).

Matthew Baigell, *Charles Burchfield*
(New York: Watson-Guptill Pub-
lications, 1976).

Patterson Sims, *Charles Burchfield:
A Concentration of Works from the
Permanent Collection*, exhibition
catalogue (New York: Whitney
Museum of American Art, 1980).

John I. H. Baur, *The Inlander:
Life and Work of Charles Burchfield*,
1893–1967 (Newark, Delaware:
University of Delaware Press,
1982).

Alexander Calder

*Lawnton, Pennsylvania, 1898–
New York City, 1976*

Alexander Calder studied at the
Stevens Institute of Technology in
Hoboken, New Jersey, graduating
in 1919 with a degree in mechan-
ical engineering. He later attended
drawing and painting classes at the
Art Students League in New York
(1923–26).

Calder developed the ideas for
his famous miniature "Circus" in
1925, when he made free-lance
sketches of the Ringling Brothers
and Barnum & Bailey Circus for
the *National Police Gazette* in New
York. The following year in France,
he transformed these drawings into
small cloth and wire sculptures for
the "Circus" presented in Paris,
New York, and elsewhere through
the early 1960s. In the late 1920s,
Calder's "Circus" performances in
his Paris studio brought him into
contact with leading French artists.
He was attracted to the abstract,
biomorphic forms of Miró and, dur-
ing a visit to Mondrian's studio in
1930, conceived the idea of setting
Mondrian's characteristic rectangles
into motion. To introduce abstrac-
tion and motion into his own sculp-
ture, Calder began making mobiles
—organic, Miró-like forms, made
from sheet metal and wood, painted
in the primary palette of Mondrian,
and connected to one another with
metal wires and rods. They were
set into motion first by means of
hand cranks and motors and, even-
tually, air. This new type of sculp-
ture was called "mobile" by
Calder's friend, the artist Marcel
Duchamp. Calder's "stabiles"—
standing constructions of painted
sheet metal bolted together—also
originated in the early 1930s.

Calder returned to America in
1933, settling in Roxbury, Con-
necticut; beginning in the 1950s he
also spent part of every year in
Saché, France, where he had a
studio. Throughout his career,
Calder produced mobiles and sta-
biles of increasing size and com-
plexity, which often functioned as
important components of the
many ballet and theater stage sets
he designed, including works for
Martha Graham and Erik Satie.
Large-scale versions were commis-

sioned by museums, businesses, and government organizations throughout the world. The distinctive designs and colors of Calder's sculpture also appear in the numerous gouaches, lithographs, tapestries, and household utensils he produced.

Calder was among the first American artists to acquire international stature; before 1940 he had four one-artist exhibitions in Paris, two in London, and many in New York. He was the only American artist represented in "Cubism and Abstract Art" and one of the few in "Fantastic Art, Dada and Surrealism," two significant 1936 exhibitions at the Museum of Modern Art in New York. He has had major exhibitions at leading European and American museums, including retrospectives at the Solomon R. Guggenheim Museum, New York (1964); the Musée National d'Art Moderne, Paris (1965); and Chicago's Museum of Contemporary Art (1974). "Calder's Universe," the most comprehensive retrospective of his work, opened at the Whitney Museum of American Art in late 1976, several weeks before his death. An imposing survey was held by the town of Turin, Italy, in 1983.

James Johnson Sweeney, *Alexander Calder*, exhibition catalogue (New York: The Museum of Modern Art, 1943).

Thomas M. Messer, *Alexander Calder: A Retrospective Exhibition*, exhibition catalogue (New York: The Solomon R. Guggenheim Museum, 1964).

Albert E. Elsen, *Alexander Calder: A Retrospective Exhibition, Work from 1925 to 1974*, exhibition catalogue (Chicago: Museum of Contemporary Art, 1974).

Jean Lipman, *Calder's Universe*, exhibition catalogue (New York: The Viking Press in cooperation with the Whitney Museum of American Art, 1976).

Patterson Sims, *Alexander Calder: A Concentration of Works from the Permanent Collection*, exhibition catalogue (New York: Whitney Museum of American Art, 1981).

Giovanni Carandente, *Calder*, exhibition catalogue (Turin, Italy: Palazzo a Vela, 1983).

John Chamberlain
Rochester, Indiana, 1927–

John Chamberlain grew up in Chicago, where he studied at the School of the Art Institute between 1950 and 1952. During that time he began producing abstract, welded steel sculpture influenced by David Smith, whose work he first saw at the Art Institute. The raw, industrial appearance of Chamberlain's early works foreshadowed his lifelong concern with process and material. In 1955–56, Chamberlain studied and taught sculpture at Black Mountain College, an experimental liberal arts college in North Carolina.

In 1957, soon after moving to New York, Chamberlain began incorporating automobile scraps into his sculptures, and by 1959 his metal works were composed entirely of crushed automobile parts welded together. These sculptures display the force of intuitive and gestural execution that also characterize the paintings of Willem de Kooning and Franz Kline, and expose the inherent qualities of their composite materials. However, Chamberlain's use of the car, a symbol of popular American culture, also parallels the development of Pop Art.

Chamberlain has experimented with a variety of media other than metal. Between 1963 and 1965, he made paintings featuring geometric shapes, using automobile lacquer on masonite or formica grounds. His 1966–67 sculptures are composed of pieces of urethane foam, rolled and tied together; these were followed in 1970 by a series of melted Plexiglas sculptures. Film, video, and photography are additional media which Chamberlain has explored.

Chamberlain exhibited frequently in the 1960s, both in group and one-artist shows, most frequently at the Leo Castelli Gallery in New York. A major retrospective of his work was held at the Solomon R. Guggenheim Museum, New York, in 1971. Shortly thereafter he returned to producing large sculptures from automobile parts, a group of which, known as the Texas pieces, was assembled on the Amarillo ranch of the collector Stanley Marsh, and later exhibited in New York and Houston.

Donald Judd, "Chamberlain: Another View," *Art International*, 7 (January 16, 1964), pp. 38–39.

Barbara Rose, "How to Look at John Chamberlain's Sculpture," *Art International*, 7 (January 16, 1964), pp. 36–38.

Elizabeth C. Baker, "The Secret Life of John Chamberlain," *Art News*, 68 (April 1969), pp. 48–51, 63–64.

Diane Waldman, *John Chamberlain: A Retrospective Exhibition*, exhibition catalogue (New York: The Solomon R. Guggenheim Museum, 1971).

Phyllis Tuchman, "Interview with John Chamberlain," *Artforum*, 10 (February 1972), pp. 38–43.

Michael Auping, *John Chamberlain Reliefs, 1960–1982*, exhibition catalogue (Sarasota, Florida: John and Mable Ringling Museum of Art, 1983).

Duncan Smith, "In the Heart of the Tinman: An Essay on John Chamberlain," *Artforum*, 22 (January 1984), pp. 39–43.

Chuck Close
Monroe, Washington, 1940–

Chuck Close attended several colleges in his home state of Washington before entering the Yale University School of Art and Architecture, where he earned a B.F.A. in 1963 and M.F.A. in 1964. The following year he received a Fulbright grant to study at the Akademie der Bildenen Künste in Vienna. Returning to the United States, he taught art at the University of Massachusetts, Amherst, until 1967, when he moved to New York.

As a student and young art instructor, Close painted in a gestural, Abstract Expressionist style. Toward the mid-1960s, he turned to figuration, fabricating mixed-media constructions from photographs and three-dimensional elements made from plastic and cardboard. In 1966, he began to use a new technique, in which he drew grids over photographs and transferred the images unit by unit onto huge canvases with an airbrush loaded with black paint. White and gray areas were created by removing the black paint. In 1970, with the aid of color transparencies and dye transfer prints, he developed a painting technique analogous to color photographic processes. Close's dot drawings, initiated in 1973, employ small, equal-sized dots, arranged in grids to cover the paper. Facial features and volumetric modeling are achieved by varying the density of the medium applied, be it graphite, ink, pastel, or watercolor. In contrast to the earlier photo-realist paintings, these images are unresolved, though ordered, systems of marks producing enough information to permit recognition of facial features. Close achieved an even greater degree of abstraction by replacing the dots with fingerprints of varying densities. In these representational images made by mechanical, impersonal means, Close maintains a subtle balance between description and abstraction, between minimalism and realism. Close's more recent activity has included the presentation, often in vast scale, of his own photographs.

During the 1970s, Close had several one-artist gallery exhibitions as well as small museum exhibitions, among them, those at the Museum of Contemporary Art, Chicago (1972), and the San Francisco Museum of Modern Art (1976). His work was also seen in numerous group exhibitions. The first major museum exhibition of Close's work was organized in 1980 by the Walker Art Center, Minneapolis, which circulated it to three other major museums.

William Dyckes, "The Photo as Subject: The Paintings and Drawings of Chuck Close," *Arts Magazine*, 48 (February 1974), pp. 28–33, reprinted in Gregory Battcock, ed., *Super Realism: A Critical Anthology* (New York: E. P. Dutton, 1975).

Kim Levin, "Chuck Close: Decoding the Image," *Arts Magazine*, 52 (June 1978), pp. 146–49.

Lisa Lyons and Martin Friedman, *Close Portraits*, exhibition catalogue (Minneapolis: Walker Art Center, 1980).

Joan Simon, "Close Encounters," *Art in America*, 68 (February 1980), pp. 81–83.

Joseph Cornell

*Nyack, New York, 1903–
Flushing, New York, 1972*

Between 1917 and 1921, Joseph Cornell attended Phillips Academy in Andover, Massachusetts. Returning to his home in Bayside, New York, he held a variety of jobs to help support his family until 1932, when he began earning part of his income from art. Although Cornell received little formal art training, he immersed himself in the art and culture of New York City, regularly attending the opera, ballet, theater, and films and frequenting art galleries, museums, and libraries. His eclectic artistic knowledge, combined with the inspiration of Surrealist works that he saw at the Julien Levy Gallery in New York in the early 1930s—particularly the collages of Max Ernst—encouraged him to make his first collages. Called "montages," they are characterized by odd visual juxtapositions created by cutting and recombining old engravings and reproductions. These and later montages were published in the 1940s in magazines such as *View*, an important Surrealist periodical, and *Dance Index*.

In the early 1930s, Cornell began producing his famous three-dimensional collages: small boxes sealed with glass fronts encasing the objects that delighted and obsessed him—maps, sky charts, cordial glasses, clay pipes, birds, stamps, photographs, and illustrations. The careful and enchanting arrangements of these objects explore the themes that appear again and again throughout Cornell's oeuvre: aviaries, hotels, movie stars, ballet, and astronomy. Although he never traveled to Europe, homages to literary figures and references to Old Master art and European royalty in his boxes testify to Cornell's engagement with European art and culture, particularly that of nineteenth-century France and Renaissance Italy. His use of found objects and startling juxtapositions of unrelated objects places Cornell's art squarely within the Dada and Surrealist aesthetic.

Cornell's earliest one-artist exhibitions were held at the Julien Levy Gallery, New York (1939 and 1940). His work has been included in important group exhibitions of Dada and Surrealist artists,

and, during the 1950s and 1960s, in many of the Whitney Museum's Annual Exhibitions. During Cornell's lifetime, small exhibitions of his work were organized by the Pasadena Art Museum (1967) and the Solomon R. Guggenheim Museum, New York (1967). The largest solo exhibition was organized in 1980 by the Museum of Modern Art in New York.

Diane Waldman, *Joseph Cornell*, exhibition catalogue (New York: The Solomon R. Guggenheim Museum, 1967).

John Ashbery, "Cornell: Cube Root of Dreams," *Art News*, 66 (Summer 1967), pp. 56–59, 63–64.

Dore Ashton, *A Joseph Cornell Album* (New York: The Viking Press, 1974).

Diane Waldman, *Joseph Cornell* (New York: George Braziller, 1977).

Kynaston McShine, ed., *Joseph Cornell*, exhibition catalogue (New York: The Museum of Modern Art, 1980).

Sandra Leonard Starr, *Joseph Cornell: Art and Metaphysics*, exhibition catalogue (New York: Castelli, Feigen, Corcoran, 1982).

Ralston Crawford

*St. Catharines, Ontario, 1906–
Houston, Texas, 1978*

After spending his youth in Buffalo, New York, Ralston Crawford began his art studies in 1926 at the Otis Art Institute in Los Angeles. Between 1927 and 1930, he studied at the Pennsylvania Academy of the Fine Arts in Philadelphia and at the Barnes Foundation in Merion, Pennsylvania. He continued his art training at the Académie Colarossi and the Académie Scandinave in Paris in 1932–33.

While Crawford's early work was profoundly influenced by Cézanne and the Cubist works of Picasso and Gris, whose paintings he had studied at the Barnes Foundation, his paintings and drawings of industrial and architectural subjects align him closely with the American Precisionist artists. Like them, Crawford simplified forms into geometric planes, sharpened contours, and produced smooth, untextured canvases. His later compositions

became increasingly abstract: small areas of the subject are isolated and enlarged; space is flattened; shapes are more organic, amorphous, and less representational; and there are few or no reference points—such as sky, ground, and horizon. The same precise and clean manner, however, dominates these works.

In addition to painting, Crawford worked extensively with both lithography and photography. In the latter medium, he often focused on jazz musicians in New Orleans. In 1946, *Fortune* magazine commissioned Crawford to cover the testing of the atomic bomb on Bikini island. Explosive, fragmented shapes dominate the highly abstract drawings and paintings he produced for this commission. Beginning in 1940 Crawford held many appointments as a visiting artist at American universities and colleges, and he traveled widely in his later years.

Crawford's first one-artist exhibition in 1934 at the Maryland Institute of Art in Baltimore was followed by numerous solo exhibitions at galleries and small museums throughout the United States. Important museum presentations of his work include a 1953 retrospective at the University of Alabama in Tuscaloosa, a 1958 retrospective organized by the Milwaukee Art Center, and a 1985 retrospective at the Whitney Museum.

Richard B. Freeman, *Ralston Crawford* (Tuscaloosa, Alabama: University of Alabama Press, 1953).

Edward H. Dwight and Ralston Crawford, *Ralston Crawford*, exhibition catalogue (Milwaukee Art Center, 1958).

William C. Agee, *Ralston Crawford* (Pasadena, California: Twelvetrees Press, 1983).

Edith A. Tonelli, *Ralston Crawford: Photographs/Art and Process*, exhibition catalogue (College Park, Maryland: The Art Gallery, University of Maryland, 1983).

Barbara Haskell, *Ralston Crawford*, exhibition catalogue (New York: Whitney Museum of American Art, 1985).

Stuart Davis

*Philadelphia, Pennsylvania, 1894–
New York City 1964*

Art came early and easily to Stuart Davis. His father was a newspaper and magazine art director and his mother a sculptor. Through his parents he met Robert Henri, John Sloan, and other realists. In 1909 he began studying with Robert Henri at his school in New York and within a few years Davis' work was included in important group exhibitions, among them the 1910 "Exhibition of Independent Artists" and the 1913 Armory Show.

Davis broke with the Henri-influenced realism of his student days in 1915–16, when he began employing the Post-Impressionist devices—generalization of form and non-imitative use of color—that he had admired in the paintings of Gauguin, van Gogh, and others at the Armory Show. In the 1920s he developed the essentially Synthetic Cubist style that formed the basis of all his future work, most of which focused on images of the American commercial and urban landscape. Davis traveled abroad only once in his life—to Paris in 1928–29.

During the 1930s Davis worked actively for artists' organizations. He was elected president of the Artists' Union in 1934 and served as national secretary (1936–38) and then chairman (1938–40) of the American Artists' Congress. Davis' concern for the social and economic plight of American artists during the Depression is evident from his many published articles, particularly those in *Art Front*, the Artists' Union's publication.

During the last twenty-five years of his life, Davis' art became characterized by a boldness and clarity of conception. Large planes of bright color function independently of words, letters, numbers, figures, and other simplified, albeit recognizable images. He also continued his lifelong examination of the aesthetic, philosophical, and political issues of modern art in numerous published and unpublished writings and through his teaching at the New School for Social Research, New York (1940–50).

Davis began an affiliation with the Downtown Gallery in New York in 1927 that lasted his entire life—he had eleven one-artist

exhibitions there. The Museum of Modern Art gave him his first major museum retrospective in 1945. A large, traveling retrospective was organized in 1957 by the Walker Art Center in Minneapolis. Important posthumous exhibitions of Davis' work include a 1965 traveling retrospective organized by the National Collection of Fine Arts in Washington, D.C., and a 1978 exhibition at the Brooklyn Museum.

James Johnson Sweeney, *Stuart Davis*, exhibition catalogue (New York: The Museum of Modern Art, 1945).

E. C. Goossen, *Stuart Davis* (New York: George Braziller, 1959).

H. H. Arnason, *Stuart Davis Memorial Exhibition*, exhibition catalogue (Washington, D.C.: National Collection of Fine Arts, Smithsonian Institution, 1965).

Diane Kelder, ed., *Stuart Davis: A Documentary Monograph* (New York: Praeger Publishers, 1971).

John R. Lane, *Stuart Davis: Art and Art Theory*, exhibition catalogue (Brooklyn: The Brooklyn Museum, 1978).

Patterson Sims, *Stuart Davis: A Concentration of Works from the Permanent Collection*, exhibition catalogue (New York: Whitney Museum of American Art, 1980).

Willem de Kooning
Rotterdam, The Netherlands, 1904–

Between 1916 and 1925 in Rotterdam, Willem de Kooning apprenticed to a commercial art firm and later worked for an art director in a department store while studying at night at the Rotterdam Academy of Fine Arts and Applied Sciences. He also studied in Brussels and Antwerp in 1924. De Kooning came to the United States in 1926, and by 1927 was settled in a Manhattan studio. Two years later he met the painters Stuart Davis, John Graham, and Arshile Gorky, all of whom exerted a profound influence on his development. De Kooning worked as a commercial artist until 1935, when he was employed by the Works Progress Administration Federal Art Project to design murals.

Throughout his career, de Kooning has worked in both abstract and figurative modes. The biomorphic imagery and automatist execution of his abstract work of the late 1930s was primarily influenced by the Cubism and Surrealism of Picasso, as well as by Gorky, with whom de Kooning shared a studio in the late 1930s. During this time de Kooning produced his first series of paintings of women with characteristically flattened and distorted figures–a style and a theme that reappeared throughout his career.

In 1946, de Kooning began the energetic black-and-white abstractions which appeared two years later in his first one-artist exhibition and established his reputation as a major painter. His mature work displays a unique blend of abstract and figurative styles, best exemplified by his Women series of the early 1950s. These paintings, as well as his abstract landscapes of the late 1950s and early 1960s, are characterized by increasingly violent, painterly brushstrokes and vibrant color. De Kooning's emphasis on spontaneous gesture and his assertion of the preeminence of paint have been of unrivaled importance to his fellow Abstract Expressionists as well as to successive generations of painters. He made his first bronze figurative sculptures while in Rome in 1969; by 1970 he was producing life-size bronze figures. The gestural, distorted handling of sculptural materials echoes his painting methods.

Several major presentations of de Kooning's work have taken place in Europe and the United States, including traveling exhibitions organized in 1968 by the Museum of Modern Art in New York and in 1974 by the Walker Art Center in Minneapolis. In 1978 an exhibition of recent work took place at the Solomon R. Guggenheim Museum in New York, and, a year later, the Museum of Art of the Carnegie Institute in Pittsburgh presented a retrospective. The largest retrospective of de Kooning's work in all media opened at the Whitney Museum of American Art in 1983; it then traveled to the Akademie der Künste, Berlin, and the Musée National d'Art Moderne, Centre Georges Pompidou, Paris.

223

Thomas B. Hess, *Willem de Kooning* (New York: George Braziller, 1959).

———, *Willem de Kooning*, exhibition catalogue (New York: The Museum of Modern Art for the Arts Council of Great Britain, 1968).

Philip Larson and Peter Schjeldahl, *De Kooning: Drawings/ Sculptures*, exhibition catalogue (New York: E. P. Dutton for the Walker Art Center, Minneapolis, 1974).

Harold Rosenberg, *De Kooning* (New York: Harry N. Abrams, 1974).

Diane Waldman, *Willem de Kooning in East Hampton*, exhibition catalogue (New York: The Solomon R. Guggenheim Museum, 1978).

Paul Cummings, Jörn Merkert, and Claire Stoullig, *Willem de Kooning: Drawings, Paintings, Sculpture*, exhibition catalogue (New York: Whitney Museum of American Art in association with Prestel-Verlag, Munich, and W. W. Norton, New York, 1983).

Charles Demuth
Lancaster, Pennsylvania, 1883– New York City, 1935

Charles Demuth studied art from 1905 to 1911 at the Pennsylvania Academy of the Fine Arts, where he came under the influence of Thomas Anshutz and Henry McCarter. He interrupted his studies for several brief visits to Europe, and settled in Paris between 1912 and 1914. There he witnessed firsthand the European artistic revolution; he was especially drawn to the work of Picasso, Gris, Matisse, Picabia, and Duchamp. A close friendship between Demuth and Duchamp began in 1915 when the Frenchman visited New York. Demuth's final trip to Paris in 1921 was cut short by the onset of severe diabetes; he returned to the United States and received one of the first insulin injections ever administered. His health had always been precarious; a hip injury suffered in his youth left him with a permanent limp and later in life he also developed tuberculosis. Between 1914 and his death, Demuth alternated between his studios in Lancaster, Pennsylvania, and New York.

Throughout his life, Demuth explored a variety of artistic styles. His watercolors of flowers, still lifes, and landscapes are characterized by carefully delineated lines and soft color washes. Demuth also created whimsical watercolor illustrations for stories and plays, including Émile Zola's *Nana* (1915–16), Henry James' *The Turn of the Screw* (1918), and a piquantly erotic series of illustrations based on vaudeville celebrities. His first Cubist experiments date from a 1917 trip to Bermuda with fellow modernist Marsden Hartley, who apparently brought some of his Cubist canvases with him. Demuth applied the modern vocabulary of Cubist abstraction and Futurist ray lines he had absorbed abroad to local architectural and industrial subject matter; the result was a personal brand of American realism, often called Precisionism.

After several one-artist exhibitions at the Charles Daniel Gallery (1915, 1916, 1917, 1920, and 1922), Demuth moved to Alfred Stieglitz's Intimate Gallery and later to his An American Place. He was represented in group exhibitions at the Museum of Modern Art (1929 and 1932) and the Whitney Museum's first two Biennial Exhibitions (1932 and 1934). Major posthumous exhibitions include a 1937 memorial exhibition at the Whitney Museum of American Art and a 1950 exhibition at the Museum of Modern Art devoted almost exclusively to watercolors and drawings. A small survey of his Lancaster-based work was organized for the Philadelphia Museum of Art in 1983.

Andrew Carnduff Ritchie, *Charles Demuth*, exhibition catalogue (New York: The Museum of Modern Art, 1950).

Emily Farnham, *Charles Demuth: Behind a Laughing Mask* (Norman, Oklahoma: University of Oklahoma Press, 1971).

David Gebhard and Phyllis Plous, *Charles Demuth: The Mechanical Encrusted on the Living*, exhibition catalogue (Santa Barbara, California: The Art Galleries of the University of California, 1971).

Thomas E. Norton, ed., *Homage to Charles Demuth, Still Life Painter of Lancaster*, with essays by Alvrod L. Eiseman, Sherman E. Lee, and Gerald S. Lestz (Ephrata, Pennsylvania: Science Press, 1978).

Betsy Fahlman, *Pennsylvania Modern: Charles Demuth of Lancaster*, exhibition catalogue (Philadelphia, Pennsylvania: Philadelphia Museum of Art, 1983).

Richard Diebenkorn

Portland, Oregon, 1922–

After studying at Stanford University, the University of California at Berkeley, and the California School of Fine Arts in San Francisco, Diebenkorn took an M.F.A. in 1951 from the University of New Mexico, Albuquerque. In the late 1940s, he developed an abstract painting style dominated by Cubist divisions of space and loose handling of pigment. Under the influence of Abstract Expressionism, particularly the work of de Kooning, his paintings became increasingly fluid and gestural. The 1952 Matisse exhibition in Los Angeles prompted him to brighten his palette. He had several one-artist exhibitions on the West Coast in the late 1940s and early 1950s, and established a reputation there as an important Abstract Expressionist painter. In 1955, however, living in Berkeley, California, he began working in a figurative mode, painting primarily still lifes and interiors with single figures. These paintings are characterized by the loosely brushed style employed in his early abstractions, but are divided into geometric areas of contrasting color created by images of doors, windows, furniture, cast shadows, and other rectilinear elements. In the mid-1960s, his compositions grew increasingly flat and abstract. Forms were reduced to geometric elements, anticipating the designs of the artist's mature and completely abstract paintings, the Ocean Park series, begun in 1967, two years after his move to Los Angeles. Here, vertical, horizontal, and diagonal charcoal or painted lines intersect to create areas of soft, light-filled color. The concentration of the linear intersections produces large dominating areas juxtaposed with smaller areas of similar shape. In his most recent work, Diebenkorn has integrated curvilinear elements into the grid formats of his canvases.

Diebenkorn's work has appeared in important group exhibitions, among them the 1968 and 1978 Venice Biennales and several Whitney Museum Annual Exhibitions between 1958 and 1972. His first major museum exhibition took place in 1960 at the Pasadena Art Museum. Four years later the Washington Gallery of Modern Art, Washington, D.C., presented a survey of his 1948–63 work. In 1976 a larger retrospective was seen in the East, organized by the Albright-Knox Art Gallery, Buffalo, New York.

Gerald Nordland, *Richard Diebenkorn*, exhibition catalogue (Washington, D.C.: Washington Gallery of Modern Art, 1964).

———, *Richard Diebenkorn: Paintings from the Ocean Park Series*, exhibition catalogue (San Francisco: San Francisco Museum of Art, 1972).

Robert T. Buck, Jr., Linda L. Cathcart, Gerald Nordland, and Maurice Tuchman, *Richard Diebenkorn: Paintings and Drawings, 1943–1976*, exhibition catalogue (Buffalo: Albright-Knox Art Gallery, The Buffalo Fine Arts Academy, 1976).

Nancy Marmer, "Richard Diebenkorn: Pacific Extensions," *Art in America*, 66 (January–February 1978), pp. 95–99.

Burgoyne Diller

New York City, 1906–
New York City, 1965

Burgoyne Diller's path toward the Neo-Plasticist style for which he is best known was marked by experimentation with nearly all the important phases of modern art. While attending Michigan State University in East Lansing in 1923–24, he hitchhiked to Chicago on weekends to study the paintings of the French Impressionists and Cézanne in the Art Institute. During this time he produced a series of Cézannesque still-life drawings and paintings. By 1928, when he moved to New York and began to study at the Art Students League, he was painting Cubist city views. At the League, he experimented with Analytic Cubism and the expressionistic abstraction of Kandinsky. In the early 1930s, his work became increasingly geometric, reflecting the influence of Russian Constructivism, and by mid-decade, he had turned to the Neo-Plasticism of Mondrian and Theo van Doesburg, from which he developed his mature style.

In the three types of compositions that comprise Diller's oeuvre—he titled these "themes," referring to the different combinations of rectangles and grids—he reduced form to geometric essentials and used only primary colors. With dowels and blocks of painted wood, he also fabricated small relief sculptures in this style. Diller's interpretation of de Stijl constituted one of the most abstract approaches among American artists in the 1930s. As a member of the American Abstract Artists group from 1936, Diller exhibited regularly in its annual exhibitions in the late 1930s. Between 1935 and 1940, he served as director of the Mural Division of the Works Progress Administration Federal Arts Project in New York City; he continued his affiliation with the project throughout the war, after which he began teaching at Brooklyn College.

Until recently, geometric abstraction in this country has been overshadowed by realism and Abstract Expressionism; for this reason the critical reception of Diller's work during his lifetime was limited and he had no museum exhibitions. Posthumous retrospectives of his work were organized in 1966 by the New Jersey State Museum in Trenton, and, in 1971, by the Walker Art Center in Minneapolis.

Lawrence Campbell, *Burgoyne Diller, 1906–1965*, exhibition catalogue (Trenton: New Jersey State Museum, 1966).

———, "Diller: The Ruling Passion," *Art News*, 67 (October 1968), pp. 36–37, 59–61.

Philip Larson, *Burgoyne Diller: An American Constructivist*, exhibition catalogue (Minneapolis: Walker Art Center, 1971).

Deborah Rosenthal, "Seeing Burgoyne Diller," *Artforum*, 17 (May 1979), pp. 38–39.

Nancy Troy, *Mondrian and Neo-plasticism in America*, exhibition catalogue (New Haven, Connecticut: Yale University Art Gallery, 1979).

Jim Dine

Cincinnati, Ohio, 1935–

During Jim Dine's student years—at the University of Cincinnati, the School of the Museum of Fine Arts, Boston, and Ohio University, Athens (B.F.A., 1957)—he painted in an Abstract Expressionist manner. In 1959, he moved to New York, where he met and was influenced by Allan Kaprow, Claes Oldenburg, and other artists creating Happenings; he conceived several of his own in the early 1960s. At the same time, he made paintings to which he affixed everyday objects, including such personal possessions as tools, clothes, bathroom fixtures, and furniture—a technique influenced by Robert Rauschenberg's combine paintings and assemblages, and Jasper Johns' as well as Kaprow's ideas about the interchangeability of art and life. Recurrent themes in Dine's work include painters' palettes, neckties, hearts, and bathrobes, all of which function symbolically as self-portraits. Although Dine's incorporation of common objects links him to Pop Art, his style at first differed from the hard-edge, impersonal execution most often associated with that movement. His brushstroke is more gestural, an inheritance from Abstract Expressionism. Moreover, his subject matter often functions autobiographically, making his style a more explicitly expressionistic one. Dine has also produced sculpture and drawings, and between 1967 and 1971, while living in London, he mastered the print medium, particularly etching. In the 1970s, his work became increasingly expressionistic. He added still life to his repertoire of themes, painting canvases with arrays of soft, almost ethereal glass and ceramic vessels.

Since the early 1960s, Dine has had one-artist exhibitions annually in galleries and museums in this country and Europe. His work has been included in important group exhibitions, among them the Whitney Museum Annuals and Biennials in the late 1960s and early 1970s. His first museum retrospective took place in 1970 at the Whitney Museum. In 1978 the Museum of Modern Art, New York, organized and circulated a retrospective of Dine's prints.

Max Kozloff, "The Honest Elusiveness of James Dine," *Artforum*, 3 (December 1964), pp. 36–40.

John Gordon, *Jim Dine*, exhibition catalogue (New York: Whitney Museum of American Art, 1970).

Thomas Krens, ed., *Jim Dine: Prints, 1970–1977*, exhibition catalogue (New York: Harper & Row; London: Thames and Hudson, in association with the Williams College Artist-in-Residence Program, 1977).

Constance W. Glenn, *Jim Dine: Figure Drawings, 1975–1979*, exhibition catalogue (Long Beach, California: The Art Museum and Galleries, California State University, 1979).

David Shapiro, *Jim Dine, Painting What One Is* (New York: Harry N. Abrams, 1981).

Graham W. J. Beal, *Jim Dine: Five Themes*, exhibition catalogue, with essays by Robert Creeley, Jim Dine, and Martin Friedman (Minneapolis, Minnesota, and New York: Walker Art Center, Abbeville Press, 1984).

Mark di Suvero
Shanghai, China, 1933–

Marco Polo di Suvero spent his early childhood years in Tientsin in northeast China, where his father served as an officer in the Italian navy. In 1941, the di Suvero family immigrated to San Francisco. Between 1953 and 1957, di Suvero studied sculpture and philosophy at San Francisco City College, the University of California at Santa Barbara and at Berkeley (B.A. in philosophy, 1957). In New York during the late 1950s, di Suvero began producing sprawling, abstract sculptures in which planks, beams, ladders, barrels, and other wooden components are held together by ropes, nails, and chains. His compositions derive from Constructivism; the raw, irregular, handworked surfaces and forceful, thrusting diagonals correspond to the gestural brushstrokes in the Abstract Expressionist painting of Franz Kline and Willem de Kooning.

In 1960, a few months before his first one-artist exhibition at the Green Gallery in New York,

di Suvero was severely injured in an elevator accident. Although he could not walk again until 1963, he nevertheless continued to work, and made his first welded metal sculptures in these years. In 1962, he helped found the Park Place Gallery, an important downtown cooperative gallery in New York, where he participated in group exhibitions until the gallery closed in 1967. Di Suvero produced the first of many large outdoor constructions, all over 20 feet high and built from steel and/or wood, at Point Reyes, California, in 1964–65. Those containing parts suspended by cables rely on carefully engineered balancing schemes. By virtue of their size, expanse, and incorporation of elements such as swings, ladders, and chairs, they seem to embrace the viewer. Since the late 1970s, he has also made smaller works with intricate interlocking parts.

In protest against the war in Vietnam, di Suvero moved to Europe in 1971. During the next four years, he made and exhibited outdoor sculptures in the Netherlands, West Germany, and France. A major exhibition of his sculpture was held in the Jardin des Tuileries in Paris in 1975. The same year the Whitney Museum of American Art presented a major retrospective which included outdoor installations in all five boroughs of New York City. Di Suvero maintains studios in New York and Petaluma, California.

Carter Ratcliff, "Mark di Suvero," *Artforum*, 11 (November 1972), pp. 34–42.

James K. Monte, *Mark di Suvero*, exhibition catalogue (New York: Whitney Museum of American Art, 1975).

Barbara Rose, "On Mark di Suvero: Sculpture Outside Walls," *Art Journal*, 35 (Winter 1975–76), pp. 118–25).

————, *Mark di Suvero: New Sculpture*, exhibition catalogue (Houston: Janie C. Lee Gallery, 1978).

Arthur G. Dove
Canandaigua, New York, 1880– Huntington, New York, 1946

In 1901 Arthur Dove enrolled at Cornell University to study law, following his father's wishes. Law was soon abandoned, however, in favor of art. After graduation in 1903, Dove moved to New York, where he worked as a free-lance illustrator, receiving commissions from periodicals such as *Harper's*, *Scribner's*, *Collier's*, and *The Saturday Evening Post*. He left New York in 1907 to travel and paint in France for eighteen months. The still-life paintings Dove made abroad reveal his early affinity for Impressionism and the work of Cézanne and Matisse.

After his return to the United States, Dove became associated with the influential New York dealer and photographer Alfred Stieglitz. He had his first one-artist exhibition in 1912 at Stieglitz's 291 Gallery. The pastels in this exhibition already suggest Dove's lifelong preoccupation with what he called "extraction from nature": his belief that objects and places have characteristic "spirits" or conditions of color and form that do not necessarily correspond to objective perceptions. With nature always the stimulus, he placed richly colored curvilinear patterns of organic shapes into shallow three-dimensional spaces. In later work, the circle was preeminent and often occupied the center or near center of his compositions. In some thirty collages made between 1924 and 1928, he inserted real objects into abstract arrangements, coming as close as he ever would to representation.

In the 1920s, Dove and the artist Helen Torr Weed, later his wife, lived on a 42-foot sailboat on Long Island Sound. In 1930, the well-known collector Duncan Phillips began to provide Dove with financial support in exchange for first choice of the artist's annual output. Throughout the 1930s, Dove had regular one-artist exhibitions at Stieglitz's gallery, An American Place, and participated in important group exhibitions, including the Whitney Museum's first three Biennial Exhibitions (1932, 1934, 1936). A heart attack in 1939 and subsequent kidney problems left Dove a semi-invalid for the rest of his life. He never-

theless continued to paint until his death, producing increasingly abstract work. There have been many posthumous exhibitions of Dove's work, among them, traveling retrospectives organized by the Art Galleries of the University of California at Los Angeles (1958) and by the San Francisco Museum of Art (1974).

Elizabeth McCausland, "Dove, Man and Painter," *Parnassus*, 9 (December 1937), pp. 3–6.

Duncan Phillips, "Arthur G. Dove, 1880–1946," *Magazine of Art*, 40 (May 1947), pp. 193–97.

Alan Solomon, *Arthur G. Dove*, exhibition catalogue (Ithaca, New York: Andrew Dickson White Museum of Art and Cornell University Press, 1954).

Frederick S. Wright, *Arthur G. Dove*, exhibition catalogue (Los Angeles: Art Galleries, University of California, Los Angeles, 1958).

Barbara Haskell, *Arthur Dove*, exhibition catalogue (San Francisco Museum of Art, 1974).

Sasha M. Newman, *Arthur Dove and Duncan Phillips: Artist and Patron*, exhibition catalogue (Washington, D.C.: The Phillips Collection in association with George Braziller, New York, 1981).

Ann Lee Morgan, *Arthur Dove: Life and Work, with a Catalogue Raisonné* (Newark, Delaware: University of Delaware Press, 1984).

Elsie Driggs
Hartford, Connecticut, 1898–

Elsie Driggs studied at the Art Students League in New York (1919–20) and continued her art training in Rome (1921–22). She is best known for a small number of Precisionist drawings and paintings produced in the late 1920s, and characterized by generalized forms, sharp contours, and polished surfaces. Between 1924 and 1932, Driggs exhibited regularly in group shows with Sheeler, Demuth, and other Precisionists at the Charles Daniel Gallery in New York; she had her first one-artist exhibition there in 1928. One of her paintings was included in the Whitney Museum's first

Biennial Exhibition of Contemporary American Painting in 1932. Driggs was associated with the Works Progress Administration, New York Division, in 1934, and in 1936 executed murals for the Treasury Relief Art Project and the Harlem River Housing Project. A Yaddo Foundation Fellowship in 1935 enabled her to live and paint at this artists' colony in Saratoga Springs for that summer. After the Daniel Gallery closed in 1932, Driggs had several one-artist exhibitions at the Frank K. M. Rehn Gallery (1936, 1938, and 1953). Her works of the 1920s were included in recent presentations of Precisionist painters—the exhibition organized by the Walker Art Center in Minneapolis in 1960 and that organized in 1978 by the Heckscher Museum in Huntington, New York. A retrospective at the Martin Diamond Gallery, New York, in 1980 included her later work along with examples of her Precisionist period.

Martin L. Friedman, *The Precisionist View in American Art*, exhibition catalogue (Minneapolis: Walker Art Center, 1960).

James H. Maroney, Jr., *Lines of Power*, exhibition catalogue (New York: Hirschl & Adler Galleries, 1977).

Susan Fillin Yeh, *The Precisionist Painters, 1916–1949: Interpretations of a Mechanical Age*, exhibition catalogue (Huntington, New York: Heckscher Museum, 1978).

Guy Pène du Bois

Brooklyn, New York, 1884–Boston, Massachusetts, 1958

From 1899 to 1905, Guy Pène du Bois studied at the New York School of Art with William Merritt Chase, Kenneth Hayes Miller, and Robert Henri. He made his first trip to Europe in 1905–06, painting in Paris and Brittany, and returned for an extended stay in France from 1924 to 1930. Perhaps influenced by his father, a prominent literary, art, and music critic, du Bois supported himself as a journalist between 1906 and about 1922. He worked as a reporter, then as art and music critic for the *New York American* until 1913, when he edited a special issue of the periodical *Arts and Decoration* for the Armory Show. He continued as editor of that publication intermittently until 1920, during which time he also worked briefly as assistant to Royal Cortissoz on the *New York Tribune* and as art critic for the *New York Evening Post*. He contributed articles and reviews to many periodicals, including *Vogue*, *Vanity Fair*, and *International Studio*.

Although writing occupied most of his time during these years, du Bois continued to paint. The influence of Henri is readily observed in the thick impasto brushwork and dark earth tones of du Bois' early paintings of everyday life in New York and Paris. He was represented by six paintings in the Armory Show and served on the publicity committee for that important exhibition.

In the 1920s, the Henri-inspired realism of du Bois' early work gave way to the more stylized realism for which the artist is best known. Witty, occasionally mordant, characterizations of the well-to-do in their pleasure spots—opera houses, theaters, art galleries, and racetracks—began to dominate his oeuvre. Du Bois changed his style to suit his content: with an emphasis on design and linear rhythm, he simplified and stylized forms, sharpened contours, and omitted background detail. While his subject matter changed little in his later years, his compositions became more complex, his palette lighter and richer.

Du Bois had his first one-artist show at the Whitney Studio Club in 1918. Between 1922 and 1946, he had regular solo exhibitions at the Kraushaar Galleries in New York. He was represented in nearly all the Whitney Museum's Biennial and Annual Exhibitions between 1932 and 1953. Du Bois' career as an art critic, however, continued to overshadow his reputation as a painter. In the 1930s, he wrote several monographs on artists, including Edward Hopper and John Sloan, for the Whitney Museum's American Artists Series. Through the late 1940s, he continued to contribute articles to important American art periodicals. Since du Bois' death in 1958, the Graham Gallery in New York has sponsored several one-artist exhibitions, and in 1980 the Corcoran Gallery of Art, Washington, D.C., organized a traveling retrospective of his work.

Royal Cortissoz, *Guy Pène du Bois*, American Artists Series (New York: Whitney Museum of American Art, 1931).

Guy Pène du Bois, *Artists Say the Silliest Things* (New York: American Artists Group and Duell, Sloan and Pearce, 1940).

Richard Carl Medford, *Guy Pène du Bois*, exhibition catalogue (Hagerstown, Maryland: Washington County Museum of Fine Arts, 1940).

Helen Appleton Read, *Robert Henri and Five of His Puplis: George Bellows, Eugene Speicher, Guy Pène du Bois, Rockwell Kent, Edward Hopper*, exhibition catalogue (New York: The Century Association, 1946).

Betsy Fahlman, *Guy Pène du Bois: Artist About Town*, exhibition catalogue (Washington, D.C.: The Corcoran Gallery of Art, 1980).

Richard Estes

Kewanee, Illinois, 1936–

Richard Estes studied at the Art Institute of Chicago between 1952 and 1956. For the next decade he worked as a commercial illustrator and layout designer for publishing and advertising firms in Chicago and in New York, where he moved in 1959. He did not begin to paint full-time until 1969.

Estes' work has always been representational. His paintings of the early and mid-1960s are dominated by figures in generalized, domestic, or urban environments. In the late 1960s, the settings became more distinct and descriptive, while the figures were essentially removed. He also began to base his paintings on color photographs and slides—sunny, high-key vistas of urban streets and close-up, frontal views of such familiar structures as storefronts, coffee shops, telephone booths, escalators, and subways. His paintings often incorporate complex window reflections which brighten the scene and multiply commercial detail. Estes' style, like that of most Photo-Realists, is precise and sharply focused, eliminating all evidence of the paintbrush. By 1970 figures remain only as faceless people in telephone booths, glimpsed window reflections, or indistinct drivers of passing cars. Despite the wealth of the colorful, commercial environment, the lack of human activity imbues his paintings with an eerie vacancy.

Estes has had several one-artist exhibitions since his first in New York in 1968. Participation in numerous important American and European group exhibitions devoted to New Realist painting has earned him recognition as an important influence in the revival of representation since 1970. He had a solo exhibition in 1974 at the Museum of Contemporary Art, Chicago. In 1978 the Museum of Fine Arts, Boston, organized Estes' first major museum exhibition, which traveled to three other museums.

Herbert Raymond, "The Real Estes," *Art and Artists*, 9 (August 1974), pp. 24–29.

Leon Shulman, *Three Realists: Close, Estes, Raffael*, exhibition catalogue (Worcester, Massachusetts: Worcester Art Museum, 1974).

John Canaday and John Arthur, *Richard Estes: The Urban Landscape*, exhibition catalogue (Boston: Museum of Fine Arts, 1978).

Harry F. Gaugh, "The Urban Vision of Richard Estes," *Art in America*, 66 (November–December 1978), pp. 134–37.

Dan Flavin

Jamaica, New York, 1933–

While serving in the military in Korea, Dan Flavin studied art through the University of Maryland Extension Program. When he returned to New York in 1956, he attended the Hans Hofmann School of Fine Arts for a short period, took art history courses at the New School for Social Research, and then studied at Columbia University. During the late 1950s he made colorful, Abstract Expressionist drawings, often inscribed with a text, and

painted relief constructions which frequently incorporated junk materials such as flattened tin cans.

In 1961, Flavin began to use electric lights in his assemblages. His "icons," as he called these pieces, were painted wood or masonite wall constructions, on the edges of which were mounted fluorescent or incandescent light bulbs. He created his first light piece without a supporting structure in 1963. The following year, in two one-artist exhibitions, Flavin explored the optical illusions produced by various arrangements of lights on the wall. He became increasingly interested in the interaction of his light pieces with the surrounding space, and by 1967, he was creating room-size environments of light with differently shaped and colored fluorescent tubes. Beginning in 1972, the incorporation of circular fixtures added to the design complexity of Flavin's environments. Flavin was one of the first artists to use light as the primary component of his art and he has influenced a large number of younger artists—many in southern California—to explore light and space as artistic media.

Flavin's light work has been seen since the early 1960s in one-artist as well as major group exhibitions, many of which took place in Europe. He had his first museum retrospective in 1969 in Ottawa at the National Gallery of Canada; the exhibition traveled to the Jewish Museum in New York. Solo museum exhibitions were also presented in 1973–74 in Cologne and in 1975 in Basel. Among Flavin's many commissions was the lighting of several tracks at Grand Central Station in New York in 1976.

Brydon Smith, *Fluorescent Light, etc. from Dan Flavin*, exhibition catalogue (Ottawa: The National Gallery of Canada, 1969).

Evelyn Weiss, Dieter Ronte, and Manfred Schneckenburger, *Dan Flavin: Three Installations in Fluorescent Light*, exhibition catalogue (Cologne, West Germany: Wallraf-Richartz-Museum and Kunsthalle Köln, 1973).

Emily S. Rauh and Jay Belloli, *Dan Flavin: Drawings, Diagrams and Prints, and Installations in Fluorescent Light, 1972–1975*, exhibition catalogue (Fort Worth, Texas: Fort Worth Art Museum, 1977).

Helen Frankenthaler
New York City, 1928–

Between 1946 and 1949, Helen Frankenthaler studied painting at Bennington College, Vermont, and at the Art Students League in New York. Her work of the late 1940s reveals an understanding of Picasso's Cubism, learned from Bennington instructor Paul Feeley. The influence of Gorky and Kandinsky is evident as well in the fluid lines and bright-colored organic shapes of her early abstract landscapes.

By 1950, Frankenthaler had developed friendships with the critic Clement Greenberg and many of the Abstract Expressionists. The most important influence on her mature abstract style was Pollock's 1951 exhibition at the Betty Parsons Gallery. Transforming his drip technique and Surrealist-based automatism into an original painting method, she poured and dripped thinned pigments onto unprimed canvas, allowing them to soak directly into the fabric. With this stain technique she achieved an unprecedented unity of figure, color, and ground, which had an important influence on other Color Field painters, particularly Morris Louis and Kenneth Noland. In her paintings of the mid- to late 1950s, calligraphic strokes, patches and splatters of bright color appear against blank grounds. Beginning in the mid-1960s, the forms in her paintings grew larger and less amorphous, and the colors, more brilliant and opaque. In the 1970s, single colors occasionally occupy the entire field. Since the early 1960s, Frankenthaler has also made ceramics and numerous prints.

After many gallery shows throughout the 1950s, Frankenthaler's first major museum exhibition took place in 1960 at the Jewish Museum, New York. In 1969 a major retrospective of her work was organized in New York by the Whitney Museum of American Art and the Museum of Modern Art.

Frank O'Hara, *Helen Frankenthaler: Paintings*, exhibition catalogue (New York: The Jewish Museum, 1960).

E. C. Goossen, *Helen Frankenthaler*, exhibition catalogue (New York: Whitney Museum of American Art, 1969).

Barbara Rose, *Frankenthaler* (New York: Harry N. Abrams, 1971).

E. A. Carmean, Jr., "On Five Paintings by Helen Frankenthaler," *Art International*, 22 (April–May 1978), pp. 28–33.

Andrew Forge, "Frankenthaler: The Small Paintings," *Art International*, 22 (April–May 1978), pp. 21–25.

William Glackens
Philadelphia, Pennsylvania, 1870– Westport, Connecticut, 1938

While studying at the Pennsylvania Academy of the Fine Arts (1892–95), William Glackens worked as a reporter-illustrator for various Philadelphia newspapers, including the *Record*, the *Press*, and the *Public Ledger*. He painted independently in Paris during 1895 and exhibited a painting at the 1896 Paris Salon. When he returned to the United States, Glackens settled in New York and resumed work as a magazine and newspaper illustrator. In 1898, *McClure's Magazine* sent him as both reporter and illustrator to cover the Cuban campaign of the Spanish-American War.

Glackens' early, dark-colored paintings reflect the influence of Manet and Robert Henri. Although he participated in The Eight's 1908 opening exhibition, he was only briefly involved with this urban realist group. With the exception of some drawings of lively city scenes, Glackens soon moved on to painting café, beach, and holiday settings in the style of the French Impressionists. The bright colors and heavy, flowing brushstrokes of Glackens' female portraits, nudes, and flower still lifes reveal his profound reverence for the painting of Renoir. Later, Glackens turned to Matisse, whose influence can be seen in the introduction of compartmentalized color areas and sharply delineated two-dimensional, decorative patterns.

Glackens chaired the selection committee of American works for the 1913 Armory Show. He served as the first president of the Society of Independent Artists in 1916 and 1917 and participated in most of its annual exhibitions. Between 1925 and 1932, Glackens made regular visits to Paris and southern France. The Kraushaar Galleries in New York held frequent exhibitions of his work beginning in 1925 and for many years after his death. The Whitney Museum of American Art held a memorial exhibition in 1938, and the City Art Museum of St. Louis organized a retrospective in 1966.

Guy Pène du Bois, *William J. Glackens*, American Artists Series (New York: Whitney Museum of American Art, 1931).

Ira Glackens, *William Glackens and The Eight: The Artists Who Freed American Art* (New York: Horizon Press, 1957).

Leslie Katz, *William Glackens in Retrospect*, exhibition catalogue (St. Louis: City Art Museum of St. Louis, 1966).

Richard J. Wattenmaker, *The Art of William Glackens*, exhibition catalogue (published in the Rutgers *University Art Gallery Bulletin*, I, no. 1, Rutgers, New Jersey: 1967).

Fritz Glarner
Zurich, Switzerland, 1899– Locarno, Switzerland, 1972

With the exception of short periods in Chartres and Paris, Fritz Glarner's childhood years were spent in Naples, where he attended the Royal Institute of Fine Arts (1914–20). In 1923 he moved to Paris and studied briefly at the Académie Colarossi. Although he met many avant-garde artists in Paris, Cézanne and the Neo-Impressionists had the greatest influence on his painting in this period. His semi-abstract canvases embodied simplified, rectilinear forms—boxes, steps, tables, and easels—compressed into one plane. His earliest one-artist exhibition took place in 1926 in Paris.

In 1936, after a yearlong stay in Zurich, Glarner immigrated to

the United States and settled in New York. Through 1944, he exhibited regularly with the American Abstract Artists, a group of geometric abstractionist painters, including Josef Albers and Burgoyne Diller, who sought to reduce painting to its essentials—the interaction of pure forms and colors. In the mid-1940s, Glarner developed his mature painting style, which he termed Relational Painting. Like Mondrian, with whom he was in close contact between 1942 and 1944, Glarner balanced and contrasted rectilinear shapes of primary color, black, and white. By tapering his rectangles, however, he achieved a spatial dynamism absent from the more rigid compositions of the Dutch Neo-Plasticist. Glarner used this style in circular as well as rectangular compositions.

Glarner completed several architectural commissions, including murals in New York for the Time-Life Building (1958–60) and the Dag Hammarskjöld Library in the United Nations Building (1961–62). His first major museum exhibition was organized in 1970 by the San Francisco Museum of Art.

In 1971, Glarner resettled in Switzerland. The following year, shortly before his death, the Kunsthalle in Bern opened a major exhibition of his work.

Natalie Edgar, *Fritz Glarner, 1944–1970*, exhibition catalogue (San Francisco, California: San Francisco Museum of Art, 1970).

Max Bill, Carlo Huber, and Fritz Glarner, *Fritz Glarner*, exhibition catalogue (Bern, Switzerland: Kunsthalle Bern, 1972).

Margit Staber, *Fritz Glarner*, (Zurich, Switzerland: ABC Verlag, 1976).

Arshile Gorky

*Khorkom, Armenia, 1904–
Sherman, Connecticut, 1948*

Arshile Gorky, born Vosdanik Adoian, grew up in the Van province of Armenia. In 1915, the Turkish army invasion forced his family to flee, and in 1920, following his mother's death, Gorky and one of his sisters arrived in America, where they joined relatives in Watertown, Massachusetts. Gorky studied at Boston's New School of Design from late

1922 to 1924, when he moved to New York. In 1925, after studying briefly at the National Academy of Design, he entered the Grand Central Art School and shortly thereafter began teaching drawing; he was a faculty member between 1926 and 1931. He worked for the Works Progress Administration Federal Art Project between 1935 and 1939, producing murals for Newark Airport (1935–37). Gorky's first one-artist exhibition took place in 1934 and he subsequently participated in selected Whitney Museum Biennials and Annuals and in important group exhibitions at the Museum of Modern Art, New York.

Like Stuart Davis and John Graham, two artists with whom he developed close friendships in the early 1930s, Gorky believed that only after an artist has "digested" the great art of the past could he hope to rival it.

Throughout the 1920s, he painted still lifes, landscapes, and portraits in the style of Cézanne. In the late 1920s, he interpreted, in still-life form, the Synthetic Cubism of Picasso and Braque. During the 1930s and 1940s, Gorky was profoundly influenced by Surrealism and the abstractions of Kandinsky. The enigmatic, Surrealist imagery of Gorky's mature work, while essentially abstract, alludes to natural and often sexual forms, as well as to remembered fragments of his Armenian heritage. His emphasis on spontaneous execution, freedom of line from mass, paint buildup, and vibrant color were of crucial importance to those younger painters who would develop as Abstract Expressionists, particularly de Kooning, with whom Gorky shared a studio in the late 1930s.

In early 1946, a fire in Gorky's Sherman, Connecticut, studio destroyed much of his work. Several weeks later he underwent a serious operation for cancer. A month after an automobile accident paralyzed his painting arm in June 1948, Gorky took his own life.

Important posthumous exhibitions of Gorky's work include a memorial exhibition in 1951 at

the Whitney Museum of American Art and two retrospectives—one organized in 1962 by the Museum of Modern Art, New York, with the Gallery of Modern Art, Washington, D.C.; another in 1981, by the Solomon R. Guggenheim Museum, New York.

Ethel Schwabacher, *Arshile Gorky Memorial Exhibition*, exhibition catalogue (New York: Whitney Museum of American Art, 1951).

Harold Rosenberg, *Arshile Gorky: The Man, The Time, The Idea* (New York: Horizon Press, 1962).

Jim M. Jordan and Robert Goldwater, *The Paintings of Arshile Gorky: A Critical Catalogue* (New York and London: New York University Press, 1980).

Harry Rand, *Arshile Gorky: The Implications of Symbols* (Montclair, New Jersey: Allanheld, Osmun & Co., and Abner Schram; London: George Prior, 1981).

Diane Waldman, *Arshile Gorky, 1904–1948: A Retrospective*, exhibition catalogue (New York: Harry N. Abrams in collaboration with The Solomon R. Guggenheim Museum, 1981).

Adolph Gottlieb

*New York City, 1903–
New York City, 1974*

Adolph Gottlieb first enrolled in the Art Students League in New York in 1920. A year later he went to Europe, spent six months in Paris, where he attended sketch classes at the Académie de la Grande Chaumière, and then traveled to Berlin, Munich, Dresden, and Vienna. After his return to New York in 1922, Gottlieb finished high school and studied at the Parsons School of Design, Cooper Union, the Educational Alliance School of Art, and again at the Art Students League. Although Gottlieb's European experiences stimulated his interest in modern art, his interiors and city views of the 1920s remained in the realist style of John Sloan, with whom he had studied at the League.

In the 1930s, under the influence of Milton Avery, and through him Matisse, Gottlieb's work became more expressionistic and abstract. He simplified his figurative and landscape forms and often defined their contours with dark lines. Gottlieb had his first one-artist exhibition in 1930 at the

Dudensing Gallery in New York. Between 1935 and 1939, he exhibited regularly in New York with The Ten, a group of avantgarde abstract and expressionist painters.

In the 1940s, Gottlieb came under the influence of Surrealism, Cubism, and primitive art, interests he shared with his close friend since the 1930s, Mark Rothko, and other young painters of the emerging New York School of Abstract Expressionism. His series Pictographs (1941–51) presents mythic and symbolic images, selected in a random, free-associative fashion in irregular grids. From 1951 to 1957, he produced the series Grids and Imaginary Landscapes, in which skies filled with floating disk shapes appear above landscapes or seascapes. He worked on a third series, again called Imaginary Landscapes, in the mid-1960s. His last paintings, Bursts (1957–74), adopt relatively uniform color fields in which disk shapes hover above tangled clusters of thick, black strokes.

Gottlieb exhibited extensively from the 1940s until his death. He participated in nearly every Whitney Museum Annual in the 1940s and 1950s and had solo exhibitions at the Jewish Museum, New York (1957), and the Walker Art Center, Minneapolis (1963). A 1968 retrospective was presented jointly in New York by the Solomon R. Guggenheim Museum and the Whitney Museum. A posthumous traveling retrospective was organized in 1981 by the Adolph and Esther Gottlieb Foundation.

Clement Greenberg, *An Exhibition of Oil Paintings by Adolph Gottlieb*, exhibition catalogue (New York: The Jewish Museum, 1957).

Martin Friedman, *Adolph Gottlieb*, exhibition catalogue (Minneapolis: Walker Art Center, 1963).

Robert Doty and Diane Waldman, *Adolph Gottlieb*, exhibition catalogue (New York: Frederick A. Praeger for the Whitney Museum of American Art and The Solomon R. Guggenheim Museum, 1968).

Mary Davis MacNaughton and Lawrence Alloway, *Adolph Gottlieb: A Retrospective*, exhibition catalogue (New York: The Arts Publisher in association with the Adolph and Esther Gottlieb Foundation, 1981).

O. Louis Guglielmi

Cairo, Egypt, 1906–
Amagansett, New York, 1956

O. Louis Guglielmi was born in Cairo to parents of Italian descent. He lived with his mother in Milan and Geneva before immigrating to New York in 1914. While still in high school, Guglielmi attended classes at the National Academy of Design in New York (1920–26).

Many of Guglielmi's early paintings were urban architectural studies realized with the meticulous Precisionist means that were to inform nearly all his future work—sharp delineation of color areas, an emphasis on geometric forms, a tendency to minimize modeling, atmospheric effects, and evident brushwork. In the 1930s and early 1940s, Guglielmi produced the paintings for which he is best known: compositions in which forlorn figures, either alone or in groups, appear in bleak urban settings. These fantastic and Surrealist works frequently included enigmatic imagery, such as a towering or collapsing Brooklyn Bridge, distorted musical instruments, and severed bodies. Some paintings contain disturbing and critical references to the Depression and war and their social consequences.

Beginning in 1932, Guglielmi spent the first of eleven summers at the MacDowell Colony, a well-known artists' retreat in New Hampshire. He was employed by the Works Progress Administration/Federal Art Project in the late 1930s. Based on work he submitted to the Project, Guglielmi was selected by Edith Halpert to join her Downtown Gallery in New York, where he had solo exhibitions in 1938, 1948, and 1951. He participated in nearly all the Whitney Museum Biennials and Annuals held during his lifetime.

After his discharge from the army in 1945, Guglielmi began to experiment with greater formal abstraction. Bridges, buildings, and figures were fragmented and reshaped in Cubist fashion. This semi-abstract Precisionism, influenced by Stuart Davis and Charles Sheeler, evolved to a complete abstraction, at times akin to that of Joan Miró as well as of the American Abstract Expressionists, by the time of Guglielmi's death in 1956.

Although Guglielmi was represented in many important group exhibitions of Surrealist artists, unfavorable criticism—directed in particular at the diversity of his styles—precluded any one-artist museum exhibitions during his lifetime. A memorial exhibition was held at the Nordness Gallery in New York in 1958 and a traveling retrospective was organized in 1980 by the Rutgers University Art Gallery.

O. Louis Guglielmi, "I Hope to Sing Again," *Magazine of Art*, 37 (May 1944), pp. 173–77.

Martin L. Friedman, *The Precisionist View in American Art*, exhibition catalogue (Minneapolis: Walker Art Center, 1960).

John Baker, "O. Louis Guglielmi: A Reconsideration," *Archives of American Art Journal*, 15 (1975), pp. 15–19.

John Baker, *O. Louis Guglielmi: A Retrospective Exhibition*, exhibition catalogue (New Brunswick, New Jersey: Rutgers University Art Gallery, 1980).

Philip Guston

Montreal, Canada, 1913–
Woodstock, New York, 1980

Philip Guston attended the Manual Arts High School in Los Angeles (1927–28), where he became a close friend of Jackson Pollock. As an artist, Guston was self-taught except for a brief period spent at the Otis Art Institute in Los Angeles in 1930.

Guston's early interest in Renaissance masters such as Uccello, Mantegna, and Piero della Francesca, and in the early paintings of Giorgio de Chirico, is reflected in his figurative work of the 1930s and 1940s. The social and political subject matter he favored in those years was inspired by the Mexican muralists José Clemente Orozco, Diego Rivera, and David Alfaro Siqueiros, whose work Guston studied in Mexico in 1934. In 1934–35 he worked for the Public Works Administration in Los Angeles, and from 1935 to 1940 in the mural division of the Works Progress Administration/Federal Art Project in New York. During the 1940s, Guston derived most of his income from teaching, at the University of Iowa in Iowa City (1941–45), and at Washington University in St. Louis (1945–47).

Through the Federal Art Project, Guston met Davis, de Kooning, Gorky, and other painters experimenting with abstraction. Although by the early 1940s, he was recognized as a leading figurative painter, by the end of that decade he had abandoned representational subject matter in favor of abstraction, and, in the 1950s, established a reputation as a leading Abstract Expressionist. In his abstractions, interlocking strokes of vibrant color are concentrated toward the center of neutral fields. Guston reintroduced recognizable images into his work in the late 1960s. His paintings after 1966 feature certain recurring motifs, such as Ku Klux Klan figures, shoes, cigarettes, paintbrushes, and light bulbs, all representing personal fantasies.

Between 1938 and 1963, Guston participated in most of the Whitney Museum's Annual and Biennial Exhibitions. Although he had had several one-artist gallery and museum exhibitions in the 1940s and 1950s, his first major retrospective did not take place until 1962, at the Solomon R. Guggenheim Museum, New York. In 1966, two important solo exhibitions of Guston's work were organized, by the Jewish Museum, New York, and the Rose Art Museum, Brandeis University, Waltham, Massachusetts. Guston died in 1980, several weeks after the opening of a major retrospective of his work, organized by the San Francisco Museum of Modern Art.

H. H. Arnason, *Philip Guston*, exhibition catalogue (New York: The Solomon R. Guggenheim Museum, 1962).

Sam Hunter, *Philip Guston: Recent Paintings and Drawings*, exhibition catalogue (New York: The Jewish Museum, 1965).

Dore Ashton, *Yes, but . . . : A Critical Study of Philip Guston* (New York: The Viking Press, 1976).

Ross Feld and Henry T. Hopkins, *Philip Guston*, exhibition catalogue (New York: George Braziller in association with the San Francisco Museum of Modern Art, 1980).

Norbert Lynton, *Philip Guston: Paintings, 1969–1980*, exhibition catalogue (London: The Whitechapel Art Gallery, 1982).

Duane Hanson

Alexandria, Minnesota, 1925–

During the 1940s and early 1950s, Duane Hanson studied art at the University of Washington, Seattle, Macalester College, St. Paul, Minnesota, and the Cranbrook Academy of Art, Bloomfield Hills, Michigan, from which he received an M.F.A. in 1951. In 1953, after teaching for a year in Connecticut, Hanson went to West Germany, where he taught for seven years in the United States Army School. He continued teaching when he returned to the United States, in Atlanta (1961–65) and Miami (1965–69).

During these years Hanson made semi-abstract sculpture, suggestive of the figure, from a variety of materials, including stone, wood, ceramics, and bronze. As he became dissatisfied with his work in the mid-1960s, Pop Art and the sculpture of George Segal encouraged him to explore an increasingly realistic and illusionistic approach. In 1966, angered by the deaths of several women during illegal abortions, he created *Abortion*, a plaster sculpture of a dead woman, his first emphatically realist sculpture. He produced more works with social commentary, depicting victims of a gangland murder, scenes of Vietnam, and race riots. While the earlier pieces were made from plaster, in 1967 he developed the working method he has used since to create his mature, hyperrealistic figures: painted, fiberglass-reinforced, polyester resin bodies, cast from life, clothed, and accompanied by appropriate props. The violent themes disappeared in the late 1960s, replaced by satiric, and occasionally farcical, American stereotypes—a sloppy housewife in hair curlers, gaping, camera-laden tourists, baton twirlers, and weary businessmen. In the early 1970s, he began to focus on working-class figures—a secretary, janitor, waitress, construction worker, guard. In these later sculptures fewer props were used, and the subjects took on melancholy, introspective expressions, reflecting Hanson's poignant view of loneliness and isolation in our society. In the early 1980s Hanson began to work in bronze, casting figures in editions and pursuing public commissions.

Hanson's sculpture was exhibited in several one-artist gallery exhibitions in Florida and New York in the late 1960s and early 1970s and became internationally known as a result of his participation in the 1972 "Documenta 5" exhibition in Kassel, West Germany. He had his first museum exhibition in Europe, two years later, opening at the Württembergischer Kunstverein in Stuttgart. His first American museum exhibition was circulated in 1976–77 by the Edwin A. Ulrich Museum of Art, Wichita State University.

Joseph Masheck, "Verist Sculpture: Hanson and De Andrea," *Art in America*, 60 (November–December 1972), pp. 90–97.

Kirk Varnedoe, "Duane Hanson: Retrospective and Recent Work," *Arts Magazine*, 49 (January 1975), pp. 66–70.

Martin H. Bush, *Duane Hanson*, exhibition catalogue (Wichita, Kansas: Edwin A. Ulrich Museum of Art, Wichita State University, 1976).

Donald B. Kuspit, "Duane Hanson's American Inferno," *Art in America*, 64 (November–December, 1976), pp. 89–91.

Kirk Varnedoe, *Duane Hanson* (New York, Harry N. Abrams, 1985).

Marsden Hartley

*Lewiston, Maine, 1877–
Ellsworth, Maine, 1943*

Marsden Hartley commenced his art studies with a scholarship to the Cleveland School of Art in 1898. The following year he moved to New York, where he studied at the New York School of Art (1899) and at the National Academy of Design (1900–04). His summers in Maine provided subject matter for the Post-Impressionist mountain landscapes that comprised his first one-artist exhibition, held in 1909 at Alfred Stieglitz's 291 Gallery.

Exhibitions at Stieglitz's gallery of the work of Matisse, Cézanne, and Picasso encouraged Hartley's interest in modern European artists. In Paris, on his first European trip (1912–13), he experimented extensively with Cubist principles, combining them with the mystical aesthetics of Kandinsky to create what he called Cosmic Cubist paintings. On his early trips to Berlin (1913 and 1914–15), he incorporated bright-colored German military symbols into similar Cubist formats, producing his most powerful paintings, the War Motif series. Hartley exhibited widely and established a reputation in Europe. Upon his return to America in late 1915, he was disappointed by the lukewarm response of Americans, who interpreted the War Motif paintings as evidence of pro-German sentiment.

After 1916, Hartley's abstract style faltered, and he spent the rest of his itinerant and often lonely life experimenting with a variety of subjects and approaches. He used a vivid palette to render landscapes of New Mexico and Mont Sainte-Victoire in southern France. Dogtown Common (Gloucester, Massachusetts) and Garmisch-Partenkirchen (Bavarian Alps) were painted with dark, earth tones and with an emphasis on flat and angular forms. His portraits of Maine and Nova Scotia friends establish the sitters' characteristics with archaic and geometrically severe designs. Beginning in 1938, Hartley spent most of his time in Maine, where he produced some of his most beautiful and expressive works—paintings of Mount Katahdin in rich tones of red and purple, and views of the Maine coast which show the continuing influence of his friend Albert Ryder.

Hartley had many one-artist exhibitions in Stieglitz's galleries. He was able to support himself through sales and stipends from Stieglitz, and devoted nearly all his time to painting and writing poetry. Hartley participated in many group exhibitions with other American modernists, including all the Whitney Museum Biennials that were held in his lifetime (1932–43). Major posthumous retrospectives were organized by the University Gallery at the University of Minnesota, Minneapolis, in 1952 and the Whitney Museum of American Art in 1980.

Marsden Hartley, *Adventures in the Arts* (New York: Boni and Liveright, 1921).

Elizabeth McCausland, *Marsden Hartley* (Minneapolis: University of Minnesota Press, 1952).

Barbara Haskell, *Marsden Hartley*, exhibition catalogue (New York: Whitney Museum of American Art in association with New York University Press, 1980).

Marsden Hartley, *On Art*, edited by Gail R. Scott (New York: Horizon Press, 1982).

Lyndel King, *Marsden Hartley, 1908–1942; The Ione and Hudson D. Walker Collection*, exhibition catalogue (Minneapolis: University Art Museum, University of Minnesota, 1982).

Robert Henri

*Cincinnati, Ohio, 1865–
New York City, 1929*

Robert Henri, born Robert Henry Cozad (the family changed its name in 1883), enrolled at the Pennsylvania Academy of the Fine Arts in the fall of 1886. Two years later, he continued his art training in Paris, studying with Bouguereau at the Académie Julian. He exhibited his work in the Paris Salons of 1896 and 1899, and returned many times to Europe, often for extended stays.

Henri began his long and dedicated teaching career in 1892 at the Philadelphia School of Design for Women. From 1900 on he made New York his home and held teaching positions there at the New York School of Art and the Art Students League. In 1909 he founded his own school. Many students were attracted by Henri's energy and innovative teaching methods, including artists who went on to make important contributions—among them, Edward Hopper, Patrick Henry Bruce, and Stuart Davis. Henri's support of American art extended beyond the classroom. His unfailing commitment to urban realist art earned for it a respected and important place in the history of American art. He believed in an indigenous art, free of foreign dominance and academic restrictions; he tried, through his influence in the Society of American Artists and the National Academy of Design, to have his colleagues represented in their annual exhibitions. These attempts failed, prompting Henri to organize The Eight's first exhibition, at the Macbeth Galleries in 1908. Henri was also active in organizing the 1910 "Exhibition of Independent Artists," in which not only The Eight, but a much expanded group of progressive artists participated. In 1911, he procured funds to establish the MacDowell Club, a showcase for progressive art.

Although he was undoubtedly the leader of The Eight, in his own work Henri avoided the urban realism of his colleagues and painted rural landscapes and, later, portraits. Something of Manet and Frans Hals, artists whose work he found particularly attractive, can be felt in Henri's dark, penetrating portraits. His subjects included Irish peasants, Spanish gypsies, American Indians, blacks, and children, as well as a few of his upper-class patrons.

Henri had important one-artist exhibitions at the Pennsylvania Academy of the Fine Arts (1897), and the Macbeth Galleries (1902), and was represented by five paintings in the 1913 Armory Show. During his last years, Henri spent winters in New York and summers in Ireland. In 1931 a major memorial exhibition was held at the Metropolitan Museum of Art, New York. A large-scale retrospective opened in 1984 at the Delaware Art Museum and traveled to four other American museums.

Robert Henri, *The Art Spirit* (New York and Philadelphia: J. P. Lippincott, 1923).

William I. Homer, *Robert Henri and His Circle* (Ithaca, New York: Cornell University Press, 1969).

Donelson F. Hoopes, *Robert Henri, 1865–1929*, exhibition catalogue (New York: Chapellier Galleries, 1976).

Bennard B. Perlman, *The Immortal Eight* (Westport, Connecticut: North Light Publishers, 1979).

Bennard B. Perlman, *Robert Henri: Painter*, exhibition catalogue (Wilmington, Delaware: Delaware Art Museum, 1984).

Eva Hesse

Hamburg, Germany, 1936–
New York City, 1970

In 1939, Eva Hesse and her family fled Nazi Germany and settled in New York City. She later studied art at the Pratt Institute of Design, the Art Students League, and Cooper Union. She received a B.F.A. from the Yale School of Art and Architecture in 1959.

At her first one-artist exhibition, held in 1963 at the Allan Stone Gallery, New York, Hesse showed paintings and drawings that combined the stylistic freedom of Abstract Expressionism with collage elements influenced by Pop Art. Her drawings soon were dominated by a mixture of organic and machine-like imagery suggesting sculptural qualities. During a year in Germany (1964–65) she explored this imagery further in wall relief sculptures made from found objects and diverse materials such as wire, mesh, plaster, papier-mâché, and cord. Hesse had her first extensive exhibition while abroad— at the Städtische Kunsthalle Düsseldorf in 1965.

After her return to New York, Hesse produced sculptures with inexpensive and flexible materials— fiberglass, latex, gauze, tubing, and string. Her pieces typically hang from the ceiling, lean against the wall, or contain elements that sprawl across the floor, making environmental factors, such as gravity and wall support, integral parts of her work. Hesse often created shapes suggestive of the human body—skin, muscles, and sexual organs. Repetition occurs in many of her pieces: seemingly identical units repeated within a single sculpture display subtle irregularities of texture and form. Her reliance on serial formats and her preference for monochrome reveal the important influence of Minimalism on her work, but her exploration of unconventional and malleable materials and her attention to the interaction between sculpture and environment were concerns she shared with Post-Minimal artists working in the late 1960s. Her work was included in two important group exhibitions in 1969 which examined these artistic tendencies: the Whitney Museum's "Anti-Illusion: Procedures/Materials" exhibition and "Live in Your Head: When Attitudes Become Form" at the Kunsthalle Bern.

In 1969 Hesse underwent the first of three unsuccessful operations to remove a brain tumor; she died in May 1970. In 1972 the Solomon R. Guggenheim Museum, New York, organized a major retrospective of her work. The Whitechapel Art Gallery in London presented a Hesse retrospective in 1979. In 1982 a traveling survey of her drawings was sponsored by the Allen Memorial Art Gallery of Oberlin College.

Cindy Nemser, "An Interview with Eva Hesse," *Artforum*, 8 (May 1970), pp. 59–63.

Robert Pincus-Witten, "Eva Hesse: Post-Minimalism into Sublime," *Artforum*, 10 (November 1971), pp. 32–44.

Linda Shearer and Robert Pincus-Witten, *Eva Hesse: A Memorial Exhibition*, exhibition catalogue (New York: The Solomon R. Guggenheim Museum, 1972).

Lucy R. Lippard, *Eva Hesse* (New York: New York University Press, 1976).

Ellen H. Johnson, *Eva Hesse: A Retrospective of the Drawings*, exhibition catalogue (Oberlin, Ohio: Allen Memorial Art Museum, Oberlin College, 1982).

Hans Hofmann

Weissenburg, Bavaria, 1880–
New York City, 1966

Hans Hofmann spent his childhood in Munich where in 1898 he began studying art. Between 1904 and 1914, the financial support of a Berlin art collector enabled him to live in Paris. There, he attended the Académie de la Grande Chaumière; Matisse was among his classmates. He met many other avant-garde artists in Paris, including Picasso and Braque, but it was his friendship with Robert Delaunay that most strongly influenced his development as a colorist.

In 1915 Hofmann opened his first art school in Munich. From this point until 1935, his teaching commitments made it difficult for him to find time to paint. The few extant works from this period reveal his familiarity with Cubism. He was invited to teach at the University of California, Berkeley, in the summer of 1930 and again in 1931, at which time he had his first one-artist exhibition in the United States, at the California Palace of the Legion of Honor, San Francisco. In 1932 Hofmann closed his Munich school and settled permanently in America. A year later, he opened an art school in New York, which was succeeded the following year by the Hans Hofmann School of Fine Arts. In 1935 he established a summer school in Provincetown, Massachusetts. An influential teacher, Hofmann introduced the most avantgarde concepts of European painting to his students, a number of whom became artists of major stature, among them Louise Nevelson, Carl Holty, and Lee Krasner. He also wrote several books and numerous essays in which he set forth his practical and philosophical artistic principles.

As his completely abstract works of the 1940s demonstrate, Hofmann shared the aesthetic concerns of the Abstract Expressionists. Biomorphic forms, similar to those of Kandinsky, Gorky, and de Kooning, and paint-laden brushstrokes of bright, Fauve color fuse into explosive, undulating compositions. Hofmann's first one-artist exhibition in New York, in 1944 at Peggy Guggenheim's Art of This Century Gallery, brought recognition of his artistic achievement. In 1958 he closed his schools so that he could devote more time to painting, and it was about this time that distinctive, floating rectangles of solid color began to appear in his work. The interaction of these forms produced an emphatic spatial tension, a hallmark of Hofmann's mature painting style.

Hofmann participated in nearly every Whitney Museum Annual between 1945 and his death in 1966. Retrospectives of his work were organized in 1957 by the Whitney Museum of American Art in New York in association with the Art Galleries of the University of California, Los Angeles, and in 1963, by the Museum of Modern Art, New York. In 1970 the Art Museum of the University of California, Berkeley, opened a Hans Hofmann wing, with a permanent collection of forty-five works. Six years later, a major retrospective was organized jointly by the Hirshhorn Museum and Sculpture Garden, Washington, D.C., and the Museum of Fine Arts, Houston.

Hans Hofmann, *Search for the Real and Other Essays* (Andover, Massachusetts: Addison Gallery of American Art, 1948).

Frederick S. Wight, *Hans Hofmann*, exhibition catalogue, with an essay by the artist (Berkeley and Los Angeles, California: University of California Press for the Art Galleries of the University of California, Los Angeles, and the Whitney Museum of American Art, New York, 1957).

Hans Hofmann, *Hans Hofmann*, introduction by Sam Hunter (New York: Harry N. Abrams, 1963).

William C. Seitz, *Hans Hofmann*, exhibition catalogue (New York: The Museum of Modern Art, 1963).

Walter Darby Bannard, *Hans Hofmann: A Retrospective Exhibition*, exhibition catalogue (Houston: The Museum of Fine Arts; Washington, D.C.: Hirshhorn Museum and Sculpture Garden, Smithsonian Institution, 1976).

Edward Hopper

Nyack, New York, 1882–
New York City, 1967

Edward Hopper studied illustration at the Correspondence School of Illustrating in New York (1899–1900). Between 1900 and 1906, he attended the New York School of Art, where he studied illustration and, beginning in 1902, painting with William Merritt Chase and Robert Henri. He traveled through Europe in 1906–07. The French Impressionist paintings he saw in Paris encouraged him to brighten his previously dark, Henri-inspired palette and to loosen his brushstroke. When he returned to New York he earned his living as a commercial illustrator, painting only in his spare time. Although his paintings were included in the 1913 Armory Show and in annual group exhibitions at the MacDowell Club, Hopper won his first critical and financial success with the etchings of familiar aspects of American life that he produced between 1915 and 1923. By the early 1920s, oil and watercolor were again his major media. At his first one-artist exhibition at a commercial gallery— in 1924 at New York's Frank K. M.

Rehn Gallery—Hopper sold sixteen watercolors. He was finally able to cease working as an illustrator.

In the course of the 1920s, Hopper's Impressionist painting style gradually gave way to his well-known spare and direct manner, emphasizing the contrast between light and shadow and introducing unusual vantage points—through windows and doorways and from high and low. Throughout his career, Hopper returned again and again to the same subjects. Cape Cod, where he and his wife, Jo, spent nearly every summer after 1924, inspired frequent paintings of sailing ships, lighthouses, rocky coasts, and New England houses. Best known are Hopper's paintings of the everyday and often banal realities of modern America—railroads, el stations, streets, and house, office, and theater interiors. The isolated figures, estranged couples, empty rooms, and ubiquitous windows imbue Hopper's work with a deep sense of mystery, loneliness, and sadness. Hopper's is a unique and emotionally charged realism.

Hopper's accomplishments were recognized during his lifetime. His *House by the Railroad* (1925) was the first painting to enter the Museum of Modern Art's permanent collection. He participated in nearly every Whitney Museum Biennial and Annual from 1932 until his death. Major retrospectives of his work were held at the Museum of Modern Art in 1933, and at the Whitney Museum of American Art in 1950 and 1964. In 1952 the American Federation of Arts selected Hopper (and three other artists) to represent the United States in the Venice Biennale. He received numerous awards and honorary degrees. After the death of his wife in 1968, Hopper's entire artistic estate was bequeathed to the Whitney Museum, which has organized several posthumous exhibitions—a presentation of selections from the Hopper Bequest (1971), an exhibition featuring Hopper's prints and illustrations (1979), and a major retrospective that traveled internationally (1980–81).

Alfred H. Barr, Jr., *Edward Hopper: Retrospective Exhibition*, exhibition catalogue (New York: The Museum of Modern Art, 1933).

Lloyd Goodrich, *Edward Hopper Retrospective Exhibition*, exhibition catalogue (New York: Whitney Museum of American Art, 1950).

Lloyd Goodrich, *Edward Hopper*, exhibition catalogue (New York: Whitney Museum of American Art, 1964).

Brian O'Doherty, "Portrait: Edward Hopper," *Art in America*, 52 (December 1964), pp. 68–88.

Gail Levin, *Edward Hopper: The Art and the Artist* (New York: W. W. Norton in association with the Whitney Museum of American Art, 1980).

Jasper Johns

Augusta, Georgia, 1930–

Jasper Johns received his first formal art training in 1947–48 at the University of South Carolina in Columbia. He spent the next two years in the army in Japan and in 1952 settled in New York, where he supported himself with odd jobs, including making window displays for department stores, and devoted his spare time to art.

Few of Johns' works from his early New York years survive. In 1954 and 1955 he began to produce compositions based on the most familiar of objects—numbers, targets, and the American flag. Although the rich surface texture of his canvases, attained through the use of encaustic and through loose brushwork, appears to be a vestige of Abstract Expressionism, Johns' focus on ordinary objects of predetermined design conflicted markedly with Abstract Expressionist subject matter. Johns' handling and choice of subjects were inspired by his close friends Robert Rauschenberg and the composer John Cage, who believed in a thorough integration of art and life.

In the late 1950s and 1960s Johns introduced other motifs into his work—words, letters, and maps of the United States, and often attached real objects to the canvas. He also produced bronze sculptures of everyday objects such as beer cans, flashlights, and light bulbs. In lithographs and drawings he reworked motifs from his paintings. Johns' elevations of the ordinary,

his persistent blurring of the lines between illusion and reality, and his detached, anti-expressionist spirit provided a powerful influence, particularly on Pop artists. Beginning in 1972 Johns' principal motif in paintings, drawings, and prints was a colorful, cross-hatched pattern, repeated over the canvas. His recent work explores elaborate, interactive realistic imagery.

Johns' first one-artist exhibition in 1958 at the Leo Castelli Gallery in New York included his flag, target, and number paintings; the show brought him immediate critical and commercial success. Throughout the 1960s and 1970s he had numerous solo exhibitions at galleries and museums in the United States, Europe, and Japan. His first important museum exhibition took place in 1964 at the Jewish Museum in New York. Several major retrospectives followed, the most comprehensive of which was organized in 1977 by the Whitney Museum of American Art.

Leo Steinberg, "Jasper Johns: The First Seven Years of His Art" (1962), rev. ed. in *Other Criteria: Confrontations with Twentieth-Century Art* (New York: Oxford University Press, 1972), pp. 17–54.

Alan R. Solomon and John Cage, *Jasper Johns*, exhibition catalogue (New York: The Jewish Museum, 1964).

Max Kozloff, *Jasper Johns* (New York: Harry N. Abrams, 1968).

Michael Crichton, *Jasper Johns*, exhibition catalogue (New York: Harry N. Abrams in association with the Whitney Museum of American Art, 1977).

Centre Georges Pompidou, Musée National d'Art Moderne, *Jasper Johns*, exhibition catalogue, with essays by Pontus Hultén, Alain Robbe-Grillet, and Pierre Restany (Paris: 1978).

Christian Geelhaar, *Jasper Johns; Working Proofs* (New York and London: Petersburg Press, 1980).

Richard Francis, *Jasper Johns*, Modern Masters Series (New York: Abbeville Press, 1984).

Donald Judd

Excelsior Springs, Missouri, 1928–

In 1948 Donald Judd attended classes at the Art Students League. He studied at Columbia University between 1949 and 1953, returning from 1957 to 1962 to study art history at the graduate level. In 1959 he began writing art criticism for *Art News* and later for *Arts Magazine*, and since then he has written many essays on contemporary art, including his own work.

After a decade of painting in an Abstract Expressionist style, Judd made his first wood sculpture in 1962. By 1963–64, when he began using painted aluminum and iron, stainless steel, and Plexiglas, his pieces took on the characteristic box shape that remained the core of all his subsequent work. One of the most important aspects of Judd's sculpture—the serial organization of elements—first appeared in the form of cuts in self-contained pieces, then as square projections on long, rectangular wall pieces, and finally as sculptures whose identically sized box units are completely freestanding. Intervals between the serial components are equal or determined by arithmetic calculations. The geometric shapes and use of transparent and reflective materials produce a clean, industrial appearance.

Since 1971 Judd has made large, outdoor sculpture. His work rejects traditional sculptural notions of the balance of parts in favor of a focus on the whole, and the clarity and literalness of the fabricated object—ideas which were crucial to the development of Minimalist sculpture, of which Judd was a leader.

Judd's first important one-artist exhibition opened in 1963 at the Green Gallery in New York. Since then his work has been included in numerous group and solo exhibitions in the United States as well as in Europe and Japan. In 1968, the Whitney Museum of American Art organized his first one-artist museum exhibition. This was followed three years later by an exhibition at the Pasadena Art Museum. In 1975, a major retrospective was presented by the National Gallery of Canada, Ottawa. In the early 1980s, Judd created comprehensive installations of his works in Marfa, Texas.

William C. Agee, *Don Judd*, exhibition catalogue (New York: Whitney Museum of American Art, 1968).

John Coplans, *Don Judd*, exhibition catalogue (Pasadena, California: Pasadena Art Museum, 1971).

William C. Agee, "Unit, Series, Site: A Judd Lexicon," *Art in America*, 63 (May–June 1975), pp. 40–49.

Brydon Smith and Roberta Smith, *Donald Judd*, exhibition catalogue (Ottawa, Ontario: The National Gallery of Canada, 1975).

Donald Judd, *Complete Writings, 1959–1975* (Halifax, Nova Scotia: The Press of the Nova Scotia College of Art and Design; New York: New York University Press, 1976).

Ellsworth Kelly
Newburgh, New York, 1923–

Ellsworth Kelly began his art training at Pratt Institute in Brooklyn (1941–42). In 1946, after military service in Europe, he resumed his studies at the School of the Museum of Fine Arts, Boston. Between 1948 and 1954 he lived in France, attending the École des Beaux-Arts in Paris, and studying Romanesque art and architecture. During his first year abroad Kelly painted figurative works in a flattened, archaic style related to that of Klee and Picasso. In 1949, however, he adopted a radically abstract style, influenced by the Constructivist and Neo-Plasticist movements dominating Parisian art in the 1940s. His paintings and wood relief constructions embody simple compositions based on geometric shapes derived from architectural and natural details. In 1950, he met Jean Arp, whose random approach to composition prompted Kelly to produce paintings in which the grid-like distribution of geometric elements obeyed the laws of chance. The reductive, hard-edge style of Kelly's early abstractions has remained the salient characteristic of his work throughout his career.

Kelly had his first one-artist exhibition in Paris in 1951. Since his return to New York in 1954, he has established himself as a major geometric abstractionist, having frequent solo shows in galleries here and abroad and participating in important group exhibitions. From the late 1950s on, he has used both rectilinear and curved shapes, and his palette has ranged from bright, unmodulated colors to more limited schemes of black and white, or variations of gray. Some of his best-known compositions contain two or more panels. His numerous sculptures, collages, and prints echo his paintings. He has received several public commissions, including a mural for UNESCO in Paris, completed in 1969, and a sculpture for Lincoln Park in Chicago, in 1981.

Kelly's first one-artist museum exhibition took place in 1972 at the Albright-Knox Art Gallery, Buffalo, New York. The following year the Museum of Modern Art, New York, organized a retrospective of his work. In 1979, the Metropolitan Museum of Art in New York mounted an exhibition of his recent work, and the Stedelijk Museum in Amsterdam circulated a major retrospective throughout Europe. The Whitney Museum of American Art presented a retrospective exhibition of Kelly's sculpture in 1982.

Diane Waldman, *Ellsworth Kelly: Drawings, Collages, Prints* (Greenwich, Connecticut: New York Graphic Society, 1971).

John Coplans, *Ellsworth Kelly* (New York: Harry N. Abrams, 1973).

E. C. Goossen, *Ellsworth Kelly*, exhibition catalogue (New York: The Museum of Modern Art, 1973).

Elizabeth C. Baker, *Ellsworth Kelly: Recent Paintings and Sculptures*, exhibition catalogue (New York: The Metropolitan Museum of Art, 1979).

Barbara Rose, *Ellsworth Kelly: Paintings and Sculptures, 1963–1979*, exhibition catalogue (Amsterdam: Stedelijk Museum, 1979).

Patterson Sims and Emily Rauh Pulitzer, *Ellsworth Kelly: Sculpture*, exhibition catalogue (New York: Whitney Museum of American Art, 1982).

Edward Kienholz
Fairfield, Washington, 1927–

Edward Kienholz studied at several schools in Washington State in the late 1940s and early 1950s. In Washington and Los Angeles, where he moved in 1953, he held a variety of jobs, including hospital orderly, mental institution attendant, car salesman, and dance band manager. In 1956 he opened the Now Gallery in Los Angeles, and when it closed the following year, he opened the Ferus Gallery; both were among the earliest avant-garde art galleries in Southern California.

In 1954, Kienholz produced his first wood relief paintings—plywood panels to which smaller pieces of wood are attached in abstract arrangements. The freely painted surfaces suggest the influence of Abstract Expressionism. In the late 1950s, he began incorporating found objects into his reliefs. From groups of boxes enclosing body parts, he shifted to freestanding sculptures composed entirely of found objects and junk materials, and in 1961 he created the first of his environments. These tableaux, which he continues to produce, contain furniture, rugs, junk materials, and figures made from plaster, fiberglass, and other materials. The sad figures are often monstrously distorted and their settings rife with suggestions of physical violence. The subjects of his tableaux have included an abortion (1962), a Los Angeles bar full of lonely people (1965), a mental hospital (1966), and a war memorial (1968). Most of Kienholz's works represent disturbing reflections on the decay and decadence he finds in contemporary society. The juxtaposition of incongruous objects, images, and media, the use of visual and verbal puns, and the hallucinatory drama of his work echo the American social and Surrealist temperament of Peter Blume and O. Louis Guglielmi.

After several one-artist gallery exhibitions in California in the 1950s and early 1960s, Kienholz had his first major museum exhibition in 1966, at the Los Angeles County Museum of Art. In the 1970s, nearly all the major exhibitions of his work were mounted in Europe. He fabricated *Still Live* (1974), an environment that actually poses physical danger to the

viewer, and *The Art Show* (1973–76), which portrays the public at the opening of a gallery exhibition. The Volksempfängers series (1975–77), in which radios refer to those that were mass-marketed in Germany during the 1930s as tools for Nazi propaganda, was exhibited at the Berlin Nationalgalerie in 1977. A survey of his art was held at the San Francisco Museum of Modern Art in 1984.

Maurice Tuchman, *Edward Kienholz*, exhibition catalogue (Los Angeles: Los Angeles County Museum of Art, 1966).

Max Kozloff, "Edward Kienholz" (1968), reprinted in Max Kozloff, *Renderings: Critical Essays on a Century of Modern Art* (New York: Simon and Schuster, 1968), pp. 243–48.

Pontus Hultén, *Edward Kienholz: 11 Tableaux*, exhibition catalogue (Zurich: Kunsthaus; London: Institute of Contemporary Arts, 1971).

Willy Rotzler, Roland H. Wiegenstein, and Jörn Merkert, *Edward Kienholz: Volksempfängers*, exhibition catalogue (West Berlin: Nationalgalerie; Zurich: Galerie Maeght, 1977).

Franz Kline
Wilkes-Barre, Pennsylvania, 1910– New York City, 1962

Between 1931 and 1935, while attending Boston University, Franz Kline took art classes at the Boston Art Students League. In 1935, he went to London, where he attended Heatherley's Art School in 1937–38. In 1938 he returned to America and settled in New York.

During the 1930s and 1940s, Kline painted interiors, cityscapes, and landscapes of the Pennsylvania coal-mining area in which he had grown up. Painterly and expressionistic, these early works reveal the influence of the American realists Albert Pinkham Ryder and Reginald Marsh.

In 1949, Kline enlarged some of his sketches with a projector, producing disparate patterns which prompted him to begin painting abstractly. Using house-painters'

brushes and fast-drying black-and-white enamels, he made bold, sweeping, strokes across the canvas. Kline's emphasis on gesture, overall composition, and the primacy of paint were concerns he shared with de Kooning, Pollock, and other painters of the emerging New York School. He was recognized as a major Abstract Expressionist painter soon after a group of black-and-white abstractions were exhibited at his first one-artist show in 1950 at the Egan Gallery, New York. Although he reintroduced color into his painting in the mid-1950s, the formal structure of his work remained unchanged, and his black-and-white paintings have received the greatest attention.

During the 1950s Kline taught at Black Mountain College, North Carolina, Pratt Institute, New York, and the Philadelphia Museum School of Art. His work was included in important group exhibitions, among them the 1957 São Paulo Bienal in Brazil, the 1956 and 1960 Venice Biennales, and many of the Whitney Museum's Annual Exhibitions. In 1962 a memorial exhibition of his work was presented by the Gallery of Modern Art in Washington, D.C. Traveling retrospectives were organized in 1963 by the Museum of Modern Art in New York, and in 1968 by the Whitney Museum of American Art in New York. The next major exhibition did not take place until 1979, when the Phillips Collection in Washington, D.C., presented a show of Kline's color abstractions.

Elaine de Kooning, *Franz Kline Memorial Exhibition*, exhibition catalogue (Washington, D.C.: Washington Gallery of Modern Art, 1962).

John Gordon, *Franz Kline, 1910–1962*, exhibition catalogue (New York: Whitney Museum of American Art, 1968).

Albert Boime, *Franz Kline: The Early Works as Signals*, exhibition catalogue (Binghamton, New York: University Art Gallery, State University of New York; Purchase, New York: Neuberger Museum, State University of New York, 1977).

Harry F. Gaugh, *Franz Kline: The Color Abstractions*, exhibition catalogue (Washington, D.C.: The Phillips Collection, 1979).

Gaston Lachaise
Paris, 1882–New York City, 1935

Encouraged by his cabinet-maker father, the thirteen-year-old Gaston Lachaise began his art training at the École Bernard Palissy in Paris. Between 1898 and 1904, he studied at the Académie Nationale des Beaux-Arts and while enrolled there exhibited four times at the annual Salon des Artistes.

Sometime between 1900 and 1903, Lachaise met Isabel Dutaud Nagle, a Canadian-American woman from Boston who was to become his primary source of artistic inspiration and emotional support. In 1906, Lachaise immigrated to Boston to be near Isabel, whom he married in 1914. He worked in Boston as an apprentice to the sculptor Henry H. Kitson, and when Kitson moved to New York in 1912, Lachaise followed. He soon left Kitson's studio to serve as chief assistant to the New York sculptor Paul Manship until 1921, when he received the first of his public commissions, a frieze for the lobby of the American Telephone and Telegraph Building.

In his own sculpture, Lachaise was obsessed with the female form. Isabel served as the model for many of his bronze female figures, which are characterized by full hips, abdomens, and breasts, small high waists, and slender legs. The early, small, and roughly modeled sculptures of Isabel became large, finely polished, and increasingly ample in Lachaise's later work. His focus on unorthodox postures and isolated, erotically distorted parts of the female anatomy reveals his love of large, swelling forms. The sculptor's sensibility remained European; his work recalls the female sculptures of Maillol, Nadelman, and Brancusi. In the 1920s and early 1930s, Lachaise made portrait heads of Isabel and leading artists and intellectuals of his day, including John Marin, Georgia O'Keeffe, Lincoln Kirstein, and E. E. Cummings.

Lachaise had his first one-artist exhibition in 1918 at the Stephan Bourgeois Galleries in New York. He was affiliated with the Kraushaar Galleries between 1922 and 1931. But his work received little recognition during his lifetime; after 1926, he had only two solo gallery exhibitions, at Alfred Stieglitz's Intimate Gallery (1927) and at the Joseph Brummer Gallery in Washington, D.C. (1928). In January 1935, shortly before his death, the Museum of Modern Art mounted a retrospective of his work. Another major retrospective was organized in 1963 by the Los Angeles County Museum of Art and surveys of his work have been circulated by the Lachaise Foundation.

Hilton Kramer, et al., *The Sculpture of Gaston Lachaise* (New York: The Eakins Press, 1967).

Gerald Nordland, *Gaston Lachaise: The Man and His Work* (New York: George Braziller, 1974).

Patterson Sims, *Gaston Lachaise: A Concentration of Works from the Permanent Collection*, exhibition catalogue (New York: Whitney Museum of American Art, 1980).

Deborah Waters, *Gaston Lachaise: Sculpture and Drawings*, exhibition catalogue (San Bernardino, California: The Art Gallery, California State College, 1980).

Herschel B. Chipp, *Gaston Lachaise: 100th Anniversary Exhibition; Sculpture and Drawings*, exhibition catalogue (Palm Springs, California: Palm Springs Desert Museum, 1982).

John Holverson, *Gaston Lachaise: Sculpture & Drawings*, exhibition catalogue (Portland, Maine: Portland Museum of Art, 1984).

Alfred Leslie
Bronx, New York, 1927–

In 1946, after high school graduation and less than a year of Coast Guard service, Alfred Leslie moved to Manhattan. During the next two years he studied briefly at the Art Students League and at New York University under William Baziotes and Tony Smith, who introduced him to Pollock, de Kooning, and other Abstract Expressionists.

Although Leslie painted in both abstract and realist modes in the 1950s, he was best known for his abstractions, which display the slashing brushstrokes, intense color, and freely splattered paint found in de Kooning's work. His figurative works were characterized by strong contrasts, loose brushwork, and softly modeled forms. In 1962 Leslie abandoned abstraction and the figure became his primary motif. For a brief period he painted from photographs, then began working directly from life. The meticulous rendering of his single figures—nude or clothed in contemporary dress—contrasts with their nondescript, monochromatic settings. In the 1970s, he also painted groups of family and friends, frequently introducing more background detail. The symmetrical, frontal poses, harsh light, and direct gaze of his figures create a mood of stillness and clarity. Leslie's uncompromising realism and occasionally his arrangement of figures invite comparison with compositions of such old masters as David and Caravaggio.

Since the early 1950s, Leslie has also produced films, collaborating on several with Robert Frank. In the 1950s and early 1960s, his paintings were seen in several one-artist shows, as well as in the famous "Sixteen Americans" exhibition at the Museum of Modern Art in 1958. A 1966 fire in his Manhattan studio destroyed much of his work, including his films. His next one-artist exhibition was in 1969. In 1976 the Museum of Fine Arts, Boston, organized an exhibition which traveled to several other museums in the United States.

Linda Nochlin, "Leslie, Torres: New Uses of History," *Art in America*, 64 (March–April 1976), pp. 74–76.

Robert Rosenblum, *Alfred Leslie*, exhibition catalogue (Boston: Museum of Fine Arts, 1976).

Frank H. Goodyear, Jr., *Contemporary American Realism Since 1960* (Boston: New York Graphic Society in association with the Pennsylvania Academy of the Fine Arts, 1981).

Gerard Haggerty, *Alfred Leslie*, exhibition catalogue (New York: Allan Frumkin Gallery, 1978).

Sol LeWitt

Hartford, Connecticut, 1928–

Sol LeWitt received a B.F.A. from Syracuse University in 1949. After military service in Korea, he moved to New York, where he studied illustration at the School of Visual Arts and later worked as a graphic artist for *Seventeen* magazine and for the architect I.M. Pei.

Before beginning the sculpture and drawings for which he is best known, LeWitt made paintings whose figures were based on those in Eadweard Muybridge's serial photographs. In the early 1960s, he produced two-dimensional canvases and painted wood "wall structures," as he called them, in which squares were the central motifs. He also fabricated free-standing, rectangular structures, lacquered in monochromes. Major influences on his early work were Albers' Homage to the Square series, Johns' Flags, and Frank Stella's early stripe paintings.

The grid is the basic ingredient of LeWitt's mature sculpture, which comprises three-dimensional open wood and enameled steel objects in which the overall configurations vary, but a cube always remains the core structure. By the mid-1960s, he had begun to refer to his work as conceptual art, believing its most important aspect to be the original design. The execution, while it had to be carried out precisely, could be handled by assistants. In his search for basic, primal structures with which to make art, LeWitt was joined by such Minimalists as Tony Smith, Donald Judd, Frank Stella, and Robert Morris. LeWitt's conceptual ideas were implicit in his wall drawings, begun in 1968. Their titles define in detail the work and process: various predetermined points on a wall are linked together by lines, or all combinations of arcs and lines—straight and not straight—are mapped out. Recently he has made grids into which are inserted photographs of adjacent views of a room, resulting in a photographic "map" of the room.

Since 1965 LeWitt has had regular one-artist exhibitions in galleries and museums throughout the United States. His work has been exhibited just as frequently in Europe. Major museum exhibitions of his work were mounted in 1970 by the Gemeentemuseum in The Hague and in 1978 by the Museum of Modern Art in New York. A retrospective of his wall drawings was organized by the Wadsworth Atheneum in Hartford, Connecticut, in 1981.

Sol LeWitt, "Paragraphs on Conceptual Art," *Artforum*, 5 (June 1967), pp. 79–83.

The Hague Gemeentemuseum, *Sol LeWitt*, exhibition catalogue (The Hague, Netherlands: 1970).

Lawrence Alloway, "Sol LeWitt: Modules, Walls, Books," *Artforum*, 13 (April 1975), pp. 38–43.

Donald B. Kuspit, "Sol LeWitt the Wit," *Arts Magazine*, 52 (April 1978), pp. 118–24.

Alicia Legg, ed., *Sol LeWitt*, exhibition catalogue (New York: The Museum of Modern Art, 1978).

Sol LeWitt, *Autobiography* (New York: Multiples, 1980).

Roy Lichtenstein

New York City, 1923–

In 1939, his last year of high school, Roy Lichtenstein enrolled in summer art classes with Reginald Marsh at the Art Students League. He later received a B.F.A. (1946) and an M.F.A. (1949) from Ohio State University. From 1951 to 1963, when he moved to New York, Lichtenstein worked as a graphic and engineering draftsman and taught art while painting in his spare time.

In the early 1950s, Lichtenstein produced Cubist paintings and assemblages incorporating images of the American Old West. Although in the late 1950s he painted in a non-figurative Abstract Expressionist style, in 1961 he reintroduced recognizable material into his work, using comic-strip subjects, common household items, and images taken from advertisements. He also began to develop his mature painting style which employed Benday dots, heavy black outlines, and restricted colors, usually red, yellow, and blue. Lichtenstein's synthesis of representational imagery and an essentially abstract, yet precise and refined style was a decided reaction against Abstract Expressionism. His portrayal of the banal and commonplace linked his work to that of other artists of the emerging Pop Art movement, such as Andy Warhol, Jim Dine, and Claes Oldenburg.

Lichtenstein subsequently painted landscapes and Abstract Expressionist brushstrokes in his Benday-dot style. He also parodied modern masters—Cézanne, Monet, Picasso, and Mondrian—converting their works into comic-strip formulations and thereby commenting on the workings of a consumer civilization. In the 1970s, his thematic material grew to include classical architecture, mirrors, and Purist, Futurist, Expressionist, and Surrealist art. Lichtenstein has also made sculpture in ceramic polychrome, brass, bronze, and aluminum and produced many prints.

Lichtenstein had his first one-artist exhibitions in the early 1950s. Since the early 1960s he has had numerous solo shows in galleries and museums in the United States and Europe and has participated in many important group exhibitions, among them the 1966 Venice Biennale and selected Whitney Museum Annual and Biennial Exhibitions. In 1967, his first major museum exhibition was organized jointly by the Pasadena Art Museum and the Walker Art Center, Minneapolis, and traveled to Europe. Two years later the Solomon R. Guggenheim Museum, New York, presented a major exhibition, and in 1981, the Saint Louis Art Museum circulated internationally an exhibition of Lichtenstein's work of the previous decade.

John Coplans, *Roy Lichtenstein*, exhibition catalogue (Pasadena, California: Pasadena Art Museum, 1967).

Diane Waldman, *Roy Lichtenstein*, exhibition catalogue (New York: The Solomon R. Guggenheim Museum, 1969).

Diane Waldman, *Roy Lichtenstein* (Milan, Italy: Gabriele Mazzota Editore, 1971).

John Coplans, ed., *Roy Lichtenstein* (New York: Praeger Publishers, 1972).

Jack Cowart, *Roy Lichtenstein, 1970–1980*, exhibition catalogue (New York: Hudson Hills Press in association with The St. Louis Art Museum, 1981).

Lawrence Alloway, *Roy Lichtenstein*, Modern Masters Series (New York: Abbeville Press, 1983).

Morris Louis

Baltimore, Maryland, 1912–
Washington, D.C., 1962

In 1929 Morris Louis (born Morris Bernstein) entered the Maryland Institute of Fine and Applied Arts in Baltimore. Three years after his graduation in 1933, he moved to New York, where he worked in the Easel Project of the Works Progress Administration/Federal Art Project. He returned to Baltimore in 1940 and began teaching art. Extant paintings of the late 1930s indicate Louis' interest in Social Realist themes as well as landscape, both subjects rendered in a dark, expressionist manner. In abstract paintings of the late 1940s and early 1950s, energetic networks of paint lines and splatters cover the canvas, suggesting the influence of Miró and Pollock.

In 1952, Louis settled in Washington, D.C., where he continued teaching and met Kenneth Noland, who became a close friend. The following year Louis and Noland visited the New York studio of Helen Frankenthaler. In 1954, Louis adopted her newly developed painting technique—layers of near-transparent pigment stained into primed or unprimed canvas—in his first mature paintings, the Veils series. For the next two years, Louis returned to his earlier, more calligraphic style, but in late 1957 he resumed work on the Veils.

In this group of paintings, large, fan-shaped color areas spread outward from one edge of the canvas to the other. In 1959–60, he produced the Floral stain paintings—streams of bold color radiating from a central oval shape—and paintings with vertically aligned layers of monochromatic color. In the Unfurled series of 1960–61, separate, diagonal rivulets of more opaque color, positioned on either side of a large white field, stream off the canvas edge. His Stripe paintings, 1961–62, contain adjacent but distinct vertical bands of different colors. In all of these works, Louis treated hue, form, and texture as one entity, communicating color sensation perhaps more directly and poetically than any other Color Field painter.

Louis exhibited in America and Europe in the decade before his death of cancer in 1962. The first museum exhibition of his work took place the following year at the Solomon R. Guggenheim Museum, New York. Major exhibitions of Louis' work were also organized by the Museum of Fine Arts, Boston (1967), the Städtische Kunsthalle Düsseldorf (1974), and the National Collection of Fine Arts, Washington, D.C. (1979).

Lawrence Alloway, *Morris Louis, 1912–1962: Memorial Exhibition, Paintings from 1954–1960*, exhibition catalogue (New York: The Solomon R. Guggenheim Museum, 1963).

Michael Fried, *Morris Louis, 1912–1962*, exhibition catalogue (Boston: Museum of Fine Arts, 1967).

E. A. Carmean, Jr., *Morris Louis: Major Themes and Variations*, exhibition catalogue (Washington, D.C.: National Gallery of Art, 1976).

Dean Swanson and Diane Upright Headley, *Morris Louis: The Veil Cycle*, exhibition catalogue (Minneapolis: Walker Art Center, 1977).

Stanton Macdonald-Wright

*Charlottesville, Virginia, 1890–
Pacific Palisades, California, 1973*

Stanton Macdonald-Wright had painting tutors from the age of five. After his family moved west in 1900, he studied at the Art Students League in Los Angeles (1904–05). In 1907 he moved to Paris, where he studied at the Sorbonne, the Académie Colarossi, the Académie Julian, and the École des Beaux-Arts. Although none of Macdonald-Wright's early Paris work is extant, photographs of figurative paintings suggest they were syntheses of Cézannesque forms and Impressionist techniques.

Macdonald-Wright met Morgan Russell in 1911 and together they developed a style of painting they would soon term Synchromism. This style developed out of their study of various color theories, particularly those of the painter Ernest Percyval Tudor-Hart, with whom both had studied. Synchromism prescribed color as the generating element of form, volume, and movement. The earliest "Synchromies" were based on figure and still-life motifs, often borrowed from older artists, such as Michelangelo, Rubens, and Rodin. These semi-abstract compositions were created from intersecting planes and arcs of bright, pure color. The first two exhibitions of the early Synchromies were held during 1913–14 in Munich and Paris.

The first exhibition of Synchromism in the United States opened at the Carroll Galleries, New York, in the spring of 1914. Macdonald-Wright's most important contributions as a Synchromist came shortly after this show, in his completely non-objective paintings of 1914–15. He returned to painting Synchromies with figurative motifs in 1916, relying more than ever on Cubist fragmentation. A number of these canvases were exhibited in Macdonald-Wright's first solo exhibition in New York—at Alfred Stieglitz's 291 Gallery in 1917— and then at the Charles Daniel Gallery the following year.

Macdonald-Wright moved to California in 1919, making it his home base until his death. He exhibited his work very infrequently for the next thirty-five years, turning instead to other interests, including cinematography, architectural decoration, and the teaching of art history and Oriental aesthetics. He returned to making non-objective and figurative Synchromist paintings in 1954. Two years later, his first retrospective, which included his 1950s paintings, was presented by the Los Angeles County Museum of Art. In 1967, the National Collection of Fine Arts in Washington, D.C., organized a retrospective of Macdonald-Wright's work.

Richard F. Brown, *A Retrospective Showing of the Work of Stanton Macdonald-Wright*, exhibition catalogue (Los Angeles: Los Angeles County Museum of Art, 1956).

David W. Scott and Stanton Macdonald-Wright, *The Art of Stanton Macdonald-Wright*, exhibition catalogue (Washington, D.C.: Smithsonian Institution Press for the National Collection of Fine Arts, 1967).

Frederick S. Wight and Stanton Macdonald-Wright, *Stanton Macdonald-Wright: A Retrospective Exhibition, 1911–1970*, exhibition catalogue (Los Angeles: The U.C.L.A. Art Galleries and the Grunwald Graphic Arts Foundation, 1970).

Gail Levin, *Synchromism and American Color Abstraction, 1910–1925*, exhibition catalogue (New York: George Braziller in association with the Whitney Museum of American Art, 1978).

Brice Marden

Bronxville, New York, 1938–

Brice Marden studied at Florida Southern College, Boston University School of Fine and Applied Arts (B.F.A., 1961), and the School of Art and Architecture, Yale University (M.F.A., 1963) before moving to New York in 1963.

While at Yale, Marden abandoned the gestural, Abstract Expressionist painting style he had pursued in Boston and began producing paintings divided into several rectangular areas of solid color. Since then his work has adhered closely to a reductive aesthetic. His canvases of the mid-1960s are covered with thick layers of encaustic pigment in single, somber colors, inspired by the subdued palettes of Manet, Velázquez and Goya. The lower borders of these color panels are left uneven and paint-splattered, ending just short of the canvas edge. This device, derived from Jasper Johns' early flag and target paintings, along with the heavy paint buildup, serves to enliven the somber simplicity of his paintings. It was also in the mid-1960s that Marden began composing works from two separate panels of a single color; by 1968 he was making diptychs and triptychs from panels of different colors, joined together along their vertical edges. Panels joined horizontally, like those of Ellsworth Kelly, date from 1970. In the mid-1970s, Marden began to replace his earlier dark tones with brighter colors and more complex construction.

Since Marden's first one-artist exhibition in New York in 1966, he has maintained a reputation as a major Minimalist painter and has had numerous solo exhibitions in American and European galleries and museums. The first museum retrospective of Marden's work was organized in 1975 by the Solomon R. Guggenheim Museum, New York. A second retrospective was held in 1981 at the Whitechapel Art Gallery, London, and the Stedelijk Museum, Amsterdam.

Roberta Smith, "Brice Marden's Painting," *Arts Magazine*, 47 (May–June 1973), pp. 36–41.

Dore Ashton, *Brice Marden Drawings, 1963–1973*, exhibition catalogue (Houston, Texas: Contemporary Arts Museum, 1974).

Janet Kutner, "Brice Marden, David Novros, Mark Rothko: The Urge to Communicate through Non-Imagistic Painting," *Arts Magazine*, 50 (September 1975), pp. 61–63.

Linda Shearer, *Brice Marden*, exhibition catalogue (New York: The Solomon R. Guggenheim Museum, 1975).

Stephen Bann and Roberta Smith, *Brice Marden: Paintings, Drawings, and Prints, 1975–1980*, exhibition catalogue (London: Whitechapel Art Gallery, 1981).

John Marin

*Rutherford, New Jersey, 1870–
Cape Split, Maine, 1953*

John Marin was nearly thirty years old before he received any formal art training. He studied at the Pennsylvania Academy of the Fine Arts in Philadelphia (1899–1901) and at the Art Students League in New York (1901–03). Between 1905 and 1910, Marin traveled throughout Europe, spending most of his time in Paris, where he produced many etchings and watercolors of the city's landmarks and picturesque views. His watercolors indicate the influence of French Impressionism, Post-Impressionism, and Whistler. Alfred Stieglitz, whom Marin met in Paris in 1909, was impressed with Marin's work and gave him his first one-artist exhibition the following year at the 291 Gallery in New York. They developed a close friendship, and Stieglitz guaranteed Marin financial support, enabling him to devote all of his time to painting.

Marin mastered the watercolor medium early in his career; he did not begin to use oils regularly until after 1928. Without ever being purely abstract, Marin's mature painting style—expressive, dynamic, and colorful—shows Futurist and Cubist influences. His New York cityscapes are vivid pictorial equivalents of the buildings, bridges, angles, and movements of

the city. In Marin's equally dynamic paintings of the Maine coast, broad calligraphic strokes describe ground, trees, water, clouds, and sky. Marin's attraction to Maine began with his first summer there in 1914 and he returned nearly every summer to its coastal towns.

Wide recognition of Marin, during his lifetime and posthumously, is evidenced by the many exhibitions of his work. He exhibited regularly at each of Stieglitz's three successive galleries (Little Galleries of the Photo-Secession, later known as 291, The Intimate Gallery, and An American Place). Two major New York museums—the Metropolitan Museum of Art and the Museum of Modern Art—held one-artist exhibitions of Marin's work, in 1924 and 1936, respectively. In 1947 the Institute of Contemporary Art in Boston organized a traveling retrospective. A memorial exhibition in 1955 traveled to several major American museums. The Los Angeles County Museum of Art organized a traveling exhibition in 1970–71.

E. M. Benson, *John Marin: The Man and His Work* (Washington, D.C.: The American Federation of Arts, 1935).

Henry McBride, Marsden Hartley, and E. M. Benson, *John Marin: Watercolors, Oil Paintings and Etchings*, exhibition catalogue (New York: The Museum of Modern Art, 1936).

Dorothy Norman, ed., *The Selected Writings of John Marin* (New York: Pellegrini & Cudahy, 1949).

Dorothy Norman, MacKinley Helm, and Frederick S. Wight, *John Marin: Memorial Exhibition*, exhibition catalogue (Los Angeles Art Galleries, University of California, Los Angeles, 1955).

Sheldon Reich, *John Marin: A Stylistic Analysis and Catalogue Raisonné* (Tucson, Arizona: University of Arizona Press, 1970).

Cleve Gray, ed., *John Marin by John Marin* (New York, San Francisco, and Chicago: Holt, Rinehart and Winston, 1977).

Reginald Marsh

Paris, France, 1898–
Dorset, Vermont, 1954

The son of two artists, Reginald Marsh began to draw at an early age. After graduating from Yale University in 1920, he worked in New York as a free-lance artist for the *Daily News* (1922–25) and as a member of the original staff of *The New Yorker* (1925–31), recording scenes of city life, particularly vaudeville and theater.

Marsh's only art training came from intermittent study at the Art Students League in New York in the early 1920s. He joined the Whitney Studio Club in 1923 and had his first one-artist exhibition there the following year. Beginning in 1925–26, he took many long trips to Europe, where he studied and copied Old Master paintings. He experimented with and became accomplished in many media, particularly egg tempera, engraving, and etching.

Like Kenneth Hayes Miller, the League teacher Marsh revered most, his favorite subject was New York street life, particularly Fourteenth Street, and he maintained a studio there beginning in 1929. Many of his paintings depict the city's people, often workers, crowded into subways, elevated trains, burlesque houses, nightclubs, and at the beach. The nervous lines and bulging masses of Marsh's figures convey a vitality and robust sexuality that differentiate his work from the more socially and politically conscious art of some of his contemporaries. To further his understanding of anatomy, Marsh worked at dissection in the early 1930s at Columbia University and Cornell University Medical College. His fluency with the figure is most evident in his famous depictions of Coney Island and its frolicking bands of near-naked bodies.

In the mid-1930s, Marsh was commissioned by the Treasury Department art program to paint two frescoes in the Post Office Building in Washington, D.C., and to execute murals in the rotunda of the United States Custom House in New York. In 1935 he began teaching at the Art Students League, and in 1949 he was appointed head of the Department of Painting at the Moore Institute of Art, Science, and Industry in Philadelphia; he retained both positions for the rest of his life.

Marsh's work was included in nearly all the Whitney Museum's Annual and Biennial Exhibitions during his lifetime. The Frank K. M. Rehn Gallery in New York presented regular exhibitions of his work from 1930 to 1953. The Whitney Museum of American Art held a memorial exhibition in 1955, and in 1972 the Newport Harbor Art Museum in California organized a major traveling retrospective.

In 1978 Felicia Meyer Marsh, the artist's second wife, bequeathed a large number of oils, temperas, and watercolors to the Whitney Museum, which presented an exhibition of selections from this bequest the following year. In 1983 the Whitney Museum of American Art at Philip Morris held another Marsh exhibition, entitled "Reginald Marsh's New York," which traveled to several American museums.

Lloyd Goodrich, *Reginald Marsh*, exhibition catalogue (New York: Whitney Museum of American Art, 1955).

Thomas H. Garver, *Reginald Marsh: A Retrospective Exhibition*, exhibition catalogue (Newport Beach, California: Newport Harbor Art Museum, 1972).

Lloyd Goodrich, *Reginald Marsh* (New York: Harry N. Abrams, 1972).

Edward Laning, *The Sketchbooks of Reginald Marsh* (Greenwich, Connecticut: New York Graphic Society, 1973).

Norman Sasowsky, *The Prints of Reginald Marsh* (New York: Clarkson N. Potter, 1976).

Marilyn Cohen, *Reginald Marsh's New York: Paintings, Drawings, Prints, and Photographs*, exhibition catalogue (New York: Whitney Museum of American Art in association with Dover Publications, 1983).

Agnes Martin

Maklin, Saskatchewan, Canada,
1912–

After moving to the United States in 1932, Agnes Martin attended Western Washington State College (1935–38) and the University of New Mexico in Albuquerque (1946–47). Between 1941 and 1952 she studied intermittently at Teachers College, Columbia University, earning a B.S. and an M.A. During this time she also taught in public schools and universities in Washington, Oregon, Delaware, and New Mexico. In 1957 Martin settled at Coenties Slip in Lower Manhattan.

In the late 1940s Martin produced conventional still-life and portrait paintings. She abandoned these narrative themes in the early 1950s for a simplified Surrealist vocabulary of symbolic, biomorphic forms influenced by the Abstract Expressionist work, especially that of Mark Rothko, that she saw in New York. Beginning in 1959, she applied pencil and paint grids to her canvases, a mode that became characteristic of her mature style. She occasionally attached objects such as nails to the canvas in regular patterns, paralleling the grid formats. The reductive style and serial presentation of components was inspired by the work of Josef Albers and Ellsworth Kelly, the latter a neighbor at Coenties Slip. However, the irregularity of Martin's grids and the soft, lyrical color fields into which she sometimes introduced value shifts differentiate her painting from the polished, bright-colored, and unmodulated canvases of other Minimalist painters.

In the late 1950s and early 1960s, Martin had several one-artist exhibitions in New York. She returned to live in New Mexico in 1967 and did not paint for several years, but when she resumed in 1972, her compositional formats remained essentially unchanged. Her palette brightened in her later paintings, reflecting the coloration of the New Mexico landscape. Her recent work has been exhibited frequently in one-artist and group gallery exhibitions. In 1973 the Institute of Contemporary Art of the University of Pennsylvania, Philadelphia, held a small retrospective of her early

work and the Museum of Modern Art in New York presented an exhibition of prints. Four years later the Arts Council of Great Britain organized an exhibition at the Hayward Gallery in London.

Lawrence Alloway, *Agnes Martin*, exhibition catalogue (Philadelphia: Institute of Contemporary Art, University of Pennsylvania, 1973).

Lawrence Alloway, "Agnes Martin," *Artforum*, 11 (April 1973), pp. 32–36.

Lizzie Borden, "Agnes Martin: Early Work," *Artforum*, 11 (April 1973), pp. 39–44.

John Gruen, "Agnes Martin: 'Everything, everything is about feeling . . . feeling and recognition,'" *Art News*, 75 (September 1976), pp. 91–94.

Dore Ashton, *Agnes Martin Paintings and Drawings, 1957–1975*, exhibition catalogue (London: Hayward Gallery, 1977).

Robert Morris
Kansas City, Missouri, 1931–

After studying engineering at the University of Kansas, Robert Morris attended the Kansas City Art Institute (1948–50) and the California School of Fine Arts, San Francisco (1950–51). He also attended Reed College, Portland, Oregon, for two years before settling in San Francisco in 1955. There he painted and worked in improvisatory theater and film.

In 1961, Morris moved to New York, where he studied art history at Hunter College (M.A., 1963), and began to concentrate on sculpture. His earliest pieces, Dada-like assemblages of various materials and everyday objects clearly influenced by Jasper Johns, explore the relationships between art and language, measurement and process. In the mid-1960s, he established a reputation as a leading Minimalist sculptor, producing geometric sculptures from plywood, fiberglass, aluminum, and other industrial materials. By eliminating parts in favor of the whole, Morris emphasizes the sculpture's relationship to the viewer and to the surrounding space. A fusion of materials and process takes place in the Earthworks and Antiform pieces he began in 1966: sculptures composed of dirt, rope, or strands of felt, whose disordered configurations are determined by gravity and chance. Since the late 1960s, Morris has made large-scale, outdoor earth projects; some incorporate weather conditions, and others were designed in accordance with astronomical cycles. He has also experimented with other forms, such as mazes and sound installations. Recent sculptures consist of interlocking complexes of cubes, cylinders, beams, grids, and fences as well as curved mirrors in which these parts are reflected, and elaborate apocalyptic painting-sculptures. Morris has published numerous essays on art, and has also collaborated as a dancer and choreographer with several avant-garde performers. His latest work has taken on an increasingly political tone and made use of representation and the figure.

In 1969, after frequent one-artist exhibitions and inclusion in numerous group shows, Morris had a major museum exhibition, organized jointly by the Detroit Institute of Arts and the Corcoran Gallery of Art, Washington, D.C. The Whitney Museum of American Art presented an exhibition of Morris' sculpture the following year. He has had exhibitions at European museums as well, in 1971 at the Tate Gallery, London, and in 1977 at the Stedelijk Museum, Amsterdam.

Annette Michelson, *Robert Morris*, exhibition catalogue (Washington, D.C.: The Corcoran Gallery of Art, 1969).

Marcia Tucker, *Robert Morris*, exhibition catalogue (New York: Whitney Museum of American Art, 1970).

Michael Compton and David Sylvester, *Robert Morris*, exhibition catalogue (London: The Tate Gallery, 1971).

Carter Ratcliff, "Robert Morris: Prisoner of Modernism," *Art in America*, 67 (October 1979), pp. 96–109.

Marti Mayo, *Robert Morris: Selected Works, 1970–1980*, exhibition catalogue (Houston, Texas: Contemporary Arts Museum, 1981).

Elie Nadelman
*Warsaw, Poland, 1882–
New York City, 1946*

Elie Nadelman's artistic development reflects his eclectic absorption of many aspects of Western European and American art and culture. In 1899 and 1901, he briefly studied art in his native Warsaw. During a six-month stay in Munich in 1903–04, the collections of the Bayerisches Nationalmuseum and the Glyptothek kindled what was to become a lifelong interest in folk art and classical sculpture. In 1904, Nadelman moved to Paris, where he spent the next ten years. Inspired by the work of Michelangelo and Rodin, as well as the Louvre's classical sculpture, Nadelman produced elegant marble and bronze statues, emphasizing the figure's curvilinear qualities. Yet even at this early date, Nadelman often accentuated the underlying structure of the human figure by re-composing its form into geometric constants. These proto-Cubist tendencies later led Nadelman to claim a more significant role in the development of Cubism than he has subsequently been assigned.

During the years 1905–14, Nadelman's work became known in Europe through one-artist exhibitions in Paris, Barcelona, and London. His move to the United States in 1914 was facilitated by his patron, Helena Rubinstein. One year after his arrival in New York, Nadelman had his first American one-artist exhibition at Alfred Stieglitz's 291 Gallery. This was followed by many solo exhibitions in New York at the Scott and Fowles Gallery and at M. Knoedler & Co.

The attenuated, tubular shapes Nadelman had experimented with in marble and bronze in Paris were further developed in New York. He now translated this style into wood and plaster, producing the dancers, circus performers, and musicians—complete with clothing and furniture—for which he is most famous. These figures reflect his growing interest in American folk art. When his folk art collection was sold in 1937, he had amassed nearly 15,000 items.

In 1924, Nadelman started experimenting with a process called galvanoplasty, the addition of bronze to the surface of plaster molds. The figure's flowing contours were still emphasized, but details of the face, joints, hands, and feet were blurred, leaving the works amorphous and inchoate. In his later years, Nadelman produced editions of small papier-mâché, plaster, and marble figures.

Nadelman was always reclusive; after 1930, he retreated to his Riverdale, New York, estate, exhibiting no more and selling very little. As a result, his art was nearly forgotten in his last years. It has received posthumous attention through several exhibitions, most importantly, at the Museum of Modern Art in 1948, and in 1975 at the Whitney Museum of American Art.

William Murrell, *Elie Nadelman*, Younger Artists Series (Woodstock, New York: William M. Fisher, 1923).

Lincoln Kirstein, *The Sculpture of Elie Nadelman*, exhibition catalogue (New York: The Museum of Modern Art, 1948).

Lincoln Kirstein, *Elie Nadelman* (New York: The Eakins Press, 1973).

John I. H. Baur, *The Sculpture and Drawings of Elie Nadelman*, exhibition catalogue (New York: Whitney Museum of American Art, 1975).

Jeanne L. Wasserman and James B. Cuno, *Three American Sculptors and the Female Nude: Lachaise, Nadelman and Archipenko*, exhibition catalogue (Cambridge, Massachusetts: Fogg Art Museum, Harvard University, 1980).

Louise Nevelson
Kiev, Russia, 1899–

In 1905, Louise Nevelson (born Louise Berliawsky) and her family emigrated from Russia to Rockland, Maine. During the 1920s in New York, she studied painting and drawing, first privately, then at the Art Students League. Her developing interest in Picasso and Cubism led her to Europe in 1931, where she studied with Hans Hofmann at his Munich school. Back in New York in 1932, she assisted Diego Rivera on his murals for the New Workers' School. In 1937 she joined the Works Progress Administration as a teacher at the Educational Alliance School of Art, New York. Although she is best known as a sculptor, Nevelson also studied voice, drama, and modern dance.

At her first one-artist exhibition, in 1941 at the Nierendorf Gallery, New York, Nevelson showed small Cubist figures made of stone, terracotta, wood, and metal. In 1943 she began constructing abstract wood assemblages, whose ready-made components frequently suggest the images of contemporary Surrealist painters—such as Baziotes, Rothko, and Gottlieb. By the mid-1950s, she had begun to incorporate wooden shapes of increasingly diverse origin into boxes, reliefs, columns and, finally, walls. The walls, constructed in modular units and painted a uniform color—usually black—were conceived and exhibited as environmental installations, each with an underlying theme.

Nevelson's work has been exhibited frequently in museum exhibitions and she has had four major retrospectives: at the Whitney Museum of American Art (1967); the Museum of Fine Arts, Houston (1969); the Walker Art Center, Minneapolis (1973); and the Phoenix Art Museum (1980). The Whitney Museum in 1980 presented an exhibition, "Louise Nevelson: Atmospheres and Environments," in which sculptures from her earlier environmental exhibitions were reassembled.

John Gordon, *Louise Nevelson*, exhibition catalogue (New York: Whitney Museum of American Art, 1967).

Arnold B. Glimcher, *Louise Nevelson* (New York: E. P. Dutton, 1972).

Martin Friedman, *Nevelson: Wood Sculptures*, exhibition catalogue (New York: E. P. Dutton for the Walker Art Center, Minneapolis, 1973).

Louise Nevelson, *Dawns and Dusks* (New York: Charles Scribner's Sons, 1976).

Richard Marshall and Edward Albee, *Louise Nevelson: Atmospheres and Environments*, exhibition catalogue (New York: Clarkson N. Potter in association with the Whitney Museum of American Art, 1980).

Laurie Wilson, *Louise Nevelson: The Fourth Dimension*, exhibition catalogue (Phoenix, Arizona: Phoenix Art Museum, 1980).

Jean Lipman, *Nevelson's World*, introduction by Hilton Kramer (New York: Hudson Hills Press in association with the Whitney Museum of American Art, 1983).

Barnett Newman

New York City, 1905– New York City, 1970

Between 1922 and 1927, while enrolled in City College, New York, as a philosophy major, Barnett Newman also attended the Art Students League. After graduating from City College, he worked for two years in his father's clothing manufacturing firm, then returned to study at the League. During the 1930s, he worked as a substitute art teacher in the city high schools.

In Newman's crayon drawings, watercolors, and oil paintings of the mid-1940s, bright-colored, fluid forms serve as metaphors for plants and animals, growth and regeneration. These elongated biomorphic shapes anticipate his mature style, beginning in 1948, in which the canvas is divided vertically into several rectangular areas of color. Narrow stripes of markedly contrasting color, later known as "zips," characteristically separate the color blocks or denote the canvas edge. Newman's painting concerns are echoed in his sculpture, begun in 1950, and in his lithographs, executed in the 1960s.

Although Newman associated with the Abstract Expressionists and shared their search for new ways to express universal and subliminal themes, he sought to evolve an art independent of European influences, based on rational, intellectual principles. Newman set forth these philosophical principles in numerous essays and lectures. In his canvases he rejected the painterly mode of the gestural Abstract Expressionists of the 1950s, producing smooth, hard-edge forms which anticipate the Minimalist art of the 1960s.

Newman's work has been shown frequently in one-artist gallery shows, and in almost all the Whitney Museum Annual Exhibitions held during the 1960s. In 1958, he had his first retrospective, at Bennington College, Vermont. In 1965, he represented the United States in the São Paulo Bienal in Brazil. His famous series of paintings—The Stations of the Cross, executed between 1958 and 1966—was exhibited at the Solomon R. Guggenheim Museum in New York the following year. A year after Newman's death in 1970 the Museum of Modern Art in New York organized a retrospective that circulated throughout Europe.

Lawrence Alloway, *Barnett Newman: The Stations of the Cross: Lema Sabachthani*, exhibition catalogue (New York: The Solomon R. Guggenheim Museum, 1966).

Thomas B. Hess, *Barnett Newman* (New York: Walker and Company, 1969).

Thomas B. Hess, *Barnett Newman*, exhibition catalogue (New York: The Museum of Modern Art, 1971).

Harold Rosenberg, *Barnett Newman* (New York: Harry N. Abrams, 1978).

Brenda Richardson, *Barnett Newman: The Complete Drawings, 1944–1969*, exhibition catalogue (Baltimore, Maryland: The Baltimore Museum of Art, 1979).

Isamu Noguchi

Los Angeles, California, 1904–

Isamu Noguchi, the son of a Japanese poet and an American writer, spent his childhood in Japan. At the age of thirteen he returned to the United States to attend high school in Indiana. Noguchi worked briefly in 1922 as an apprentice to Gutzon Borglum, a sculptor known primarily for his public monuments. Borglum discouraged his assistant's desire to be a sculptor and in early 1923, Noguchi enrolled in Columbia University as a pre-medical student. Noguchi began studying art again in 1924 at the Leonardo da Vinci School in New York, where the academic sculptor Onorio Ruotolo recognized and nurtured his talent.

On Guggenheim fellowships to Paris in 1927 and 1928, Noguchi worked as a studio assistant to Constantin Brancusi, who encouraged the young sculptor to experiment with abstraction. He returned to New York in 1929; in 1930–31 he visited China and Japan. Noguchi's major works of the mid-1940s combine flat, interlocking, amoeba-like forms similar to the biomorphic shapes of Arp, Miró, and Tanguy. However, his lifelong study of ancient art—particularly that of the Orient—has played an equally significant role in his art. In the

early 1930s, he produced figurative works in the style of *haniwa*—an ancient Oriental pottery form he studied on the first of many extensive trips to Japan.

Noguchi's concern for the role of art in everyday life is revealed in the furniture, light fixtures, outdoor works, "environments," gardens, playgrounds, and bridges he has designed. His best-known Japanese-style gardens include those for UNESCO headquarters in Paris (1956–58) and for the Beinecke Rare Book and Manuscript Library at Yale University (1960–64). In 1935, Noguchi designed the first of more than twenty stage sets for modern dance pioneer Martha Graham. All of Noguchi's work is characterized by an ascetic gracefulness, an emphasis on the intrinsic qualities of the medium—be it bronze, wood, metal, ceramic, earth, or his favored stone—and a conception of space as a primary sculptural component.

Noguchi maintains studios in both the United States and Japan and has had retrospectives in both countries—in 1968 at the Whitney Museum of American Art and in 1973 at the Minami Gallery in Tokyo. A comprehensive traveling exhibition of sculpture, stage set designs, and environmental works was organized in 1978 by the Walker Art Center in Minneapolis. Two years later, "The Sculpture of Spaces," adapted from the Walker Art Center's exhibition, was presented at the Whitney Museum.

John Gordon, *Isamu Noguchi*, exhibition catalogue (New York: Frederick A. Praeger for the Whitney Museum of American Art, 1968).

Isamu Noguchi, *A Sculptor's World*, Foreword by R. Buckminster Fuller (New York: Harper & Row, 1968).

Martin Friedman, *Noguchi's Imaginary Landscapes*, exhibition catalogue (Minneapolis: Walker Art Center, 1978).

Sam Hunter, *Isamu Noguchi* (New York: Abbeville Press, 1978).

Nancy Grove, *The Sculpture of Isamu Noguchi, 1924–1979* (New York: Garland Publishers, 1980).

Isamu Noguchi, *The Sculpture of Spaces*, exhibition catalogue (New York: Whitney Museum of American Art, 1980).

Kenneth Noland

Asheville, North Carolina, 1924–

After serving four years in the Air Force, Kenneth Noland attended Black Mountain College, near his home town in North Carolina, from 1946 to 1948. There he studied primarily with Ilya Bolotowsky and for one semester with Josef Albers, whose abstract geometric paintings profoundly influenced the development of Noland's mature abstract work. In 1948 Noland went to Paris to study painting and sculpture with the sculptor Ossip Zadkine. It was the work of Paul Klee, however, that had the most discernible influence on Noland's early paintings—flat, non illusionistic arrangements of abstract linear shapes and graffiti-like elements, suggesting figures, animals, and architecture.

In 1952, while teaching at the Washington Workshop Center of the Arts, Noland became a close friend of fellow instructor Morris Louis. The following year, Noland and Louis visited the New York studio of Helen Frankenthaler, whose newly developed stain technique impressed them both deeply. For the next several years, Noland experimented with several abstract styles and various techniques, producing canvases stained with thin washes as well as paintings with heavy paint buildup. In 1958, he completed his first mature stain paintings, composed of concentric rings of contrasting color centered on fields of raw canvas. These were followed in the late 1950s and early 1960s, by cruciform, lozenge, and chevron patterns, rendered in an increasingly hard-edge style. Diamond-shaped canvases and horizontal stripe paintings date from the mid-1960s. Early in the 1970s, he produced circular, diamond, and rectangular-shaped paintings with striped grid patterns, followed by more eccentrically shaped canvases toward mid-decade. Since 1980 he has returned to earlier motifs, now painting with a thickly applied gelatinous surface. Like other Color Field painters, Noland achieved a complete unity of form, paint, and ground. In 1968, he began making sculpture related to his painting and frequently influenced by the work of David Smith, a friend of Noland's in the 1950s. His more recent works employ a thick impastoed surface to render simple abstract motifs.

From the early 1950s, Noland's work has been regularly exhibited in galleries and museums in this country and in Europe. Major museum exhibitions were organized in 1965 by the Jewish Museum, New York, and in 1977 by the Solomon R. Guggenheim Museum, New York.

Michael Fried, *Kenneth Noland*, exhibition catalogue (New York: The Jewish Museum, 1965).

Kenworth Moffett, "Noland," *Art International*, 17 (Summer 1973), pp. 22–33, 91–93, 100.

Kenworth Moffett, *Kenneth Noland* (New York: Harry N. Abrams, 1977).

Diane Waldman, *Kenneth Noland: A Retrospective*, exhibition catalogue (New York: The Solomon R. Guggenheim Museum in collaboration with Harry N. Abrams, 1977).

Georgia O'Keeffe

Sun Prairie, Wisconsin, 1887–

After studying at the Art Institute of Chicago (1905–06) and at the Art Students League in New York (1907–08), Georgia O'Keeffe abandoned painting because of family difficulties and doubts about her artistic direction. For the next two years she worked as a commercial illustrator in Chicago. She returned to painting in 1912, when she attended art classes at the University of Virginia, and between 1912 and 1917, she taught art at schools in Amarillo and Canyon, Texas, and South Carolina and Virginia. In late 1914, O'Keeffe studied art at Teachers College, Columbia University, with the painter-printmaker Arthur Wesley Dow, who encouraged his students to find new means of artistic expression, based on the oriental-inspired writings of Ernest Fenollosa. Dow had a profound influence on O'Keeffe.

Alfred Stieglitz gave O'Keeffe her first one-artist exhibition in 1917 at his 291 Gallery, presenting the abstract charcoal drawings and watercolors she made in late 1915, her first mature works. In 1918 O'Keeffe moved to New York; she and Stieglitz were married in 1924. For the next two decades, O'Keeffe exhibited regularly at Stieglitz's Intimate Gallery and its successor,

An American Place. Beginning in 1929, O'Keeffe spent summers in New Mexico and in 1949, three years after Stieglitz's death, she began living there year-round. She has never tired of painting the stark and monumental landscape of the Southwest.

With other members of the Stieglitz circle of avant-garde American artists—Marin, Hartley, Dove, and Demuth—O'Keeffe shared a deep reverence for nature and a determination to express that vision in personal abstract terms. She began her well-known paintings of large, close-up views of flowers around 1919. Although most of these paintings are semi-abstract, O'Keeffe observed nature directly and magnified its details, a technique also adopted by the photographers Stieglitz, Charles Sheeler, Edward Steichen, Imogen Cunningham, and Paul Strand.

In the 1940s and 1950s, O'Keeffe had several museum retrospectives, as well as solo exhibitions at the Downtown Gallery in New York. In the late 1950s and 1960s she traveled widely, in Europe, South America, Asia, and the Pacific. This frequent air travel inspired a series of works based on rivers seen from above, with even more simplified forms and greater emphasis on light. During the 1970s, deteriorating eyesight slowed the pace of her painting and she began to spend more time organizing and presenting her life's work—a process initiated by the traveling retrospective organized in 1970 by the Whitney Museum of American Art, the largest O'Keeffe exhibition ever assembled.

Daniel Catton Rich, *Georgia O'Keeffe*, exhibition catalogue (Chicago: The Art Institute of Chicago, 1943).

Lloyd Goodrich and Doris Bry, *Georgia O'Keeffe*, exhibition catalogue (New York: Whitney Museum of American Art, 1970).

Georgia O'Keeffe, *Georgia O'Keeffe* (New York: The Viking Press, 1976).

Laurie Lisle, *Portrait of an Artist: A Biography of Georgia O'Keeffe* (New York: Seaview Books, 1980).

Patterson Sims, *Georgia O'Keeffe: A Concentration of Works from the Permanent Collection*, exhibition catalogue (New York: Whitney Museum of American Art, 1981).

Lisa Mintz Messinger, *Georgia O'Keeffe*, exhibition catalogue, published in *The Metropolitan Museum of Art Bulletin*, 42 (Fall 1984).

Claes Oldenburg

Stockholm, Sweden, 1929

Claes Oldenburg was born in Sweden; his family came to America in 1936 and settled in Chicago. He attended Yale University (1946–50), majoring in literature and art, then returned to Chicago, where he worked as a reporter and attended classes at the Art Institute of Chicago until 1954. During these years he produced primarily figurative paintings and drawings.

Oldenburg's move to New York in 1956 brought him into contact with Allan Kaprow, whose environments and Happenings exerted a strong influence on the younger artist. In 1960, in his Ray Gun Show, Oldenburg presented his first environment, *The Street*, using it as the setting for his first Happening. *The Street* was an ensemble of figures, signs, and objects representing a slum environment and made from cardboard, string, scraps, and other found debris. He explored these media further in *The Store* (1961–62), an actual storefront he filled with food, shoes, and clothing, all made from plaster and papier-mâché, and painted bright colors. *The Bedroom Ensemble* (1963–64) was a re-creation of a Southern California motel room. In 1962 he had begun working on giant, sewn, soft sculptures of common objects—typewriters, foods, car parts, bathroom fixtures—using canvas, vinyl, and other fabrics stuffed with kapok. The forms often refer to parts of the human body and have sexual connotations. He made three versions of these everyday objects: a "hard" one, of cardboard; a "ghost" of canvas; and a soft version of vinyl.

Beginning in 1965 Oldenburg sketched plans for numerous public monuments of colossal household objects, among them a pair of scissors, a plug, a drainpipe, and an ironing board. The first proposal to be executed was *Monument for Yale University: Lipstick* (1969). Aided by the fabricators Lippincott, Inc., Oldenburg continues to produce monumental metal sculpture.

Oldenburg's preoccupation with the objects of modern culture allied him closely with the Pop Art movement and by the mid-1960s, he had established a reputation as one of its leading exponents. His first major museum exhibition took place in 1969 at the Museum of Modern Art in New York and traveled to Europe. Two years later the Pasadena Art Museum organized an exhibition of Oldenburg's monument proposals; in 1975 the Walker Art Center in Minneapolis presented an exhibition focusing on six specific themes, including the Geometric Mouse, Three-Way Plug, and Clothespins.

Barbara Rose, *Claes Oldenburg*, exhibition catalogue (New York: The Museum of Modern Art, 1969).

Barbara Haskell, *Claes Oldenburg: Object into Monument*, exhibition catalogue (Pasadena, California: Pasadena Art Museum, 1971).

Ellen H. Johnson, *Claes Oldenburg* (Baltimore, Maryland: Penguin Books, 1971).

Walker Art Center, *Oldenburg: Six Themes*, exhibition catalogue, introduction by Martin Friedman and interviews with the artist (Minneapolis, Minnesota:1975).

Coosje van Bruggen and Claes Oldenburg: *Dessins, aquarelles et estampes*, exhibition catalogue (Paris: Centre Georges Pompidou, Musée National d'Art Moderne, 1977).

Coosje van Bruggen and Claes Oldenburg, *Claes Oldenburg, Large-scale Projects, 1977–1980* (New York: Rizzoli International, 1980).

Philip Pearlstein

Pittsburgh, Pennsylvania, 1924–

In 1949, Philip Pearlstein graduated with a B.F.A. from Carnegie Institute of Technology, Pittsburgh, and moved to New York. For the next eight years he supported himself as a typographer and mechanical draftsman for industrial catalogues. In addition to painting, he studied art history at New York University's Institute of Fine Arts (M.A., 1955), writing on Francis Picabia.

During his first years in New York, Pearlstein's primary artistic preoccupation was landscape, which he painted in an Abstract Expressionist style, with churning paint surfaces in somber tones. He chose aspects of nature—clusters of rocks and tangles of roots—that lent themselves to the all-over compositional emphasis of Action Painting. His landscapes of the late 1950s, painted in Italy when he was on a Fulbright scholarship, show a steady movement toward realism and illusionism. In 1962 he began painting directly from models, producing loosely brushed studies of nudes seated on the floor. His mature painting style, developed by the mid-1960s, retains the abrupt cropping of figures and severe foreshortening of his early figurative work, but abandons the lax brushwork in favor of a sharp, precise rendering of forms. His nudes appear either alone or in pairs and are bathed in a harsh, artificial light that accentuates the contrasting shadows. Erotic suggestion and conventional beauty are eschewed; the human form is treated almost as a still-life object. In the 1970s, although he continued to paint from the figure, he returned to landscape in oils, watercolors, and prints.

Since the early 1950s Pearlstein has exhibited extensively in one-artist and group exhibitions, developing a reputation as a leading realist painter. He has lectured widely and taught at several schools, including Pratt Institute and, since 1968, at Brooklyn College. Pearlstein's first museum retrospective opened in 1970 at the Georgia Museum of Art, the University of Georgia, Athens, and traveled to two other institutions. Several retrospectives of his prints and drawings were held in the 1970s. In 1983 a traveling retrospective was organized by the Milwaukee Art Museum.

Linda Nochlin, *Philip Pearlstein*, exhibition catalogue (Athens, Georgia: Georgia Museum of Art, The University of Georgia, 1970).

Ellen Schwartz, "A Conversation with Philip Pearlstein," *Art in America*, 59 (September–October 1971), pp. 50–57.

Michael Auping, *Philip Pearlstein: Paintings and Watercolors*, exhibition catalogue (Sarasota, Florida: John and Mable Ringling Museum of Art, 1981).

Russell Bowman, Philip Pearlstein, and Irving Sandler, *Philip Pearlstein: A Retrospective*, exhibition catalogue (New York and London: Milwaukee Art Museum, Alpine Fine Arts Collection, 1983).

Jackson Pollock

*Cody, Wyoming, 1912–
The Springs, New York, 1956*

Jackson Pollock grew up in rural and suburban areas of Arizona and California. He enrolled in the Manual Arts High School in Los Angeles in 1928, a classmate of Philip Guston. Two years later he moved to New York, where he studied at the Art Students League until 1933. While working on the Works Progress Administration/ Federal Art Project from 1935 to 1942, he produced landscapes and figurative paintings whose rhythmic compositions and curvilinear forms reveal the profound influence of his League teacher, the American Scene painter and muralist Thomas Hart Benton. Pollock also admired the Mexican muralists José Clemente Orozco and Diego Rivera, and worked with David Alfaro Siqueiros in 1938. Although he ultimately rejected the social and political content in the work of these older artists, the expressionism and large-scale format of their art continued to inspire him.

In the late 1930s, Pollock came under the influence of Picasso's surrealistic works and he began filling his compositions with mythical and totemic imagery. In 1943 Peggy Guggenheim gave him the first of his many one-artist exhibitions at her Art of This Century Gallery in New York, as well as a contract that extended through 1947 and allowed him to paint full time. In 1947 Pollock's mature and radically innovative painting style emerged. He worked from all sides of his composition, dripping and pouring paint onto the canvas, which he placed directly on the floor. The results were complex linear patterns that lack a single focal point and appear to extend beyond the limits of the canvas. In its emphasis on spontaneous gesture, the energetic involvement of the artist's body, and the primacy of paint, Pollock's mature work constitutes perhaps the most avant-garde and influential achievement of the Abstract Expressionists.

After Pollock and the painter Lee Krasner were married in 1945, they lived in The Springs, Long Island, New York. In the late 1940s and early 1950s, Pollock had many one-artist shows—most frequently at the Betty Parsons Gallery in New York. He participated in important group exhibitions in the United States and in Europe, including nearly all the Whitney Museum Annuals between 1946 and 1954 and two Venice Biennales (1948, 1950). Despite Pollock's international renown, he never traveled outside the United States. He died in an automobile accident in 1956 in The Springs. Beginning with a memorial exhibition that year, the Museum of Modern Art, New York, has organized four exhibitions of Pollock's work, including a major retrospective in 1967. The most recent survey took place at the Centre Georges Pompidou, Musée National d'Art Moderne, Paris, in 1982.

Sam Hunter, *Jackson Pollock*, exhibition catalogue, published in *The Museum of Modern Art Bulletin*, 24 (1956–57).

Frank O'Hara, *Jackson Pollock* (New York: George Braziller, 1959).

Francis V. O'Conner, *Jackson Pollock*, exhibition catalogue (New York: The Museum of Modern Art, 1967).

William Rubin, "Jackson Pollock and the Modern Tradition," *Artforum*, 5 (February, March, April, May 1967).

Francis V. O'Connor and Eugene Victor Thaw, eds., *Jackson Pollock: A Catalogue Raisonné of Paintings, Drawings, and Other Works* (New Haven, Connecticut: Yale University Press, 1978).

Centre Georges Pompidou, Musée National d'Art Moderne, *Jackson Pollock*, exhibition catalogue with 22 essays by various authors (Paris, 1982).

Elizabeth Frank, *Jackson Pollock*, Modern Masters Series (New York: Abbeville Press, 1983).

Francis Frascina and Charles Harrison, *Abstract Expressionism and Jackson Pollock* (Milton Keynes, England: Open University Press, 1983).

Richard Pousette-Dart

St. Paul, Minnesota, 1916–

The son of a painter and a poet, Richard Pousette-Dart grew up in Valhalla, New York. After a brief stint at Bard College in Annandale-on-Hudson, New York, he moved to New York City in 1936, where he worked as an assistant to the sculptor Paul Manship and then for several years as a secretary and bookkeeper. He painted and drew only at night until 1940, when he began to paint full-time. Pousette-Dart's work of the late 1930s and early 1940s is Cubist in style and incorporates totemic images and biomorphic shapes similar to those in the work of his contemporaries Pollock, Gottlieb, and Rothko.

Pousette-Dart had his first one-artist exhibition in 1941, and three years later participated in the important exhibition "Abstract Painting and Sculpture in America" at the Museum of Modern Art in New York. In the late 1940s and 1950s, the specific shapes of his earlier painting dissolved somewhat, giving way to an increased emphasis on overall composition, bright color, and meticulous paint build-up. Layer upon layer of paint produces a luminous, vibrating surface that evokes the mythical and spiritual themes of the Abstract Expressionists.

Pousette-Dart had many solo exhibitions in the 1940s in New York, and between 1949 and 1973, his work was included in nearly every Annual and Biennial Exhibition at the Whitney Museum of American Art, which also gave him his first major retrospective in 1963. Since 1959, he has taught at several art schools and universities in the New York area.

In the 1960s and 1970s, the biomorphic shapes of Pousette-Dart's abstractions became very small and were scattered evenly across the canvas, functioning in pointillist fashion as frames for color, rather than as distinct pictorial elements. Many of these paintings are dominated by central circular or elliptical shapes, the primary colors of which contrast with those of the backgrounds. A major exhibition of these later works was organized in 1974 by the Whitney Museum.

John Gordon, *Richard Pousette-Dart*, exhibition catalogue (New York: Frederick A. Praeger for the Whitney Museum of American Art, 1963).

Vivien Raynor, "An Arts Magazine Profile: Richard Pousette-Dart," *Arts Magazine*, 39 (January 1965), pp. 34–39.

James K. Monte, *Richard Pousette-Dart*, exhibition catalogue (New York: Whitney Museum of American Art, 1974).

Lucy R. Lippard, "Richard Pousette-Dart: Toward an Invisible Center," *Artforum*, 13 (January 1975), pp. 51–53.

Gail Levin, "Richard Pousette-Dart's Emergence as an Abstract Expressionist," *Arts Magazine*, 54 (March 1980), pp. 125–29.

Maurice Prendergast

St. John's, Newfoundland, 1859–New York City, 1924

As a young man, Maurice Prendergast made his living in Boston, first working for a dry goods store and later as an illustrator and calligrapher. He received his first formal art training in Paris in 1891 at the Académie Julian. Painting outside the Académie studios, however, was more important for his development. Early watercolors of the French seaside resort of Dieppe and Parisian street scenes, as well as his later oils, reflect his attraction to the painting of Cézanne and the Nabis group: Bonnard, Vuillard, Vallotton, and their associates. On his next European trip (1898–99), Prendergast spent most of his time in Italy, where he discovered the work of the Venetian Renaissance master Carpaccio. This encouraged him to use a warmer palette and to portray crowds, processions, and festivals, rather than the individuals and small groups which had characterized his earlier work in Paris.

When Prendergast was not traveling in Europe, he lived with his younger brother, Charles, in Winchester, Massachusetts. His brother's frame-making business provided their main source of income until Maurice started selling his paintings and watercolors. He began visiting New York frequently in the early 1900s, when he commenced his well-known series of watercolors of Central Park, which capture the late nineteenth-century bourgeois elegance of the park. At this time, Prendergast began exhibiting at New York's Macbeth Galleries. His inclusion in its historic 1908 exhibition of The Eight has often been misinterpreted to suggest an affinity between Prendergast and the concerns of this urban realist group. In fact, Prendergast's work, in subject and technique, differs considerably from that of The Eight.

The increasingly abstract development of Prendergast's later work reflects the Post-Impressionist art he encountered on his four European trips between 1907 and 1914 and at the 1913 Armory Show in New York. Although the Prendergast brothers made New York their home after 1914, Maurice continued to paint seascapes inspired by summers on the New England coast. His outdoor scenes were first rendered in watercolor—a medium he excelled at throughout his life—and then developed into oil compositions in his studio.

Prendergast's paintings were included in numerous group exhibitions at New York galleries from 1900 on; his watercolors and monotypes were exhibited in a large survey at the Cincinnati Art Museum in 1901. Another major exhibition of his work during his lifetime took place in 1915 at the Carroll Galleries in New York. Memorial exhibitions were held by the Cleveland Museum of Art (1926) and by the Whitney Museum of American Art (1934). In 1960, the Museum of Fine Arts, Boston, sponsored a retrospective of Prendergast's work and in 1976, the University of Maryland Art Gallery organized a traveling retrospective.

Hedley Howell Rhys, *Maurice Prendergast, 1859–1924*, exhibition catalogue (Boston: Museum of Fine Arts, 1960).

Eleanor Green, Ellen Glavin, and Jeffrey R. Hayes, *Maurice Prendergast*, exhibition catalogue (College Park, Maryland: The University of Maryland Art Gallery, 1976).

David W. Scott, *Maurice Prendergast*, exhibition catalogue (Washington, D.C.: The Phillips Collection, 1980).

Patterson Sims, *Maurice B. Prendergast: A Concentration of Works from the Permanent Collection*, exhibition catalogue (New York: Whitney Museum of American Art, 1980).

Man Ray

Philadelphia, Pennsylvania, 1890–Paris, France, 1976

Man Ray (born Emmanuel Radinski) learned the basics of architecture, engineering, and lettering in high school in Brooklyn, New York. After graduation he worked as a commercial illustrator for various New York firms, studying in his free time at the Art Students League and the National Academy of Design. In 1912 he attended drawing classes taught by Robert Henri and George Bellows at the Ferrer Center, a New York educational center founded by sympathizers of the Spanish anarchist Francisco Ferrer.

Under a variety of modernistic influences provided by the 1913 Armory Show and exhibitions at Alfred Stieglitz's 291 Gallery, Man Ray experimented with painting, sculpture, and photography. Cubism in particular impressed him and its stylistic components appear in his paintings of this time. A compulsive artistic innovator, Man Ray was one of the few American artists to make significant contributions to the international avant-garde art movements of Dada and Surrealism. Between 1915 and 1921, he and Marcel Duchamp were key members of the New York Dada contingent. In 1920, he helped to found, along with Katherine Dreier, Duchamp, and others, the Société Anonyme, a pioneering organization for the collection and exhibition of modern art in the United States.

In 1921, after Man Ray and Duchamp published the first and only issue of *New York Dada*, Man Ray followed the French artist to Paris. Soon he was making films and, in the darkroom, solarizations and the first "rayographs" ("cameraless photographs" produced by placing objects on unexposed photographic paper and then exposing them to light for a few seconds). With the end of Dada and the advent of Surrealism, Man Ray's films, photographs, and paintings took on Surrealist overtones. His most famous sculptures, or "objects," usually combine several media and evoke surreal, and often humorous, associations.

Because his art was so avant-garde, Man Ray's first one-artist exhibitions in New York, at the Charles Daniel Gallery (1915, 1916,

and 1919) and those in the 1920s at various galleries in Paris, were generally critical and commercial failures. His commercial photography, penetrating photographic portraits of French painters, sculptors, writers, and composers, provided most of his income during the 1920s. By the mid-1930s, however, Surrealism had become recognized as a significant art force and Man Ray's work was in great demand for individual and group exhibitions. The Nazi occupation of Paris in 1940 drove Man Ray back to the United States, and he settled in Hollywood, California. In 1951 he returned to Paris, where he worked prolifically until his death.

Man Ray's work has been included in numerous photography exhibitions and in nearly all the important Dada and Surrealist group exhibitions. Retrospectives were organized by the Los Angeles County Museum of Art in 1966, the Boymans-van Beuningen Museum, Rotterdam, in 1971, and the Frankfurt Kunstverein in 1979. In 1974 the New York Cultural Center presented a comprehensive survey of his art.

Man Ray, *Self Portrait*, Atlantic Monthly Press Book (Boston and Toronto: Little, Brown and Company, 1963).

Jules Langsner, *Man Ray*, exhibition catalogue, with essays by the artist and seven other contributors (Los Angeles: Los Angeles County Museum of Art, 1966).

Alain Jouffroy, *Man Ray*, exhibition catalogue (Rotterdam: Museum Boymans-van Beuningen, 1971).

Roland Penrose, *Man Ray* (Boston: New York Graphic Society, 1975).

Arturo Schwarz, *Man Ray: The Rigour of Imagination* (New York: Rizzoli International, 1977).

Ad Reinhardt

Buffalo, New York, 1913– New York City, 1967

After graduating from Columbia University in 1935, Adolph Frederick Reinhardt attended both the National Academy of Design and the American Artists' School in New York. His art was always abstract, even in his student works of the mid-1930s, and in 1937 he began exhibiting with the American Abstract Artists. Reinhardt's paintings and collages of the late 1930s, with their interlocking, hard-edge, rectilinear shapes of solid color, resemble those of Carl Holty, his instructor at the American Artists' School and fellow member of the American Abstract Artists. While employed by the Easel Project of the Works Progress Administration/Federal Art Project from 1937 to 1941, Reinhardt produced small Synthetic Cubist canvases. During the 1940s, he replaced the crisp, geometric forms with loose, calligraphic strokes distributed evenly over the canvas. Although this style appeared similar to that of the emerging Abstract Expressionists, it derived from Oriental art, one of the subjects he studied at New York University's Institute of Fine Arts between 1946 and 1952.

By the end of the 1940s, stimulated by the work of Piet Mondrian and Josef Albers, Reinhardt reintroduced into his painting a grid structure of rectangular color blocks, from which he developed in the early 1950s the severely reductionist style for which he is best known. His mature works feature symmetrically placed rectangles of a single color with subtle variations in value. After 1960, he produced only black paintings, in which the shifts in color value became barely perceptible. The striking simplicity of these paintings established Reinhardt as an important precursor of Minimalism.

Reinhardt began teaching at Brooklyn College in 1947 and at Hunter College, New York, in 1961. He wrote extensively about art, and was one of the most articulate and scholarly artists of his generation. He also produced numerous incisive, occasionally caustic, collage-cartoons parodying the art world.

Beginning in the 1940s, Reinhardt exhibited at the Betty Parsons Gallery, New York, and in many Whitney Museum Annuals. The Jewish Museum in New York held the first one-artist museum exhibition of Reinhardt's work in late 1966, less than a year before his death. In 1972–73, the Städtische Kunsthalle in Düsseldorf circulated an exhibition through Europe, and in 1980, the Solomon R. Guggenheim Museum, New York, presented an exhibition of Reinhardt's mature paintings. A survey of paintings and drawings was organized by the Staatsgalerie Stuttgart in 1985.

Lucy R. Lippard, *Ad Reinhardt*, exhibition catalogue (New York: The Jewish Museum, 1966).

Ad Reinhardt, *Art-as-Art: The Selected Writings of Ad Reinhardt*, ed. Barbara Rose (New York: The Viking Press, 1975).

Margit Rowell, *Ad Reinhardt and Color*, exhibition catalogue (New York: The Solomon R. Guggenheim Museum, 1980).

Patterson Sims, *Ad Reinhardt: A Concentration of Works from the Permanent Collection*, exhibition catalogue (New York: Whitney Museum of American Art, 1980).

Lucy R. Lippard, *Ad Reinhardt* (New York: Harry N. Abrams, 1981).

Larry Rivers

Bronx, New York, 1923–

Larry Rivers began painting in 1945, after military service and a brief period studying music at the Juilliard School, and playing the saxophone in jazz bands in and around New York City. He studied at Hans Hofmann's school (1947–48), and under William Baziotes and other New York School painters at New York University (1949–51).

Rivers' early expressionist figure paintings and drawings earned him moderate critical success. He soon became less interested in the spontaneity and accidentalism of the prevailing abstract styles and more

concerned with depicting specific subjects, both contemporary and historical. He took well-known images from such Old Masters as Ingres, Rembrandt, and the American painter Emanuel Leutze, and placed them in series in painterly collages. He also painted loosely brushed portraits of family and friends using multiple images. In the late 1950s, while maintaining his gestural execution, Rivers began employing stenciled letters and words, as well as images from the commercial environment—cards, cigarette advertisements, money, and signs—thus placing himself midway between Abstract Expressionism and Pop Art.

In 1963 he started to employ wood, Plexiglas, and other materials to build the forms of his paintings into relief, and since the late 1960s, he has experimented with airbrush techniques and mechanical devices for transferring images. Themes such as the Civil War, the Boston Massacre, the Russian Revolution, and—after his 1967 trip to Africa—black history, have been subjects for major paintings/constructions. Rivers has also designed several stage sets and collaborated in the production of videotapes.

Since the early 1950s, Rivers has had a steady series of one-artist exhibitions and has participated in important group shows in the United States and Europe. In 1965, his first museum retrospective was organized by the the Poses Institute of Fine Arts, Rose Art Museum, Brandeis University; it traveled to several other museums in the United States. Fifteen years elapsed before another major museum exhibition of Rivers' work took place—in late 1980 at the Kestner-Gesellschaft in Hanover.

Sam Hunter, *Larry Rivers*, exhibition catalogue (Waltham, Massachusetts: Poses Institute of Fine Arts, Brandeis University, 1965).

Sam Hunter, *Rivers* (New York: Harry N. Abrams, 1971).

Phyllis Rosenzweig, *Larry Rivers*, exhibition catalogue (Washington, D.C.: Hirshhorn Museum and Sculpture Garden, Smithsonian Institution, 1981).

Helen A. Harrison, *Larry Rivers: Performing for the Family; An Exhibition of Paintings, Sculpture, Drawings, Mixed Media Works, Films and Video, 1951–1981*, exhibition catalogue (East Hampton, New York: Guild Hall Museum, 1983).

Mark Rothko

Dvinsk, Russia, 1903–
New York City, 1970

Mark Rothko, born Marcus Roth-kowitz, immigrated with his family to Portland, Oregon in 1913. In 1925, after two years at Yale University (1921–23), he settled in New York, where he worked at odd jobs and studied intermittently at the Art Students League. Nineteen twenty-eight marked the beginning of Rothko's close friendship with Milton Avery, who exerted an important and long-lasting influence on the younger painter. The simple forms and soft, lyrical color of Avery's work remained salient features of Rothko's painting.

Rothko had his first one-artist exhibition in New York in 1933, and two years later joined with Ilya Bolotowsky, Adolph Gottlieb, and others to form The Ten, a group of experimental painters with whom he exhibited until 1939. In the early 1940s, Rothko worked closely with Gottlieb; both relied on primitive art for much of their imagery, and together they developed an art based on myth. Under the influence of European Surrealism, Rothko's imagery soon became more obscure and abstract. In 1947 he began to formulate what would become his mature style, in which luminous, color rectangles with frayed edges are stacked horizontally and seem to float within or on the canvas. His emphasis on large color expanses and flat, smooth canvas surfaces distinguishes his work from that of the more painterly Abstract Expressionists.

In 1948, Rothko—along with William Baziotes, Robert Motherwell, and David Hare—founded the short-lived Subjects of the Artist School, a loosely organized art school devoted to the open exchange of ideas between students and faculty. Rothko was one of the few Abstract Expressionists to receive major public commissions, beginning with the monumental canvases for the Four Seasons restaurant in the Seagram Building, New York (1958–59). (He completed the paintings, but unhappy with the location, did not deliver them.) Commissions for murals for Harvard University and for a chapel in Houston followed in the 1960s.

In 1961 the Museum of Modern Art in New York organized the first major one-artist exhibition of Rothko's work. Rothko became increasingly fearful of hostile public reception; between this exhibition and his death by suicide in 1970, he had no major exhibitions and showed few new paintings. In 1978 the Solomon R. Guggenheim Museum, New York, presented a major retrospective of his paintings.

Peter Selz, *Mark Rothko*, exhibition catalogue (New York: The Museum of Modern Art, 1961).

Lee Seldes, *The Legacy of Mark Rothko* (New York: Holt, Rinehart and Winston, 1974).

Diane Waldman, *Mark Rothko, 1903–1970: A Retrospective*, exhibition catalogue (New York: The Solomon R. Guggenheim Museum, 1978).

Dore Ashton, *About Rothko* (New York: Oxford University Press, 1983).

Bonnie Clearwater, *Mark Rothko: Works on Paper*, exhibition catalogue (New York: Hudson Hills Press in association with The Mark Rothko Foundation and The American Federation of Arts, 1984).

Lucas Samaras

Kastoria, Greece, 1936–

Born in Greece, Lucas Samaras was brought to New Jersey in 1948. In 1955, he entered Rutgers University, where he studied with Allan Kaprow and George Segal. After graduation in 1959, he pursued art history on the graduate level at Columbia University until 1962, specializing in Byzantine art. His early works present unusual combinations of different materials— canvases to which common objects are attached, three-dimensional glass panel arrangements painted with flowers, and figurative sculptures made from rags dipped in plaster. During this time he also performed in the Happenings created by Kaprow, Dine, Oldenburg, and Robert Whitman.

In 1960, Samaras created his first boxes, small, crude, and stuffed with plastered rags or crepe paper shaped into grotesque faces. Throughout the 1960s he produced an array of boxes, filled and covered with bizarre, often sinister arrangements of objects, such as pins, nails, knives, stuffed birds, stones, mirrors, tangled masses of hair, and colorful, winding patterns of yarn. In 1966, he made the first of his Transformation series—eyeglasses of eccentric forms and materials. These were followed in 1968 by Transformations of knives and scissors, and in 1969–70, chair Transformations. While many of his works contain tangential autobiographical references, his obsession with self is most explicit in his mid-1960s drawings derived from X-rays of his body, in his environments—the 1964 reconstruction of his New Jersey bedroom and the 1966 *Mirror Room*—and in the dreamlike Autopolaroids and photographic portraits of the 1970s in which he always appears. Although Samaras shares with Pop artists a preoccupation with ready-made objects, his work does not refer to American consumer culture, but to himself, to his body, and to childhood memories of World War II, the Greek civil war, and the rituals of the Greek Orthodox Church. His juxtaposition of incongruous elements, as well as his obsession with metamorphosis and with his own psyche, allies Samaras' work to that of the Surrealists.

Samaras' first one-artist exhibition took place in 1955, at Rutgers University. He exhibited frequently in solo and group exhibitions in New York throughout the 1960s, and internationally, beginning late in the decade. In 1971 the Museum of Contemporary Art, Chicago, exhibited a group of Samaras' boxes and the following year, the artist's first museum retrospective opened at the Whitney Museum of American Art. Museum exhibitions of his pastels and photographs have occurred since.

Lawrence Alloway, *Samaras* (New York: Pace Gallery, 1966).

Joan C. Siegfried, *Lucas Samaras: Boxes*, exhibition catalogue (Chicago: Museum of Contemporary Art, 1971).

Lucas Samaras, *Lucas Samaras*, exhibition catalogue (New York: Whitney Museum of American Art, 1972).

Kim Levin, *Lucas Samaras* (New York: Harry N. Abrams, 1975).

George Segal

New York City, 1924–

In 1942, after studying for a year at the Cooper Union School of Art and Architecture in New York, George Segal returned home to help his parents run their chicken farm in South Brunswick, New Jersey. For the next four years he studied part-time at Rutgers University, resuming full-time art training in 1947 at Pratt Institute, Brooklyn. He completed his B.S. in art education in 1949 at New York University and earned an M.F.A. from Rutgers in 1963.

From 1949 to 1958 Segal operated his own chicken farm in New Jersey to support himself while pursuing his painting, which featured loosely drawn figures against background planes of bright, raw color. In the late 1950s, Segal took part in several of Allan Kaprow's earliest Happenings. Kaprow's notion of art as an all-encompassing activity involving several media influenced Segal; in 1958 he made his first figurative sculptures, which he placed in front of paintings. Three years later, he produced his first figures, made with plaster bandages used to set broken limbs. He cast from live models, and placed the figures in everyday settings using real furniture. Throughout the 1960s and 1970s his works ranged from one or two figures with furniture, to complete environments, among the latter, a gas station, a diner, a subway, and a Forty-second Street scene. The ghost-like whiteness of his figures seems anomolous with their lifelike scale and everyday surroundings. In 1971 Segal began casting from inside the mold, acquiring more accurate impressions of the model's body. With this technique he executed a group of plaster bas-relief sculptures of sections of the body as well as full-scale figures that he occasionally painted black, bright red, or blue.

Since the mid-1950s, Segal's sculpture has been seen regularly in one-artist and group exhibitions in American and European galleries and museums. The first important museum presentation of his work took place in 1968 at Chicago's Museum of Contemporary Art. A decade later the Walker Art Center in Minneapolis organized a major traveling retrospective.

William C. Seitz, *Segal* (New York: Harry N. Abrams, 1972).

Jan van der Marck, *George Segal* (New York: Harry N. Abrams, 1975).

José L. Barrio-Garay, *George Segal: Environments*, exhibition catalogue (Philadelphia: Institute of Contemporary Art, University of Pennsylvania, 1976).

Martin Friedman and Graham W. J. Beal, *George Segal: Sculptures*, exhibition catalogue (Minneapolis: Walker Art Center, 1978).

Phyllis Tuchman, *George Segal*, Modern Masters Series (New York: Abbeville Press, 1983).

Richard Serra

San Francisco, California, 1939–

Between 1957 and 1961 Richard Serra worked in steel mills to support himself and finance his art studies at California universities. He then studied with Josef Albers at Yale University (M.F.A., 1964). After a year in Paris, he received a Fulbright grant to work in Italy, where he became involved with performance and environmental art. At his first one-artist show, in 1966 in Rome, he exhibited arrangements of cages and boxes of live and stuffed animals and birds.

After Serra returned to the United States, he made sculptures in the form of belt-like harnesses of rubber tubing, and floor pieces of thick rubber sheets, both of which often incorporated networks of neon lights. In the late 1960s, he tore thin pieces of lead into strips and placed them in crumpled piles on the floor; his Splash pieces from these same years were made by tossing molten lead into the juncture of floor and wall. The forms these pieces assumed were dictated by the materials, the process, and the force of gravity. The focus on process as well as the looping forms are reminiscent of Jackson Pollock's drip paintings. In Serra's Prop series of 1968–70, gravity remains a central issue: lead or hot-rolled steel plates are held in place against the wall by tubular rolls of lead; or they lean against one another, depending solely on the thrust and counterthrust of their own weight to provide support. The concept of

process became a permanent element in these works since the force of opposing weights must be maintained if the piece was to keep its form. Serra's works embody a strong sense of physicality and weight; their raw, unfinished surfaces transmit the sculptor's primary concerns for materiality and process.

Throughout the 1970s, Serra employed his innovative sculptural principles in large, outdoor, urban sculptures, beginning with the Skullcracker series, assembled in 1969 at the Kaiser Steelyard in conjunction with the Art and Technology exhibition that year at the Los Angeles County Museum of Art. He has also made numerous large charcoal and oil paint stick drawings, whose monolithic, black planes resemble his sculpture. In films and videotapes he has illustrated his sculptural theories and processes.

After several one-artist gallery exhibitions in both the United States and Europe, and participation in numerous group exhibitions, Serra had his first major museum exhibition in West Germany in 1978, organized by the Kunsthalle in Tübingen and the Kunsthalle in Baden-Baden. In 1980 the Hudson River Museum, Yonkers, New York, presented an exhibition of Serra's recent work.

Robert Pincus-Witten, "Richard Serra: Slow Information," *Artforum*, 8 (September 1969), pp. 34–39.

Clara Weyergraf, Max Imdahl, Lizzie Borden, and B. H. D. Buchloh, *Richard Serra: Works 66–77*, exhibition catalogue (Tübingen, West Germany: Kunsthalle; Baden-Baden: Kunsthalle, 1978).

Douglas Crimp, "Richard Serra's Urban Sculpture: An Interview," *Arts Magazine*, 55 (November 1980), pp. 118–23.

Donald B. Kuspit, "Richard Serra, Utopian Constructivist," *Arts Magazine*, 55 (November 1980), pp. 124–33.

Richard Serra and Clara Weyergraf, *Richard Serra: Interviews, etc., 1970–1980*, exhibition catalogue (Yonkers, New York: Hudson River Museum, 1980).

Yve-Alain Bois, Rosalind Krauss, and Alfred Pacquement, *Richard Serra*, exhibition catalogue (Paris: Centre Georges Pompidou, Musée National d'Art Moderne, 1983).

Ben Shahn

Kaunas, Lithuania, 1898–
New York City, 1969

Ben Shahn and his family immigrated to Brooklyn, New York, in 1906. From 1913 to 1917, Shahn worked as an apprentice in a Brooklyn lithography shop to finance his college education at New York University and City College and his art training at the National Academy of Design (1919–22). In 1925 and again in 1927–29, Shahn traveled through Europe and North Africa; on his first trip abroad he studied briefly in Paris at the Académie de la Grande Chaumière. The influences of Modigliani, Matisse, Picasso, and Cézanne, among other European artists, are evident in Shahn's early work. His desire to represent his own time and place, however, emerges in gouaches and temperas of the late 1920s. These portrayals of controversial and tragic events, often involving the struggles of American workers to unionize, earned for Shahn artistic prominence as a Social Realist painter. Throughout the 1940s, Shahn continued to produce compositions—including murals, paintings, prints, and photographs—illustrating the hardships of the Depression, war, and life in postwar America. In the 1950s and 1960s, he turned more to personal and religious motifs. Shahn's art is essentially representational; its power and expressiveness derive from the simplification of forms and the distortion of figure, line, and perspective.

During the Depression, Shahn was employed by a number of the federal relief programs. He produced designs for a mural on Prohibition in 1933–34 for the Public Works of Art Project and was commissioned by the Federal Emergency Relief Administration in 1934–35 to prepare murals for the Rikers Island penitentiary, in New York. While employed by the Farm Security Administration between 1935 and 1938, Shahn produced more murals and mural designs for

federal buildings, housing projects, and schools throughout the United States and participated in the FSA's pioneering project to document America's rural poverty in photographs. Beginning with his friendship with the photographer Walker Evans in 1933, Shahn made use of his own photographs as the basis of many of his art's images.

In the 1940s, Shahn designed posters for the Office of War Information and the Congress of Industrial Organizations. He held several teaching positions in the 1940s and 1950s, including the Charles Eliot Norton Professor of Poetry chair at Harvard University (1956–57).

Shahn had his first one-artist exhibition in 1930 at the Downtown Gallery in New York, with which he maintained an affiliation throughout his career. His work was included in nearly every Whitney Museum Biennial and Annual Exhibition held during his lifetime. His first retrospective was held in 1947 at the Museum of Modern Art. In 1961–62, the same institution organized a retrospective that traveled to four major European museums. Important posthumous exhibitions were organized by the Santa Barbara Museum of Art in 1967 and, in 1976, by the Jewish Museum in New York.

James Thrall Soby, *Ben Shahn* (New York: The Museum of Modern Art, 1947).

Selden Rodman, *Portrait of the Artist as an American. Ben Shahn: A Biography with Pictures* (New York: Harper & Brothers Publishers, 1951).

Ben Shahn, *The Shape of Content* (Cambridge, Massachusetts: Harvard University Press, 1957).

James Thrall Soby, *Ben Shahn Paintings* (New York: George Braziller, 1963).

John D. Morse, ed., *Ben Shahn* (New York: Praeger Publishers, 1972).

Bernarda Bryson Shahn, *Ben Shahn* (New York: Harry N. Abrams, 1972).

Kenneth Wade Prescott, *Ben Shahn: A Retrospective, 1898–1969*, exhibition catalogue (New York: The Jewish Museum, 1976).

Joel Shapiro

New York City, 1941–

Joel Shapiro grew up in New York City where he attended New York University, receiving a B.F.A. in 1964 and an M.F.A. in 1969. That same year he made his public debut, at the Whitney Museum's "Anti-Illusion: Procedures/Materials" exhibition with nylon filament wall pieces which revealed his interest in Process Art. Over the next several years he exhibited small slabs of unaltered substances (clay, glass, copper, lead) placed on shelves, and clusters of small nut-shaped units, made of clay, wood, and stone, textured by the workings of the hand or a tool. The very small scale and material density of these works also characterized his subsequent sculpture; in 1972 he introduced the other staple of his mature style, recognizable imagery.

Using basic geometric forms, he constructed tiny bridges, followed by houses, and later, figurative pieces. With these works Shapiro included the exhibition space as an ingredient in his sculpture. The small, dense forms situated on the floor activate, indeed emotionalize, the space of the ascetic, high-ceilinged gallery. Their associational qualities attract, but their intimate porportions distance the spectator. In the early 1980s Shapiro began to make large-scale geometric stick figures. The precarious and ambiguous poses they strike—falling, balancing on one leg—reflect the sculptor's continued interest in activating the spaces surrounding his works.

Thus, like many other Post-Minimalists, Shapiro infuses Minimalist geometry with a playful, evocative spirit. Using emotionally charged imagery, human proportions, and the traditional techniques of casting and construction, he created artworks that communicate directly with the viewer. The small, abstract sculptures he made in the late 1970s are also constructed from basic geometrical components; they are related to Post-Minimal attempts to reconsider the traditional division between abstraction and representation.

Shapiro's work has been included in numerous group exhibitions. Since 1970 he has had solo exhibitions almost annually at the Paula Cooper Gallery in New York. One-artist museum exhibitions of his work were organized by Chicago's Museum of Contemporary Art in 1976, the Whitechapel Art Gallery in London in 1980, and by the Whitney Museum in 1982.

Marc Fields, "On Joel Shapiro's Sculptures and Drawings," *Artforum*, 16 (Summer 1978), pp. 31–37.

Robert Pincus-Witten, "Strategies Worth Pondering: Bochner, Shapiro, Reise, LeWitt," *Arts Magazine*, 52 (April 1978), pp. 142–45.

John Coplans, "Joel Shapiro: An Interview," *Dialogue*, 1 (January–February, 1979), pp. 7–9.

Roberta Smith and Richard Marshall, *Joel Shapiro*, exhibition catalogue (New York: Whitney Museum of American Art, 1982).

Charles Sheeler

Philadelphia, Pennsylvania, 1883–Dobbs Ferry, New York, 1965

Dissatisfied with his studies at the School of Industrial Art of the Pennsylvania (later Philadelphia) Museum, Charles Sheeler enrolled in the Pennsylvania Academy of the Fine Arts in 1903. Sheeler joined Academy instructor William Merritt Chase and fellow students on 1904 and 1905 summer trips to England, Holland, and Spain. He traveled to Italy with his parents in 1908–09; his return to the United States took him through Paris, where he was exposed to the avant-garde art of Cézanne, the Fauves, and the Cubists.

Between 1910 and 1918, Sheeler and his close friend and fellow artist Morton Schamberg shared a small, isolated farmhouse in Doylestown, Pennsylvania, 25 miles north of Philadelphia. During this period, Sheeler made regular visits to New York, where he met Alfred Stieglitz, Louise and Walter Arensberg, and other members of the New York avant-garde art community. The need for a regular income prompted Sheeler, in 1912, to take up photography. Most of his commissions were to document architectural and advertising projects, but he consistently concentrated on the artistic possibilities of the medium.

After Schamberg's death in 1918, Sheeler moved to New York and there developed the Precisionist painting style for which he is best known. Using the decorative art and architectural details he had first photographed in the Doyles-town area, Sheeler composed still-life paintings in which objects rendered with sharp lines and geometric forms were set in distorted spatial arrangements. Similarly, to paint his "industrial landscapes," Sheeler referred to photographs he had taken of the Ford Motor Company's River Rouge Plant in Michigan in 1927–28. The forms in these paintings, although generalized, are even more precisely and cleanly rendered. In his late work (after about 1946), similar industrial forms were dissected and reconstituted in a sophisticated Cubist fashion.

Sheeler began his first sustained gallery affiliation in 1931, with the Downtown Gallery, New York, and within a year he no longer needed to rely on photographic assignments for his income. Sheeler was given a retrospective at the Museum of Modern Art in 1939. He had many important exhibitions in his later years, including a traveling exhibition organized by the Art Galleries of the University of California at Los Angeles in 1954. Sheeler suffered a severe stroke in 1959 which left him unable to paint. Among important posthumous exhibitions was the 1968 traveling retrospective organized by the National Collection of Fine Arts in Washington, D.C.

Constance Rourke, *Charles Sheeler: Artist in the American Tradition* (New York: Harcourt, Brace and Company, 1938).

William Carlos Williams and Charles Sheeler, *Charles Sheeler: Paintings, Drawings, Photographs*, exhibition catalogue (New York: The Museum of Modern Art, 1939).

Martin Friedman, Bartlett Hayes, and Charles Millard, *Charles Sheeler*, exhibition catalogue (Washington, D.C.: Smithsonian Institution Press for the National Collection of Fine Arts, 1968).

Martin Friedman, *Charles Sheeler* (New York: Watson-Guptill Publications, 1975).

Patterson Sims, *Charles Sheeler, A Concentration of Works from the Permanent Collection*, exhibition catalogue (New York: Whitney Museum of American Art, 1980).

John Sloan

Lock Haven, Pennsylvania 1871–Hanover, New Hampshire, 1951

For nearly the first twenty years of his adult life, John Sloan made his living as a commercial illustrator. He worked for the Philadelphia *Inquirer* (1892–95) and the Philadelphia *Press* (1895–1903), and took on free-lance assignments, which included illustrating Paul de Kock's novels. After settling permanently in New York in 1904, Sloan produced illustrations for magazines such as *Collier's* and *The Century*. With no conscious ambition to be a painter, he avoided formal art training, except for brief but unsatisfactory study with Thomas Anshutz at the Pennsylvania Academy of the Fine Arts in 1892 and 1893.

Sloan met his future mentor, Robert Henri, in late 1892. Sloan's first oil paintings (c. 1897) were portraits in a style influenced by Henri. Throughout his entire career, Sloan captured—on canvas and in numerous etchings—the ruddy and colorful character of the urban working classes as well as the leisure activities of the middle and upper classes. He was an important member of The Eight; his work was included in the group's exhibition at the Macbeth Galleries in 1908.

At different points in his career, Sloan introduced conscious stylistic changes into his art. Although he never traveled to Europe, exposure to the work of van Gogh, Matisse, and the Fauves at the 1913 Armory Show spurred him to brighten his palette, to pay closer attention to compositional structure, and diminish narrative content. In the 1920s, Sloan experimented with techniques such as underpainting, color glazes, and what he called "form realization"—the use of parallel linear strokes to deepen the shaded areas of three-dimensional forms. By 1925, he was regarded as one of the best American printmakers, and he continued in his later years to produce numerous etchings and occasional book illustrations. In the late

1920s and 1930s Sloan made many paintings and etchings of female nudes. He spent thirty consecutive summers in New Mexico between 1919 and 1949, and depicted the dramatic landscape and inhabitants near Santa Fe.

Sloan was elected president of the Society of Independent Artists in 1918 and served in that capacity until his death. From 1916 to 1938 he was a dedicated and popular teacher at the Art Students League. In 1918, two years after his first one-artist show at the Whitney Studio, he became a charter member of the Whitney Studio Club and participated in many of its exhibitions. He also exhibited regularly at the Kraushaar Galleries, New York, and had important one-artist exhibitions at the Addison Gallery of American Art, Andover (1938), and at Dartmouth College (1946). In his lifetime, however, Sloan sold few works, perhaps because his art ran counter to the popular stylistic trends. A major posthumous retrospective was organized in 1971 by the National Gallery of Art in Washington.

John Sloan, *Gist of Art* (New York: American Artists Group, 1939).

Lloyd Goodrich, *John Sloan, 1871–1951* (New York: Whitney Museum of American Art, 1952).

Van Wyck Brooks, *John Sloan: A Painter's Life* (New York: E. P. Dutton, 1955).

David W. Scott and E. John Bullard, *John Sloan, 1871–1951*, exhibition catalogue (Washington, D.C.: National Gallery of Art, 1971).

Patterson Sims, *John Sloan: A Concentration of Works from the Permanent Collection*, exhibition catalogue (New York: Whitney Museum of American Art, 1980).

Hood Museum of Art, Dartmouth College, *John Sloan: Paintings, Prints, Drawings*, exhibition catalogue, with a reminiscence by Helen Farr Sloan and an introduction by Robert L. McGrath (Hanover, New Hampshire: 1981).

David Smith
Decatur, Indiana, 1906–
Bennington, Vermont, 1965

David Smith's art training began in 1923, during his high school years in Paulding, Ohio, when he took a correspondence course in drawing from the Cleveland Art School. In 1924–25 he studied at Ohio University in Athens. He spent the following summer working in the Studebaker plant in South Bend, Indiana, acquiring the techniques for cutting, welding, and riveting metals that he later employed in his sculpture. In 1926 he moved to New York. Through 1931, he studied painting at the Art Students League and also privately with the painter Jan Matulka, who furthered his interest in Cubism.

By 1931 Smith was attaching objects to the surfaces of his paintings, and on a visit to the Virgin Islands in 1931–32, he made his first sculpture from bits of coral. In 1932, he began to produce welded steel sculpture; the following year he established a studio at the Terminal Iron Works in Brooklyn. Smith was influenced most profoundly by the welded iron sculptures of Picasso and Julio Gonzalez that he saw reproduced in the *Cahiers d'Art* in the 1930s. In his early work, linear elements connect Surrealist-inspired, semi-abstract forms and found objects, producing open, emphatically Cubist constructions. After two years in Europe (1935–37), he continued to develop this abstract style, at the same time, however, producing figurative works protesting war and violence, beginning in 1937–40 with Medals for Dishonor, a series of bronze medallions. His Cubist sculpture grew larger and increasingly abstract in the late 1940s and 1950s. Smith's work constituted a radical departure from traditional, volumetric sculpture, and has inspired many younger sculptors, among them Mark di Suvero, John Chamberlain, and Joel Shapiro.

Smith's first one-artist exhibition took place in 1938. In the ensuing two decades, he had more than thirty solo shows, participated in numerous group exhibitions in Europe and the United States, and taught at several colleges. His first major retrospective took place

in 1957 at the Museum of Modern Art, New York, which also organized traveling exhibitions in 1961 and 1966.

In 1962 the Italian government invited Smith to Voltri, near Genoa, to create twenty-six sculptures using found materials, for the Spoleto festival. After his return he resumed work on his final series, the Cubi, monumental stainless-steel pieces composed in Constructivist fashion from three-dimensional geometric units. Smith was working on the series when he was killed in an automobile accident in 1965. Four years later a retrospective of Smith's sculpture was organized by the Solomon R. Guggenheim Museum, New York. In 1983, major exhibitions of his work were organized by the National Gallery of Art and the Hirshhorn Museum and Sculpture Garden, Washington, D.C.

Cleve Gray, ed., *David Smith by David Smith* (New York: Holt, Rinehart and Winston, 1968).

Edward F. Fry, *David Smith*, exhibition catalogue (New York: The Solomon R. Guggenheim Museum, 1969).

Rosalind E. Krauss, *Terminal Iron Works: The Sculpture of David Smith* (Cambridge, Massachusetts, and London: The MIT Press, 1971).

Garnett McCoy, ed., *David Smith* (New York: Praeger Publishers, 1973).

E. A. Carmean, Jr., *David Smith*, exhibition catalogue (Washington, D.C.: National Gallery of Art, 1982).

Edward F. Fry and Miranda McClintic, *David Smith: Painter, Sculptor, Draftsman*, exhibition catalogue (New York: George Braziller in association with the Hirshhorn Museum and Sculpture Garden, Smithsonian Institution, Washington, D.C., 1982).

Stanley E. Marcus, *David Smith: The Sculptor and His Work* (Ithaca and London: Cornell University Press, 1983).

Karen Wilkin, *David Smith*, Modern Masters Series (New York: Abbeville Press, 1984).

Robert Smithson
Passaic, New Jersey, 1938–
Amarillo, Texas, 1973

During his childhood Robert Smithson was fascinated with science and planned to become a naturalist. While in high school, however, he became interested in art and in 1953 he won a scholarship to the Art Students League in New York.

In 1957 and for the next several years, Smithson painted and exhibited Abstract Expressionist canvases. In 1962 his art took the form of biological specimens and chemical substances placed in bottles. Although his work was to change considerably throughout his career, from this point forward scientific inquiry would always be the catalyst for his art. Crystallography, for example, inspired his sculptures of 1964–65, with their regular geometric components and smooth steel and mirror surfaces.

In 1968 Smithson exhibited, at the Dwan Gallery in New York, a collection of works he named Non-sites. He had visited a variety of rural areas despoiled by industry— the "sites" on which his art was based. The Non-site pieces were Minimalist-styled bins containing rocks and debris taken from the site and displayed alongside maps and photographs.

The work for which Smithson is best known are his Earthworks, large-scale projects created at outdoor sites. For the *Spiral Jetty on the Great Salt Lake, Utah*, 1970, he formed a monumental spiral-shaped jetty out of mud, salt crystals, and rocks. *Broken Circle/ Spiral Hill*, 1971, consists of a canal and sand jetty in the form of a broken circle, and a hill of black topsoil and white sand with a spiraling path in Emmen, Holland. These Earthworks illustrate Smithson's major concerns as an artist: the expansion of sculptural space, the affirmation of the contextural nature of art, and the predominance of concept over artifact. The important role concept came to play in his work is attributable, in part, to the impossibility of extended and permanent public viewing of his Earthworks and Sites. Thus Smithson relied increasingly on secondary media—film, photography, and essays—to communicate and record his art.

In the early 1970s, Smithson drew up proposals for parks to be built by reclaiming land from sludge heaps, strip mines, and other industry-ravaged areas. These parks were intended as explorations, not criticisms, of the precarious balance industrial man has established between himself and the natural environment. These proposals were never realized; Smithson was killed in 1973 in an airplane crash while surveying the site for his Earthwork *Amarillo Ramp* in Texas.

During the 1960s and early 1970s Smithson had a number of one-artist exhibitions, including several at the Dwan Gallery in New York. His work has also been seen in many important group exhibitions in Europe and the United States, including a retrospective at the Herbert F. Johnson Museum of Art, Cornell University, Ithaca, New York.

Susan Ginsberg and Joseph Masheck, *Robert Smithson: Drawings*, exhibition catalogue (New York: The New York Cultural Center in association with Fairleigh Dickinson University, 1974).

Nancy Holt, ed., *The Writings of Robert Smithson* (New York: New York University Press, 1979).

Robert Hobbs, *Robert Smithson: Sculpture*, essays by Lawrence Alloway, John Coplans, and Lucy R. Lippard (Ithaca, New York: Cornell University Press, 1981).

Frank Stella
Malden, Massachusetts, 1936–

Frank Stella began painting in the early 1950s, while attending Phillips Academy in Andover, Massachusetts. Between 1954 and 1958 he studied painting and history at Princeton University, where he first produced paintings in an Abstract Expressionist style influenced by Willem de Kooning, then paintings whose flat, horizontal bands of solid color reflected the influence of Mark Rothko. In late 1958, after moving to New York, Stella began his first important series, the Black Paintings, which were inspired by the static simplicity of the mature work of Rothko, Barnett Newman, and by the parallel geometries of Jasper Johns' early flags and targets. Stella placed flatly painted, horizontal and vertical black stripes one within another, creating non-illusionistic, symmetrical patterns that reiterate the shape of the canvas and thus tend to reduce the distinction between image and surface. These paintings drew considerable critical attention and in the summer of 1959 Stella joined the Leo Castelli Gallery in New York, where the following year he had the first of his numerous one-artist exhibitions.

In the early 1960s, still seeking to unite form and content, Stella began altering the canvas shape. Paintings with small notches in the stretchers were followed by canvases with open rectilinear forms—resembling an H, T, or L—and hollow polygons. In the mid-1960s he produced bright, multi-colored, and even more eccentrically shaped paintings. His adherence to hardedge designs predetermined by the canvas shape, and to smooth, quasi-industrial paint surfaces were important contributions to the development of Minimalism.

Stella had his first major museum exhibition in 1970 at the Museum of Modern Art, New York. After this, he began fabricating wood relief constructions whose components follow the strict geometric shapes of his 1960s work. By the mid-1970s, however, he was incorporating into his work some of the gestural aspects of Abstract Expressionism that he had deliberately avoided during the previous decade. His recent metal relief constructions consist of elaborate, curling shapes painted with energetic strokes of bright color and occasionally decorated with glitter. In 1978 the Fort Worth Art Museum organized a major exhibition of the relief constructions.

William Rubin, *Frank Stella*, exhibition catalogue (New York: The Museum of Modern Art, 1970).

Robert Rosenblum, *Frank Stella* (Harmondsworth, England, and Baltimore: Penguin Books, 1971).

Brenda Richardson, *Frank Stella: The Black Paintings*, exhibition catalogue (Baltimore: The Baltimore Museum of Art, 1976).

Philip Leider, *Stella Since 1970*, exhibition catalogue (Fort Worth, Texas: Fort Worth Art Museum, 1978).

Joseph Stella
Muro Lucano, Italy, 1877– New York City, 1946

In 1896, Joseph Stella immigrated to the United States. Between 1897 and 1900 he studied painting at the Art Students League and the New York School of Art. When Stella lived on New York's Lower East Side (1900–05), he made vivid, realistic drawings of immigrants and street scenes, some of which were published in late 1905 in the periodical *The Outlook*. In 1908, *The Survey* commissioned Stella to make a series of drawings of the Pittsburgh industrial scene. The resulting studies of miners and mining towns foreshadowed his later interest in the industrial landscape.

In Paris in 1911–12, Stella met Matisse, Picasso, and the Italian Futurist Carlo Carrà. Futurism influenced Stella's best mature works —the paintings of New York City and its skyscrapers, bridges, and roadways that he produced after his return to America in 1912. With their towering, majestic, and interpenetrating forms, these images glorify the mechanistic aspects of modern life. At the same time, Stella was painting simple, less abstract pictures of buildings, gas tanks, and factories. The sharp contours and smooth, generalized forms of these works aligned him with the Precisionist painters.

Stella's early Futurist paintings were shown at various places in New York, including the Société Anonyme, of which he was a charter member, the Stephan Bourgeois Galleries and the Montross Gallery. Between 1922 and his death in 1946, Stella moved between Paris, New York, and Italy. He renounced his Futurist painting theories and produced representational works, often described as Symbolist in style. Although his Futurist paintings established him as a significant figure in modern American art, the quality of his subsequent work tended to be uneven, and hence did not generate enough interest to be marketable. Stella could not make a living by painting and his later years were marked by periods of poverty.

Stella had many one-artist gallery exhibitions and a 1939 retrospective at the Newark Museum. In 1963, the Whitney Museum of American Art organized a retrospective.

Joseph Stella, "The Brooklyn Bridge (A Page of My Life)," *Transition*, 16–17 (June 1929), pp. 86–88.

———, "Discovery of America: Autobiographical Notes," *Art News*, 59 (November 1960), pp. 41–43, 64–67.

John I. H. Baur, *Joseph Stella*, exhibition catalogue (New York: Whitney Museum of American Art in association with Shorewood Publishers, 1963).

Irma B. Jaffe, *Joseph Stella* (Cambridge, Massachusetts: Harvard University Press, 1970).

Judith Zilczer, *Joseph Stella*, exhibition catalogue (Washington, D.C.: Smithsonian Institution Press for The Hirshhorn Museum and Sculpture Garden, 1983).

Clyfford Still
Grandin, North Dakota, 1904– Baltimore, Maryland, 1980

As a child growing up in Spokane, Washington, and Bow Island, Alberta, Clyfford Still spent most of his free time painting and studying art, music, and literature. In 1931 he enrolled at Spokane University with a teaching fellowship in art. After graduating in 1933, he taught at Washington State College in Pullman, Washington, until 1941. During this time he produced semiabstract landscape and figurative paintings whose angular and elongated forms presaged his mature abstract style.

While working in the shipbuilding and aircraft industries from late 1941 until 1943, Still painted little. When he resumed painting, his work became increasingly nonfigurative; by 1947, all allusions to the figure had been eliminated. His style continued basically unchanged during the rest of his career. His abstractions are composed of vertically elongated areas of dark earth tones or brilliant light tones with torn and jagged contours, frequently interspersed with zones of bright color. A sense of infinite expanse is produced by the intersection of these abstract forms with the edges of the canvas.

The primacy of paint is asserted through the rough handling of pigment. The large color areas are similar to those found in the work of the non-gestural Abstract Expressionist painters, such as Rothko and Newman.

Still had his first museum retrospective in 1943 at the San Francisco Museum of Art. Following a 1946 one-artist exhibition at Peggy Guggenheim's Art of This Century Gallery in New York, he had three solo shows at the Betty Parsons Gallery (1947, 1950, 1951).

Outspoken in his belief that the world of exhibitions and collectors compromises the integrity of the artist and the quality of his work, Still refused a number of requests from museums to participate in group and solo exhibitions. He also carefully controlled the distribution of his paintings. In 1964 he gave thirty-one paintings to the Albright-Knox Art Gallery in Buffalo, which exhibited them in 1966, and a room of the museum was dedicated to Still later that same year. He made a similar gift of twenty-eight paintings to the San Francisco Museum of Modern Art in 1976 and a permanent gallery for them was established there also. In 1979 the Metropolitan Museum of Art in New York organized a large retrospective of Still's paintings.

The Buffalo Fine Arts Academy, *Paintings by Clyfford Still*, exhibition catalogue, with notes by the artist (Buffalo: Albright Art Gallery, 1959).

Ti-Grace Sharpless, *Clyfford Still*, exhibition catalogue (Philadelphia: Institute of Contemporary Art, University of Pennsylvania, 1963).

Thomas Albright, "A Conversation with Clyfford Still," *Art News*, 75 (March 1976), pp. 30–35.

San Francisco Museum of Modern Art, *Clyfford Still*, exhibition catalogue, statement by the artist and correspondence between the artist and Henry T. Hopkins (San Francisco: 1976).

John P. O'Neill, ed., *Clyfford Still*, exhibition catalogue (New York: The Metropolitan Museum of Art, 1979).

John Storrs

Chicago, Illinois, 1885–
Mer, France, 1956

Between 1907 and 1939, John Storrs crossed the Atlantic thirty-three times. His early trips were an escape from the pressure exerted by his father to enter the real estate business, as well as a means for him to pursue art studies at schools in Germany and Paris. He also studied art in Chicago, Boston, and Philadelphia. Storrs spent the years 1912–17 studying with Rodin and is reputed to have been among the French sculptor's favorite pupils. After his father died in 1920, Storrs returned frequently to the United States because his father's will threatened to reduced his inheritance substantially if he ever became a permanent resident of a foreign country. Between 1927 and 1939, Storrs spent at least eight months of every year in the United States, even though his wife was French and he maintained a studio in Paris and a château near Orléans.

By 1917 Storrs had broken away from the Rodin-inspired naturalism that had dominated his early work and was producing stylized figurative sculpture whose flattened forms and incised lines anticipated Art Deco. His figurative work was enlivened by the faceted surfaces of Cubism. This semi-abstract work was included in Storrs' first one-artist exhibition in 1920 at the Folsom Gallery in New York, one of the first large exhibitions of modern sculpture in the United States.

In the 1920s, Storrs' work grew increasingly abstract. His "non-objective studies in form," as one critic called them, were skyscraper-like pieces endowed with a monumentality beyond their actual sizes. In the 1930s he produced sculptures composed of industrial and tool shapes that link his work to Precisionist painting. Storrs had many solo exhibitions and was represented in important group exhibitions in New York, Chicago, and Paris in the 1920s and 1930s. He received numerous sculpture commissions in Europe and the United States— many from Chicago architects. *Ceres*, installed in 1930 on top of Chicago's new Board of Trade Building, is among the best known and typical of the more conservative figurative works he produced for public commissions.

Storrs spent World War II in France, including two six-month internments in Nazi concentration camps. The resulting physical and mental stress prevented him from returning to work until 1951 and he produced little major work before his death in 1956. Although Storrs was highly respected in France at the time of his death, his work received less acclaim in the United States because he had lived most of his life abroad and because his sculpture was too avant-garde for American taste. There were no large posthumous exhibitions of Storrs' work in America until 1965, when the Downtown Gallery in New York presented a major exhibition. Retrospectives were organized in 1969 by the Corcoran Gallery of Art, Washington, D.C., and in 1977 by the Museum of Contemporary Art, Chicago.

Edward Bryant, "Rediscovery: John Storrs," *Art in America*, 57 (May–June 1969), pp. 66–71.

Herdis Bull Teilman, *Forerunners of American Abstraction*, exhibition catalogue (Pittsburgh: Museum of Art, Carnegie Institute, 1971).

Abraham A. Davidson, "John Storrs: Early Sculptor of the Machine Age," *Artforum*, 13 (November 1974), pp. 41–45.

Judith Russi Kirshner, *John Storrs (1885–1956): A Retrospective Exhibition of Sculpture*, exhibition catalogue (Chicago: Museum of Contemporary Art, 1976)'

Jennifer Gordon, Laurie McGavin, Sally Mills, and Ann Rosenthal, *John Storrs & John Flannagan: Sculpture & Works on Paper*, exhibition catalogue (Williamstown, Massachusetts: Sterling and Francine Clark Art Institute, 1980).

Yves Tanguy

Paris, France, 1900–
Woodbury, Connecticut, 1955

Nothing in the early life of Yves Tanguy indicated that he would become an artist. In 1918, he followed a family tradition by becoming an officer-trainee in the merchant marine. Two years later, he was drafted into the French army. After his discharge in 1922, he settled in Paris, and with no formal art instruction, began sketching. A Giorgio de Chirico painting he saw in 1923 prompted him to begin painting. Although Tanguy destroyed most of his early attempts, the few extant works of the early 1920s are characterized by naively executed figures and imaginary objects suspended in an undefined space. In 1925, Tanguy became a friend of André Breton, poet and leader of the Surrealist movement. The following year, one of Tanguy's works was reproduced in the magazine *La Révolution Surréaliste*, giving Tanguy status as an "official" Surrealist.

Tanguy had his first solo exhibition in 1927, at the Galerie Surréaliste in Paris. In the works exhibited, landscape settings, complete with foreground, horizon, and sky, resolved the spatial ambiguity in his early work. Recognizable objects were eliminated; the landscapes were dotted with biomorphic shapes, precisely rendered and endowed with an emphatic three-dimensionality reminiscent of de Chirico. In the 1930s and 1940s the forms became more rigid and their shadows more distinct, creating a decidedly inhospitable and supernatural mood.

In the late 1930s, Tanguy began exhibiting in galleries in New York, California, and London, and his work was included in many important group exhibitions of the Surrealists. In 1939 Tanguy came to the United States, and in 1940, he married the American Surrealist painter Kay Sage; they made Woodbury, Connecticut, their home. Eight years later, Tanguy became an American citizen. The content of his painting did not change much after his move to America; he

sought only to perfect the execution of his unique, Surrealist vision. By piling his rock-like forms one upon another, he achieved results not unlike the stark, monumental rock formations of the Finistère department of Brittany in which he had vacationed as a child.

Five months before Tanguy's death in 1955, the Wadsworth Atheneum, Hartford, Connecticut, organized a joint exhibition of the work of Tanguy and Sage. In late 1955, eight months after his death, the Museum of Modern Art, New York, presented an important retrospective of Tanguy's work. A definitive survey of his painting and drawing was organized by the Musée National d'Art Moderne, Paris, in 1982.

View Magazine, "Through the Eyes of Poets," special issue on Tanguy and Tchelitchew, includes articles by André Breton, Nicolas Calas, and James Johnson Sweeney, no. 2 (May 1942).

James Thrall Soby, *Yves Tanguy*, exhibition catalogue (New York: The Museum of Modern Art, 1955).

John Ashbery, *Yves Tanguy*, exhibition catalogue (New York: Acquavella Galleries, 1974).

Jean Maurel, Roland Penrose, and Robert Lebel, *Yves Tanguy: Retrospective, 1925–1955*, exhibition catalogue (Paris: Centre Georges Pompidou, Musée National d'Art Moderne, 1982).

Bradley Walker Tomlin

Syracuse, New York, 1899–
New York City, 1953

Bradley Walker Tomlin grew up in Syracuse, New York, where in 1917 he entered the John Crouse College of Fine Arts of Syracuse University. He graduated in 1921 with a degree in painting and a fellowship for a year's study abroad. He worked in New York as a commercial artist for a year before leaving for Europe. While abroad, he visited England and studied in Paris, at the Académie Colarossi and Académie de la Grande Chaumière. After his return to New York in 1924, he continued to do commercial work, producing cover illustrations for *House & Garden* and *Vogue*. In 1925 he spent the first of many summers at the well-known artists' colony in Woodstock, New York.

The still lifes, portraits, and landscapes that Tomlin produced in the 1920s indicate that he was experimenting with a variety of figurative modes, from the loose realism of Henri and Sloan to the clean, sharp style of Demuth and other Precisionist artists. A number of his still lifes resemble those of his close friend the painter Frank London.

In the late 1930s and early 1940s, Tomlin produced semi-abstract paintings, in which fragments of recognizable images are superimposed on Synthetic Cubist grids. Under the influence of Adolph Gottlieb's Surrealist-inspired Pictographs, Tomlin loosened his grid structure; by the late 1940s, like a number of his new colleagues, such as Pollock, de Kooning, and Guston, he began to rely on the painterly mark and gestural execution. Tomlin's mature abstractions characteristically feature thick, light-colored brushstrokes scattered across dark grounds.

Tomlin began exhibiting his work in the 1920s, in one-artist shows in New York and in the Whitney Studio Club annual exhibitions; he continued to be represented in nearly all of the Whitney Museum's Annuals during the 1940s. Major traveling retrospectives of his work were organized in 1957 by the Whitney Museum of American Art in association with the Art Galleries of the University of California, Los Angeles, and in 1975 by the Emily Lowe Gallery of Hofstra University in Hempstead, New York, and the Albright-Knox Art Gallery in Buffalo, New York.

John I. H. Baur, *Bradley Walker Tomlin*, exhibition catalogue, with notes on the artist by Philip Guston, Robert Motherwell, Duncan Phillips, and Frederick S. Wight (New York: The Macmillan Company for the Whitney Museum of American Art, 1957).

Martica Sawin, "Bradley Walker Tomlin," *Arts*, 32 (November 1957), pp. 22–25.

David Bourdon, "In Praise of Bradley Walker Tomlin," *Art in America*, 63 (September–October 1975), pp. 56–60.

Jeanne Chenault, *Bradley Walker Tomlin: A Retrospective View*, exhibition catalogue with three essays by the artist, George L. K. Morris, and Lucille and Walter Fillin (Buffalo: Albright-Knox Gallery, The Buffalo Fine Arts Academy, 1975).

George Tooker

Brooklyn, New York, 1920–

George Tooker learned the rudiments of academic composition and oil painting through childhood art lessons. He attended Phillips Academy, Andover, Massachusetts (1936–38), and Harvard University (1938–42). Although he majored in English literature, much of his time was devoted to drawing and painting. Following his graduation in 1942, Tooker enrolled at the Art Students League in New York, where he studied until mid-1945, primarily with Reginald Marsh.

In 1946, Tooker studied with Paul Cadmus, from whom he learned the Florentine Renaissance technique of egg tempera on gesso panels that he subsequently used for all his paintings. While Tooker's mature work certainly shares in the Surrealist aesthetic, it has been more appropriately described as a kind of symbolic realism. Human figures, burdened with a profound sadness and resignation, are central to all his compositions, some of which illustrate timeless themes, such as youth, beauty, old age, and death. In other, better-known paintings, Tooker depicts the loneliness, anonymity, and even terror of life in modern urban centers. Subways and bureaucratic mazes are memorable settings for his figures, and serial imagery is often employed to transform individual anguish into universal fate.

Tooker had his first one-artist exhibition in 1951 at the Edwin Hewitt Gallery in New York. His work was included in nearly all the Whitney Museum Annuals held from 1947 to 1969. In the early 1960s, Tooker moved to his present home in Hartland, Vermont. He taught at the Art Students League in New York between 1965 and 1968. The first major exhibition of Tooker's work was held in 1967 at Dartmouth College in Hanover, New Hampshire. In 1974, the Fine Arts Museums of San Francisco organized a major traveling exhibition.

Truman H. Brackett, Jr., and Robert L. Isaacson, *George Tooker*, exhibition catalogue (Hanover, New Hampshire: Jaffe-Friede Gallery, Dartmouth College, 1967).

Ralph Pomeroy, "George Tooker, Really," *Art and Artists*, 2 (April 1967), pp. 24–27.

Thomas H. Garver, *George Tooker: Paintings, 1947–1973*, exhibition catalogue (San Francisco: The Fine Arts Museums of San Francisco, 1974).

Merry A. Foresta, *George Tooker*, exhibition catalogue (Los Angeles: David Tunkl Gallery, 1980).

Nancy Walker, "George Tooker," *Art New England*, 2 (March 1981), p. 3.

Richard Tuttle

Rahway, New Jersey, 1941–

Richard Tuttle received a B.A. in Fine Arts from Trinity College in Hartford, Connecticut, in 1963. That same year he moved to New York, where he attended Cooper Union, worked as an assistant at the Betty Parsons Gallery, and made his first sculptures—a series of 3-inch, folded, and incised paper cubes. These were followed in 1964–65 by small wood wall-relief pieces painted in monochrome colors. His work, shown at Parsons Gallery, was influenced by Agnes Martin and Ellsworth Kelly, who also showed there.

In nearly all his subsequent work, Tuttle sought to press the environment into the service of the sculpture. His 1967 series of cloth octagons dyed in muted pastel colors and 1970 white paper octagons have a dematerialized quality which blurs the distinction between the object and surrounding wall or floor space. His works from the early 1970s were made by attaching small pieces of wire, rope, paper, or slats of thin plywood to the wall in such a way that the shadows cast by the materials often possessed stronger visual presences than the physical objects themselves. In other pieces conception and execution took priority: string was dropped on the floor according to predetermined movement patterns. Tuttle's professed aim was to "make objects which look like themselves." His anti-illusionistic

intentions, along with his use of inexpensive, mundane materials and practice of making objects that interact with their environments, allied him with a group of Post-Minimalist artists working in the late 1960s and early 1970s. All were interested in challenging the traditional artistic qualities of illusionism, permanence, and preciousness. His recent work consists of small folded and painted strips of paper or cardboard pasted on larger pieces of paper or directly on the wall, and multimedia assemblages.

Tuttle's work appeared in two major Post-Minimalist group exhibitions in 1969: "Anti-Illusion: Procedures/Materials" at the Whitney Museum and "Live in Your Head: When Attitudes Become Form" at the Kunsthalle Bern, Switzerland. Tuttle has had important one-artist exhibitions at the Whitney Museum (1975), at the Stedelijk Museum, Amsterdam (1979), and at the Museum Haus Lange in Krefeld, West Germany (1980).

Marcia Tucker and James Monte, *Anti-Illusion: Procedures/Materials*, exhibition catalogue (New York: Whitney Museum of American Art, 1969).

Robert Pincus-Witten, "The Art of Richard Tuttle," *Artforum*, 7 (February 1970), pp. 62–67.

Marcia Tucker, *Richard Tuttle*, exhibition catalogue (New York: Whitney Museum of American Art, 1975).

Robert Pincus-Witten, "The Art of Richard Tuttle," *Postminimalism* (New York: Out of London Press, 1977).

Centre d'Arts Plastiques Contemporains, *Richard Tuttle*, exhibition catalogue (Bordeaux, France: 1979).

Cy Twombly
Lexington, Virginia, 1929–

Cy Twombly, born Edwin Parker Twombly, Jr., studied art at the School of the Museum of Fine Arts in Boston from 1948 to 1949. The following year he attended Washington and Lee University in his hometown of Lexington, Virginia. In 1951–52, after a year of study at the Art Students League in New York, Twombly spent two summers and a winter at Black Mountain College, an experimental liberal arts college in North Carolina, where he met Ben Shahn, Robert Motherwell, and Franz Kline. His abstract drawings and paintings of the early 1950s, characterized by tangled masses of dark pencil and crayon lines scattered across light-colored fields, were to some extent influenced by Motherwell's elegant calligraphy and Surrealist automatism, Shahn's emphasis on line, and Kline's black-and-white palette.

Twombly settled in Rome, his present home, in 1957, a move that coincided with the emergence of his mature style. The tentative marks of his early compositions were now combined with legible images—words, letters, numbers—and a personal vocabulary of symbols. While these graffiti-like elements imply a reference to mass culture and thus anticipate Pop Art and Neo-Expressionism, Twombly continued to disperse his forms across the canvas in a loose, flowing, Abstract Expressionist fashion. Often the titles of his works and his peculiar symbols refer to poetry and antique, Renaissance, and Baroque art, which have fascinated him since childhood.

In the early 1950s, Twombly had several one-artist exhibitions in New York galleries, but since his move to Rome, most of his exhibitions have taken place in European galleries and museums. His first museum show opened in 1966 at the Stedelijk Museum in Amsterdam. Major retrospectives of Twombly's paintings and drawings were organized in 1976 by the Musée National d'Art Moderne, Paris, and, in 1979, by the Whitney Museum of American Art.

Robert Pincus-Witten, "Cy Twombly," *Artforum*, 12 (April 1974), pp. 60–64.

Suzanne Delehanty and Heiner Bastian, *Cy Twombly: Paintings, Drawings, Constructions 1951–1974*, exhibition catalogue (Philadelphia: Institute of Contemporary Art, University of Pennsylvania, 1975).

Heiner Bastian, *Cy Twombly: Paintings 1952–1976*, text in German and English (Berlin, West Germany: Propyläen Verlag, 1978).

Roland Barthes, *Cy Twombly: Paintings and Drawings 1954–1977*, exhibition catalogue (New York: Whitney Museum of American Art, 1979).

Padiglione d'Arte Contemporanea, *Cy Twombly: 50 Disegni, 1953–1980*, exhibition catalogue, with essays by Zeno Birolli and Gabriella Drudi (Milan, Italy: 1980).

Jacques Henric, *Cy Twombly: Oeuvres de 1973–1983*, exhibition catalogue (Bordeaux, France: Centre d'Arts Plastiques Contemporains de Bordeaux, Musée d'Art Contemporain, 1984).

Andy Warhol
Forrest City, Pennsylvania, 1930–

Born Andrew Warhola and raised in Pittsburgh, Andy Warhol attended the Carnegie Institute of Technology and received his B.F.A. in 1949. That year he moved to New York, where during the 1950s he became a highly successful commercial artist, publishing drawings in *Glamour*, *Vogue*, and other magazines and designing window displays for department stores. He became famous for his drawings of I. Miller shoes.

In the early 1960s, Warhol began making paintings using images from comic strips, advertisements, and commercial products, such as Coca-Cola bottles and Campbell's soup cans. His choice of commonplace subjects reflected his admiration for the work of Jasper Johns and Robert Rauschenberg. His first paintings exhibit a loose handling of pigment, but by 1962 he had adopted a photographic silkscreen painting process. He transformed photographs of celebrities, cows, flowers, and disasters—car accidents, suicides, an electric chair—into some of the most powerful paintings of the Pop era. The serial presentation of images taken from mass-produced printed material accentuates the banality of the commercial products and strips the disaster images of their emotional charge, imbuing all subjects with the same detached exactitude. Warhol's paintings were first exhibited in Los Angeles in 1962, then in one-artist shows in galleries in New York and Europe throughout the 1960s and 1970s.

Beginning in the mid-1960s, at The Factory, his New York studio, Warhol made films characterized by repetition and attention to commonplace and everyday reality. In 1970, the year a major traveling retrospective of his paintings was organized by the Pasadena Museum of Art, Warhol resumed painting, producing large portraits of celebrities and political figures, including Mao Tse-tung, as well as the Hammer and Sickle series. Although still based on photographs, these paintings display a gestural brushwork and paint buildup not found in his works of the 1960s.

Warhol's work is included in nearly all collections and exhibition surveys of twentieth-century art. Important one-artist exhibitions of his work include the Kunsthaus Zürich retrospective in 1978, and an exhibition of his portraits of the 1970s the following year at the Whitney Museum of American Art.

John Coplans, *Andy Warhol* (Greenwich, Connecticut: New York Graphic Society, 1970).

Rainer Crone, *Andy Warhol* (New York: Praeger Publishers, 1970).

Mary Josephson, "Warhol: The Medium as Cultural Artifact," *Art in America*, 59 (May–June 1971), pp. 40–46.

Robert Rosenblum, *Andy Warhol: Portraits of the Seventies*, exhibition catalogue (New York: Random House in association with the Whitney Museum of American Art, 1979).

Carl Haenlein, ed., *Andy Warhol: Bilder 1961 bis 1981*, exhibition catalogue, with essays by the artist, Rainer Crone, Carl Haenlein, Jonas Mekas, Robert Rosenblum (Hannover, West Germany: Kestner-gesellschaft, 1981).

Carter Ratcliff, *Andy Warhol*, Modern Masters Series (New York: Abbeville Press, 1983).

Max Weber

Bialystok, Russia, 1881–
Great Neck, New York, 1961

Max Weber's family immigrated to the United States in 1891. From 1898 to 1900, he studied art at Pratt Institute in Brooklyn, New York, and in the years following taught art at schools in Lynchburg, Virginia, and Duluth, Minnesota. In 1905, Weber went to Paris and studied at the Académie Julian, the Académie Colarossi, the Académie de la Grande Chaumière, and with Matisse in the artist's studio (1907–08).

Soon after his return to the United States in 1909, Weber had his first one-artist exhibition, at the Haas Gallery in New York. The paintings he produced in this early period reveal his absorption of the modernist styles he was exposed to abroad. He combined Matisse's bold lineation and color with Cézanne's structural principles to render his then favorite subject, the nude. These figures were exhibited in Weber's second solo exhibition, this time at Alfred Stieglitz's 291 Gallery in 1911. Although decried by a bewildered press and public, these works anticipated the profoundly Cubist character of Weber's abstract paintings of 1915–18. In such paintings, he fragmented the figure or motifs extracted from the urban environment placing them in distinctly Cubist arrangements.

All of Weber's work after 1919—painting, prints, and sculptures—is representational. Formal concerns surfaced again, however, in the 1930s, when he began to use line more independently; in the 1950s, he reintroduced Cubist distortion, investing this late work with an expressive fervor.

Through the 1920s, Weber supported himself by teaching—at the Clarence White School of Photography (1914–18) and at the Art Students League (1920–21, 1925–27). The Museum of Modern Art held a retrospective of Weber's work in 1930, but he had no real financial success until his 1941 one-artist exhibition at the Associated American Artists Gallery in New York. The following year he became affiliated with the Paul Rosenberg Gallery and had annual exhibitions there until 1947. Retrospectives of Weber's work were organized by the Whitney Museum of American Art in 1949 and by Pratt Institute and the Newark Museum in 1959. In his late years, Weber received many honors and awards. There have been several posthumous exhibitions, the most comprehensive at the Art Galleries of the University of California at Santa Barbara in 1968 and at the Jewish Museum in 1982.

Lloyd Goodrich, *Max Weber* (New York: The Macmillan Company for the Whitney Museum of American Art, 1949).

William H. Gerdts, Jr., *Max Weber*, exhibition catalogue (Newark, New Jersey: The Newark Museum, 1959).

Ala Story, *First Comprehensive Retrospective Exhibition in the West of Oils, Gouaches, Pastels, Drawings, and Graphic Works by Max Weber, 1881–1961*, exhibition catalogue (Santa Barbara, California: The Art Galleries, University of California, 1968).

Alfred Werner, *Max Weber* (New York: Harry N. Abrams, 1975).

Daryl R. Rubenstein, *Max Weber: A Catalogue Raisonné of His Graphic Work* (Chicago: The University of Chicago Press, 1980).

Percy North, *Max Weber: American Modern*, exhibition catalogue (New York: The Jewish Museum, 1982).

H. C. Westermann

Los Angeles, California, 1922–
Danbury, Connecticut, 1981

In 1947, after military service and a U.S.O. tour of the Orient with an acrobatic act, H(orace) C(lifford) Westermann settled in Chicago, where he took advertising and design courses at the School of the Art Institute until 1950. He reenlisted in the marines in 1951, and served for a year in Korea. When he returned to Chicago, he entered the School of the Art Institute. He also began working as a carpenter and was soon applying woodworking techniques to his sculpture, which he was producing exclusively by 1954.

Using wood, metal, glass, and found objects, Westermann fabricated sculptures of pure invention. Typically, his objects are enclosed in a box, their combination deriving from a personal fantasy or nightmare: a burning house, a squat brass war god, a suicide tower, a mad house. Westermann's war experiences were central to the formation of his artistic vision. The ships, shark fins, and palm trees that recur frequently in his pieces refer directly to his naval experience in the Pacific. Other works evoke a satiric humor through the use of visual paradoxes, word puns, trompe l'oeil, and unexpected juxtapositions. He also produced witty, imaginative cartoon-like drawings.

Although Westermann's art matured at a time when realism was reemerging as a viable alternative to abstraction, his style differed markedly from the Pop artist's dispassionate presentation of the banal. Westermann's assured craftsmanship imbues his humble objects with elegance and dignity. His work is reminiscent of Joseph Cornell's boxes, and corresponds also to Dada and Surrealist aesthetics —without, however, their psychological and metaphysical foundation.

From 1958 on, Westermann exhibited regularly with the Allan Frumkin Gallery in Chicago and then New York. His work has been included in important group exhibitions, such as the Museum of Modern Art's 1961 "Art of Assemblage" show. The first major museum exhibition of Westermann's work was organized in 1968 by the Los Angeles County Museum of Art. Ten years later the Whitney Museum of American Art organized a major traveling retrospective, and in late 1980, one year before the artist's death, the Arts Council of Great Britain presented a retrospective.

Dennis Adrian, "The Art of H. C. Westermann," *Artforum*, 4 (September 1967), pp. 16–22.

Max Kozloff, *H. C. Westermann*, exhibition catalogue (Los Angeles: Los Angeles County Museum of Art, 1968).

Barbara Haskell, *H. C. Westermann*, exhibition catalogue (New York: Whitney Museum of American Art, 1978).

Dennis Adrian, *H. C. Westermann*, exhibition catalogue (London: Ernest Benn in cooperation with the Arts Council of Great Britain, 1980).

Jackie Winsor

St. John's, Newfoundland, Canada, 1941–

Jackie Winsor grew up on the coast of Newfoundland. From her parents she learned the rudiments of carpentry essential in the construction of her mature sculpture. In 1951 she moved with her family to Cambridge, Massachusetts. She received a B.F.A. from Massachusetts College of Art in 1965 and an M.F.A. two years later from Rutgers University. In 1967 she settled in New York City.

Although Winsor trained as a painter, by the late 1960s she was working almost exclusively in sculpture. Her early works were small, organic-shaped wall pieces with fine hair-like extensions. Her first mature works—huge, freestanding coils of rope—were made in 1969–70. Other pieces were produced by layering, and then nailing thin slats of wood together to form cubes and cylinders, or by binding sticks and logs tightly together with twine, making squares and grids that lean against the wall. Later she wound twine and copper wire around wooden cores to form heavy, bulbous spheres and explored the sculptural possibilities of cement, bricks, sheetrock, and even tree trunks.

All of these works share certain features that are also characteristic of the large, freestanding cubes that dominated her oeuvre by 1979: the use of unconventional materials and procedures, an explicit display of process, and an almost obsessional tendency to bind and define interior spaces, resulting in the suggestion of energy under restraint. Her recent cubes are typically 3-by-3-by-3 feet and include a wooden one covered with fifty coats of acrylic paint, one stuffed with paper and set on fire, and a concrete and lathing cube inside which explosives have been detonated.

Winsor's sculptural style is as much indebted to 1960s Minimalism as it is to Process Art, as evidenced by her attachment to primary geometric configurations— cylinders, squares, cubes, and

grids—her tendency to repeat like elements, and her concern with symmetry and classical restraint. Yet the repeated manipulation of a single form, the anti-industrial, handmade quality, and an attention to small details situate her art squarely within the Post-Minimalist aesthetic of the 1970s.

Winsor's work has appeared in numerous group exhibitions and in several one-artist shows, including three at the Paula Cooper Gallery in New York (1973, 1976, 1982). She had a retrospective exhibition in 1979 at the Museum of Modern Art, New York, and at the Paula Cooper Gallery, New York, in 1982 and 1983.

Jackie Winsor and Ellen Phelan, *Jackie Winsor: Sculpture*, exhibition catalogue, with introduction by Jack Boulton (Cincinnati, Ohio: Contemporary Arts Center, 1977).

Robert Pincus-Witten, "'Winsor Knots': The Sculpture of Jackie Winsor," *Arts Magazine*, 51 (June 1977), pp. 127–33.

Roberta Smith, "Winsor Built," *Art in America*, 65 (January– February 1977), pp. 118–20.

Lucy Lippard, *Strata: Nancy Graves, Eva Hesse, Michelle Stuart, Jackie Winsor*, exhibition catalogue (Vancouver, British Columbia: The Vancouver Art Gallery, 1977).

Ellen H. Johnson, *Jackie Winsor*, exhibition catalogue (New York: The Museum of Modern Art, 1979).

Andrew Wyeth
Chadds Ford, Pennsylvania, 1917–

Andrew Wyeth attended no art schools or other academic institutions. Instead, he had private tutors until he was sixteen and his art teacher was his father, N. C. Wyeth, a distinguished illustrator. Andrew Wyeth had his first one-artist exhibition at the age of twenty, in 1937 at the Macbeth Galleries in New York, and every painting in the show was sold—a pattern which has continued throughout his career. He did not travel abroad until 1977 and has shown little interest in the avant-garde aesthetic issues that have preoccupied many of his contemporaries.

Wyeth has spent every winter of his life on a farm near Chadds Ford, Pennsylvania, where his family had moved in 1908, and nearly every summer on the Maine coast, in Port Clyde or Cushing, where his family owns land. His early paintings—primarily impressionistic nature studies—were inspired by the landscape of these areas and the work of Winslow Homer. With the death of his father in 1945, Wyeth profoundly changed the style and content of his art. He continued to work only in dry brush, watercolor, and tempera, but focused his compositions on meticulously recorded details—a berry basket, a rain-drenched rock, the sun falling on the side of a house or shed—narrative content was essentially eliminated. All evidence of contemporary culture is omitted and a timeless, rural quality pervades his paintings. After 1945, Wyeth also began painting portraits, carefully recording the features of his sitters, often several members of local families. The results are penetrating, objective studies which reveal no attempt to soften or flatter.

Wyeth has been the recipient of many awards and honors, including honorary Doctor of Fine Arts degrees from Harvard University (1955) and Swarthmore College (1958). His work has been shown in several major exhibitions, among them a traveling exhibition organized in 1966–67 by the Pennsylvania Academy of the Fine Arts in Philadelphia and one-artist exhibitions presented by the Fine Arts Museums of San Francisco in 1973, the National Museum of Modern Art in Tokyo in 1974, and New York's Metropolitan Museum of Art in 1976.

Edgar P. Richardson, *Andrew Wyeth*, exhibition catalogue (Philadelphia: Pennsylvania Academy of the Fine Arts, 1966).

Richard Meryman, *Andrew Wyeth* (Boston: Houghton Mifflin Company, 1968).

David McCord, *Andrew Wyeth*, exhibition catalogue (Boston: Museum of Fine Arts, 1970).

Wanda M. Corn, *The Art of Andrew Wyeth*, exhibition catalogue, essays by Brian O'Doherty, Richard Meryman, E. P. Richardson (Greenwich, Connecticut: New York Graphic Society for The Fine Arts Museums of San Francisco, 1973).

Betsy James Wyeth, *Wyeth at Kuerners* (Boston: Houghton Mifflin Company, 1976).

Betsey James Wyeth, *Christina's World* (Boston: Houghton Mifflin Company, 1982).

Photograph Credits

Whitney Museum of American Art
Selected Works from the Permanent Collection
was designed by Katy Homans, Homans/Salsgiver;
typeset in Monotype Walbaum by Michael & Winifred Bixler;
and printed in Japan by Dai Nippon Printing Company, Ltd.